FLYING CLOUDS

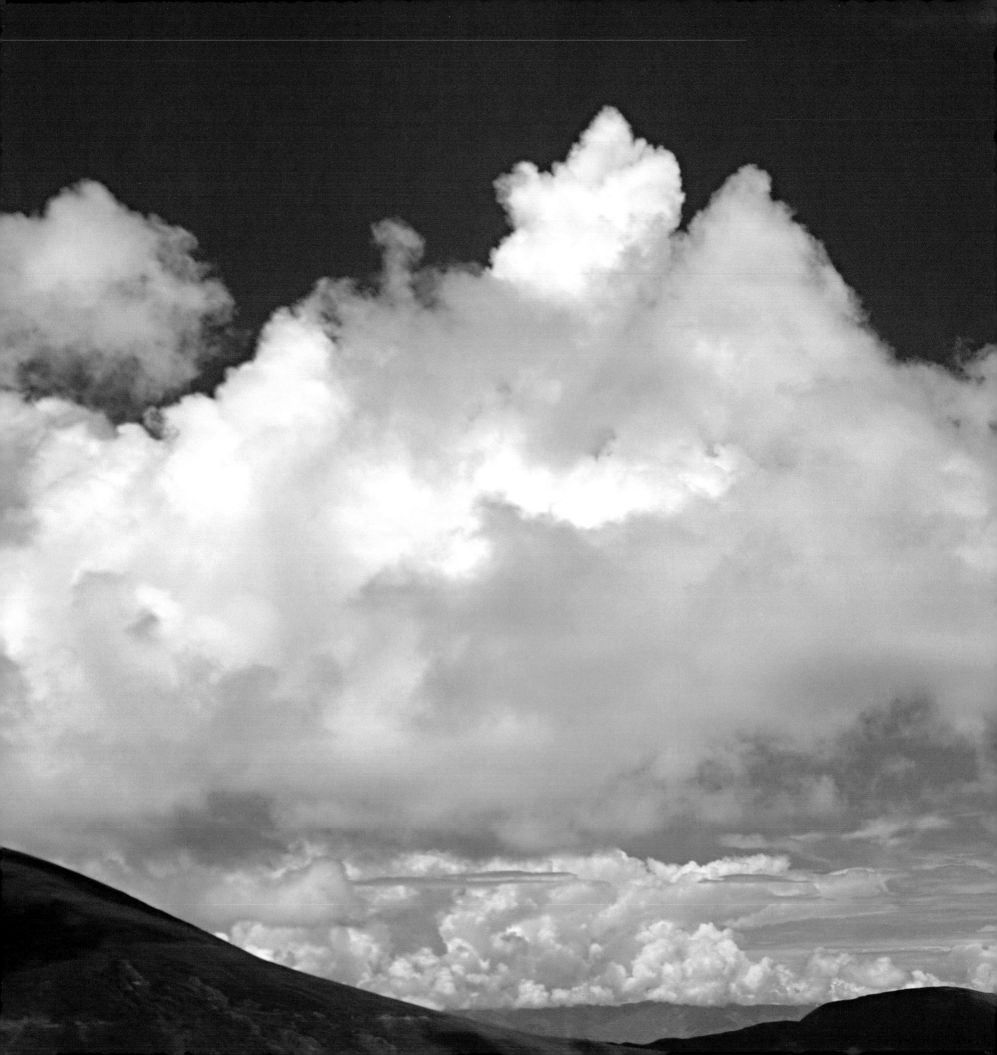

FLYING CLOUDS
WHEREVER YOU ARE, YOU ARE STILL YOU
BING YANG

PHOTOGRAPHS BY BING YANG
TEXT BY BING YANG AND DENNIS GIAUQUE

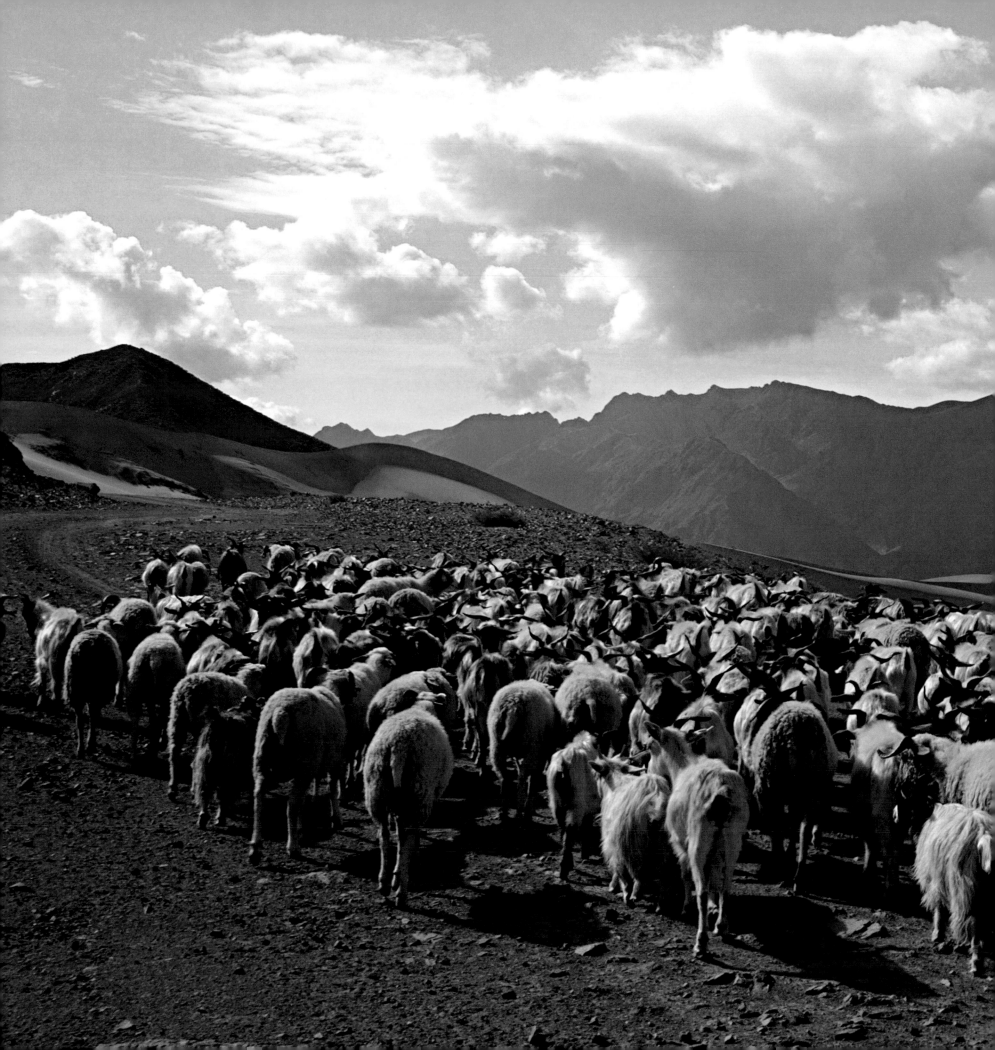

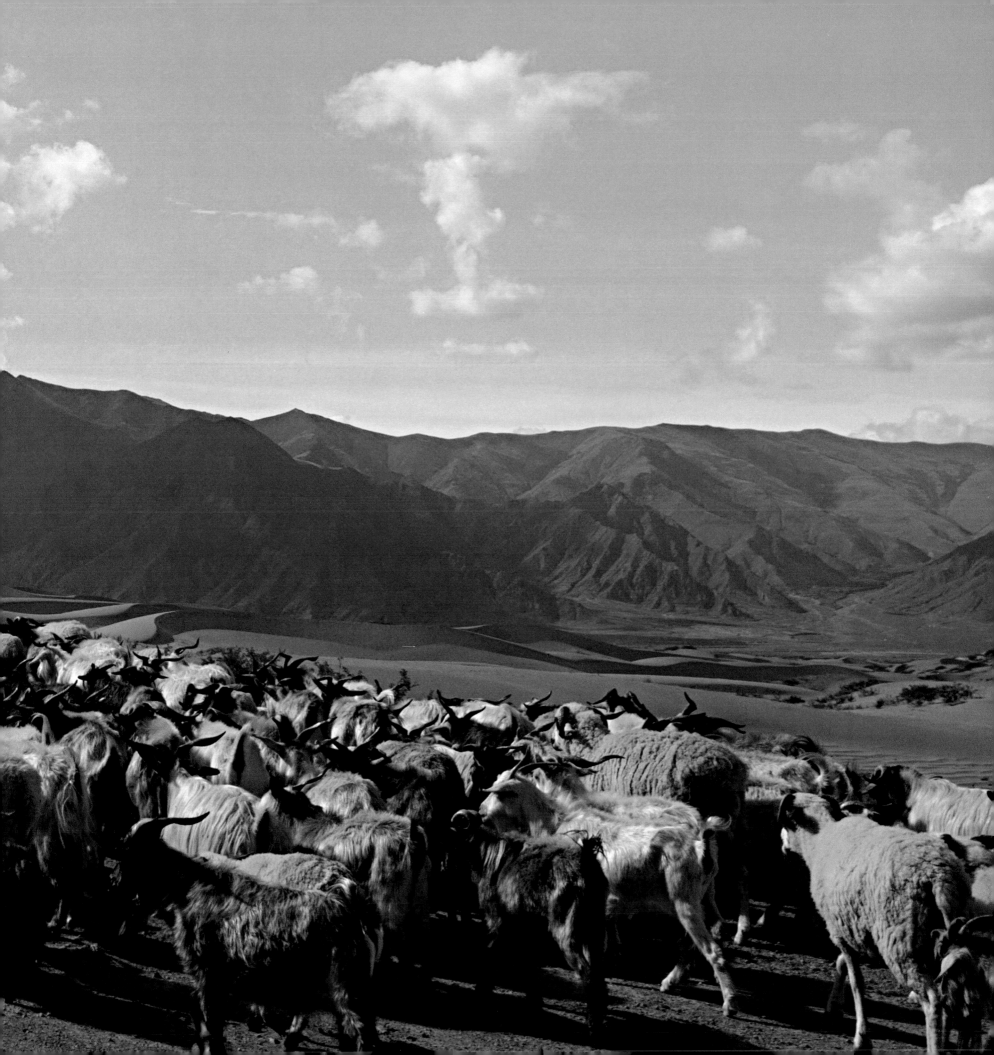

Published by the QCC Art Gallery Press, The City University of New York, Bayside, New York.

Library of Congress Cataloging-in-Publication Data

Yang, Bing, 1942-
[Works. Selections]
Flying clouds : wherever you are you are still you / photography and text Bing Yang; editor cowriter, Dennis Giauque; design editor, Chaolun Baatar.
p. cm
ISBN 978-1-936658-27-5 (alk. paper)
1. Photography of clouds—Catalogs. 2. Yang, Bing, 1942- I. Giauque, Dennis, editor. II. Yang, Bing. Photographs. Selections. III. QCC Art Gallery. IV. Title.
TR733.Y36 2014
779'.3—dc23 2014033995

Printed in Taiwan

1st ed. 1000 copies, 300pp, 29.5cm x 29.5cm

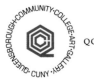

QCC ART GALLERY, THE CITY UNIVERSITY OF NEW YORK

CONTENTS

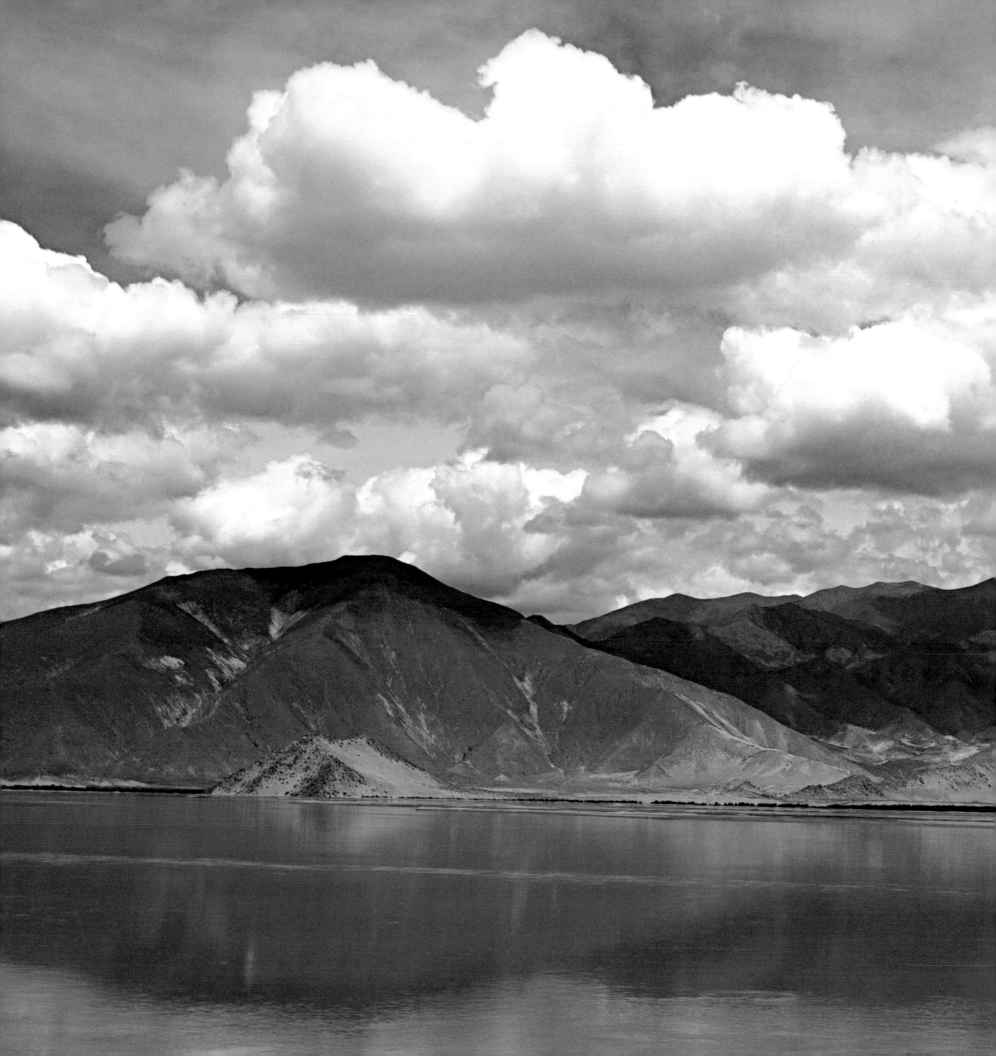

FOREWORD

We look up. We see clouds. Whether they appear still, their movement slight or belabored, or in dramatic hurry, there is portent and change. We never see stasis, we see what we've just seen, we see what will soon be seen. We just happen to see clouds in flight.

In image and in word, this is what my dear friend Bing Yang has given us in this splendid collection of photographs: this moment in movement, this movement in moment. In scenes that are vast and majestic and human and simple and thrilling, we are invited to sense, glimpse, and appreciate this experience.

Bing's photographs are of the countryside and villages and cities and people of Central and Southeast Asia, and they afford us a view of a world that is lesser known, somehow innocent, and largely timeless, certainly in comparison to what we know in the West. Yet, however faraway or curious or magnificent, the apprehension is less tourism than the reflection dawning upon us: That this time—this place, this journey—is our own too.

We see the universal in the local, the ethereal in the earth, the beautiful in the plain, the eternal in the moment—and, needless to say, the obverse as well. We see, in this collection of photographs, a gift.

Elmer Luke
Cooperstown, New York

INTRODUCTION

Art is a vehicle to the inner world, the world of pure perception and understanding. Bing Yang's photography visually records this philosophic quest, while his poetry reiterates in song. His photographic brush and written reflections emanate from his spirit. Bing Yang charts a human's course: a progressive journey beginning with our first entry into the world through a continual metamorphosis in pursuit of immortality—or rather from one's present physical existence to our final metaphysical transcendence.

Pure of spirit, we begin by receiving food and communication. We enter into the wholeness of nature, with its conflicts and contradictions in order to transcend it, perhaps just to get back to the point where we began. As for the path of a mystic: "Children are spiritual beings growing into their physicality; adults are full physical beings rediscovering their spirituality."

Bing Yang's art balances form and content with deep spirituality. He provides us with the opportunity to acquaint ourselves with his perceptions, including the ability to transcend the sometimes unbearable present moment in anticipation of tomorrow. Yang traces the sunrise and sunset of man's journey, as we mark the beginning and the end of each day. He pauses to take notice of our journey akin to Rabindranath Tagore, whose sonorous voice exclaims: "At sunrise, open and raise your heart like a blossoming flower, and at sunset bend your head and in silence complete the worship of the day."

Creativity and receptivity form the dichotomy required to embrace every stage of life to come to terms with finding oneself, sad or happy, to arrive at the final destination, oneness. Truth is freedom, our most precious commodity, but it does not consist in creating our personal paradise. Arrival at the end of our journey, the ascension to nothingness, is only the beginning of passing to "transcendence," as Giuseppe Ungaretti wrote: "m'illumino d'immenso."

Faustino Quintanilla
Executive Director, QCC Art Gallery
The City University of New York, Bayside, New York

I come to this world with nothing

PURE

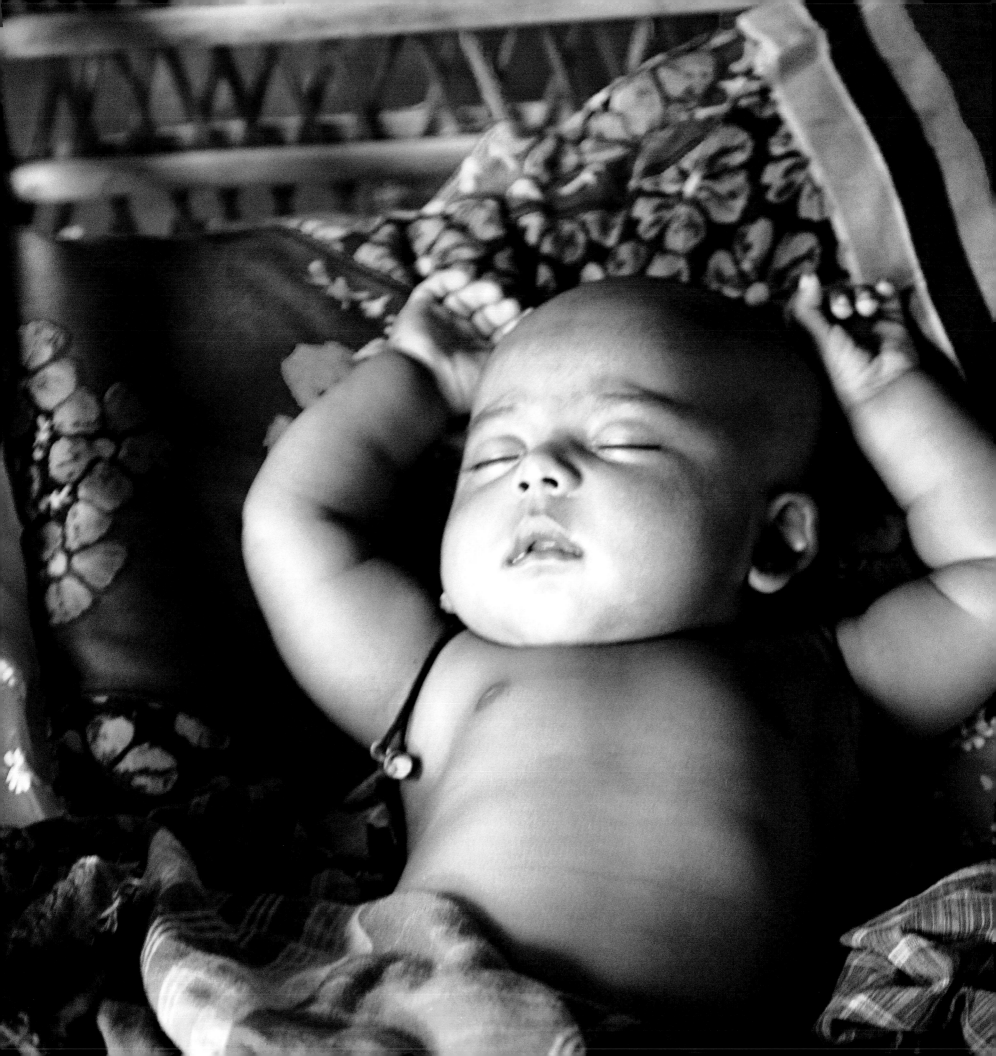

Big move small move

Run here run there

Why are they moving?

Why are they running?

Click click click saved

Barking yelling laughing

What is that sound?

What is that sound?

High low

Sharp muffled

Strange sound strange noise

Blink blink blink saved

Pieces here pieces there

Puzzles puzzles

Put together put together

World I am ready!

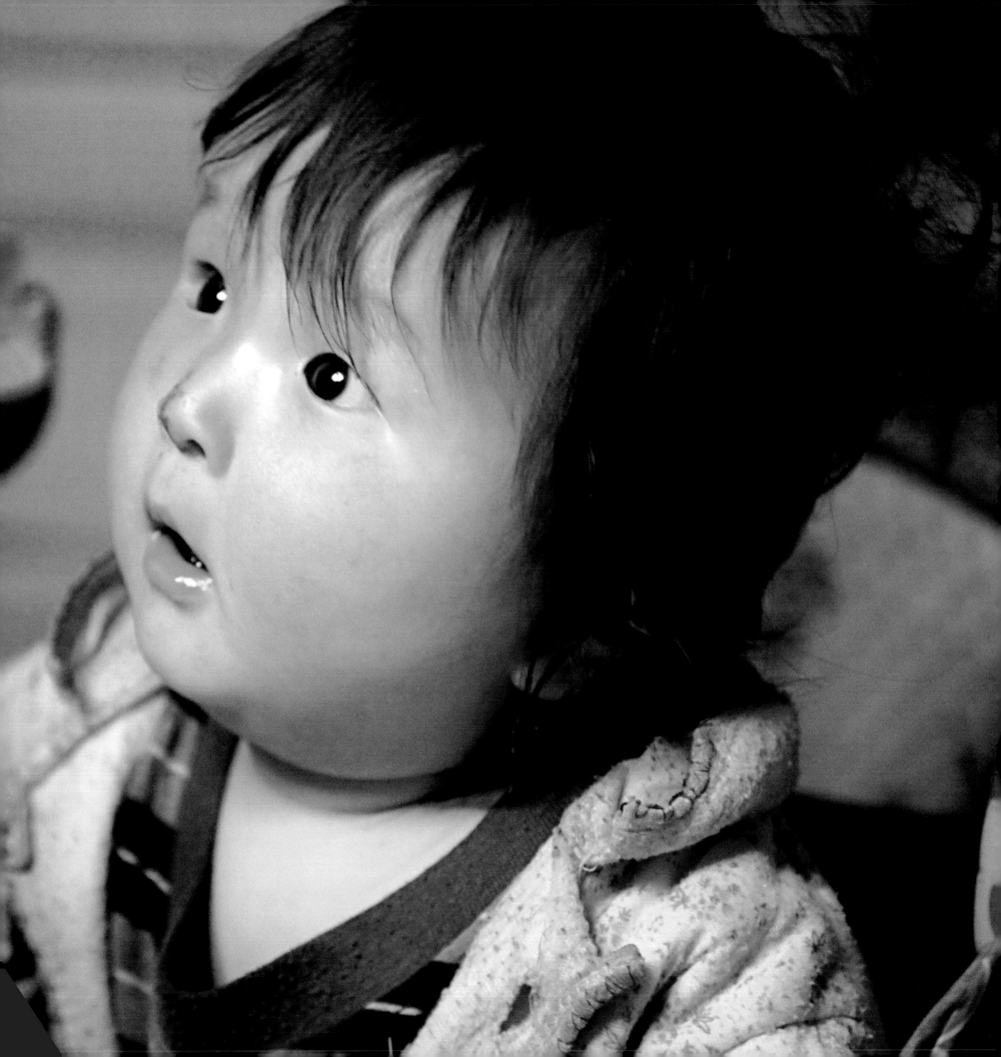

I stare, I watch, I mimic, I follow, I wander, I absorb

Hot hot
Thirsty thirsty
Water water Mom
Over there over there
They are playing with water
Can I go there
Can I go there
Don't talk don't talk to that lady
Let's go! Let's go, Mom!

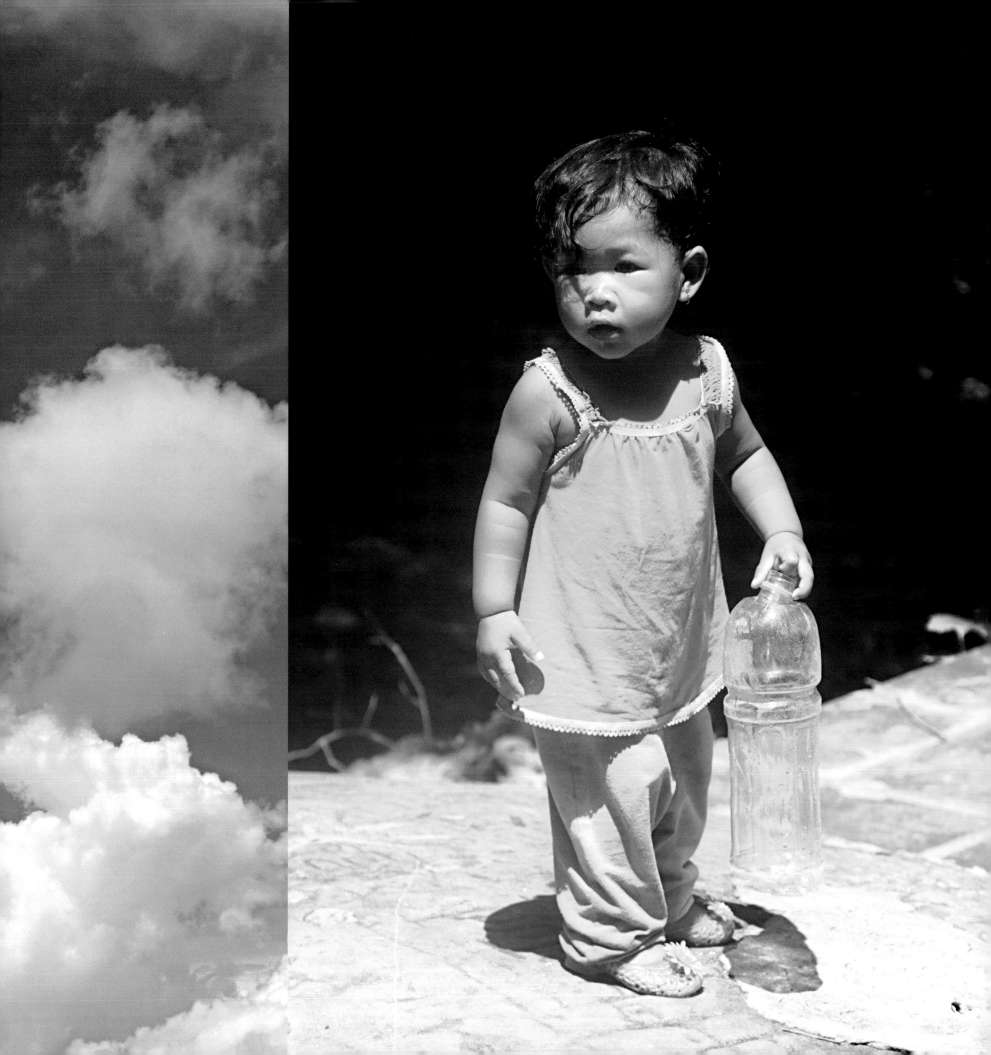

Mom's on the ground
and up
Dad's on the ground
and up
Again and again
I can do that too!
I am face down
then up
Like Mom and Dad
I can do that too!

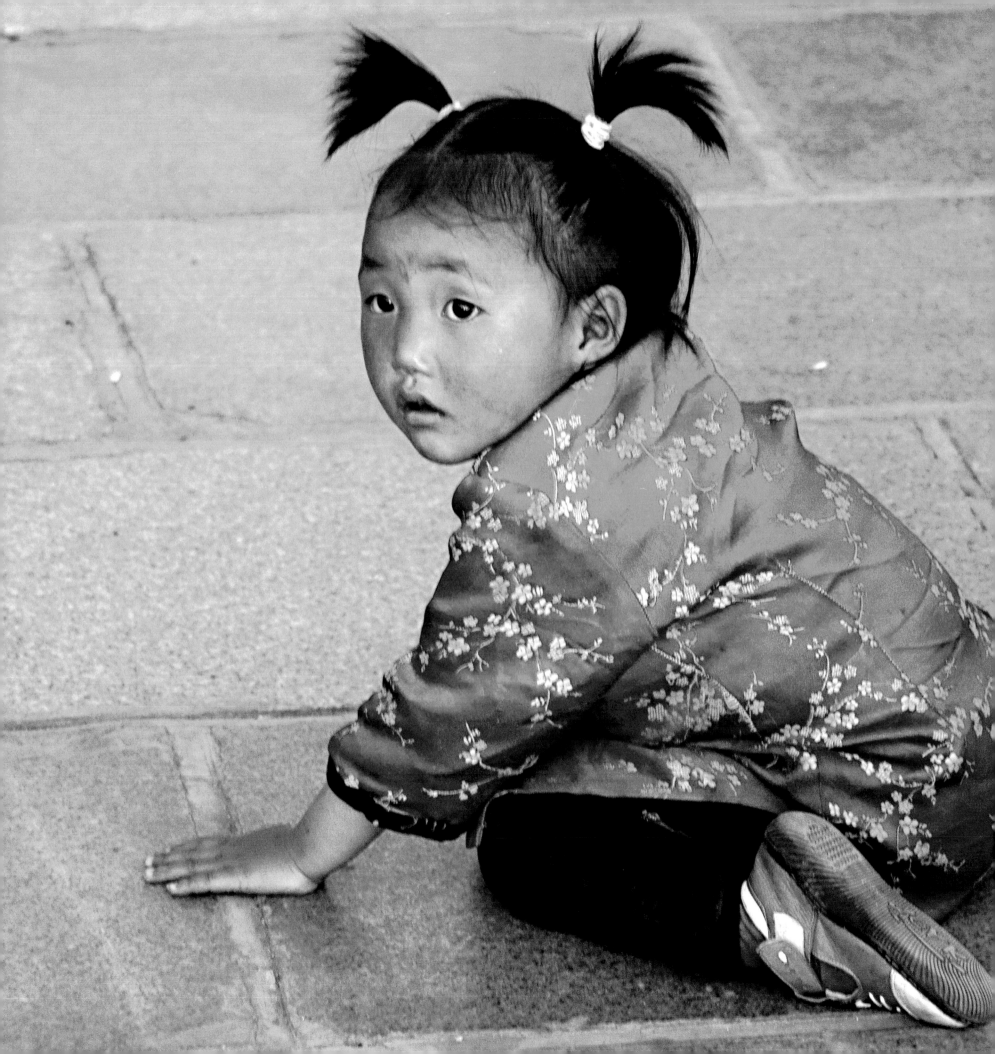

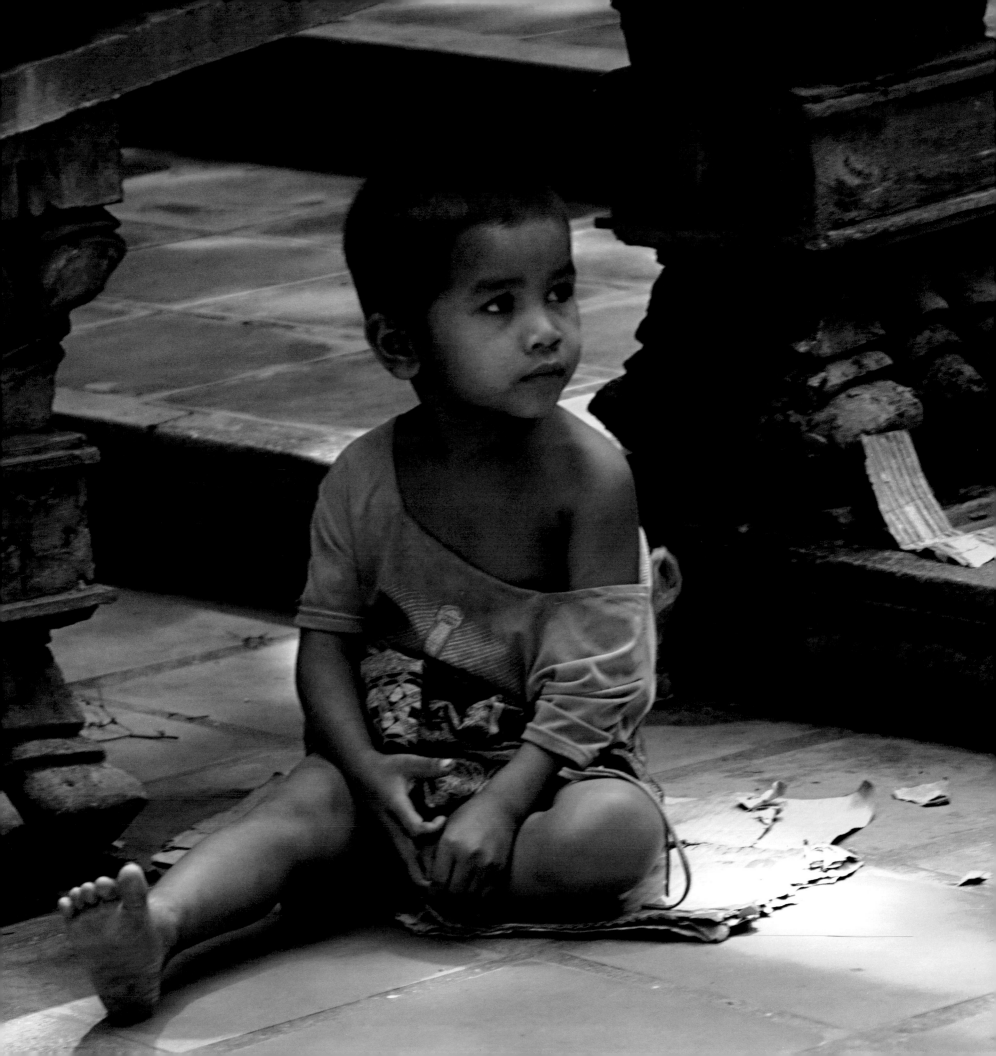

Going up

Coming down

Many people many people

Look look! A little choo-choo train

Doll doll she has a doll

Golden hair golden hair

Someday I will . . .

Old old house

Young young child

Somebody behind

Rest sit stare

Life passing by

Curious my mind

Intrigued my heart

Mom always behind me

No shouting

No wandering

Safe secure

I know she's there

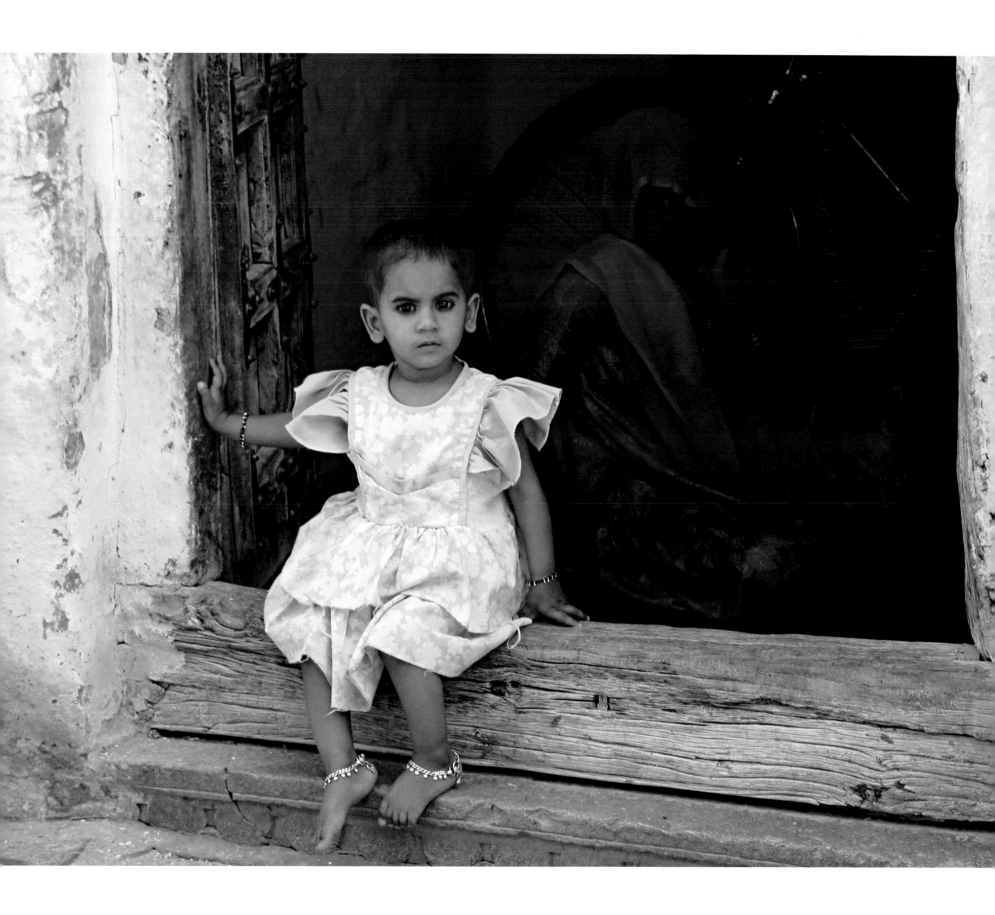

I love my sister!

When I eat

she's there

When I sleep

she's there

When I wake up

she's there

When I cry

she's there

When I pout

she's there

When I laugh

she's there

When I push her

she's there

I love my sister!

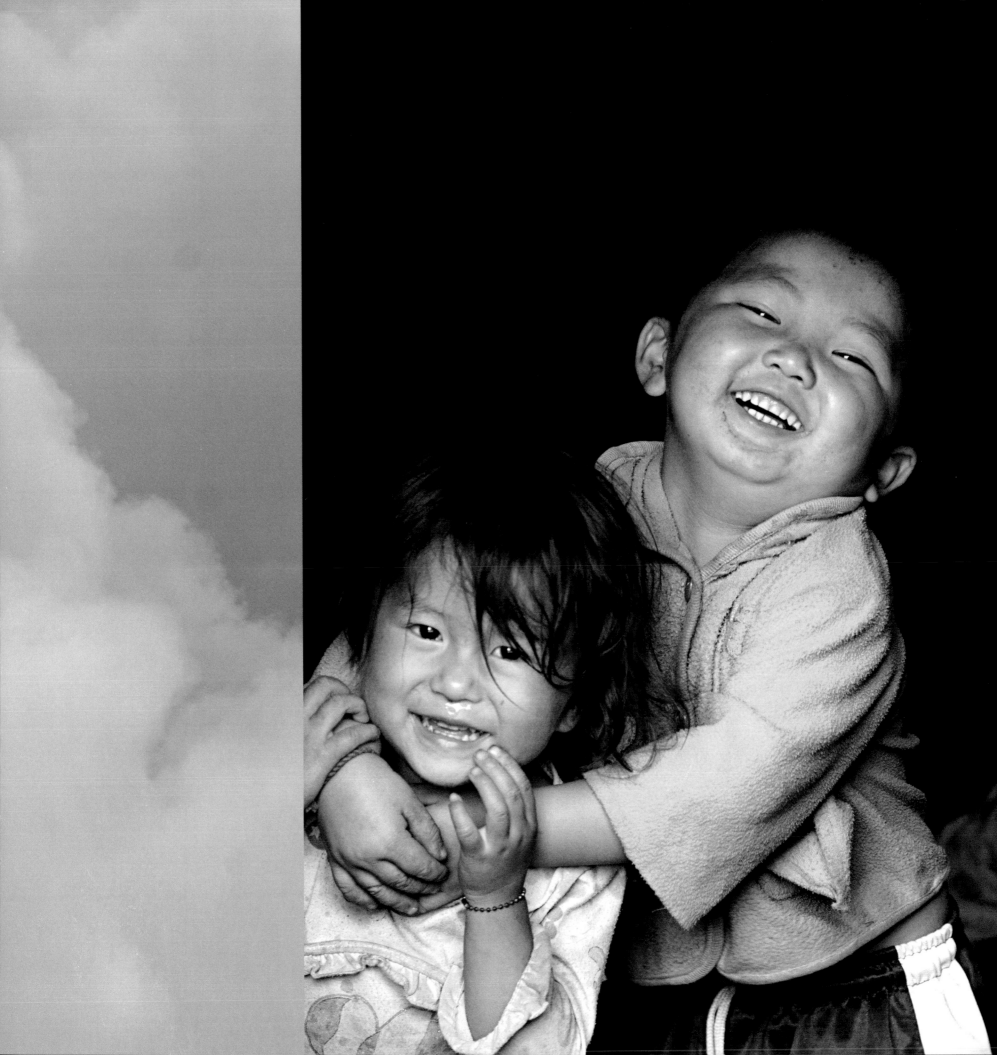

Don't go to the hill

Don't go up the hill

Don't go down the hill

Stay around the house

Watch your little sister

Why? Sister can watch herself

My friend's waiting

My friend's waiting

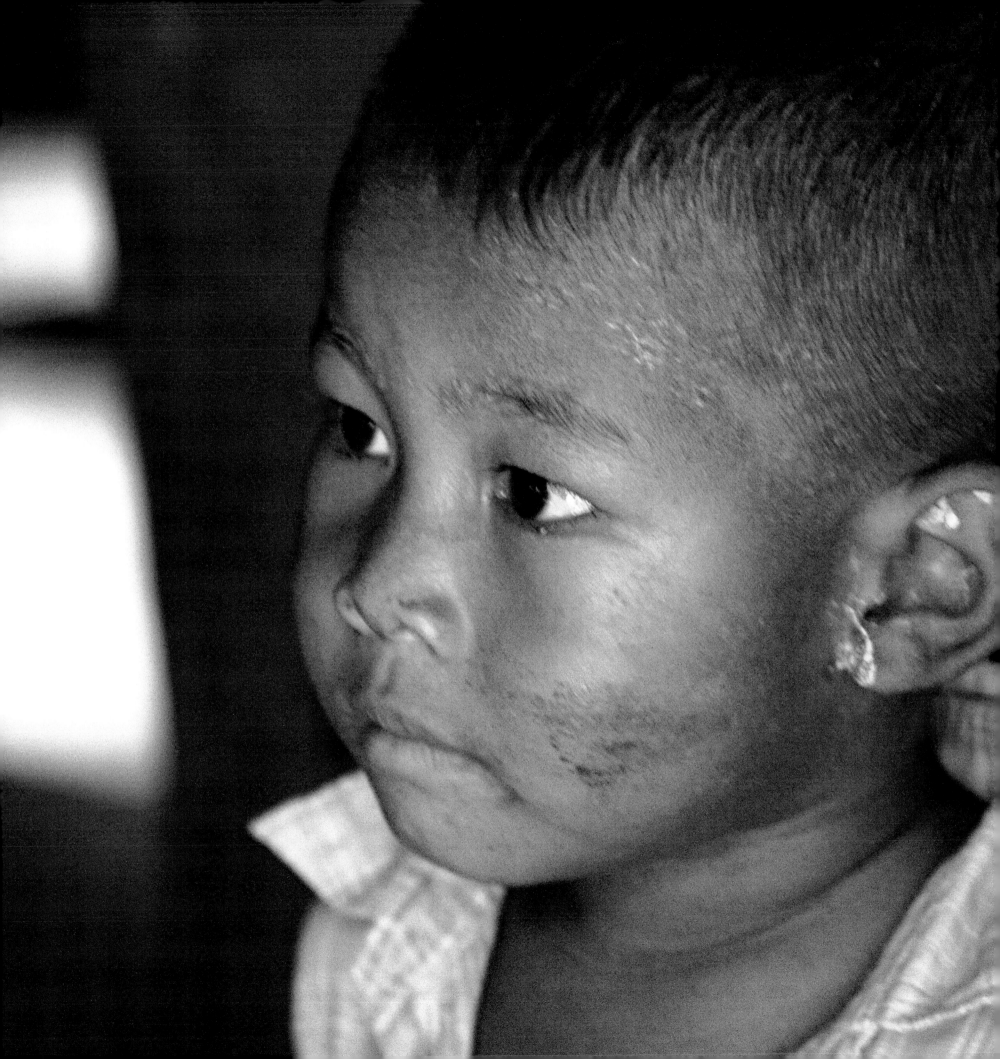

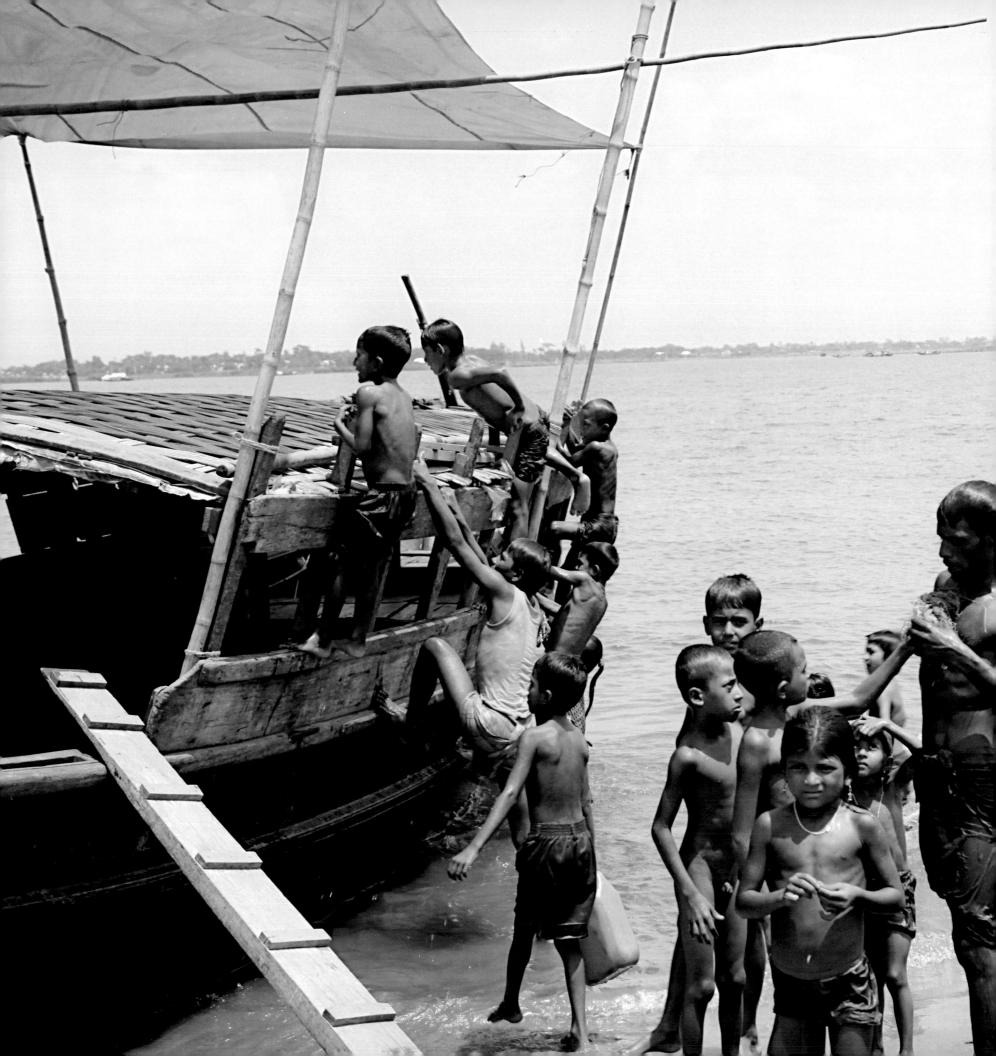

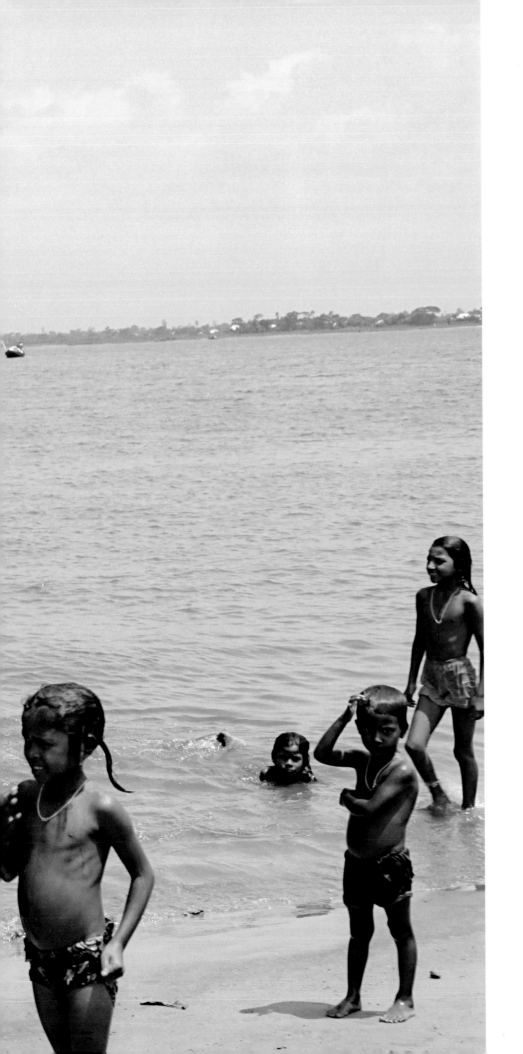

Hey you! hey you!
Don't fall don't fall
Laughing joking chasing
I'm faster no I'm faster
No no no! don't don't don't!
Gig gig gig giggles
Sunny sunny day
Cool cool water
Fun fun fun

Who are you?

What are you saying?

Why are you laughing?

I'm wondering

I'm puzzled

But

You seem nice

You seem kind

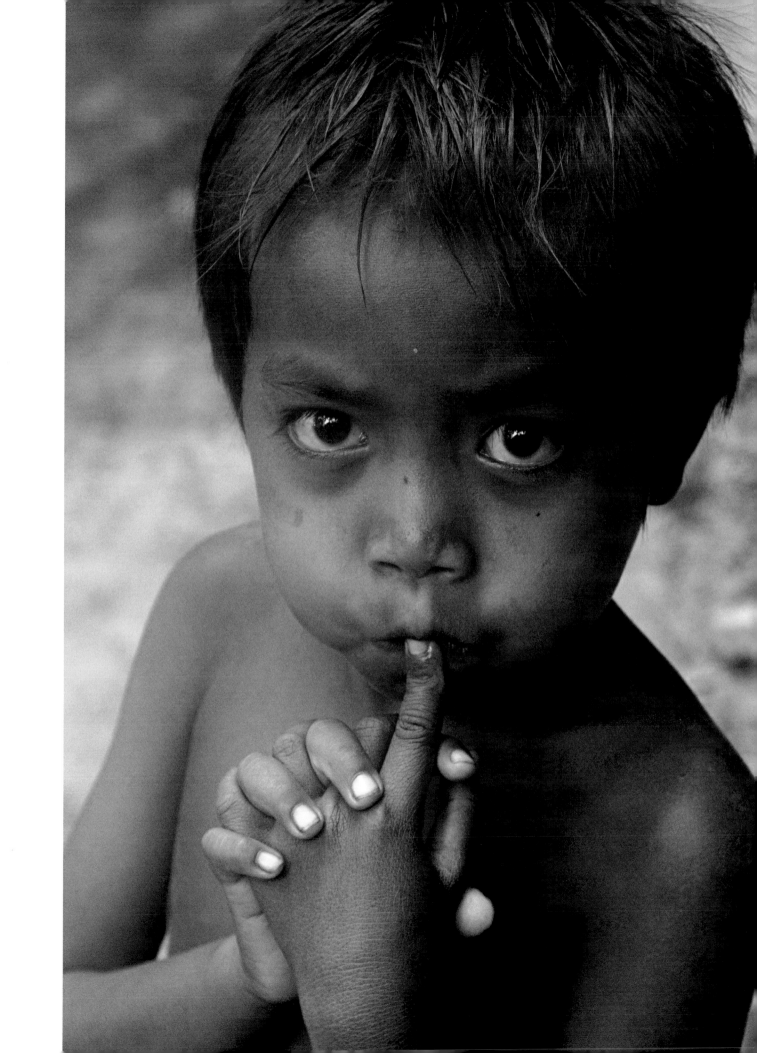

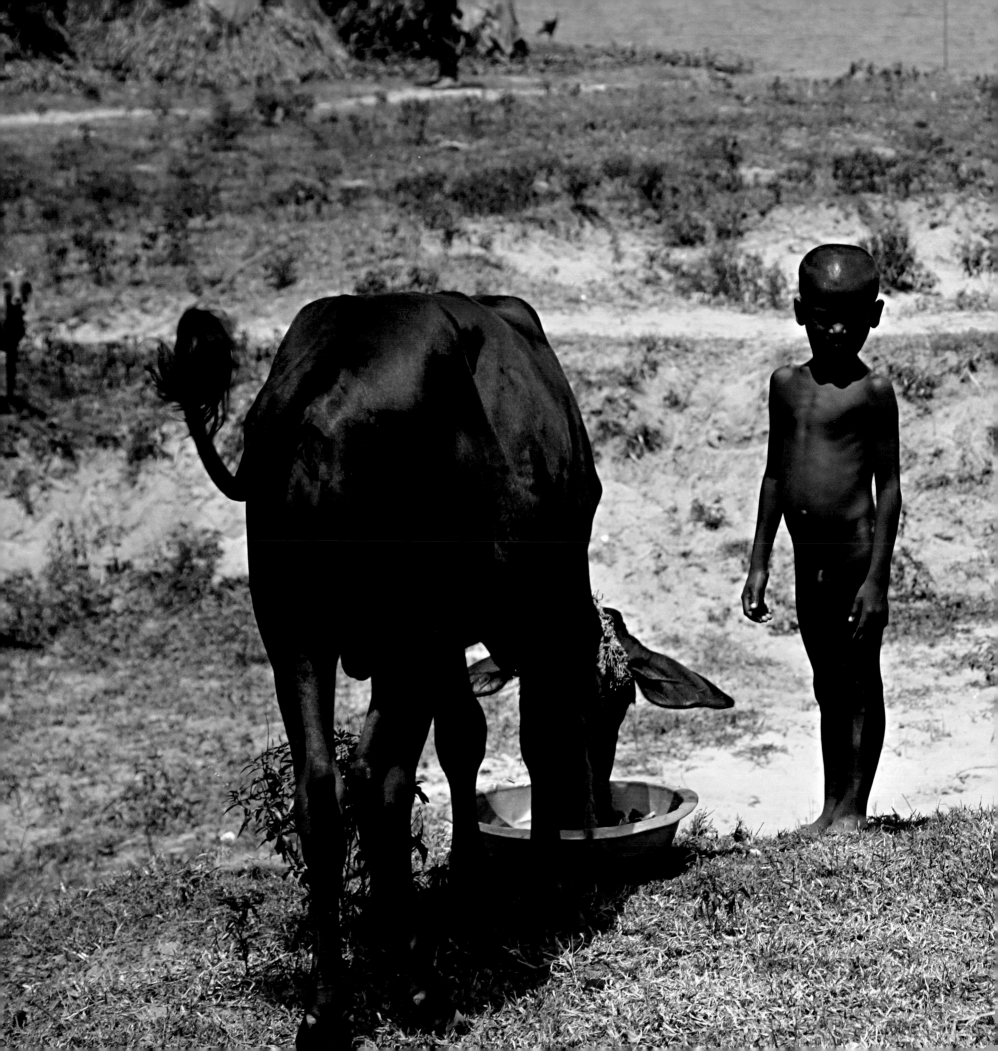

Riverbank

Sand dunes

Green grass

He's there watching me

When I run

he's searching for me

When I swim

he walks me home

When the sun sets

he is my best friend

My best friend

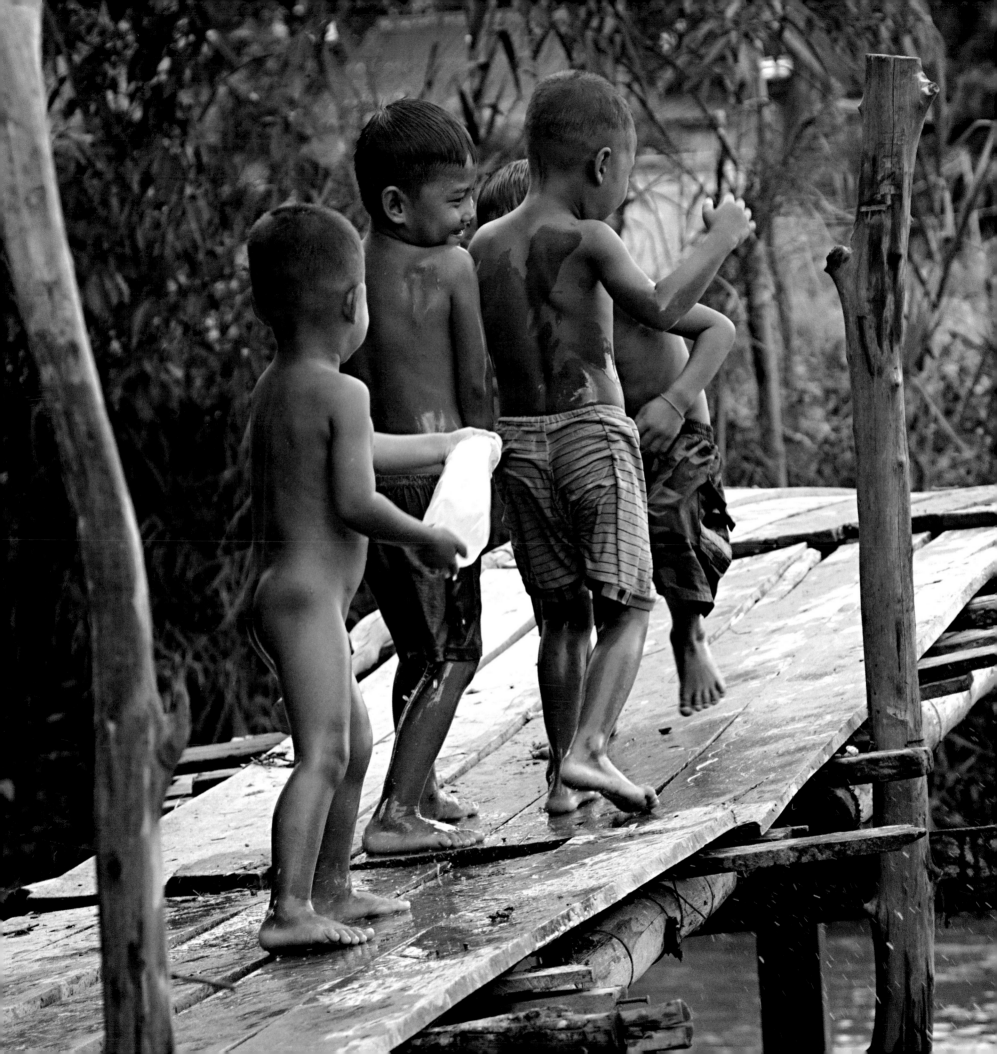

Hey! Hey!

Don't throw water on me

The bridge the river

My playground

Hot summer day

Jump off bridge

Dive into water

Murky murky water

Wish I can touch the fish

Sneak up on my friends

Scare them

Laugh laugh laugh

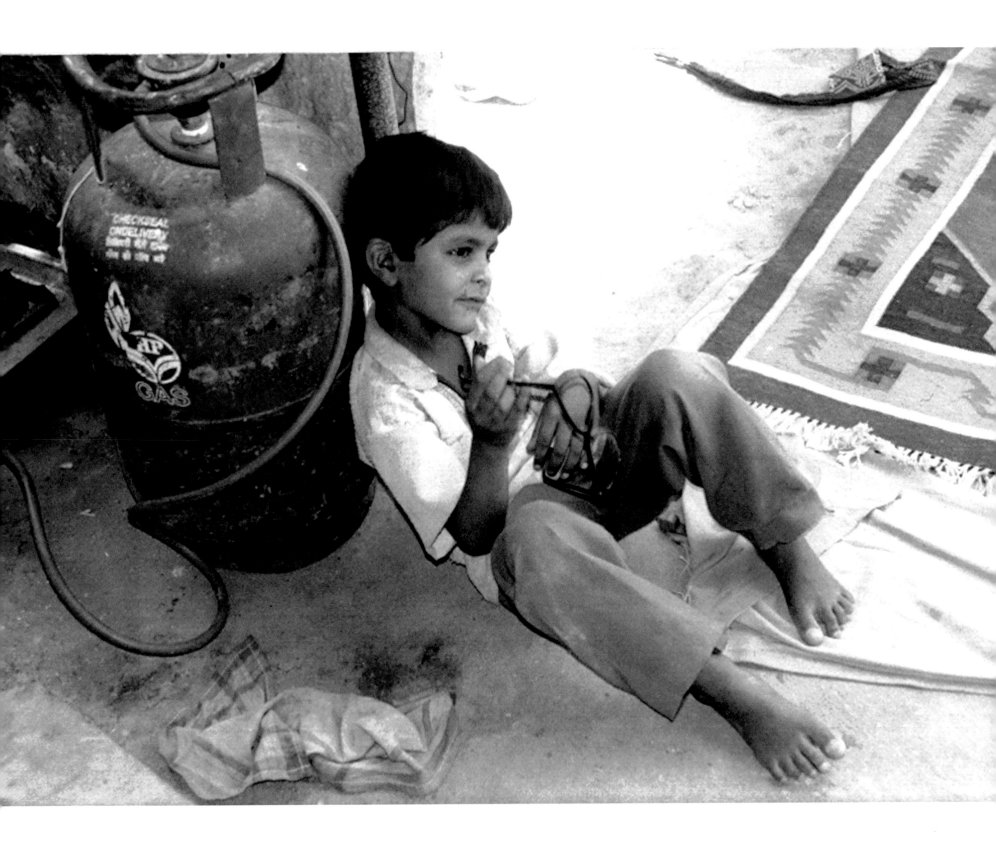

People come in the house

People leave the house

Strangers strangers

Looking at carpets

'round and 'round

Father follows them

'round and 'round

Wave and wave at me

Strange really strange!

I ignore them

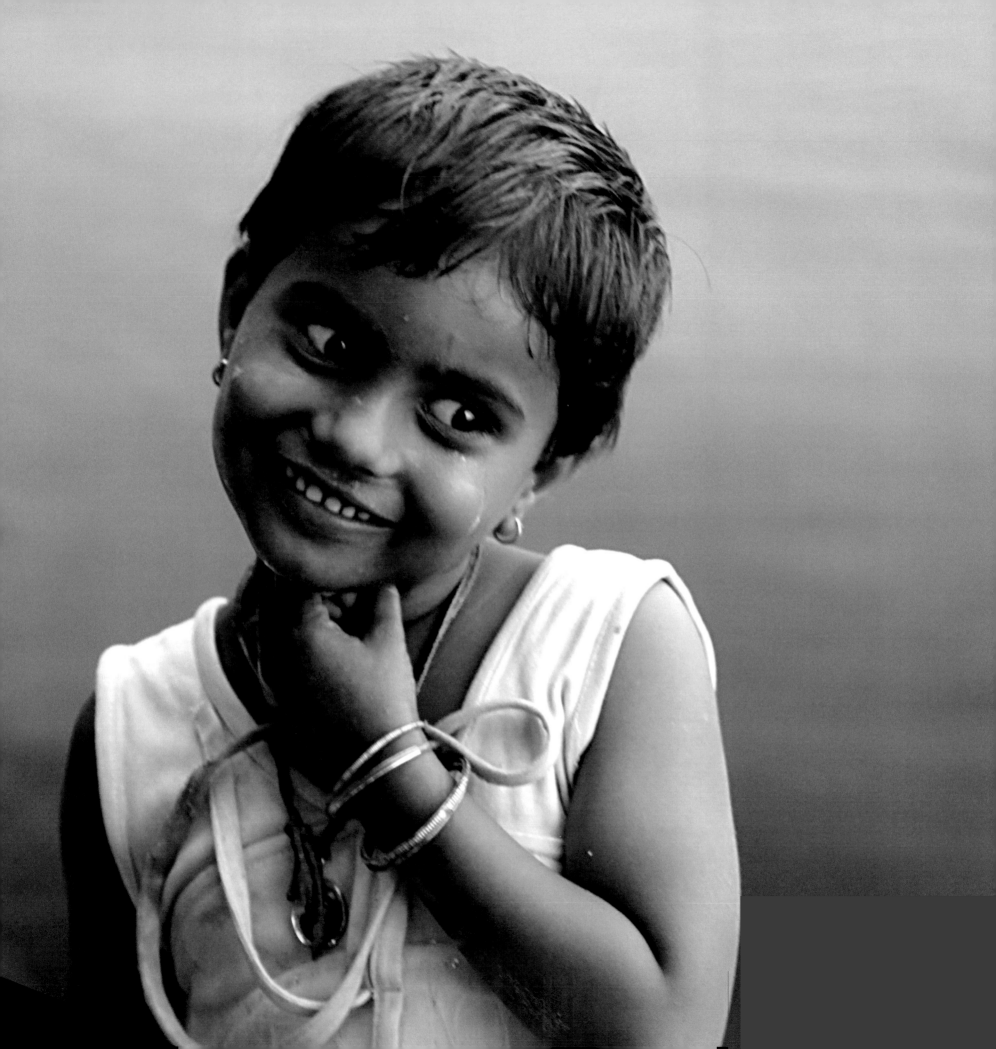

Water around me
Water around my house
Dip my feet in water
See ripples go far far away
See my face in the water
I smile she smiles
I cry she cries
I'm pretty she's pretty
She's here I'm happy
I'm here she's happy

I'm willing to walk, willing to run, willing to step out

Up in the morning

Put on my school uniform

It's pretty it's pretty

Put on my striped tie

I'm proud

I'm so proud

Mom combs my hair

Ties red ribbon

Mom smiles

You look pretty

Listen to the teacher

Where are your shoes?

Oh! under the bed

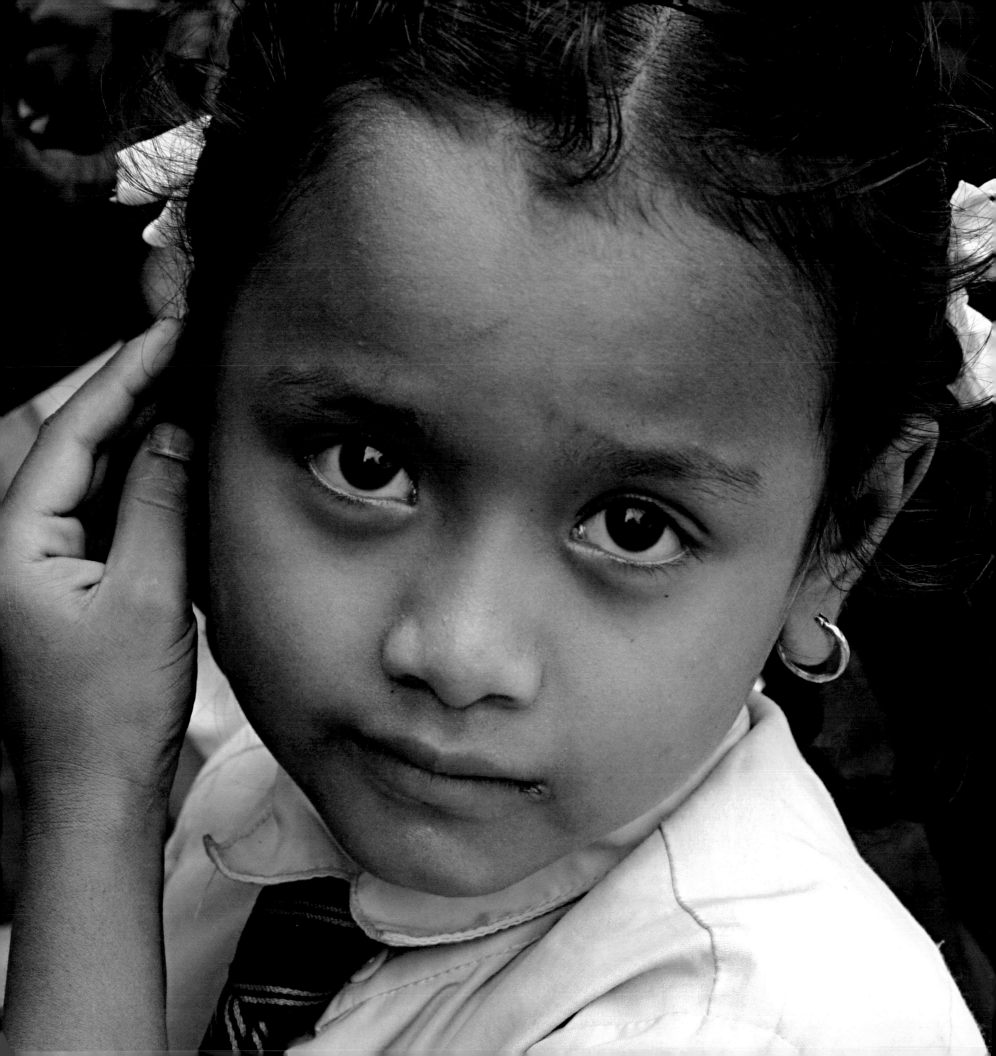

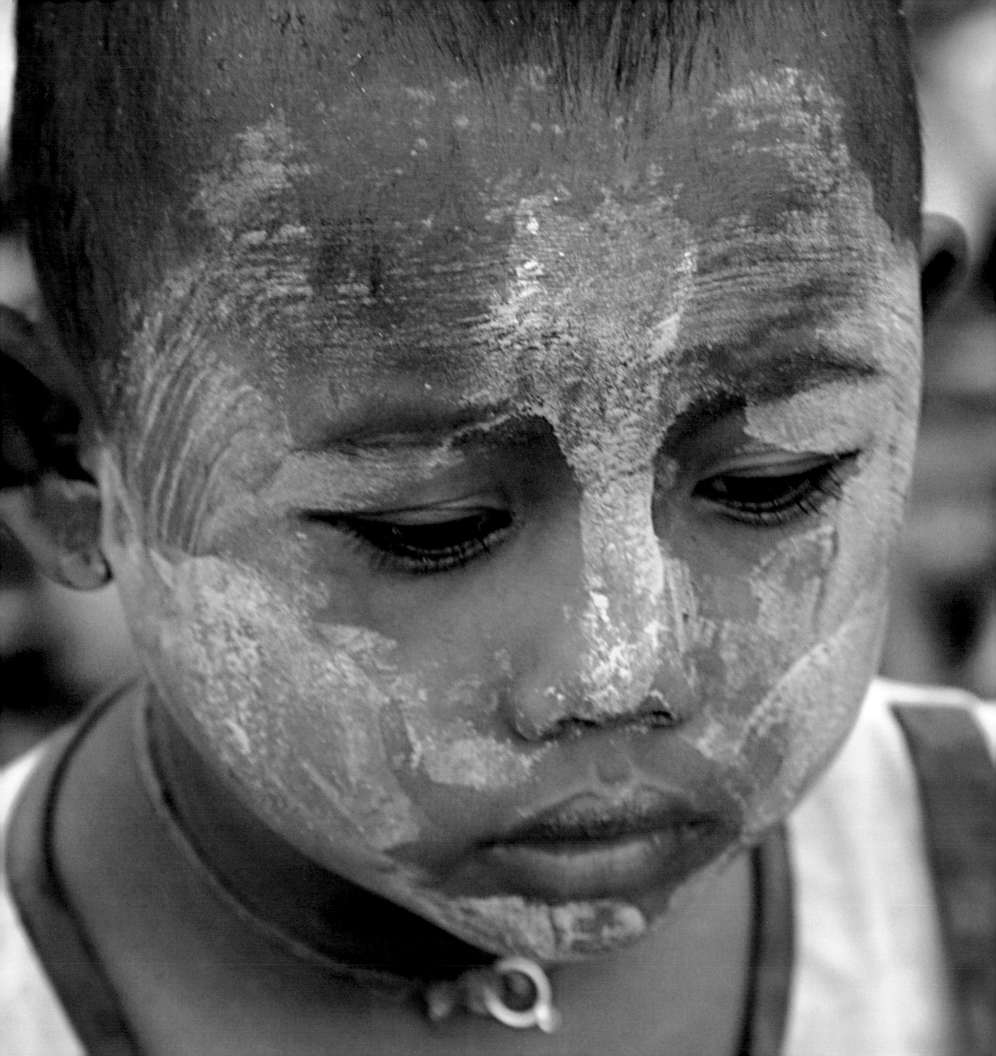

Longing longing for friends
Play ball with them
Swim with them
Talk with them
But
Why do they always tease me?
Why do they make fun of me?
Longing for friends
Longing for friends

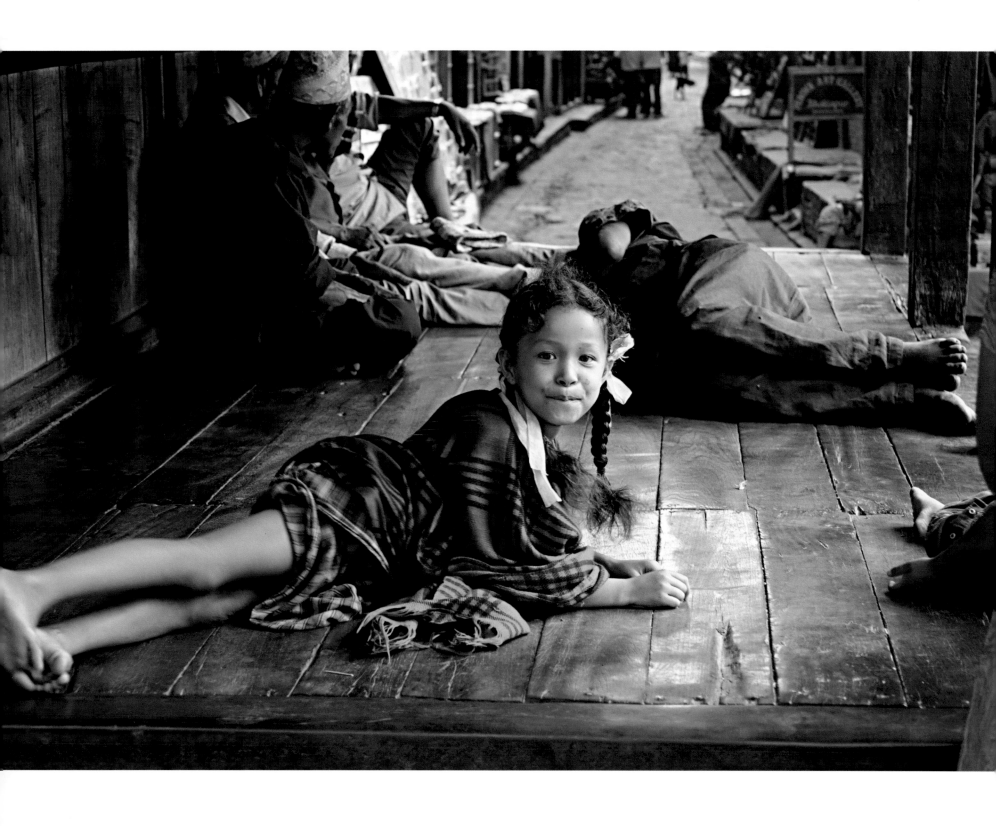

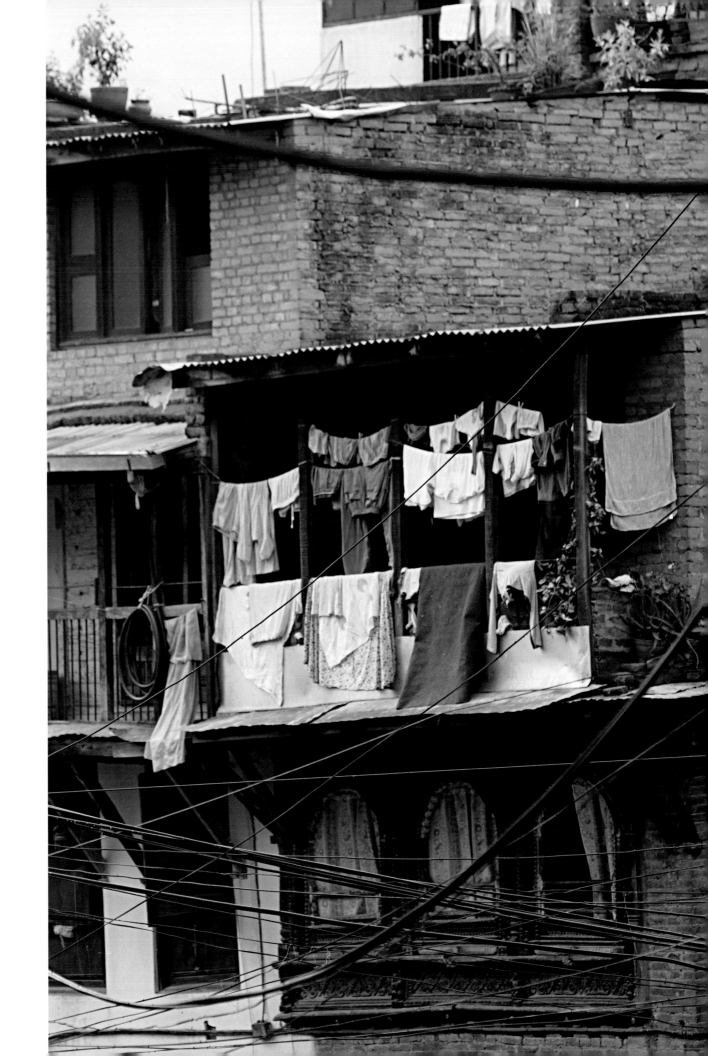

Hazy summer afternoon

Tired and sweaty

Time to find a corner

Nap nap nap

Sleep? not me

Fun it's me

They are napping

They are talking

They are loud

They are whispering

I sit I listen I don't care

Daydream

I wish . . . I wish . . .

Whenever wherever
Pick up firewood
Stack them
Mom will always have
wood for cooking
Mom always mumbles
This is too wet
This is too green
Her eyes on me
What can I do . . .

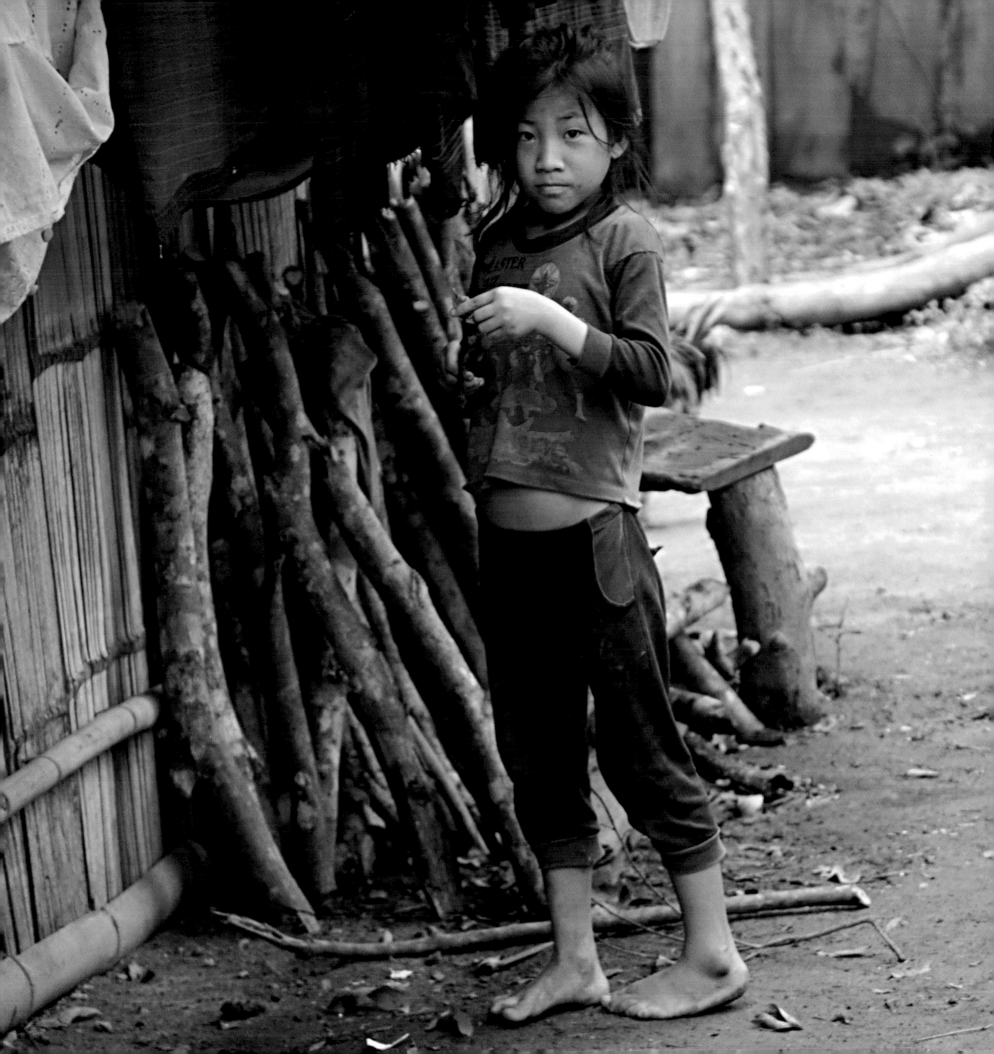

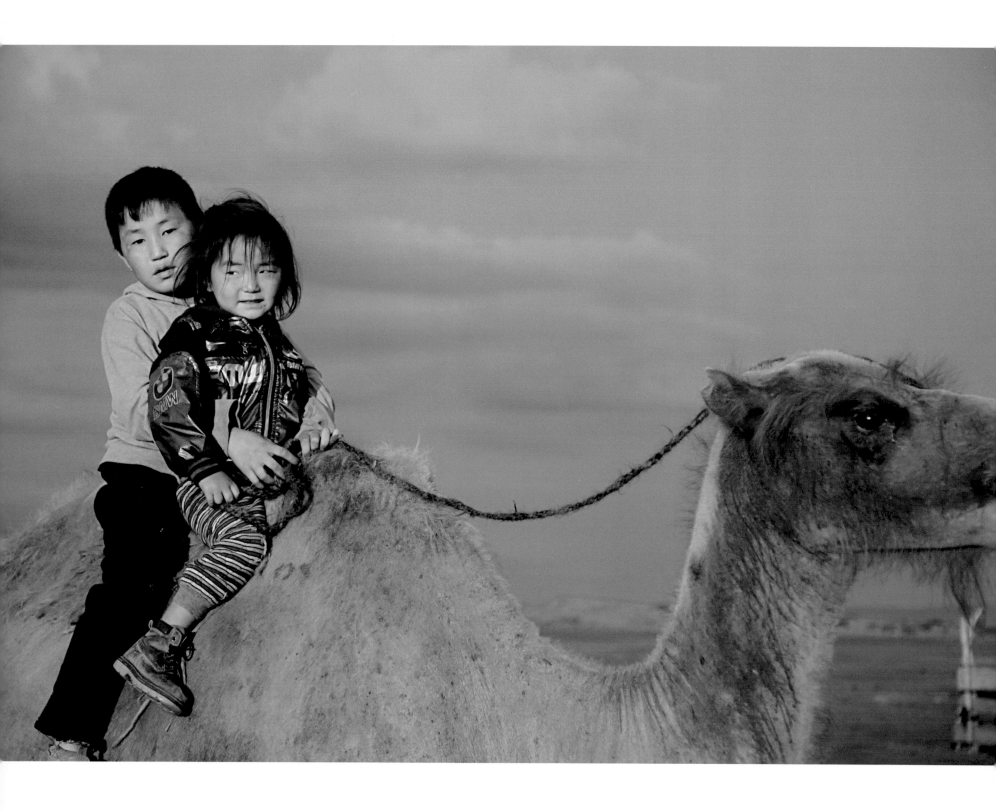

Early sunrise

My brother likes to ride camels

He is brave

I like to ride camels

I have fears

My brother says

Get on up!

Get on up!

My brother pulls me up with him

I feel safe

I feel happy

I love my camel

I love my brother!

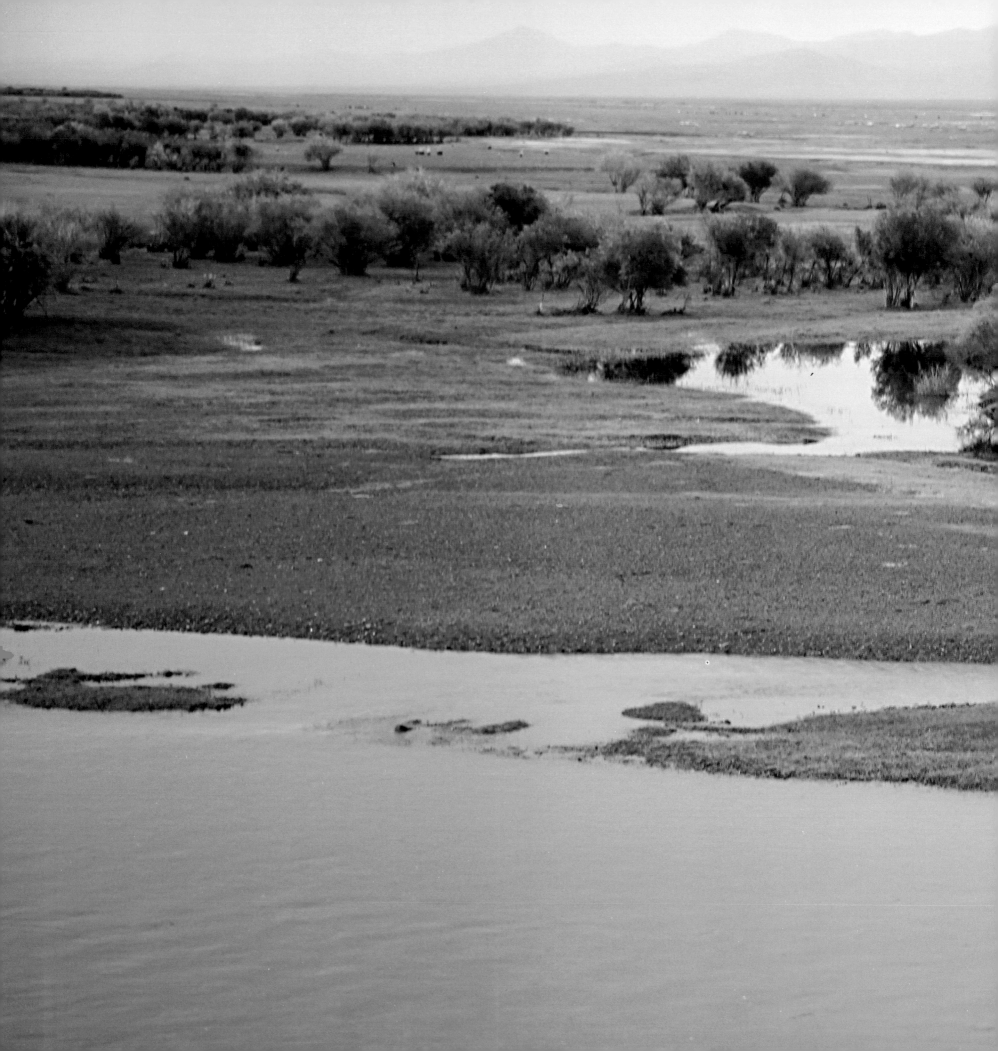

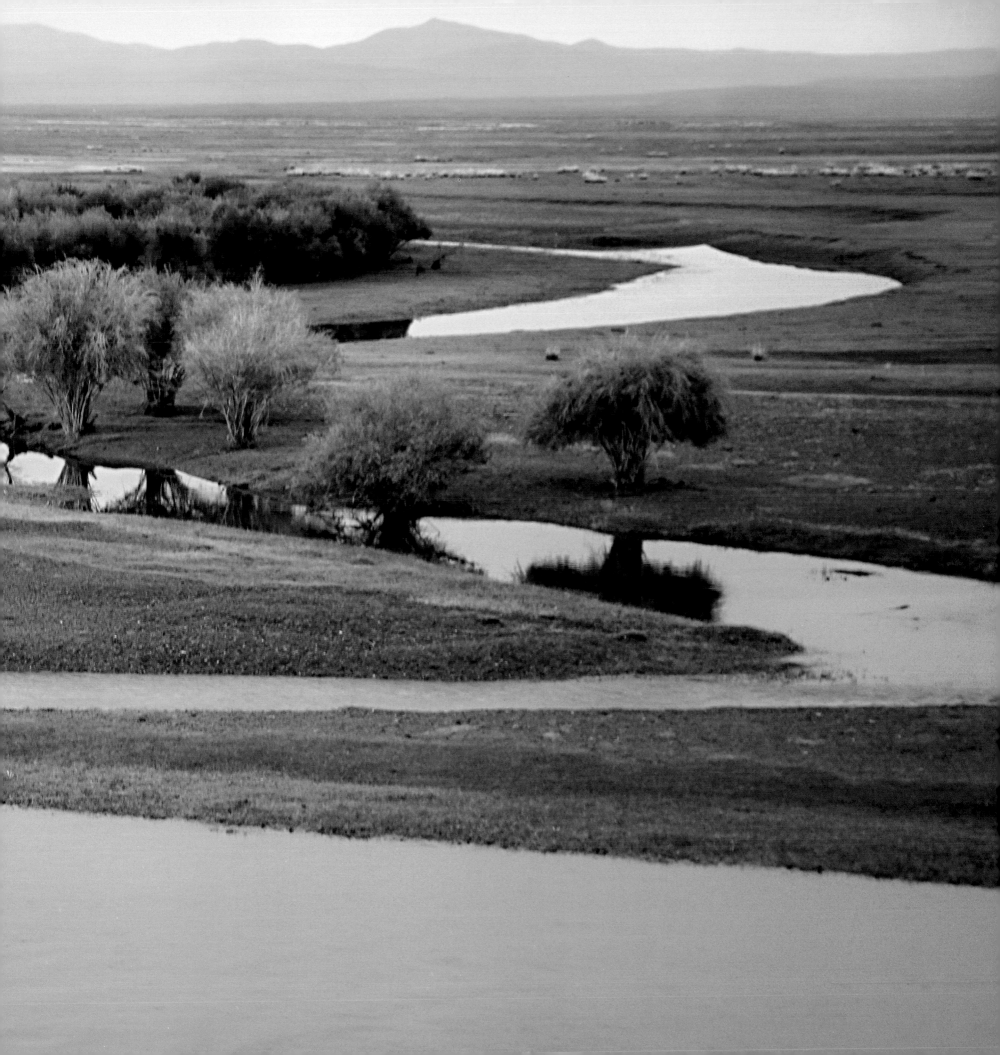

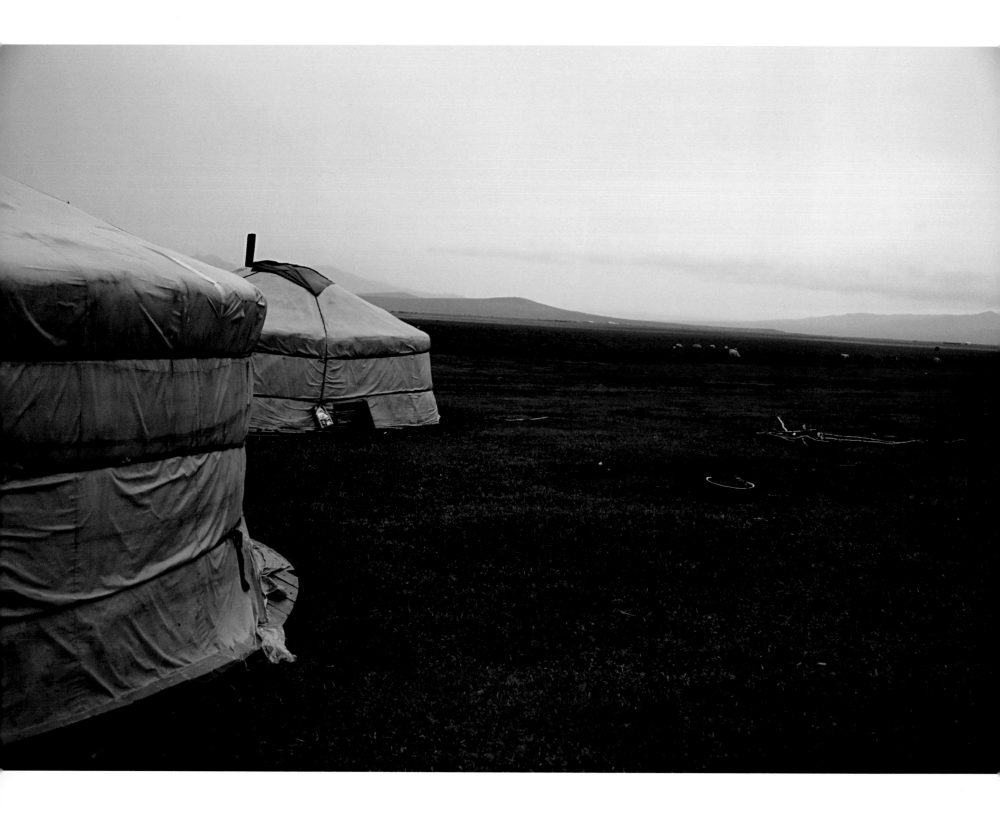

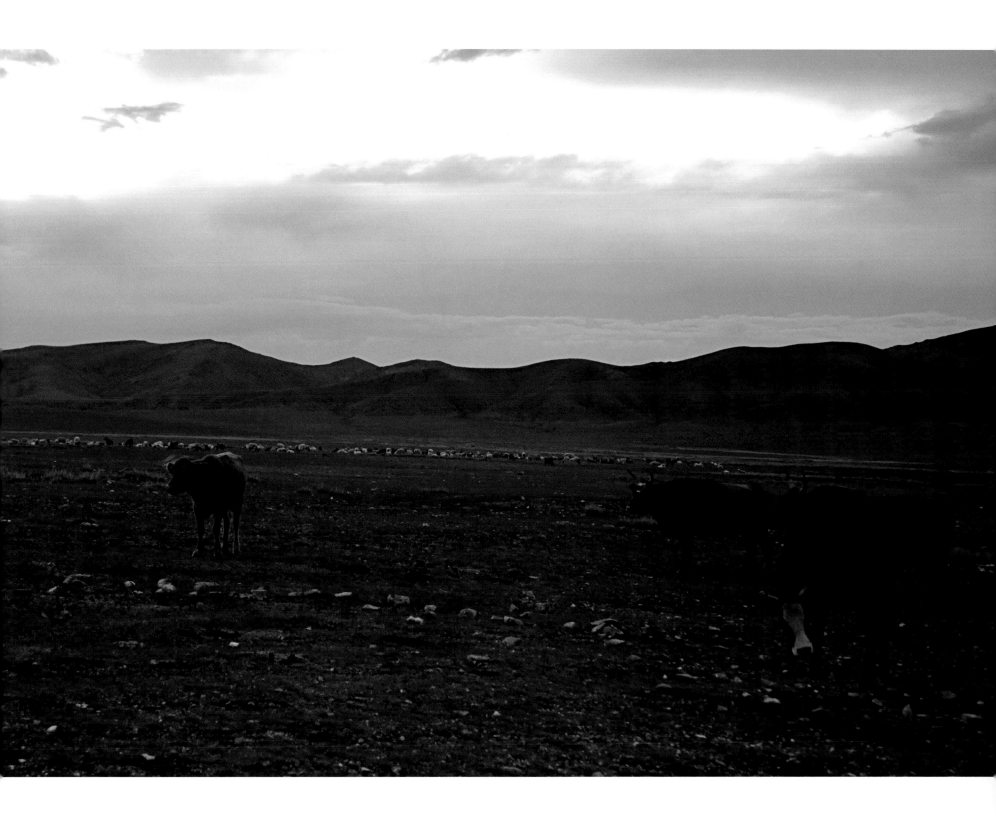

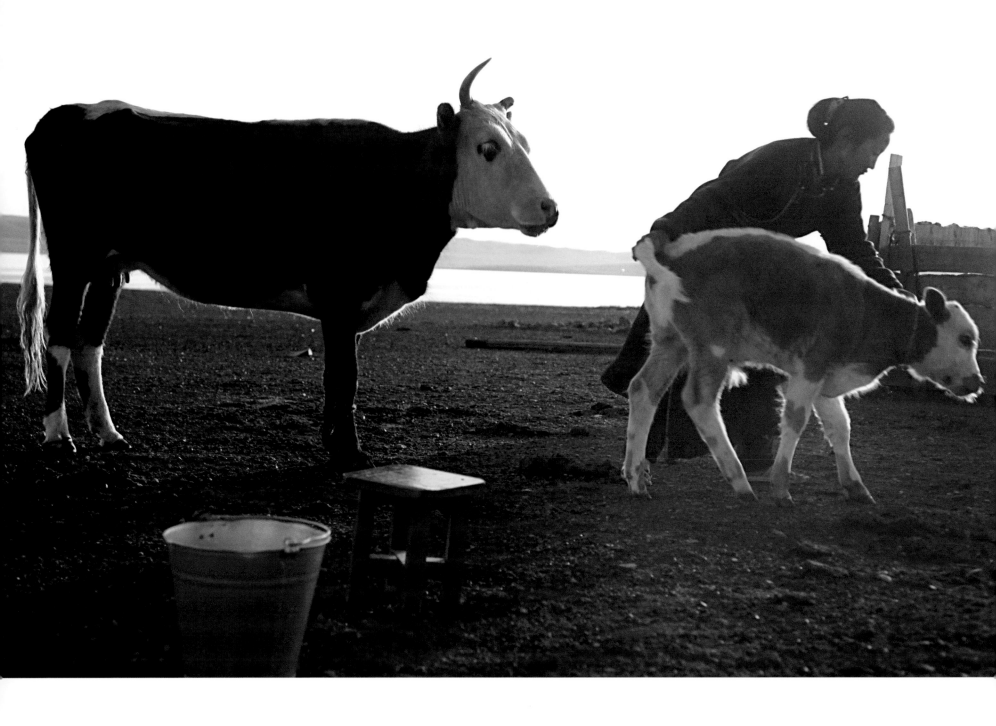

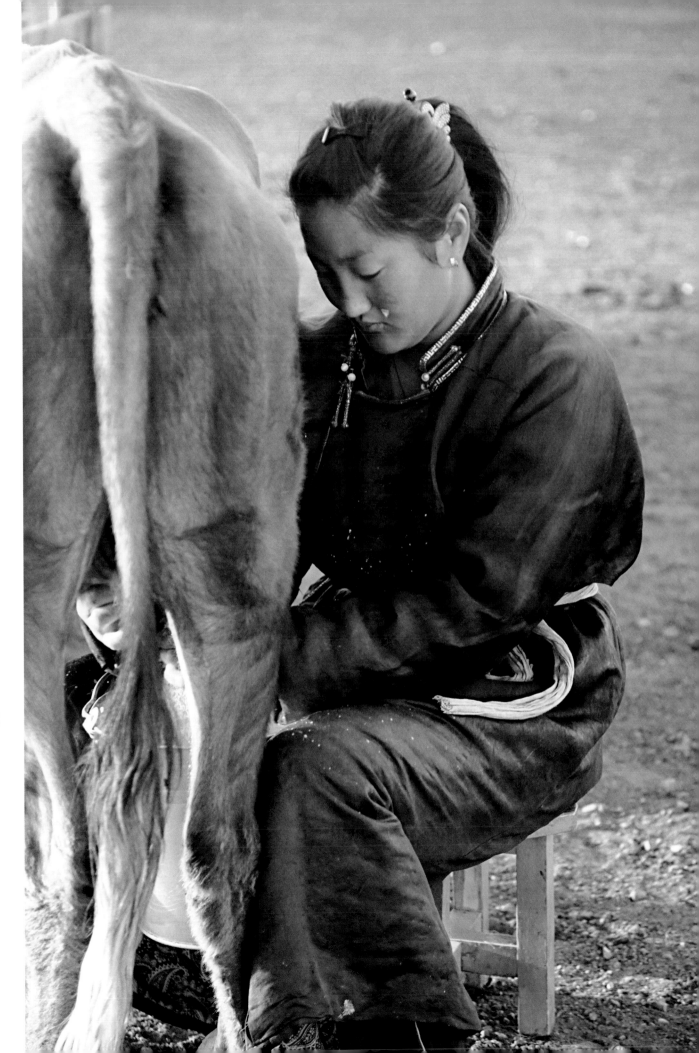

Day just broke

Sun just peeked

Morning light morning light

Contours on your hair

You're glowing you're glowing

I'm glowing too

Crisp air fades

Sunlight emerges

Young one must be fed

I'd better milk

I'd better milk

My favorite time

My favorite time

Riding camels in the morning

Sound of footsteps

pleases my heart

Sound of hissing

soothes my blood

I let you lead

where you want to go

That is where I want to be!

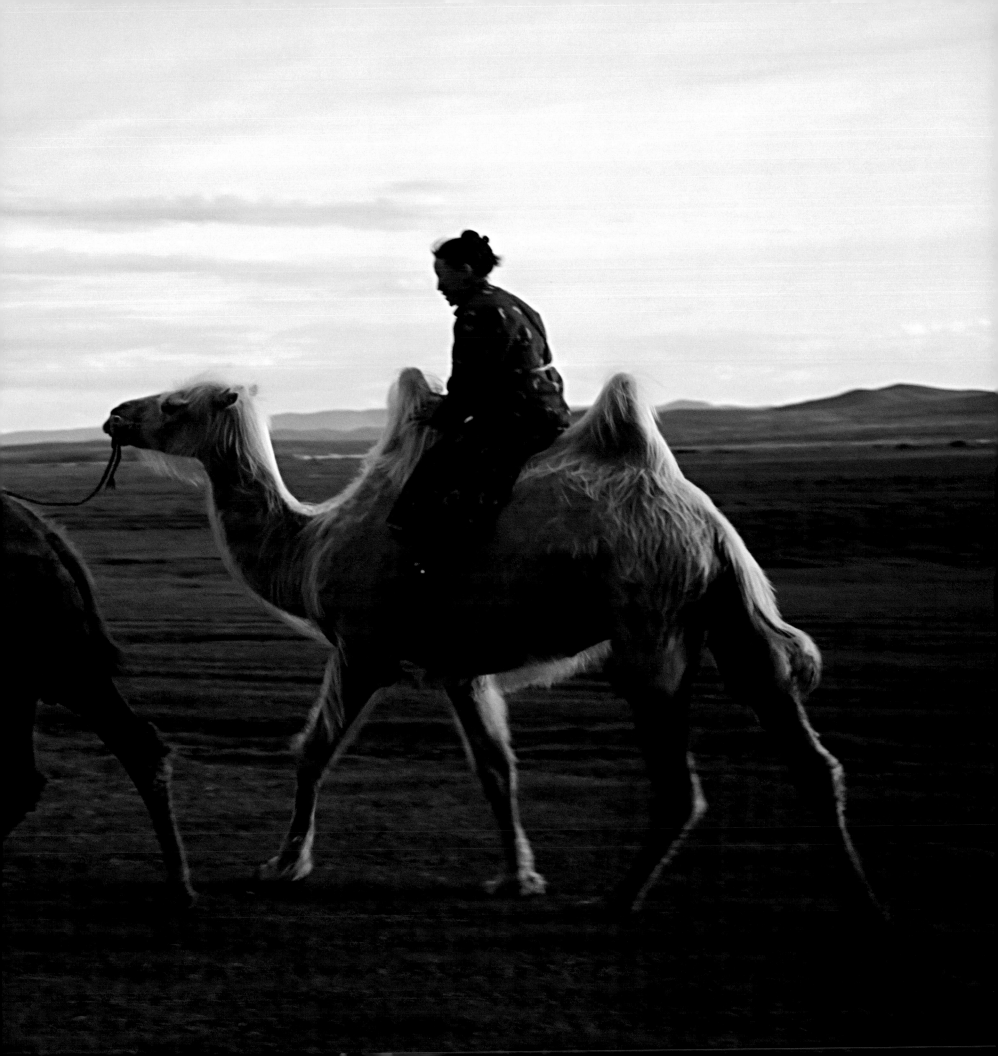

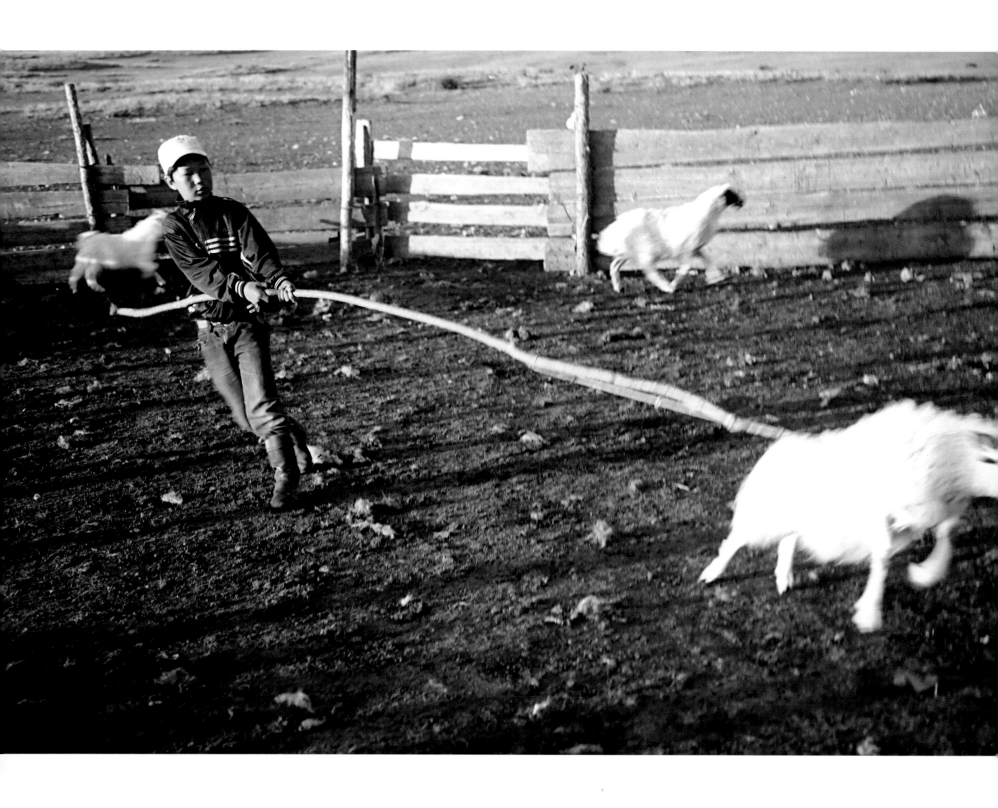

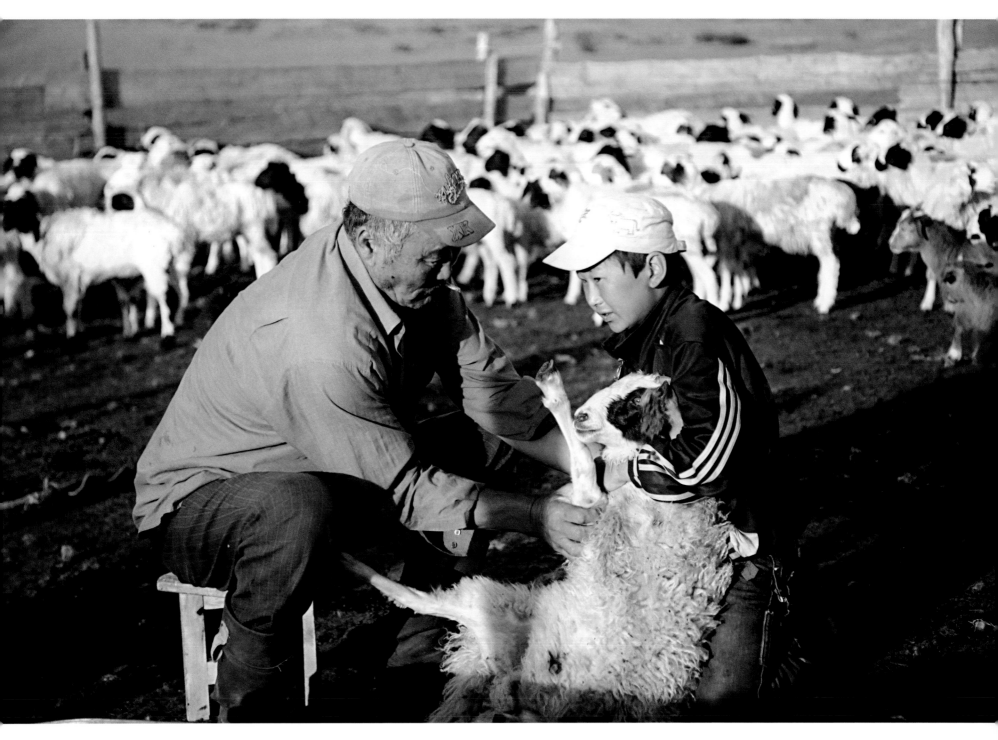

Sound of shears shears
Muffled by thick hair
Mom shears white Dad shears black
Black white gray mixed in between

Catch black catch white catch mixed
Do it fast do it quick
They are waiting they are waiting

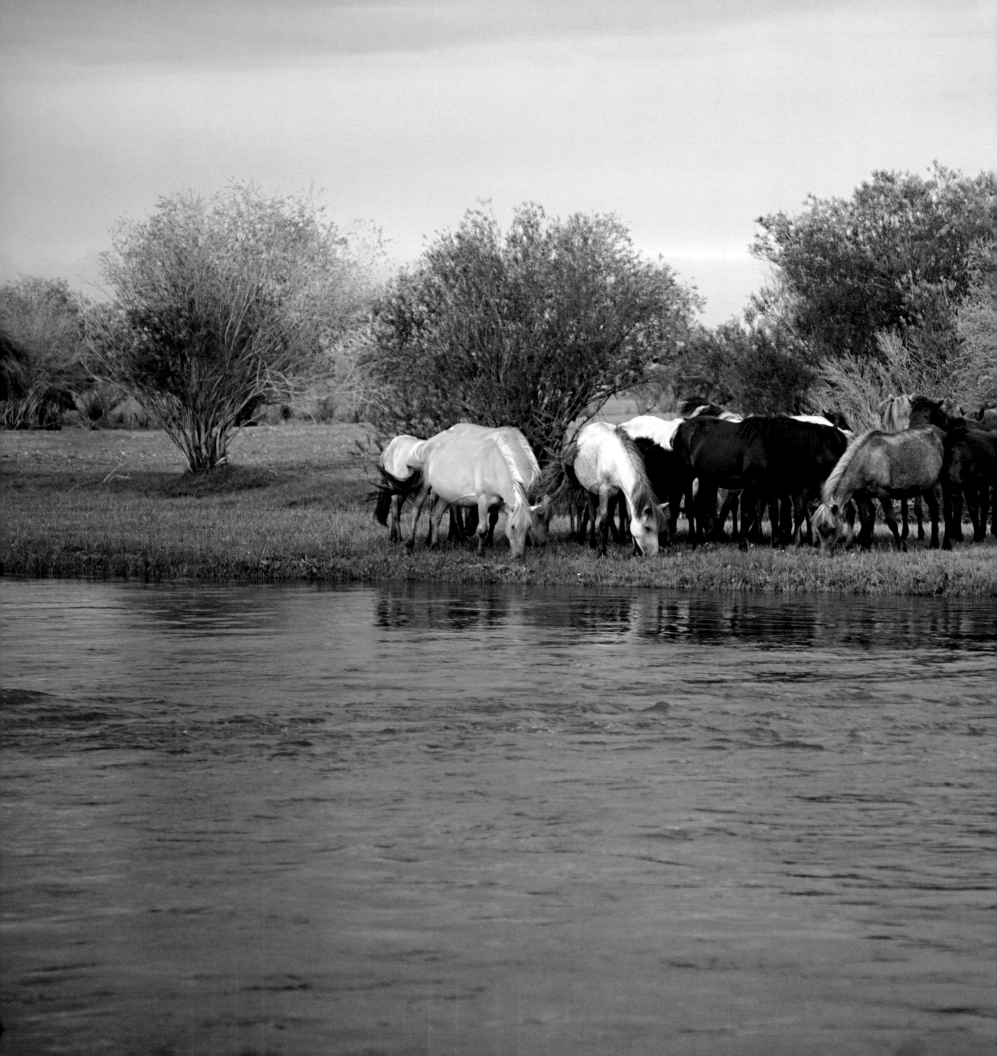

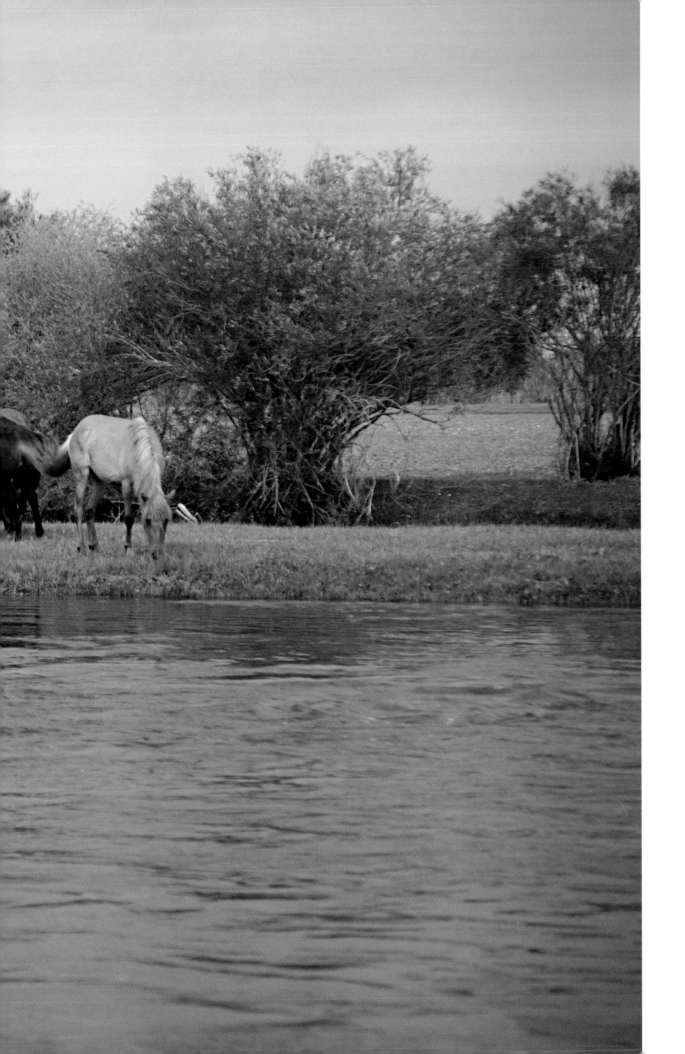

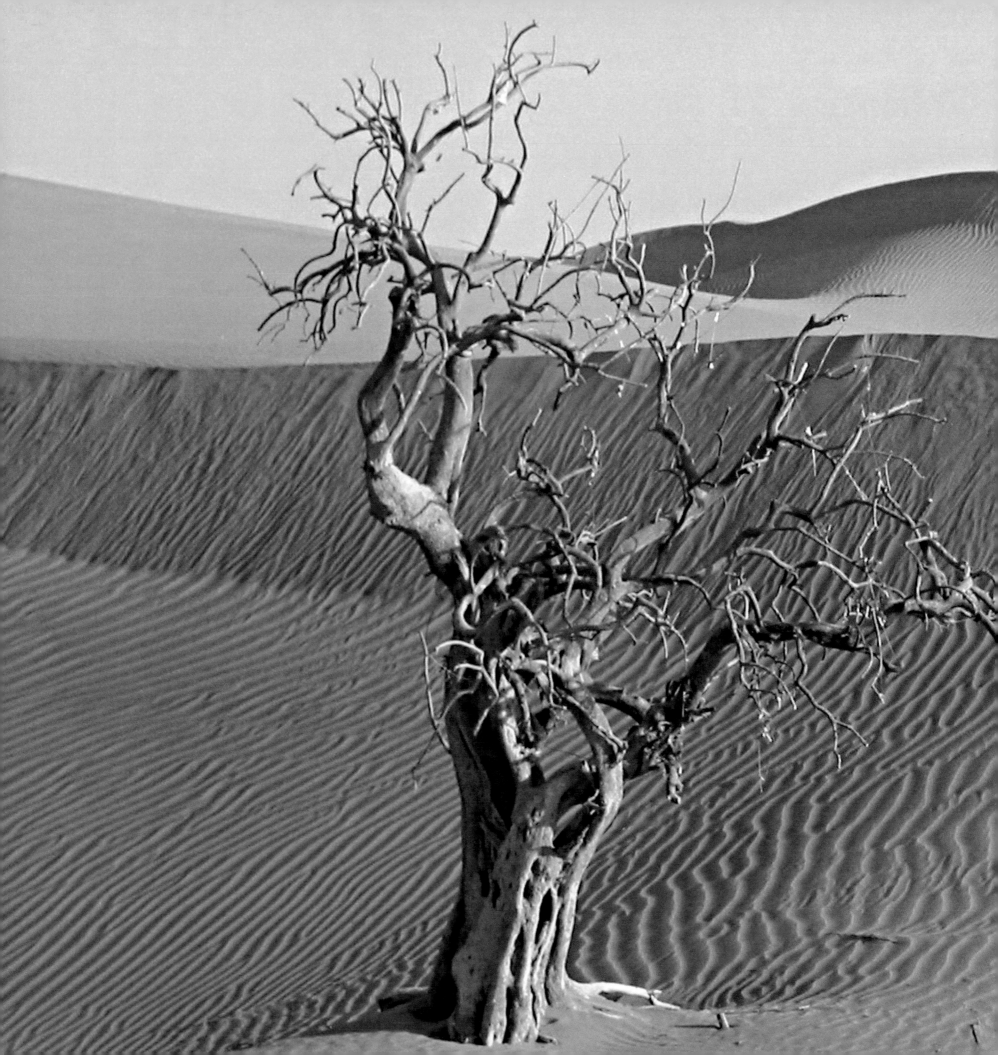

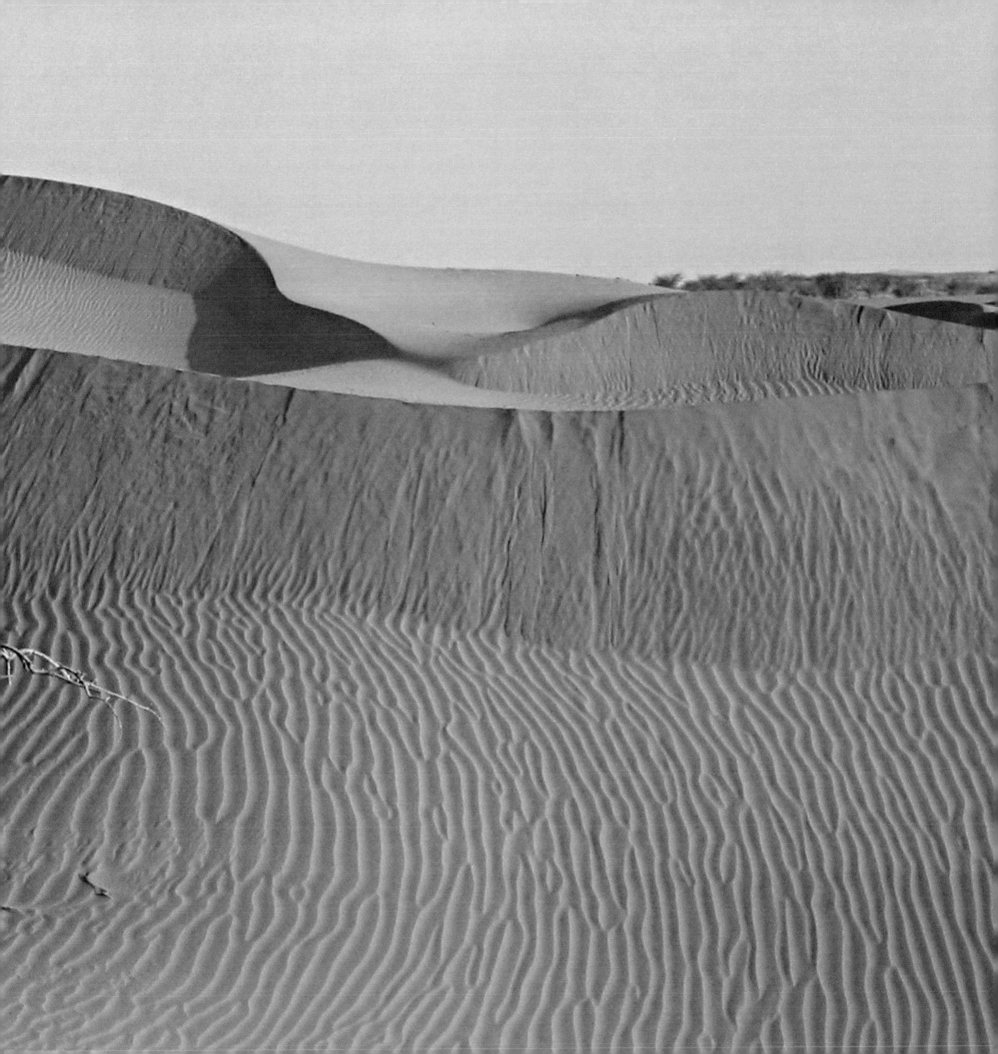

ADVENTUROUS

I want to go there, I want to do that, I want to conquer the unknown

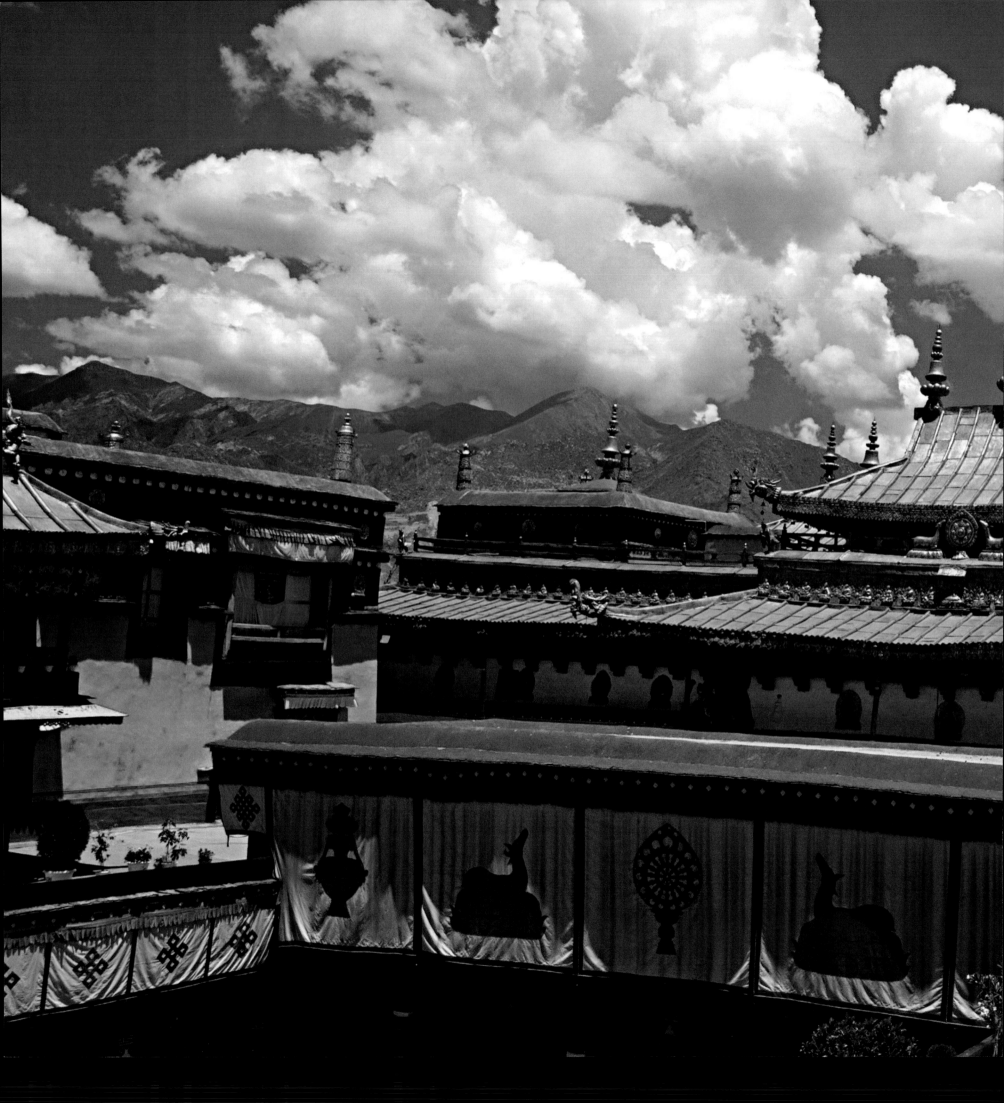

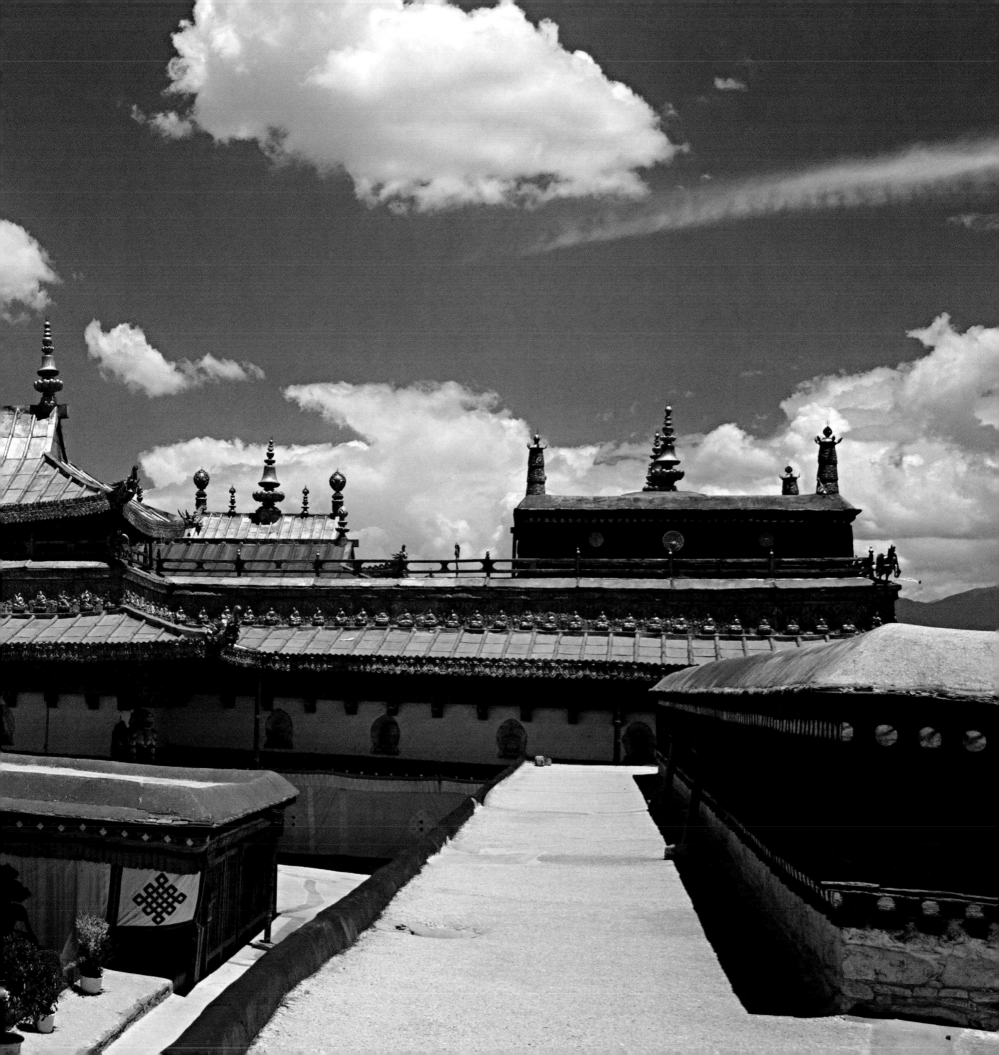

No bicycle

No new shoes

Dad touched my head

Nodded smiled

I feel sweet

I feel happy

I want to keep this forever

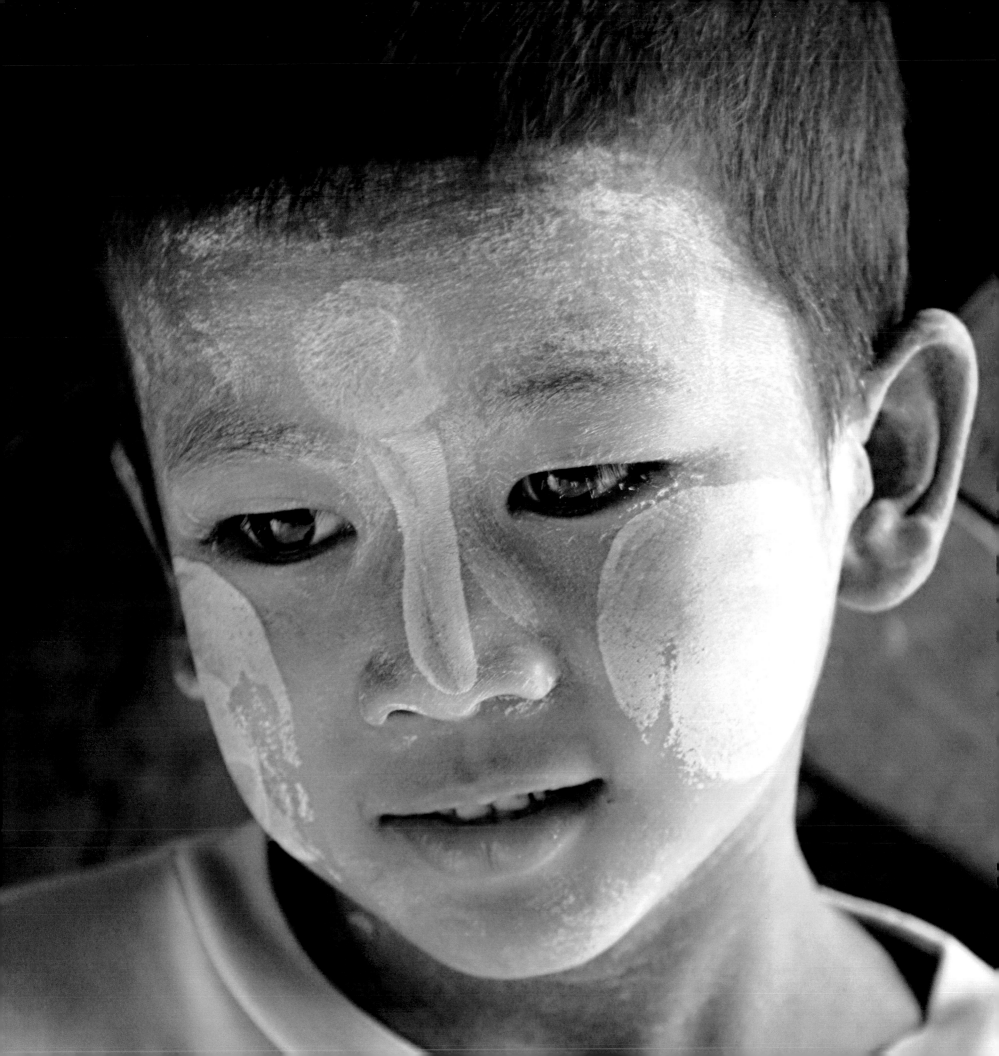

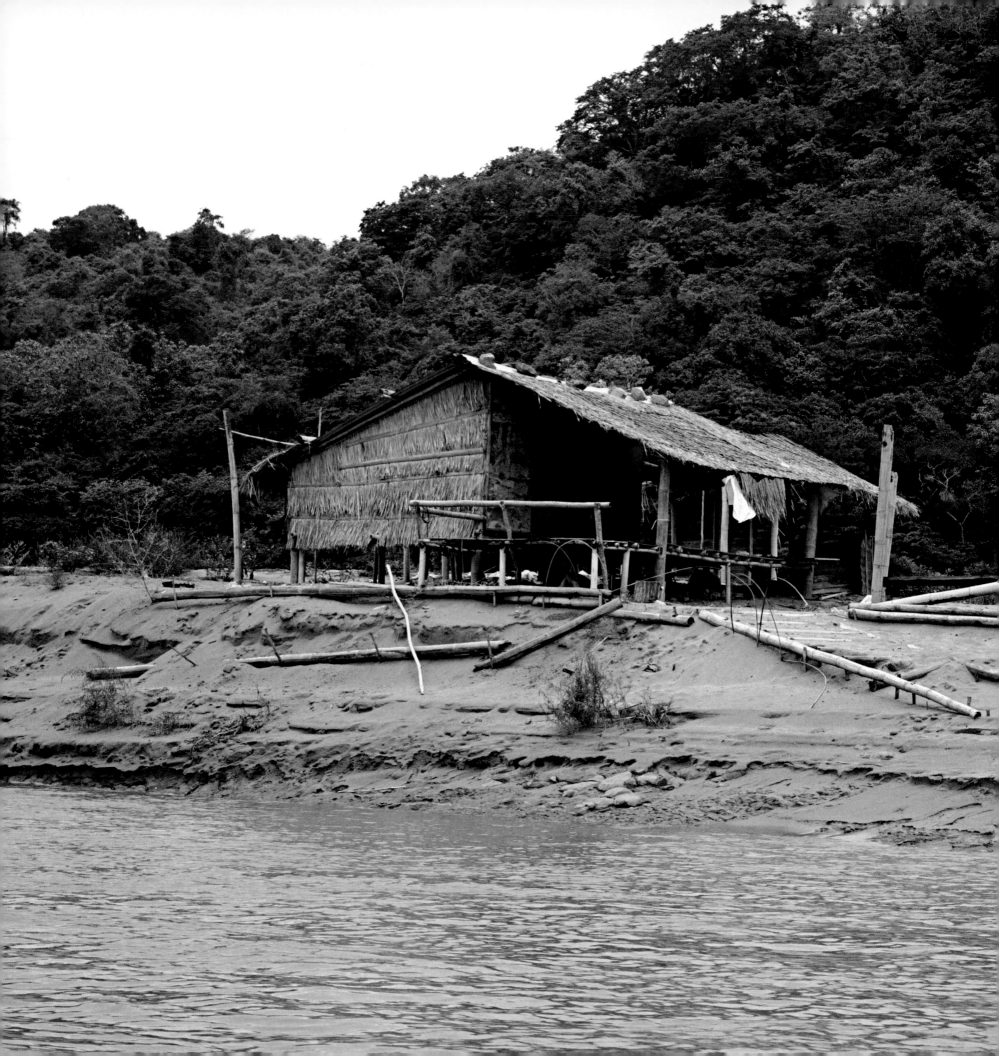

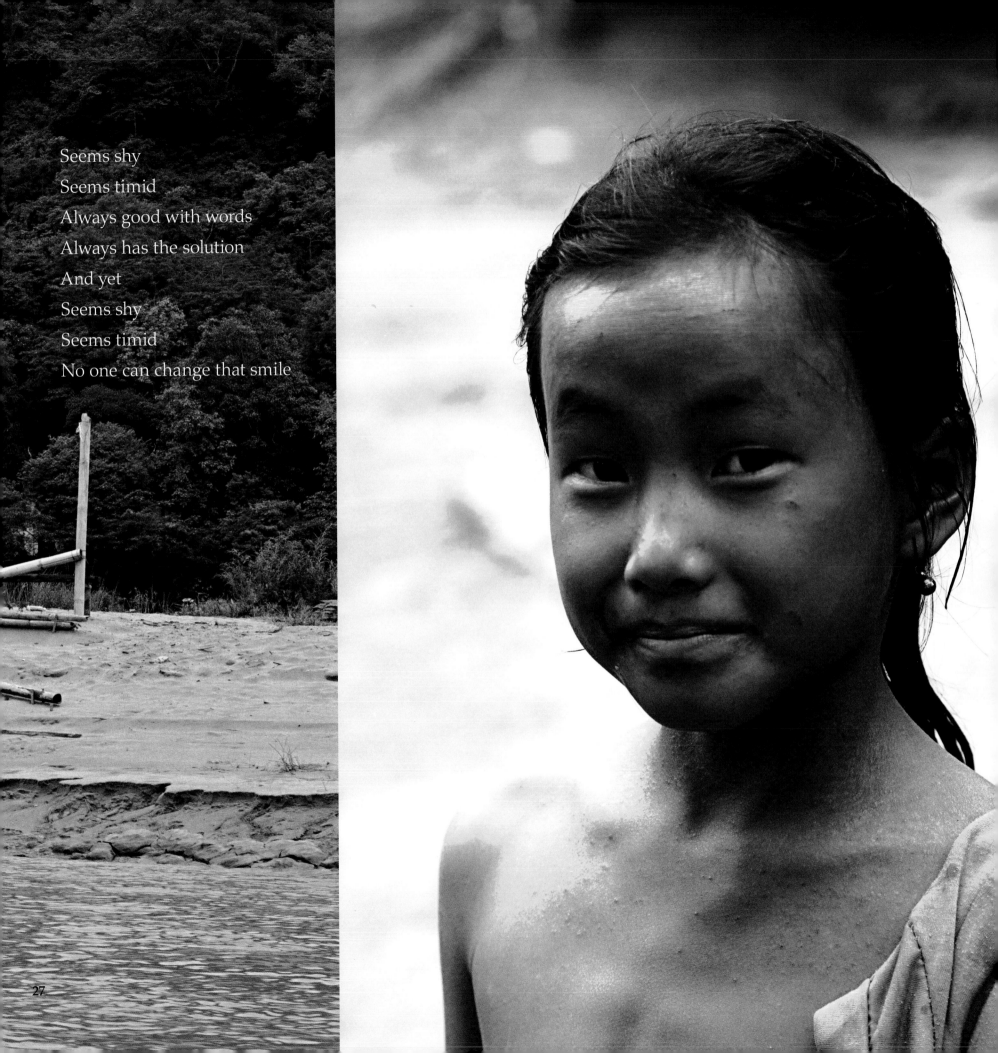

Seems shy
Seems timid
Always good with words
Always has the solution
And yet
Seems shy
Seems timid
No one can change that smile

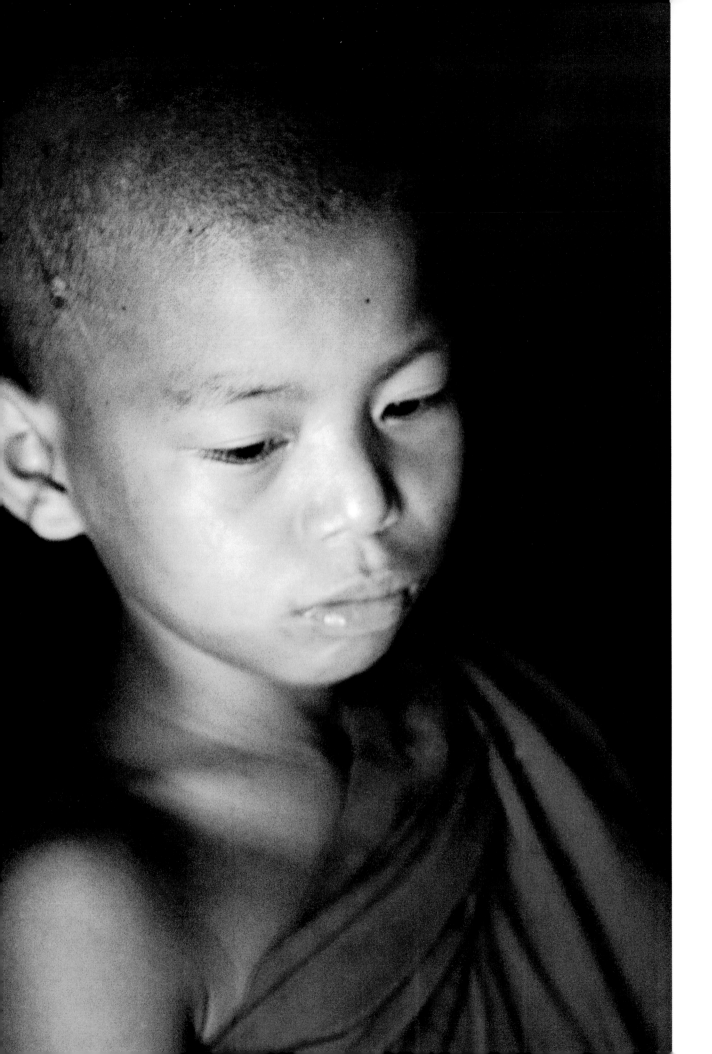

Morning class
Difficult
Morning prayer
Hard
Need focus
Need concentration
They can do it
I can do it I can do it

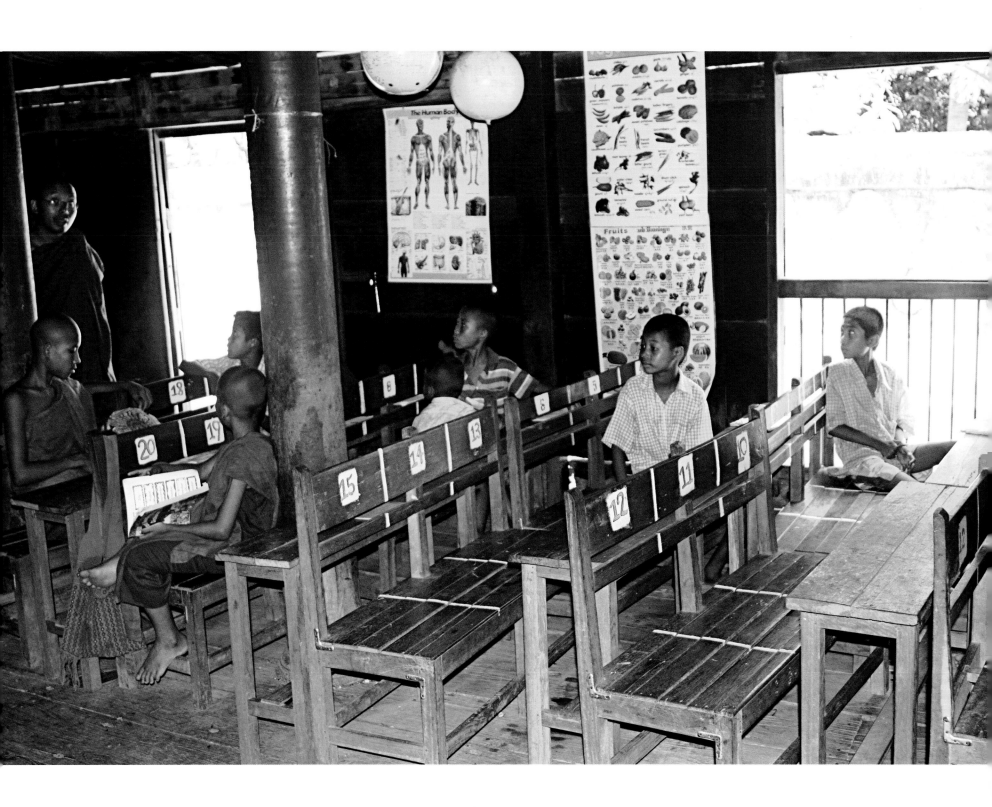

Don't tell Mother

Let's skip school

Climb the hill

Find the trees

Pick the fruit pick the fruit

Take home

No No

You can't take home

Mother will know

OK OK

Ha ha ha ha

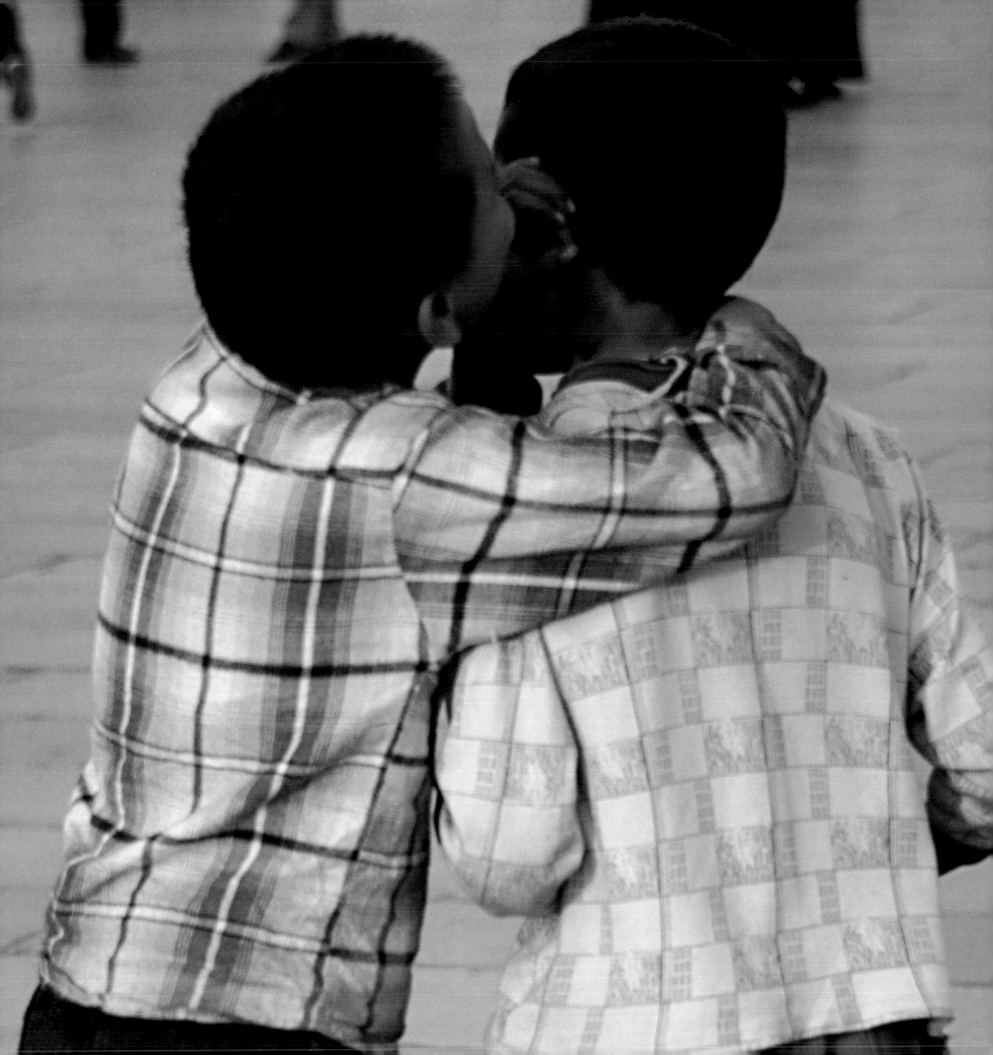

Up fourteen thousand feet

On top of the world

Down to the lake

Roll up pants

Walk into the lake

Play with the turquoise water

Feel the breeze the coolness

Push pull

Laugh yell

Echo from water echo from sky

How fun how fun my friend

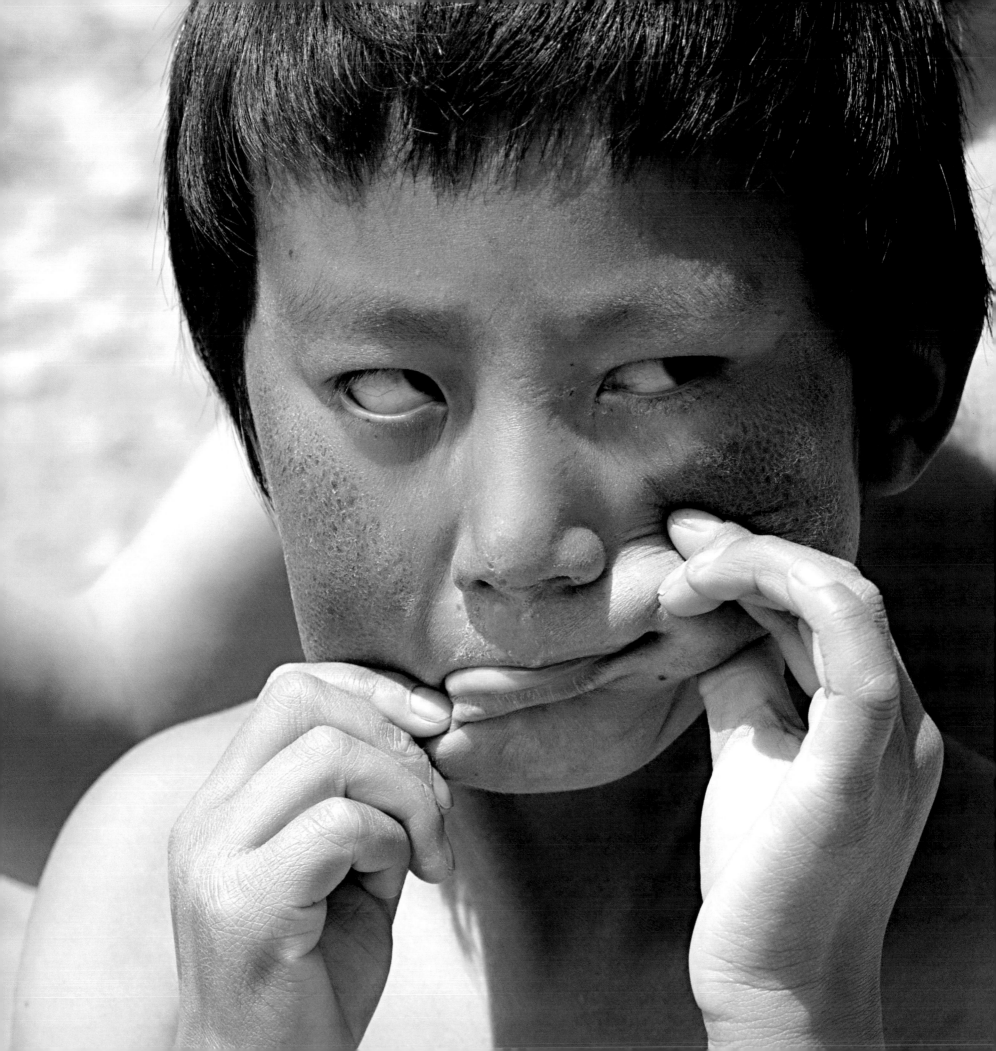

So many strangers
Always look at me
Wonder who I am what I am
But who are they what are they
I'd rather be with my friends
They know who I am
They know what I am

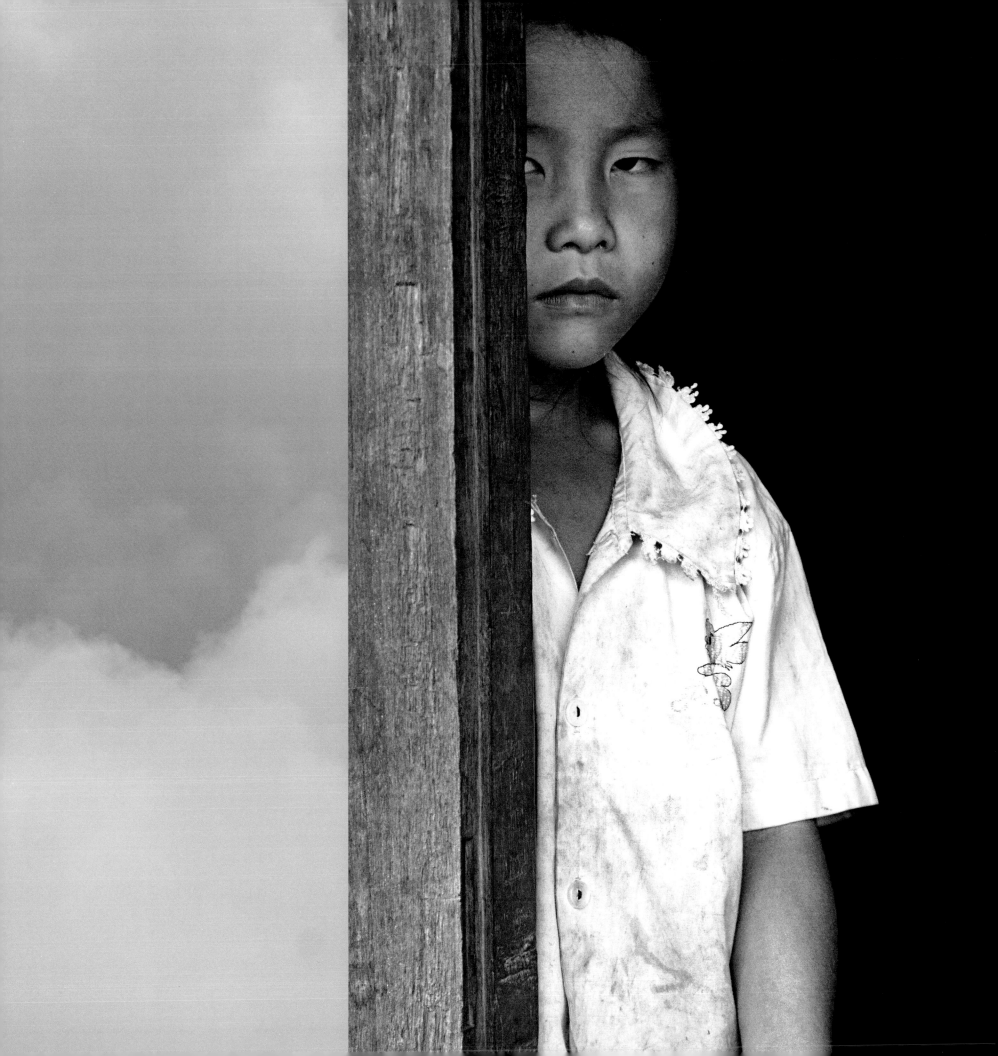

Stones steps paths

Hundreds hundreds of years

People come and go

Up and down

Contemplating this bygone place

Courtyards old old trees

Our playground

It's ours

Touch wildflowers

Embrace old trees

Chase jump laugh

This ancient place

Needs us needs us

To be alive to be alive

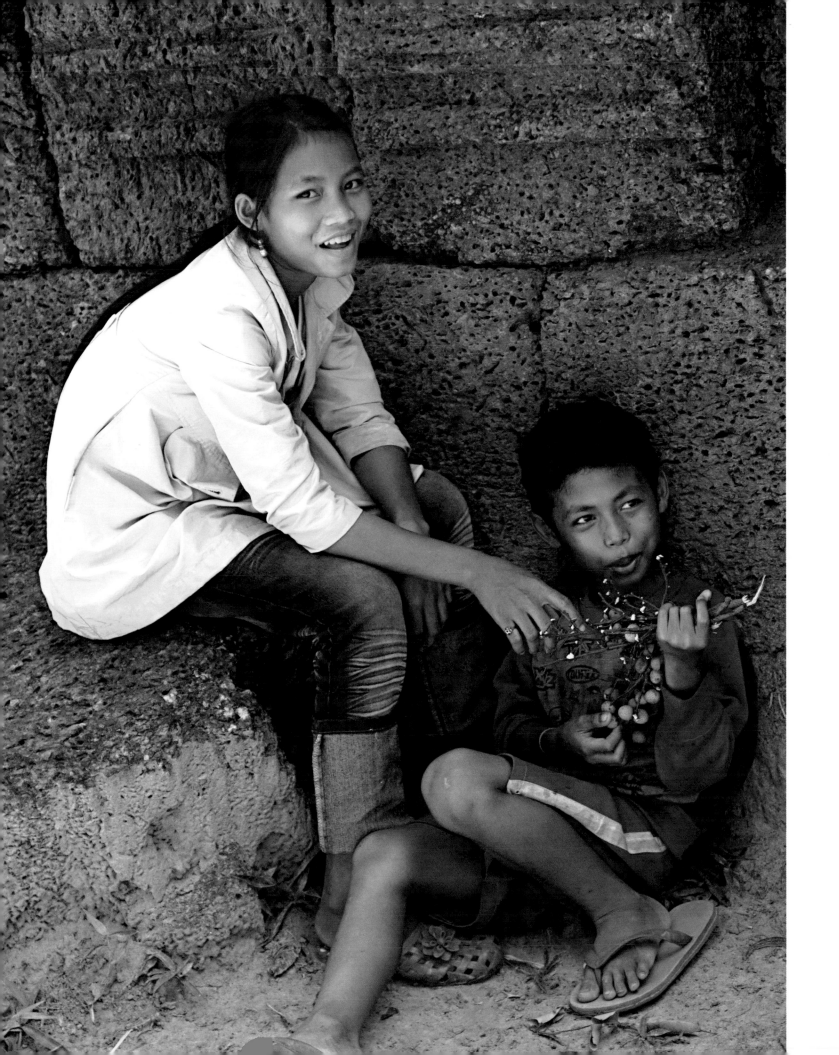

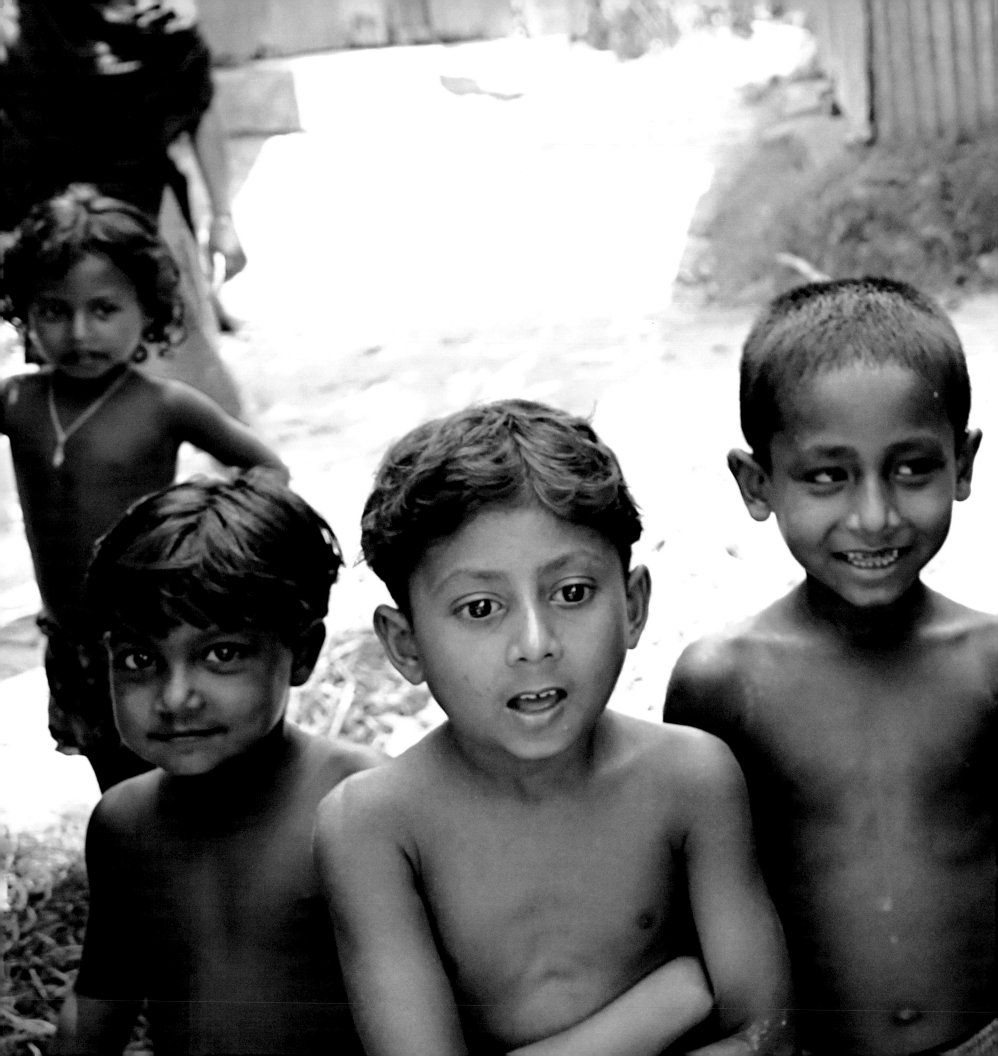

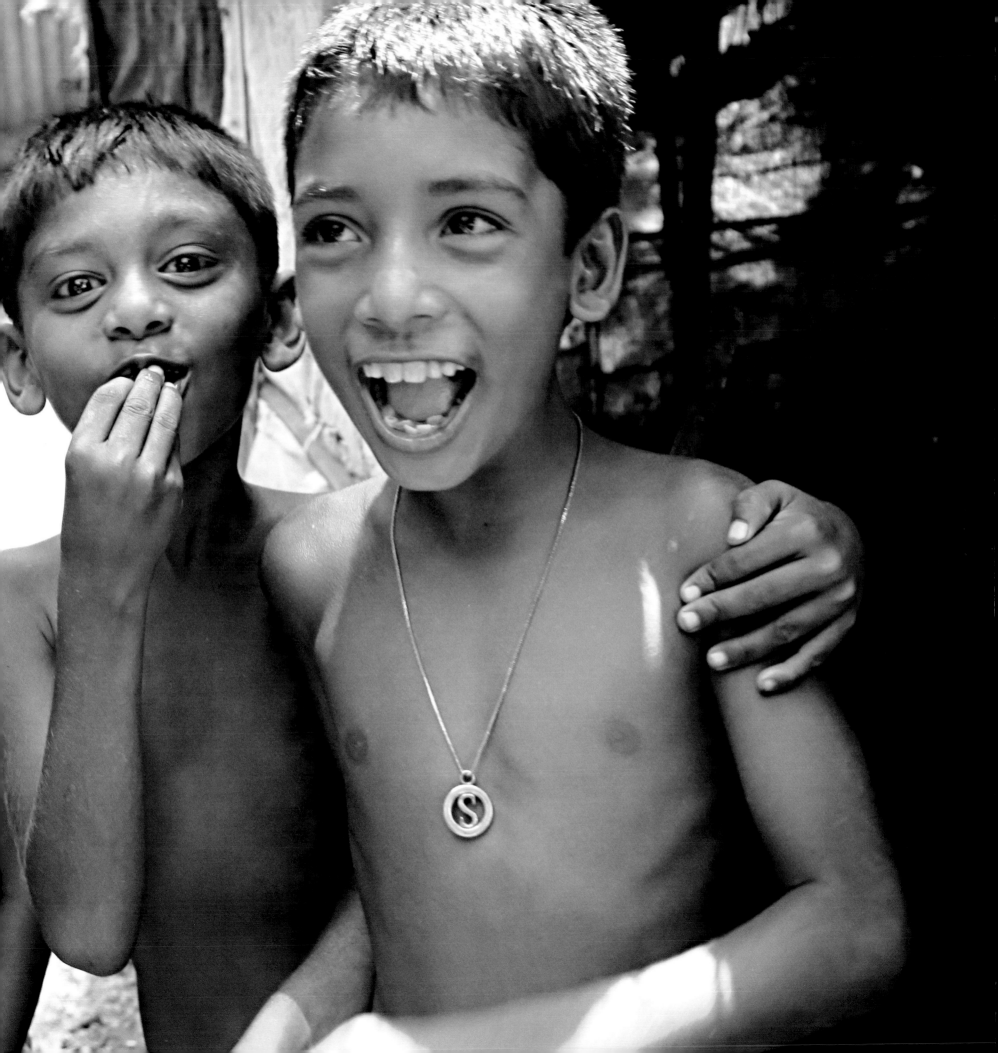

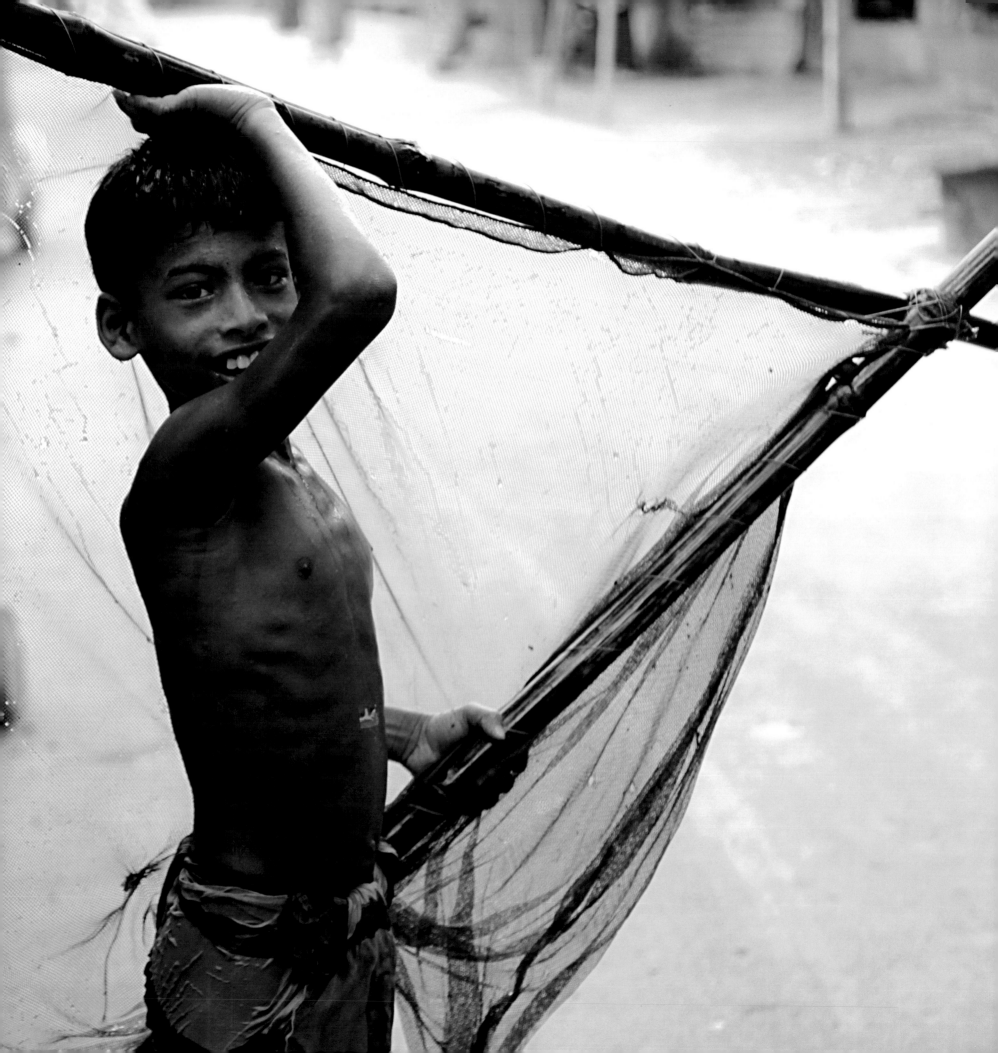

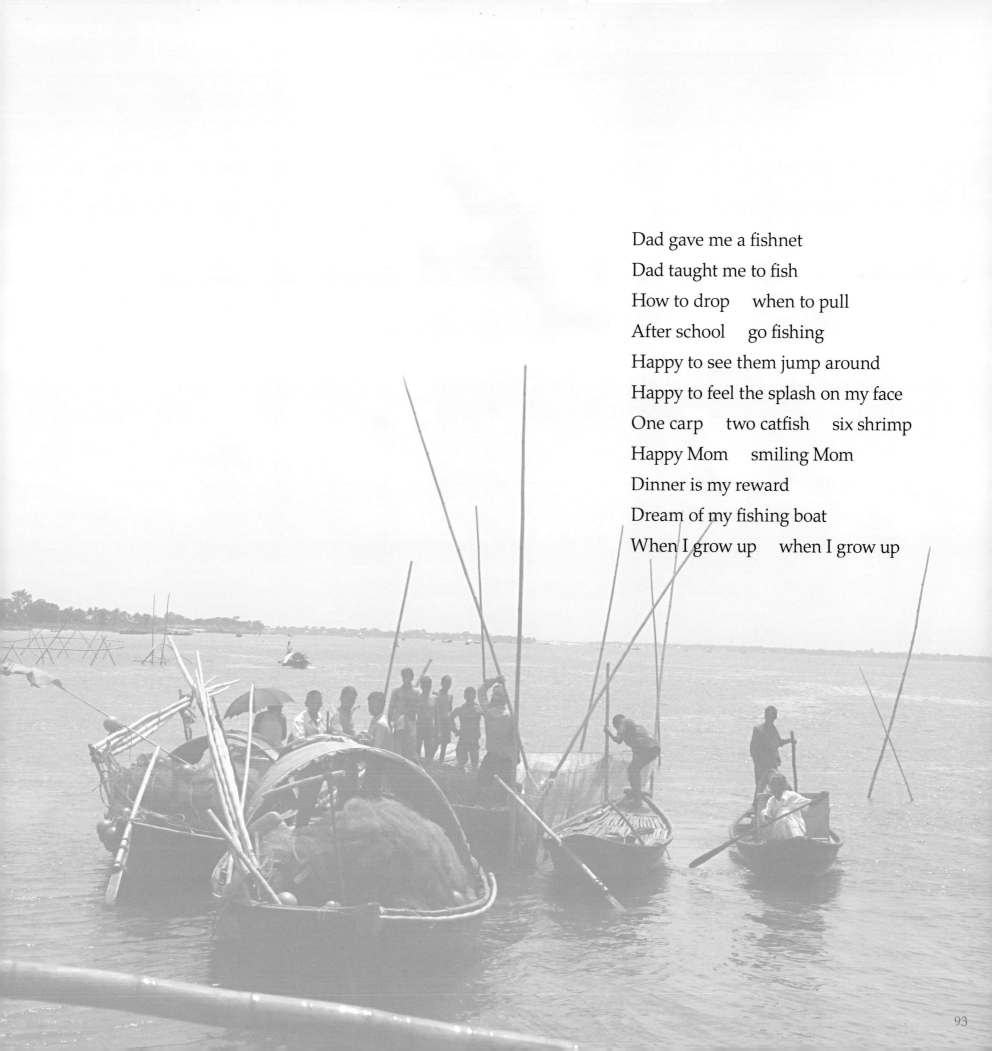

Dad gave me a fishnet

Dad taught me to fish

How to drop when to pull

After school go fishing

Happy to see them jump around

Happy to feel the splash on my face

One carp two catfish six shrimp

Happy Mom smiling Mom

Dinner is my reward

Dream of my fishing boat

When I grow up when I grow up

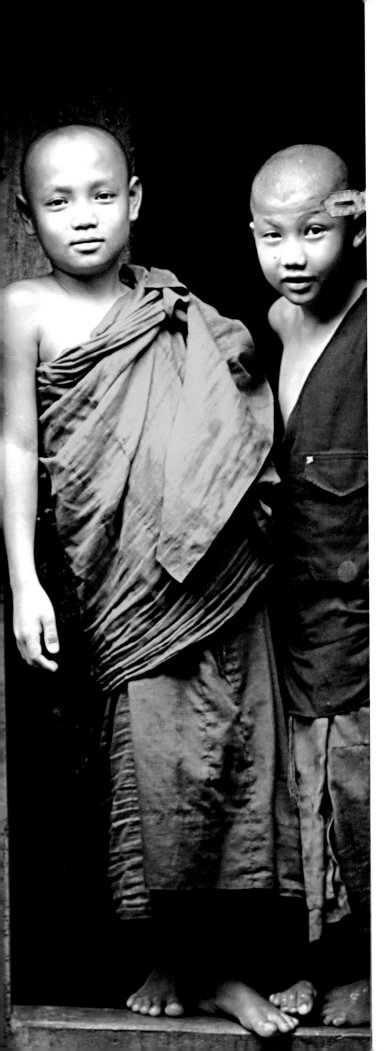

What a hot humid summer afternoon

How I look forward to a cold splash

Full tank of water

Can't wait to fill my bucket

Pour over my head

Coolness rushes over me

Throw at you throw at me

Splashing splashing splashing

Ha ha ha

Laughing joking shoving

Hurry hurry hurry

Prayer time is calling

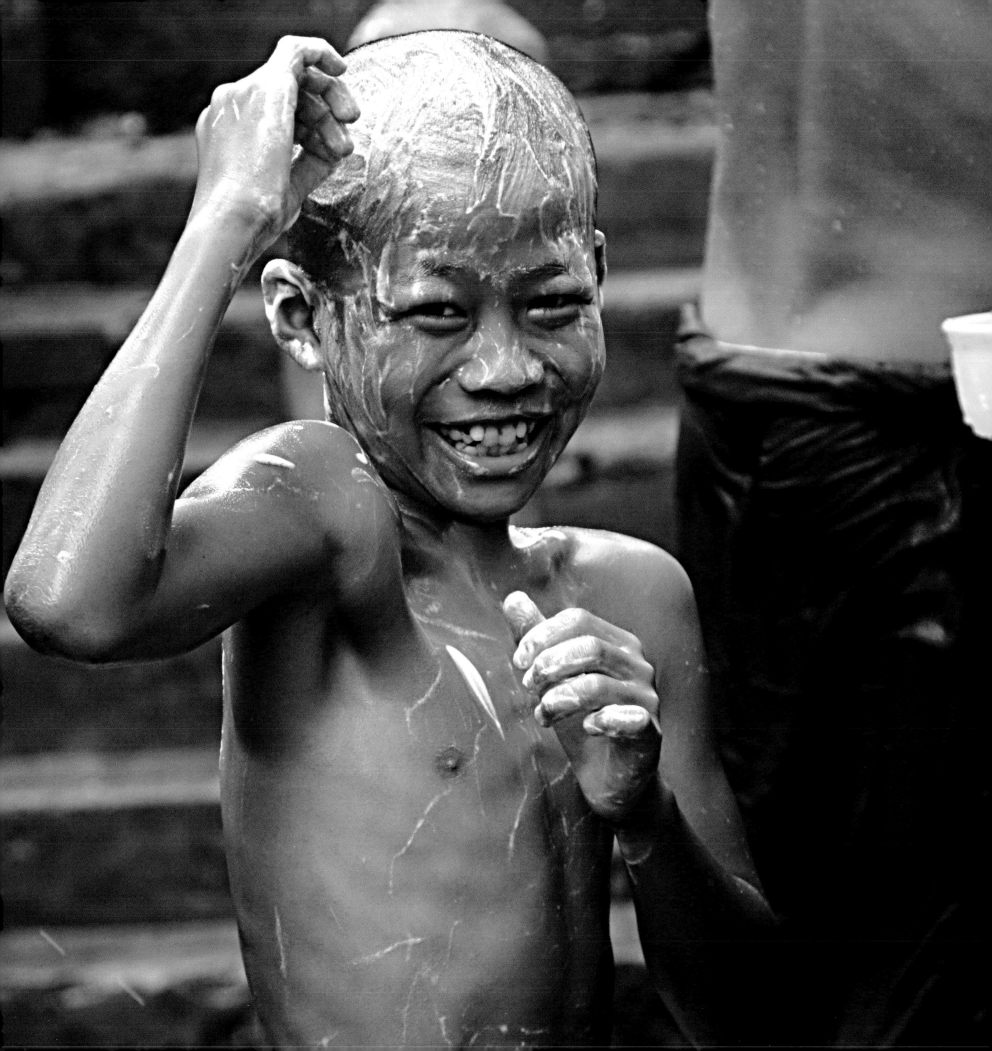

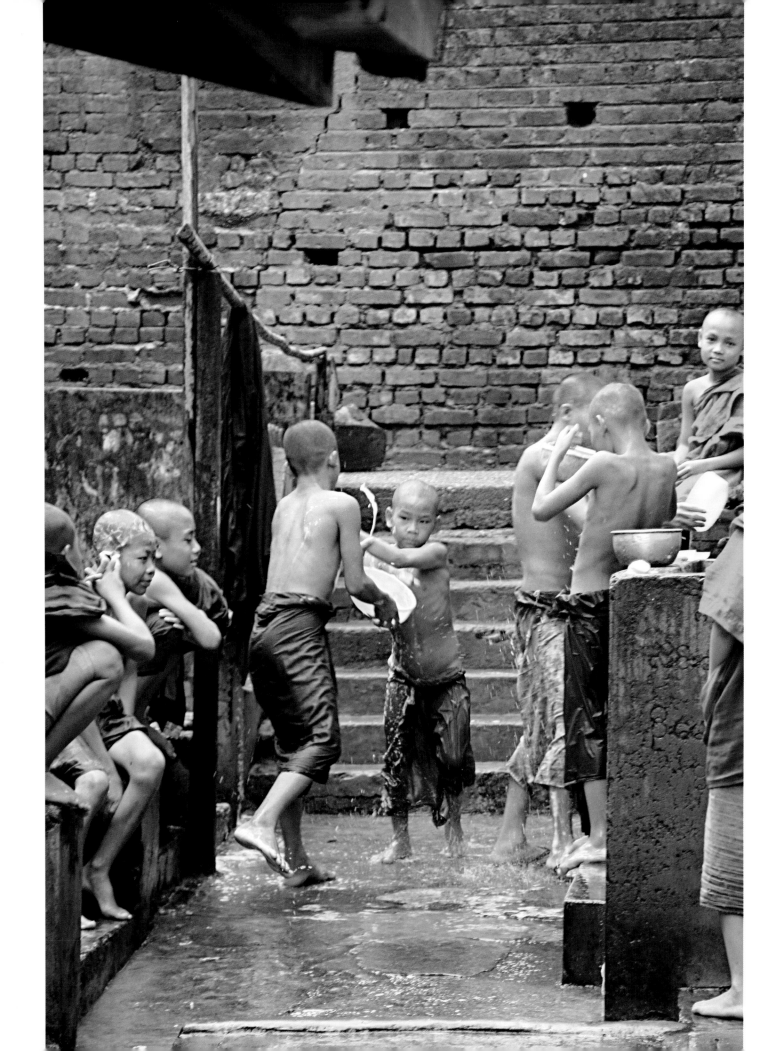

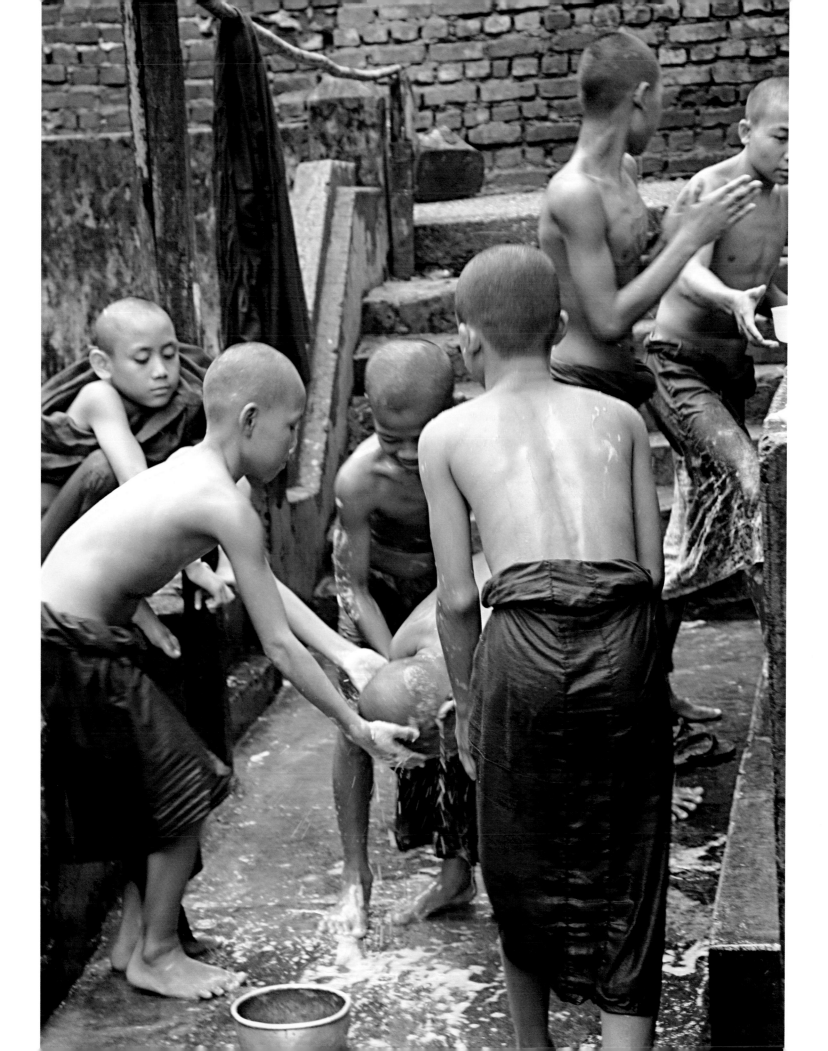

I know I can do better, I know I can argue, I know I can fight

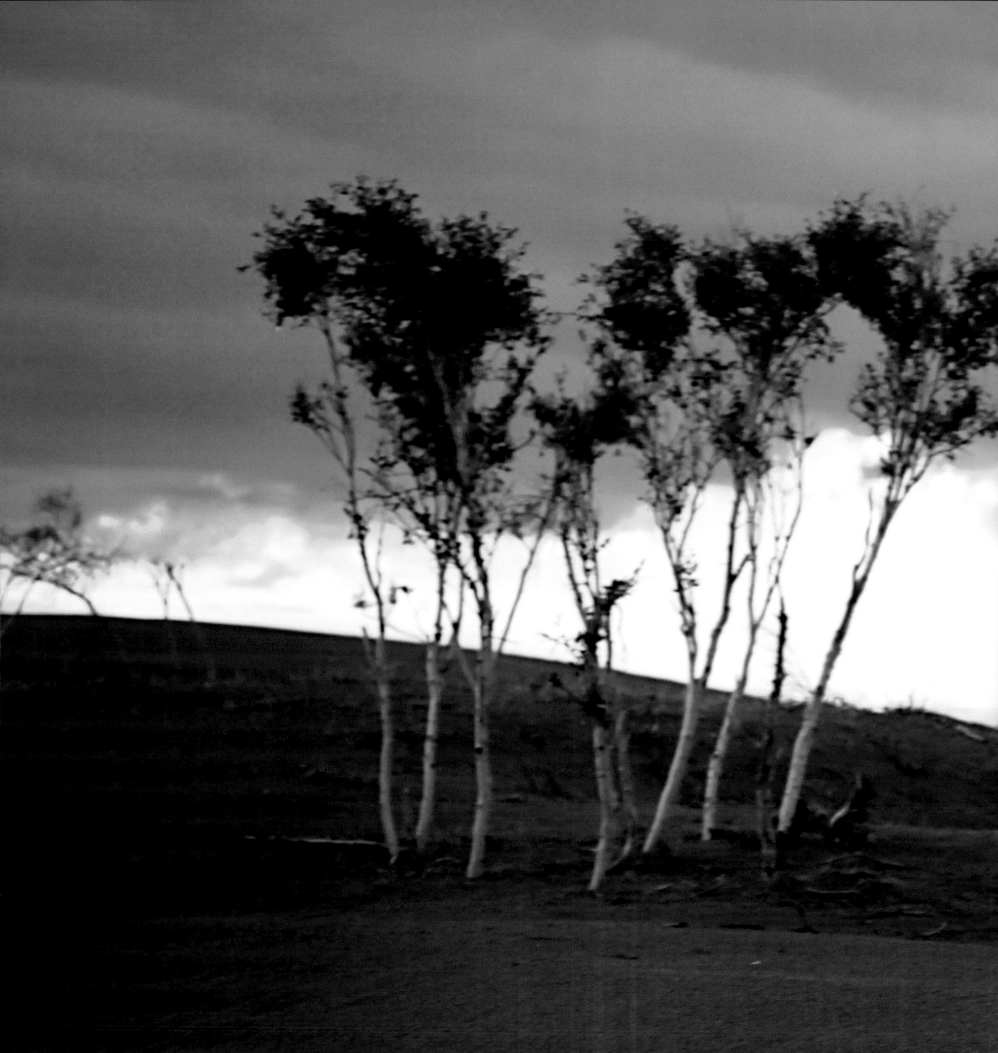

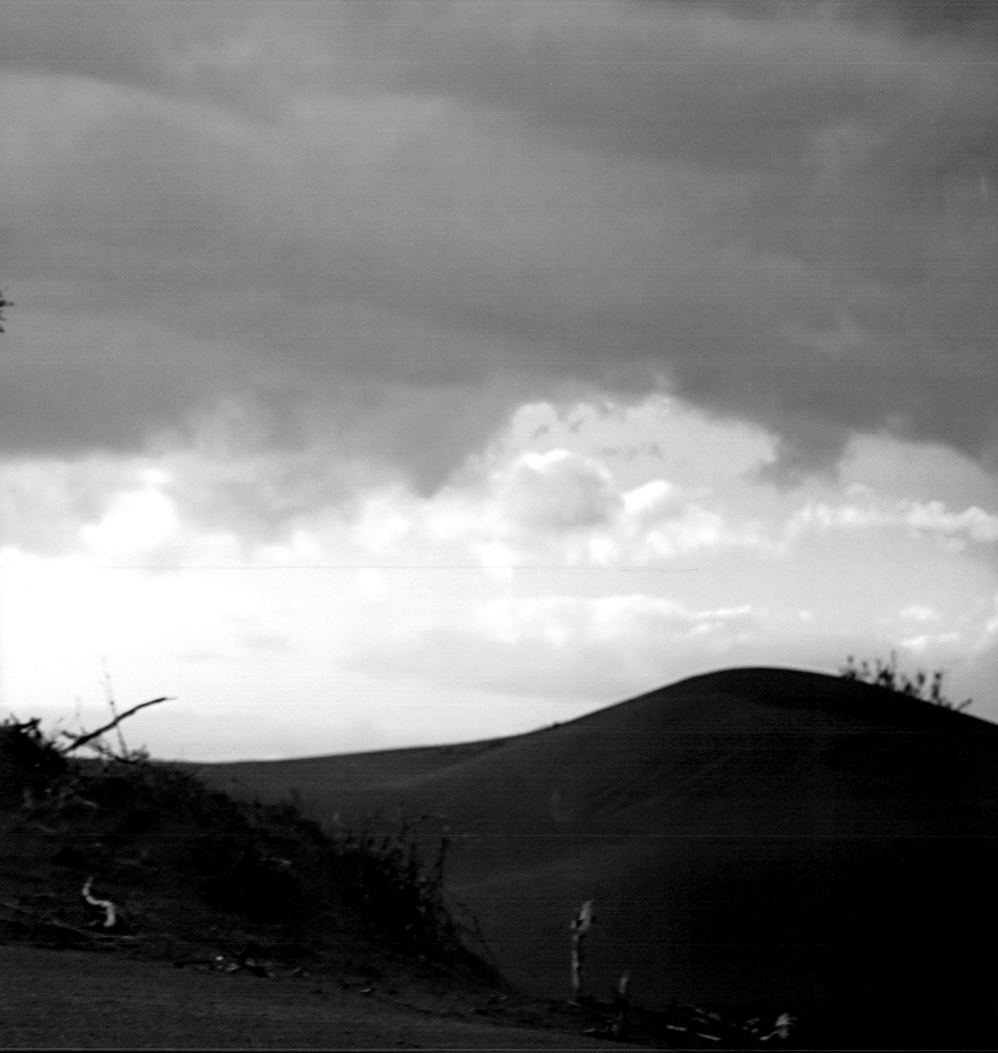

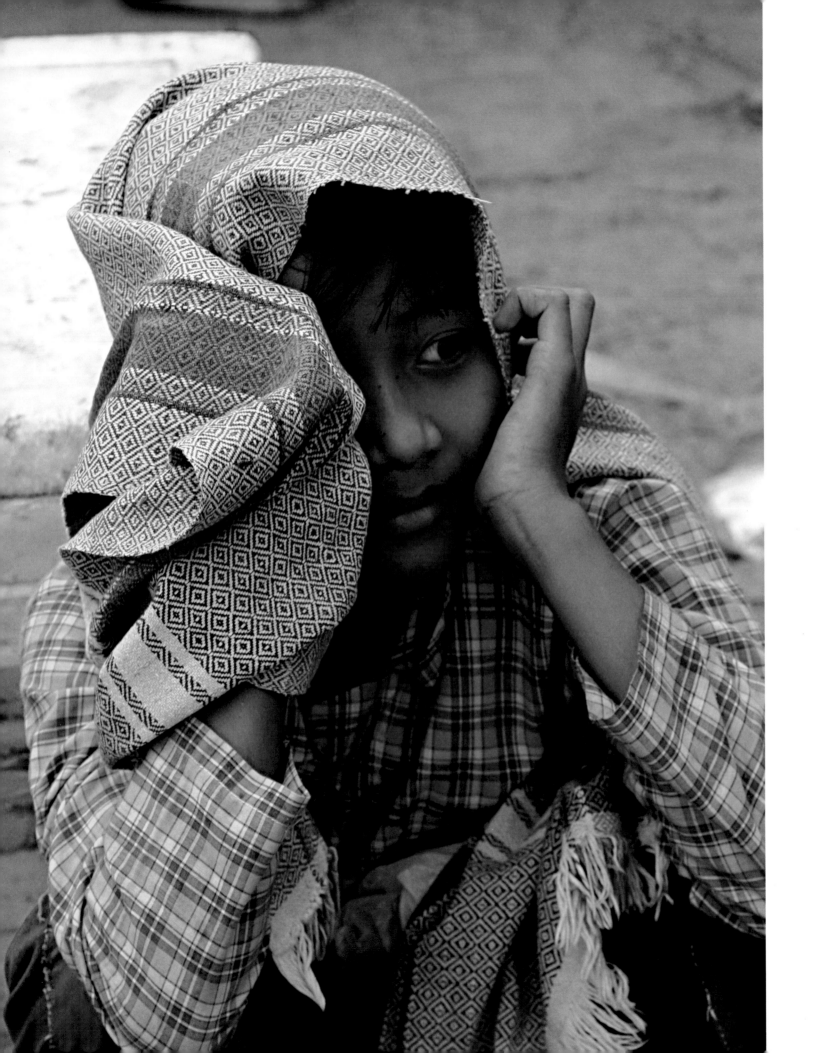

Something I can't talk about

Right time wrong place

Right place wrong time

Whichever way

Just much too much

for me to let out

All there is to do

Wait and think

Think and wait

But . . .

He is so nice so handsome

Sharp deep piercing

Filled with infinite emotions

No need to explain

No need to tell

No need to smile

The world starts there

The world ends there

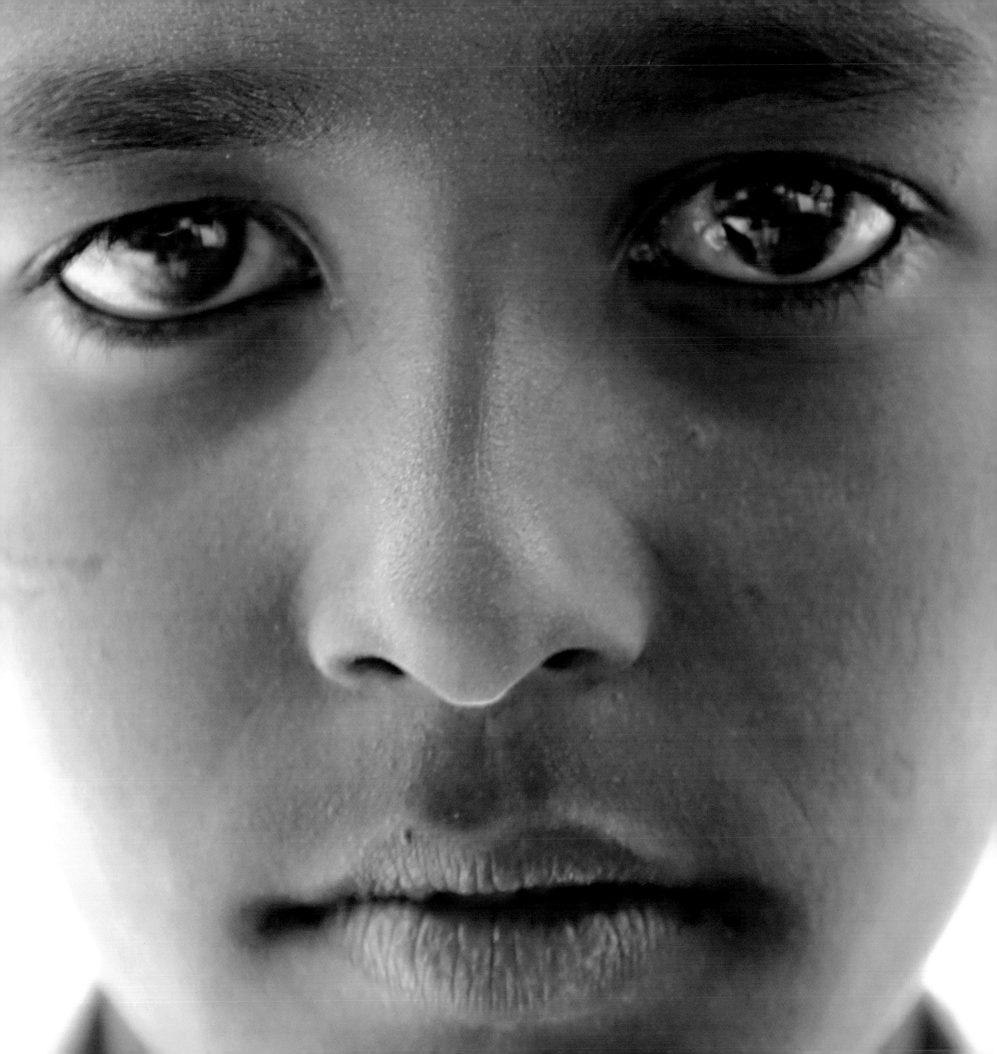

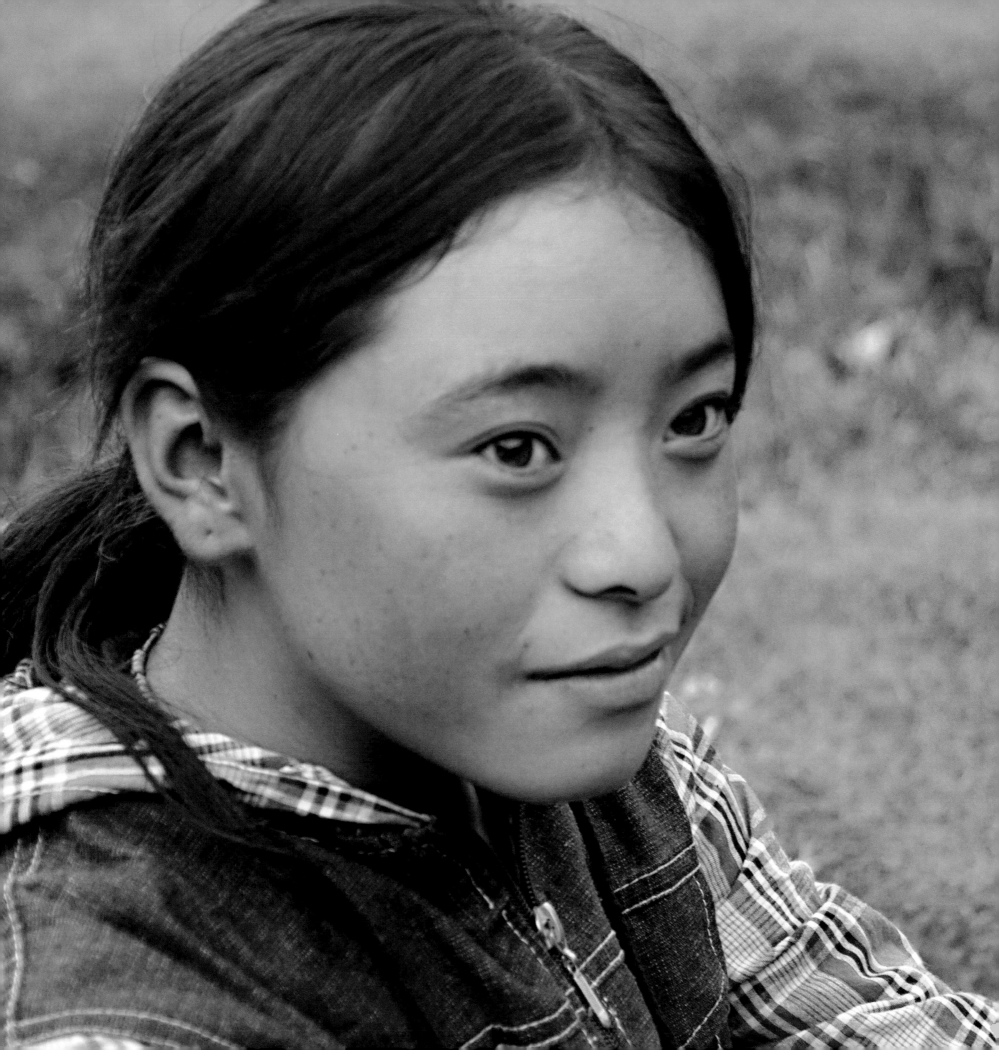

In the morning

Lugging clothes

up the mountain stream

Smooth rocks soft moss green grass

Fifteen thousand feet

Touching pure clear water

Freshness runs through my being

Whoosh whoosh

I inhale I exhale . . .

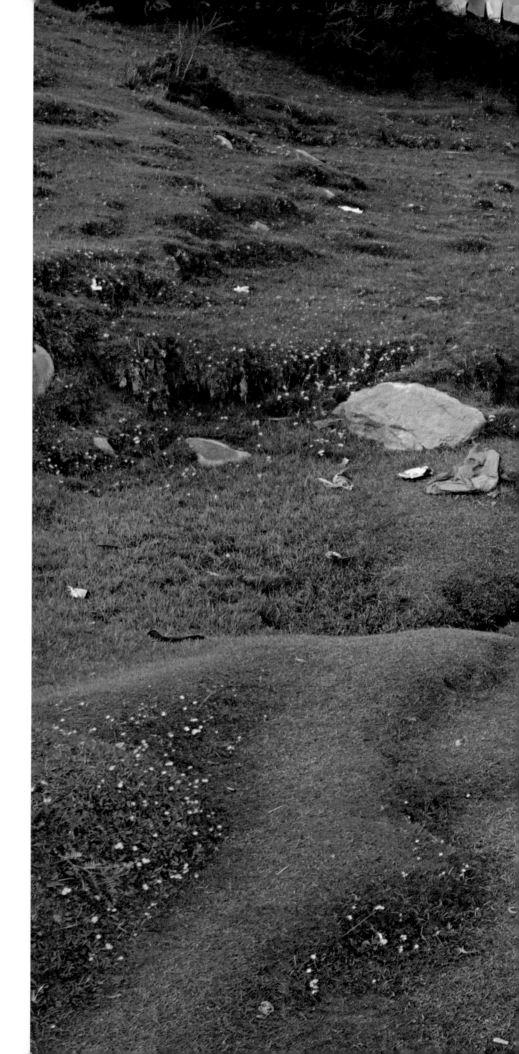

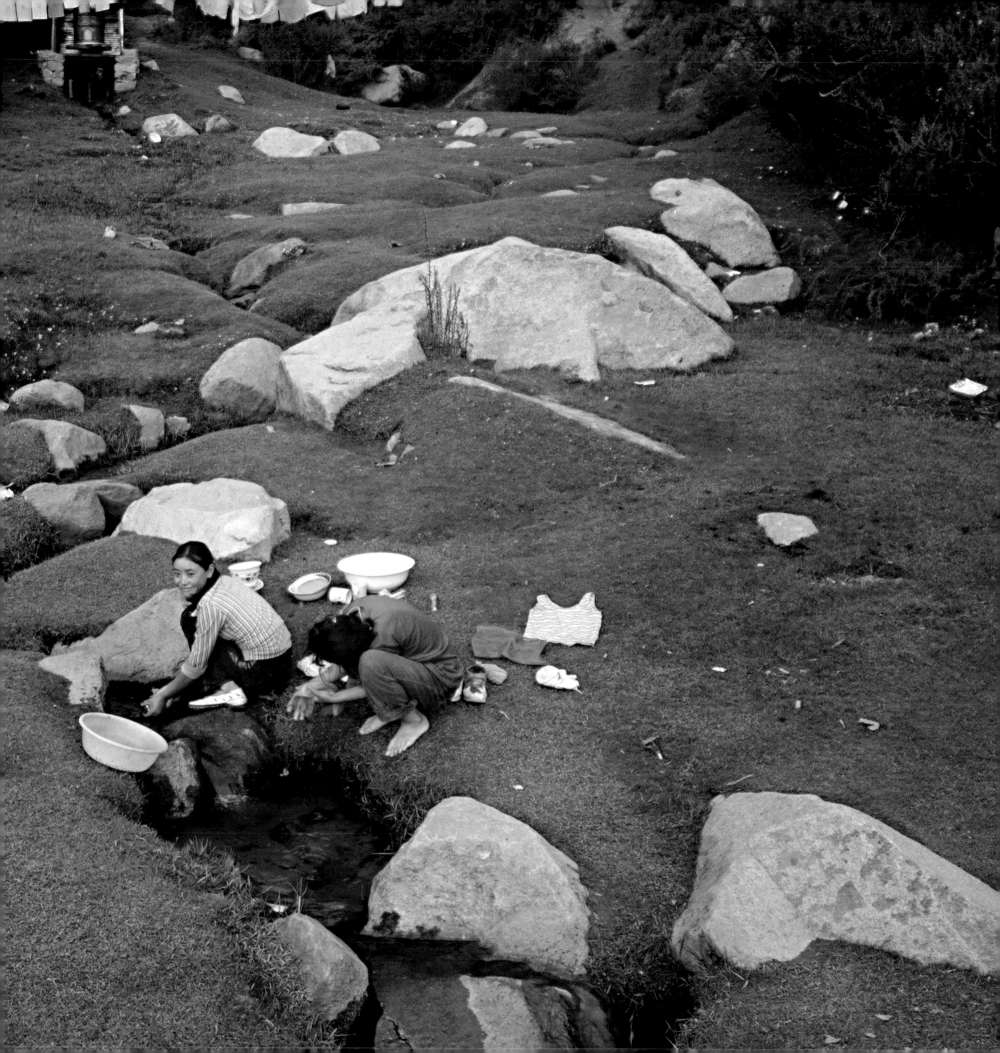

My favorite thing

To stare to think

Lost in thought

To imagine to explore

Go far far away

Create my destiny

Be where I haven't been

Meet friends I haven't met

Lost in thought

Some things happy

Some things sad

Some things exciting

Some things frightening

Wandering back

I'm still me

Wandering back

I'm still me

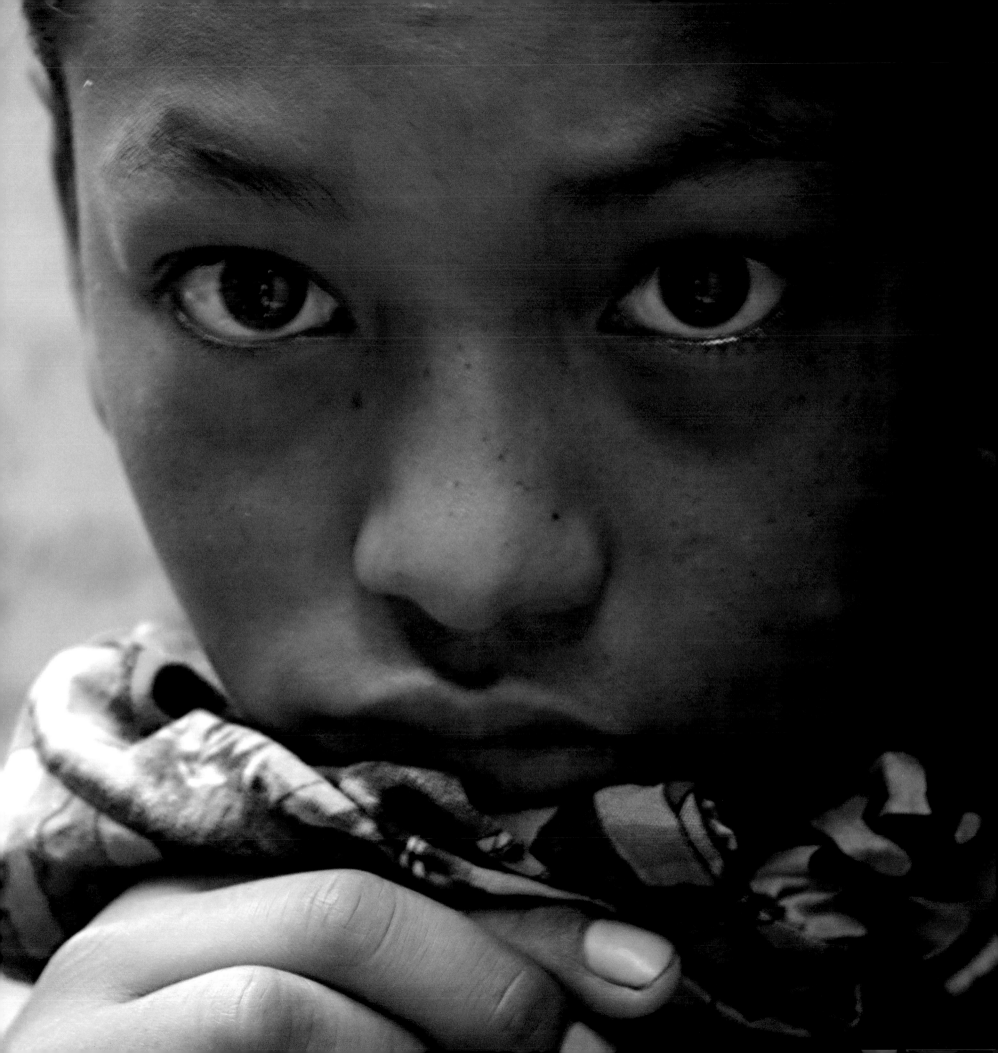

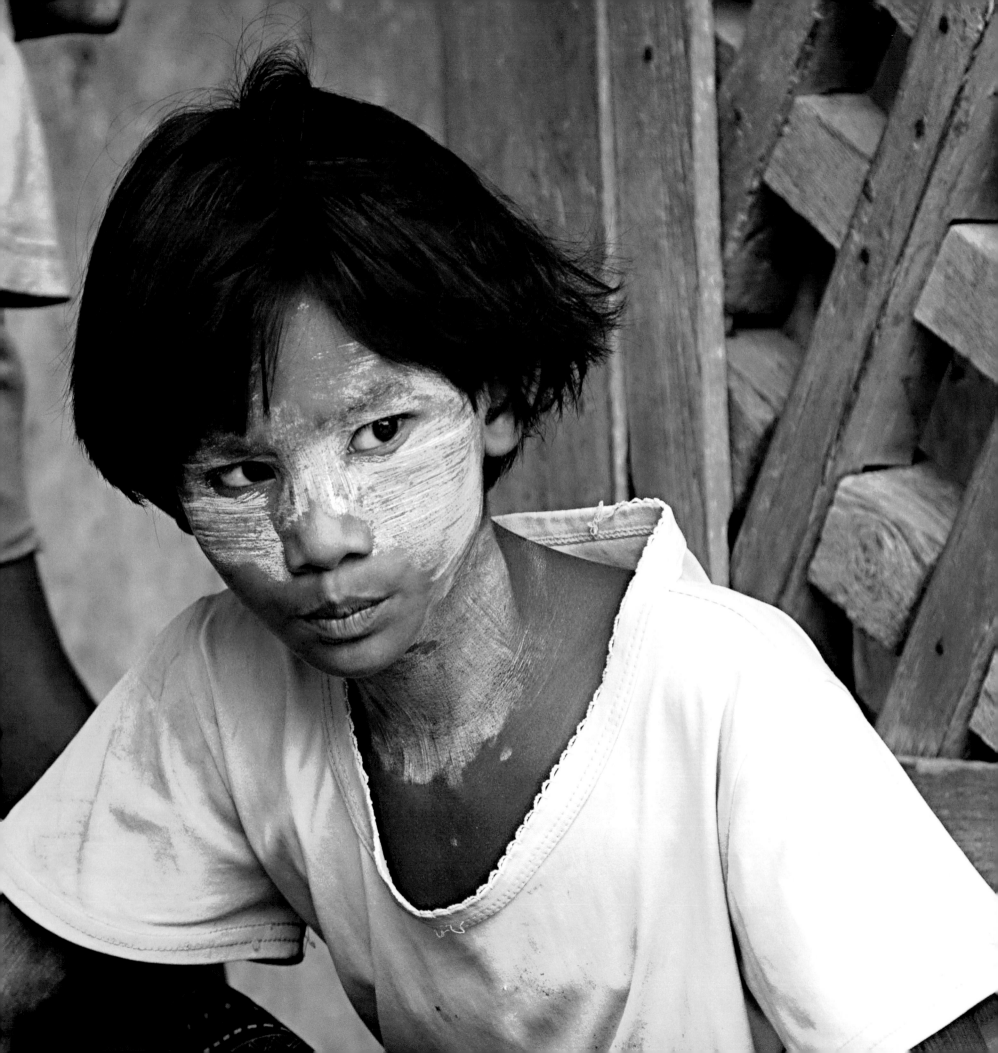

People talk

about themselves

People talk

about others

Need to talk

for confidence

Need to talk

for security

Angry hurt happy

or simply insecure

Crossed emotions

all come out

I do I don't

Oh just shut it off!

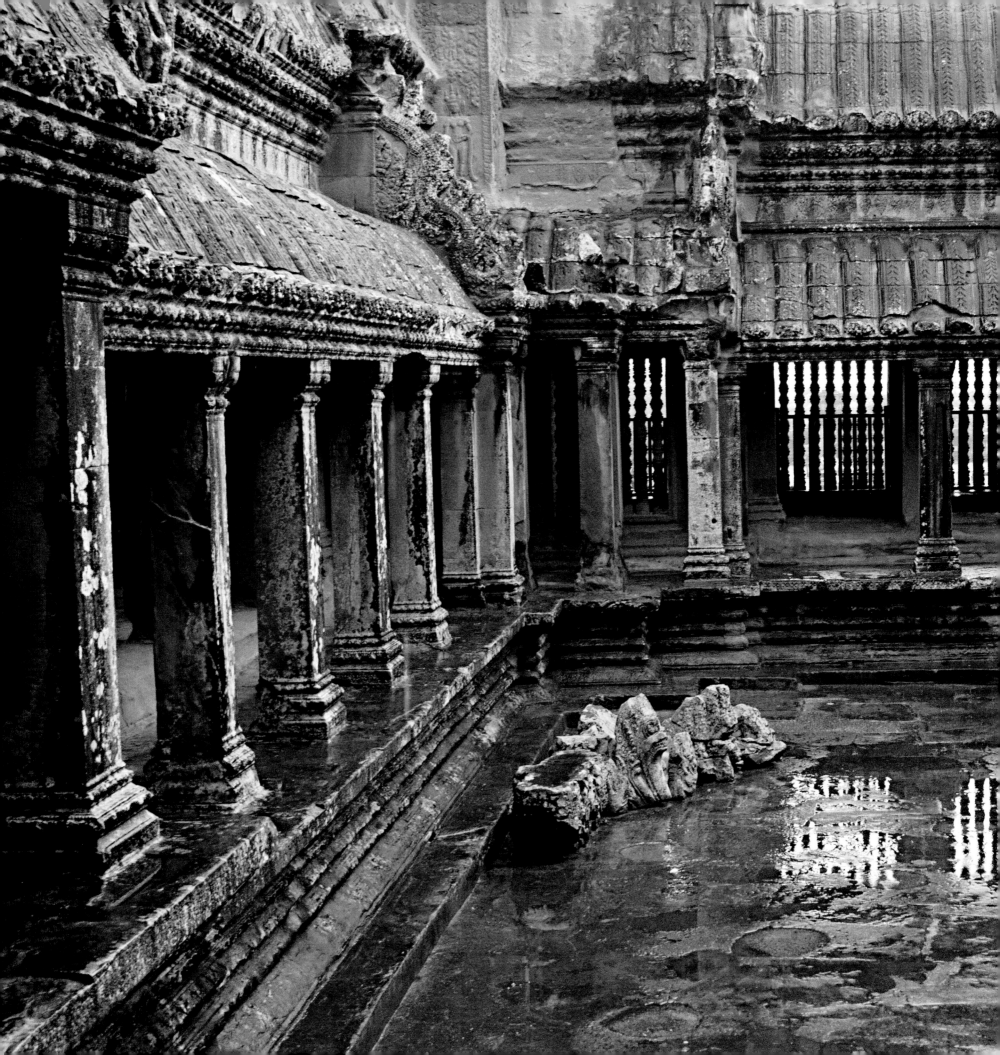

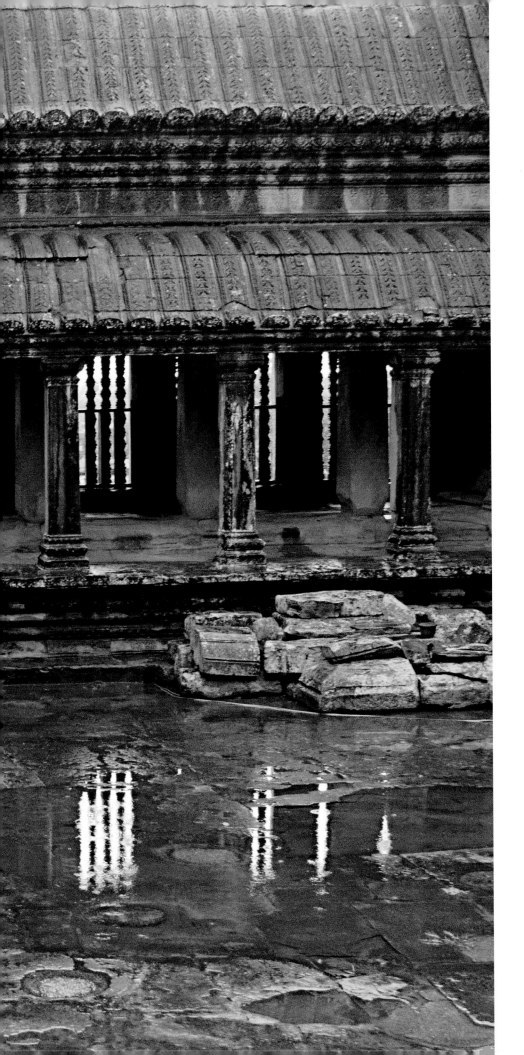

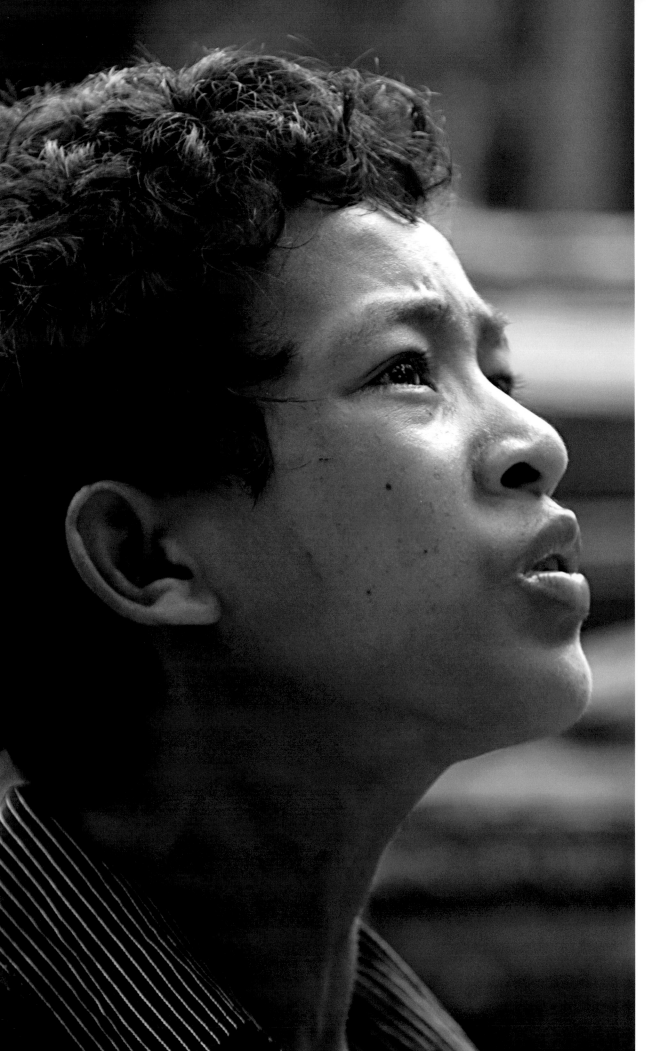

Singing sing through ancient air

echoes through treetops

floats 'round the stone temple

enchanting the stories

After school ride tricycle

along winding street

Stop at restaurants

Collect scraps home to feed pigs

Oink oink my satisfaction

Sing sing

Next day same place

My sanity my peace

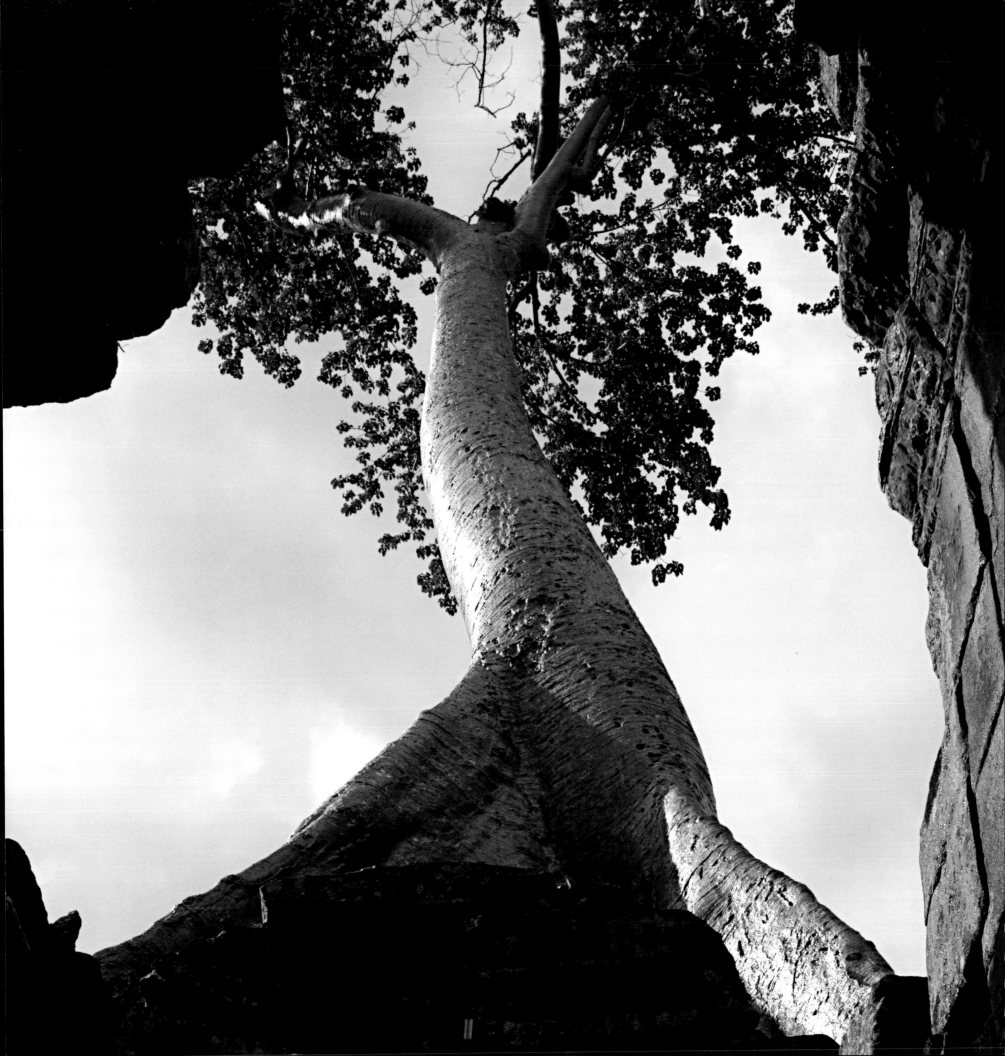

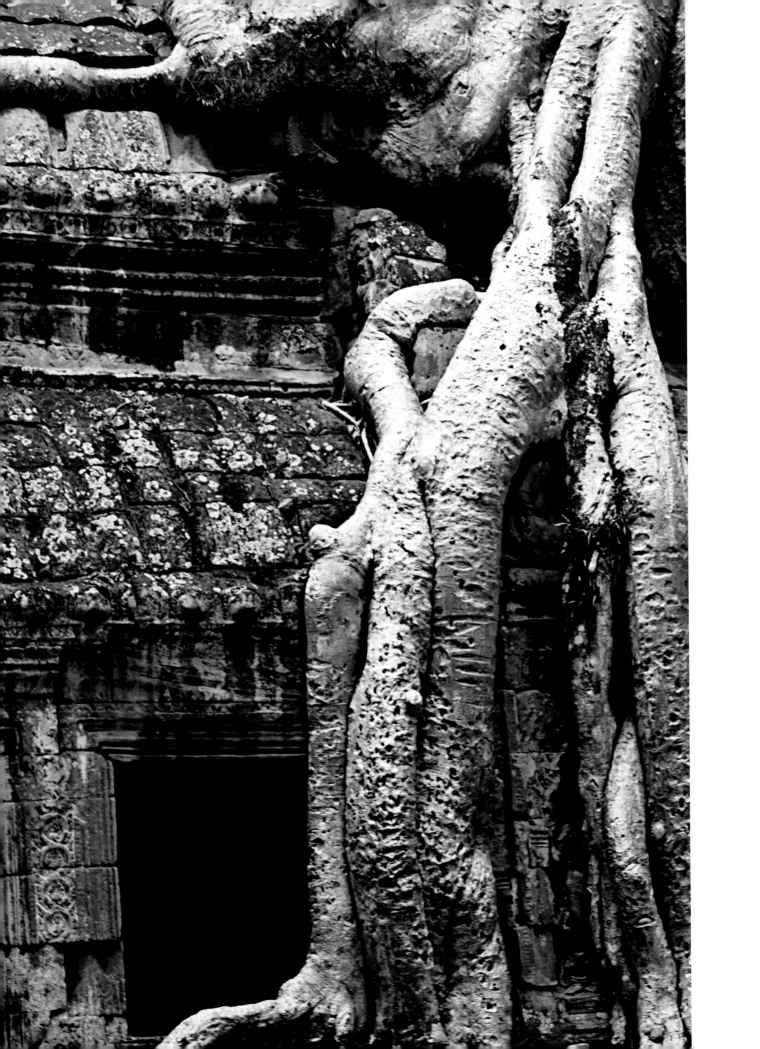

Walk through the ruins

Hand sliding across the stone wall

Step on fallen leaves

Rustle rustle rustle

Light catches my face moment to moment

Hundred-year-old trees intertwine

Buildings rocks

Never separate never able

Can't live without each other

Oh what mighty love

Oh what mighty love

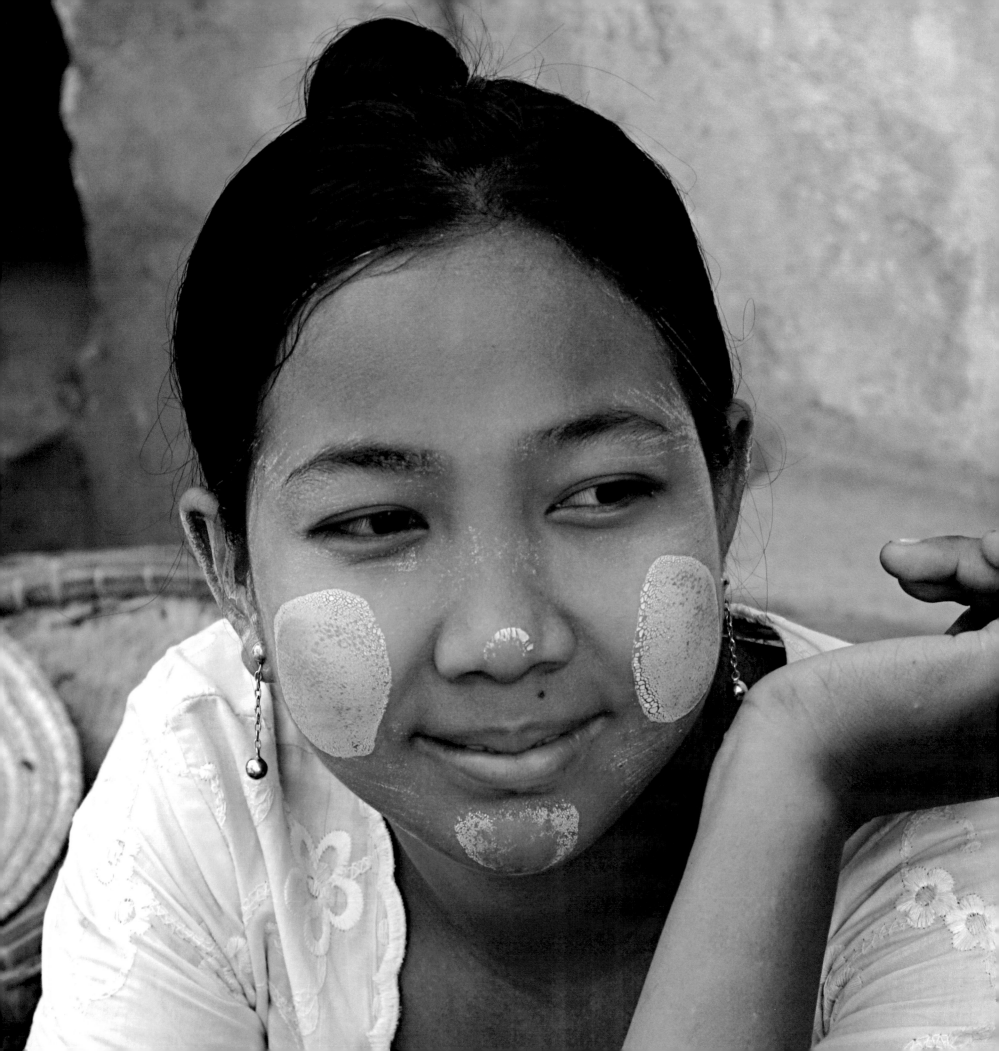

Thanaka Thanaka

Magic tree makes me pretty

Magic tree makes me dazzle

Makes me glow makes me smile

Mirror mirror

Balancing act

Where to start . . .

No forehead just two cheeks

A touch on the nose a brush on the chin

This is it

Brings a smile to my face

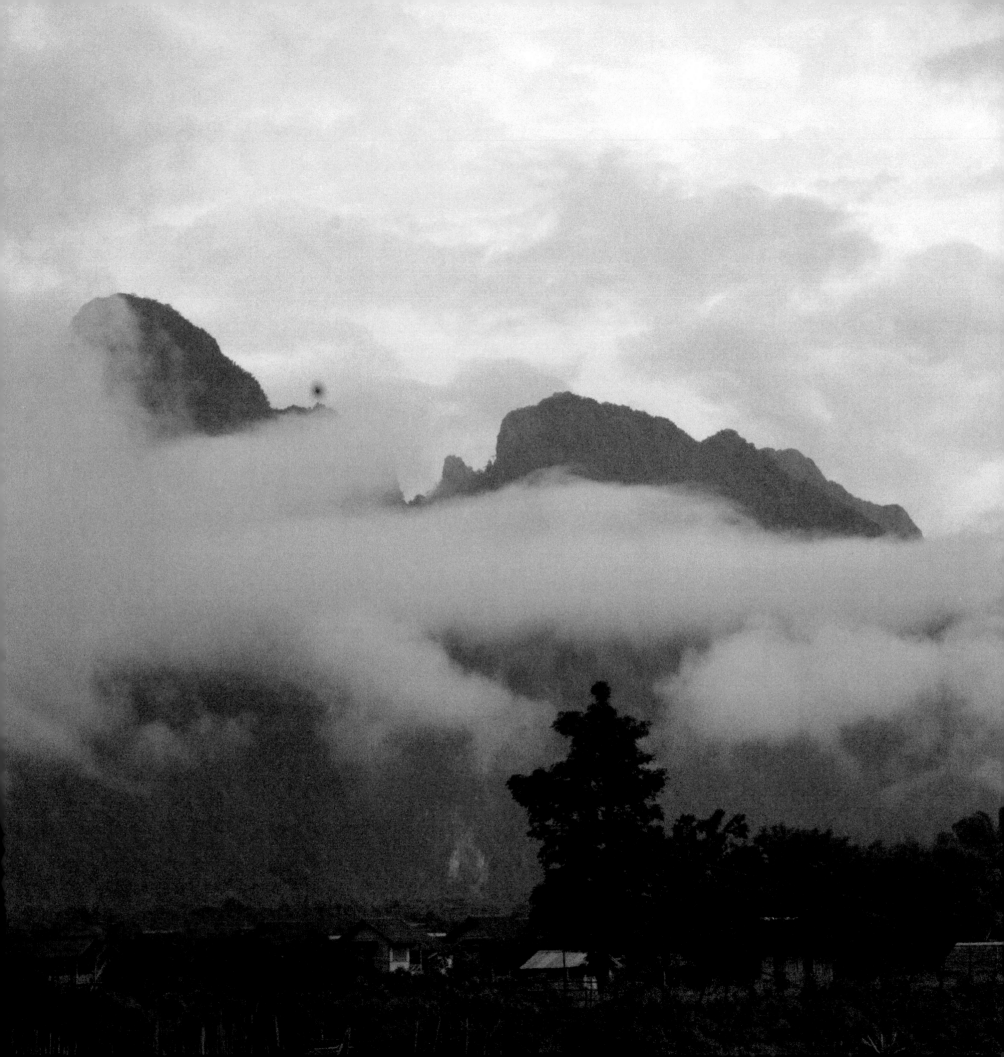

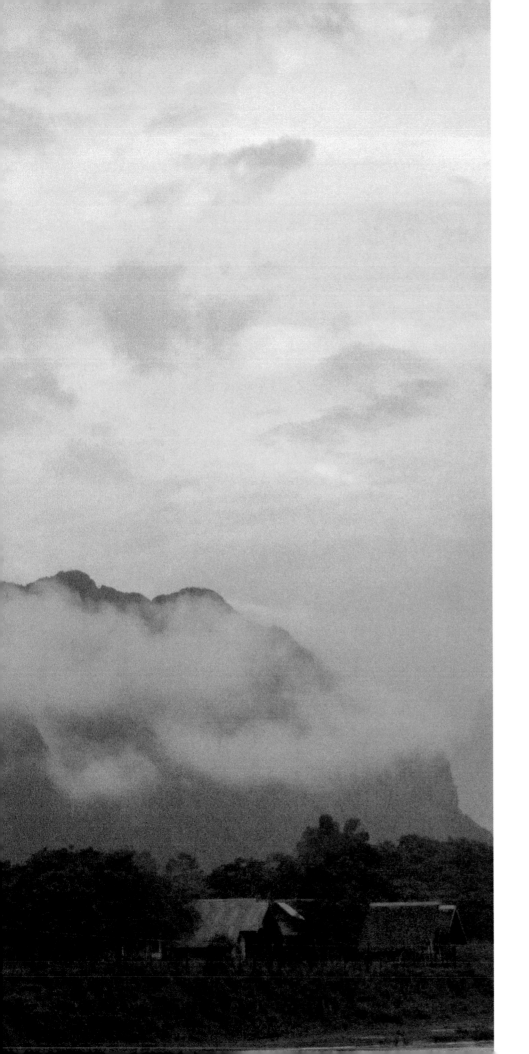

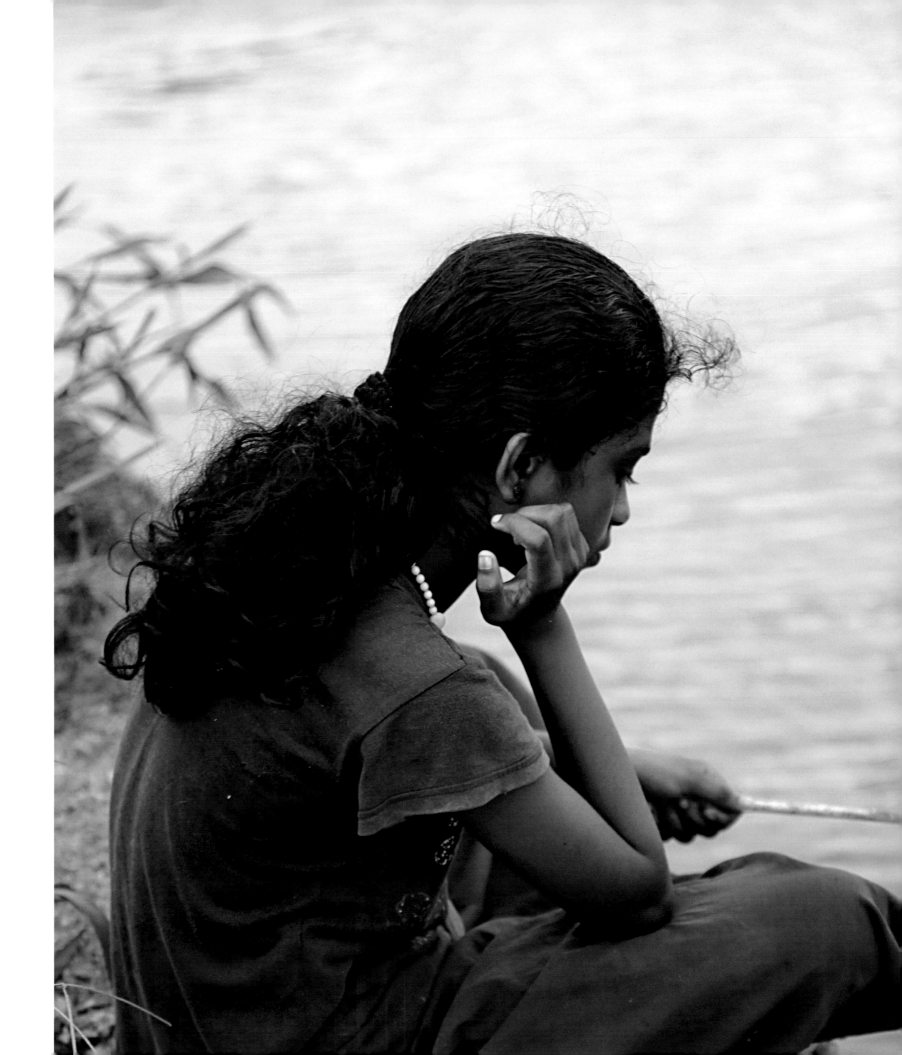

Done washing done sorting

A place to myself

A moment to myself

Fishing clears my thoughts

Focus smooths my soul

Tingling through the pole

I knew it he is here

Wish he was here wish he was here

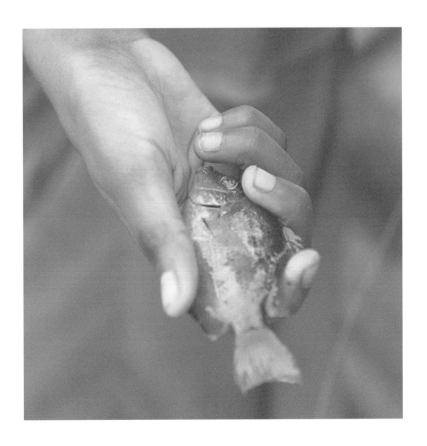

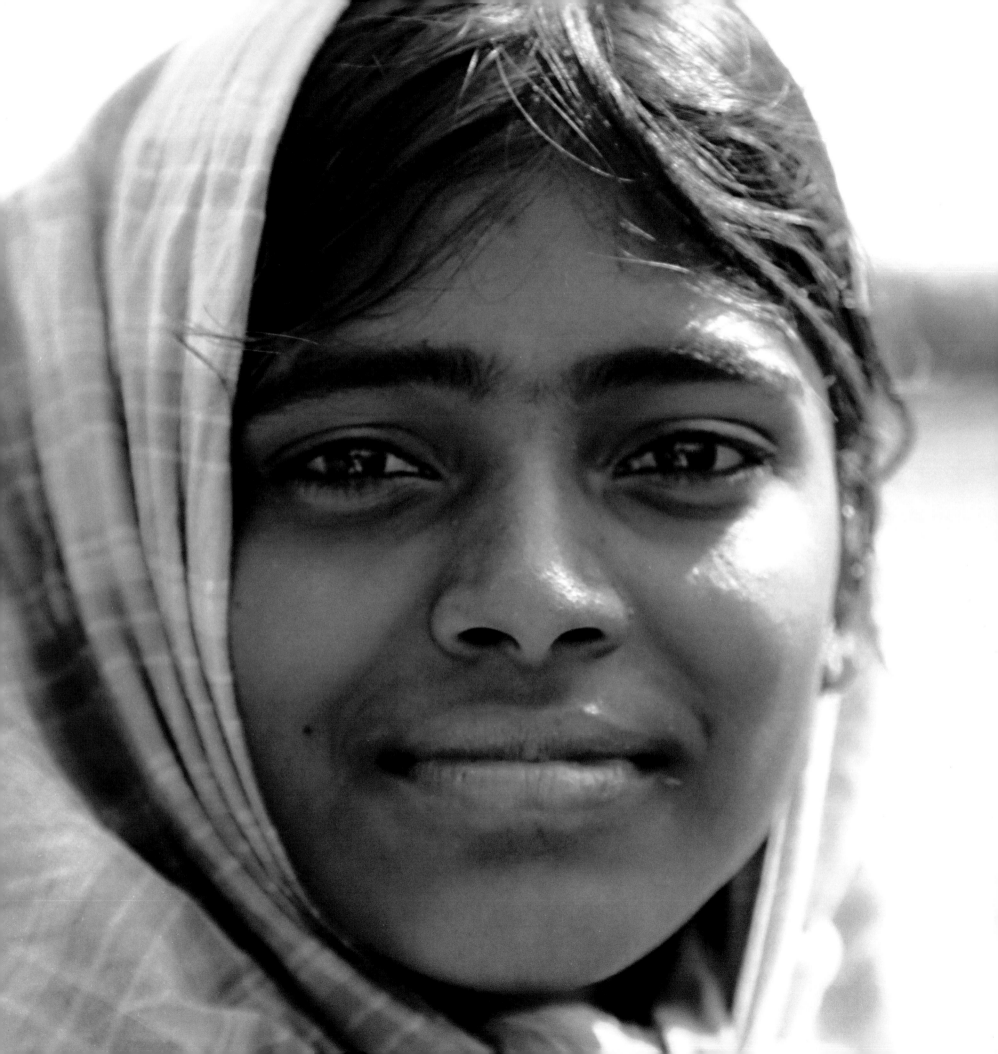

Thousand thousand corn seeds

Thousand thousand to be dropped in

Rain not far away

Rain not far away

Little green sprouts will shoot out

Little giant plants will follow

Graceful leaves sway in the wind

What sweet corn what sweet corn

MATURING

I make decisions for my destiny, without hurting others

Fancy kitchen no

Fancy utensils no

My hands

Flour mixing

Rice picking

Vegetable sorting

Poori rice beans

Turmeric cumin saffron

Sense of taste

Sense of smell

Sense of sight

Sense of joy

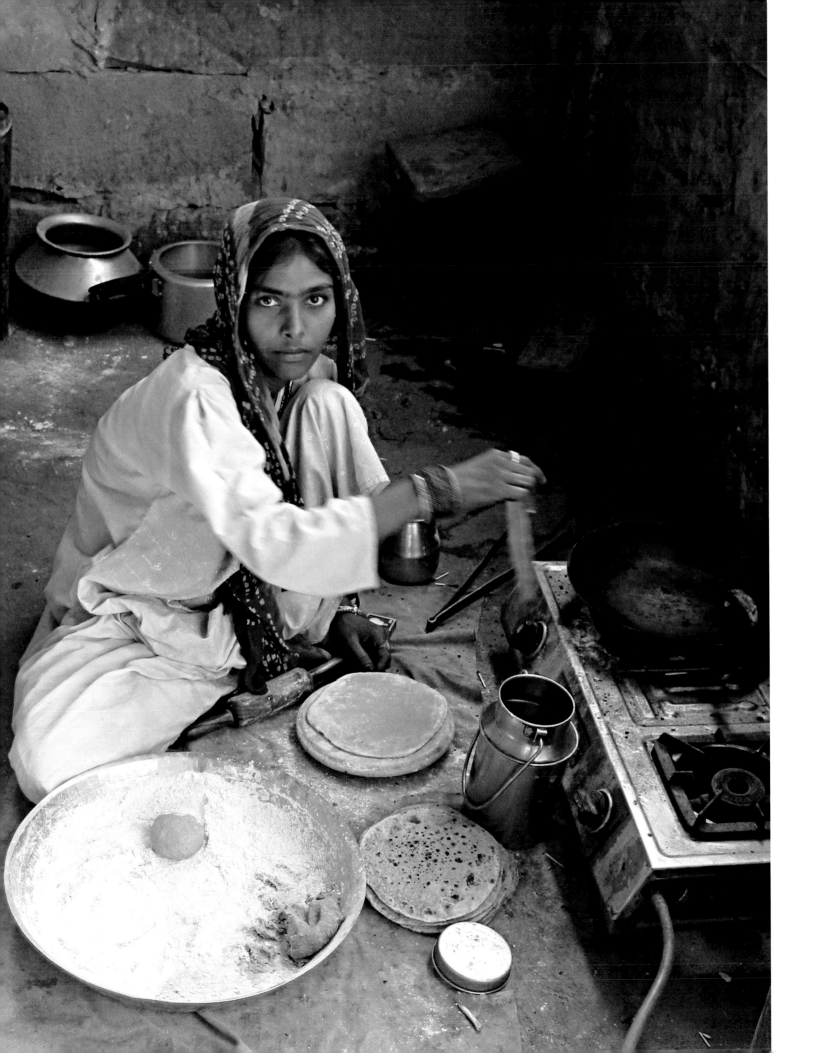

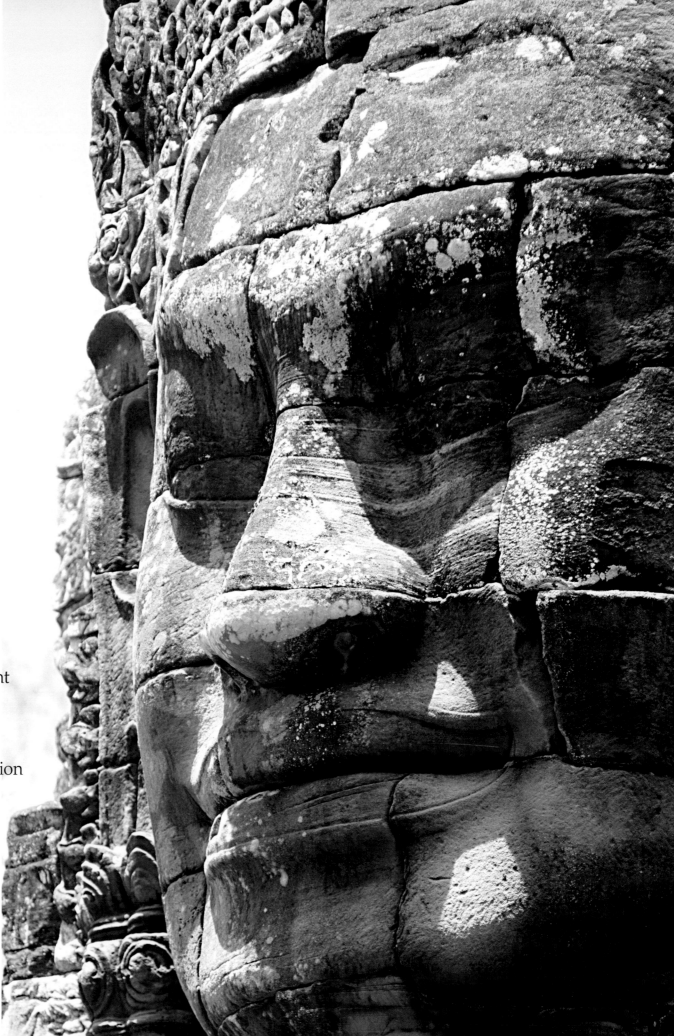

Face face
Square angular
Strong forehead
Passionate eyes
Nose to lips define contrast
Sensual sensitive intelligent
Face of time time of face
Classical modern
Metamorphosis without transition

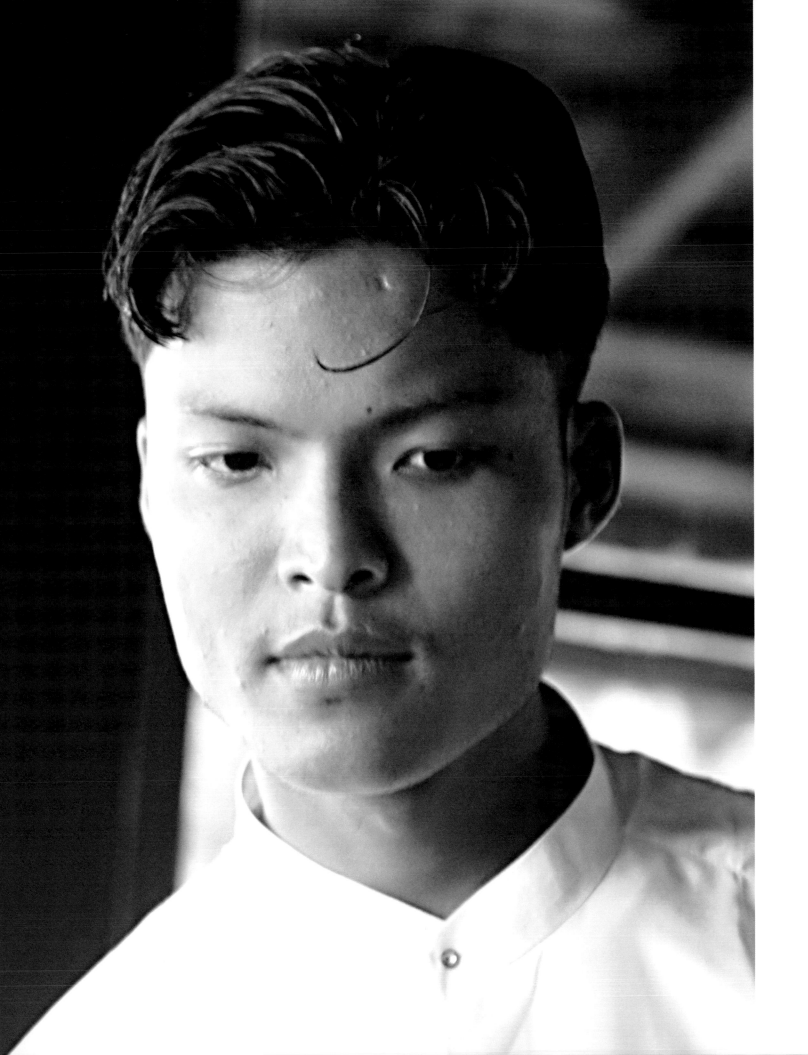

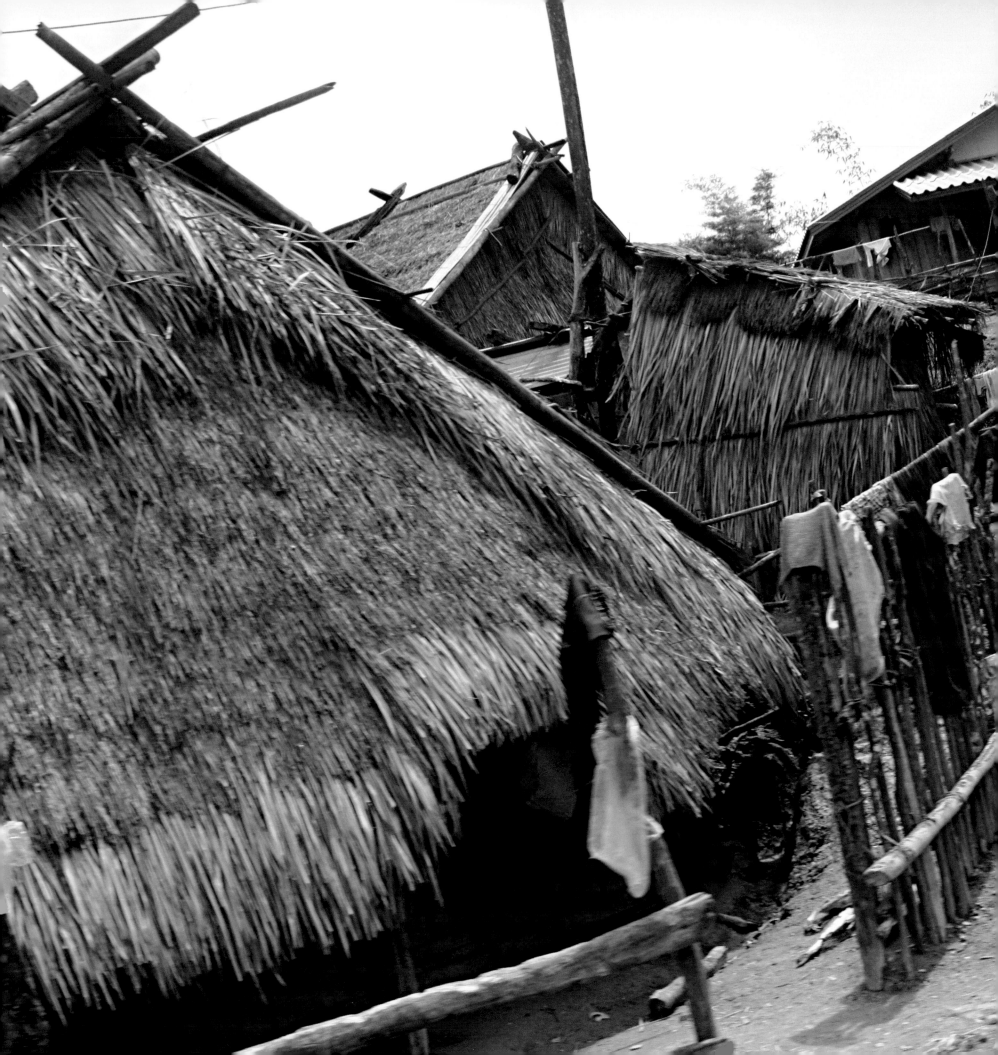

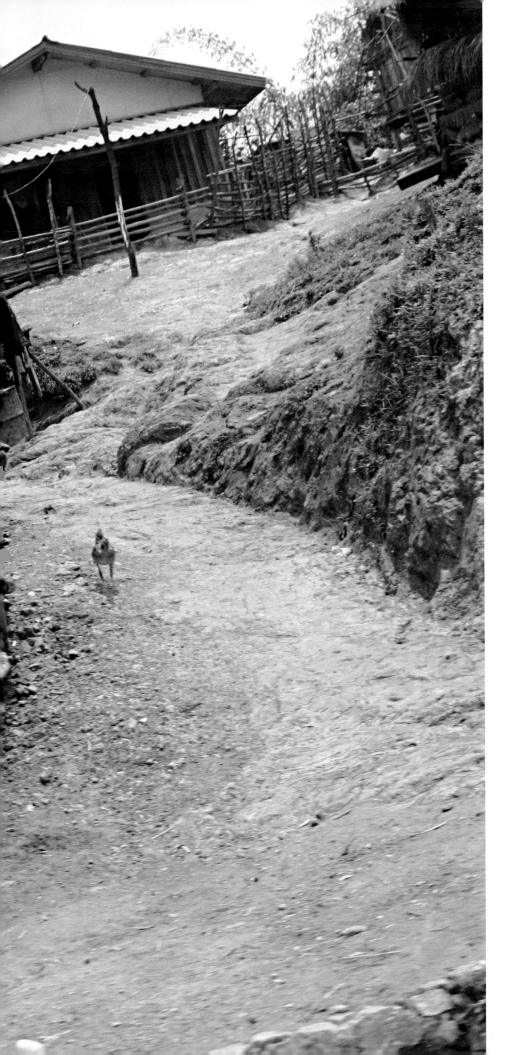

Rummaging through little treasures

Smooth colorful intricate

Held by others

Faces of satisfaction

please my heart

I smile I smile

Soak in late afternoon light

Thinking I sold well today

Resting feet touch the stones

Old old streets

Warming me cooling me

Sundown sunrise

As always

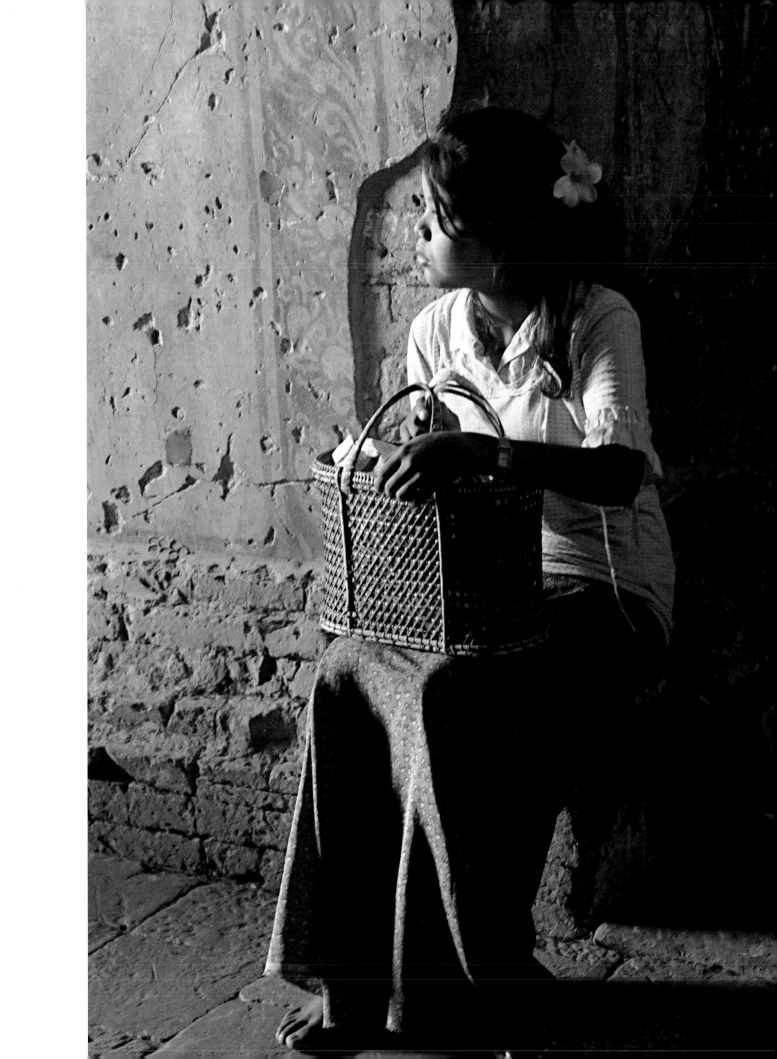

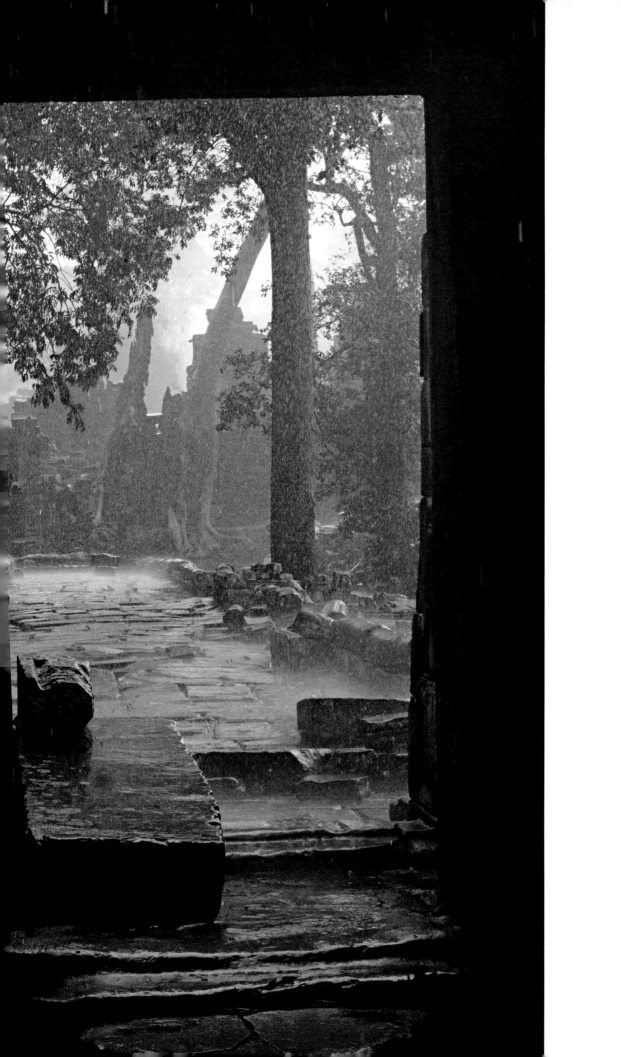

Eons eons ago

Thousands thousands of people

Under the sun under the rain under the moon

Carry stones carry rocks stack them

Chisel carve polish

Ingenious engineers exquisite artistry

City of masterpieces city of faith

Nature missed a turn mirage faded

Buried in the ground wrapped in the forest

Here you are risen again

Missing roofs missing walls missing doors

Here you are still standing still majestic

Spirit never faded faith never dimmed

Scent touch sound

Strong as ever mighty as ever

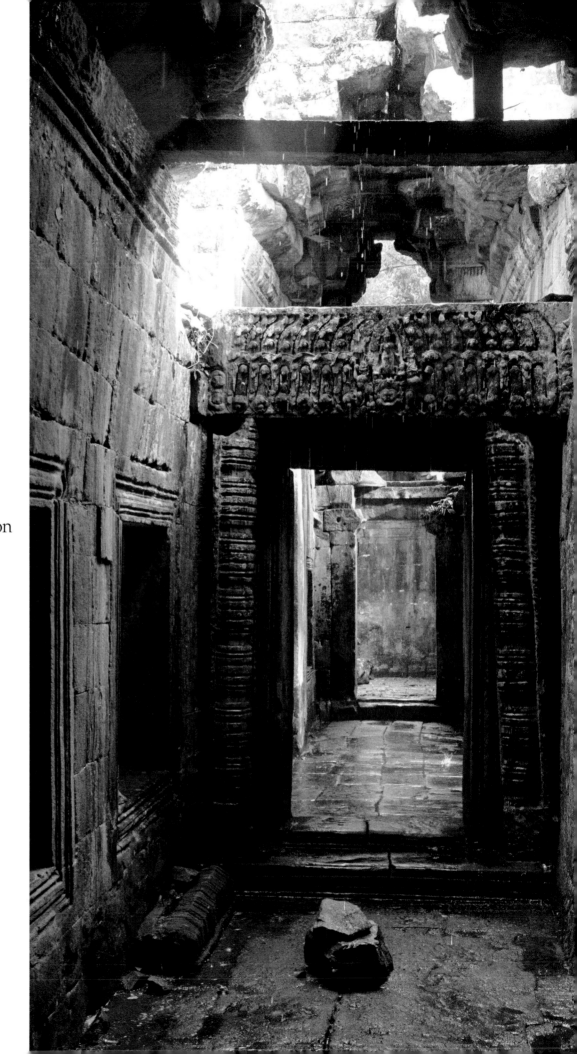

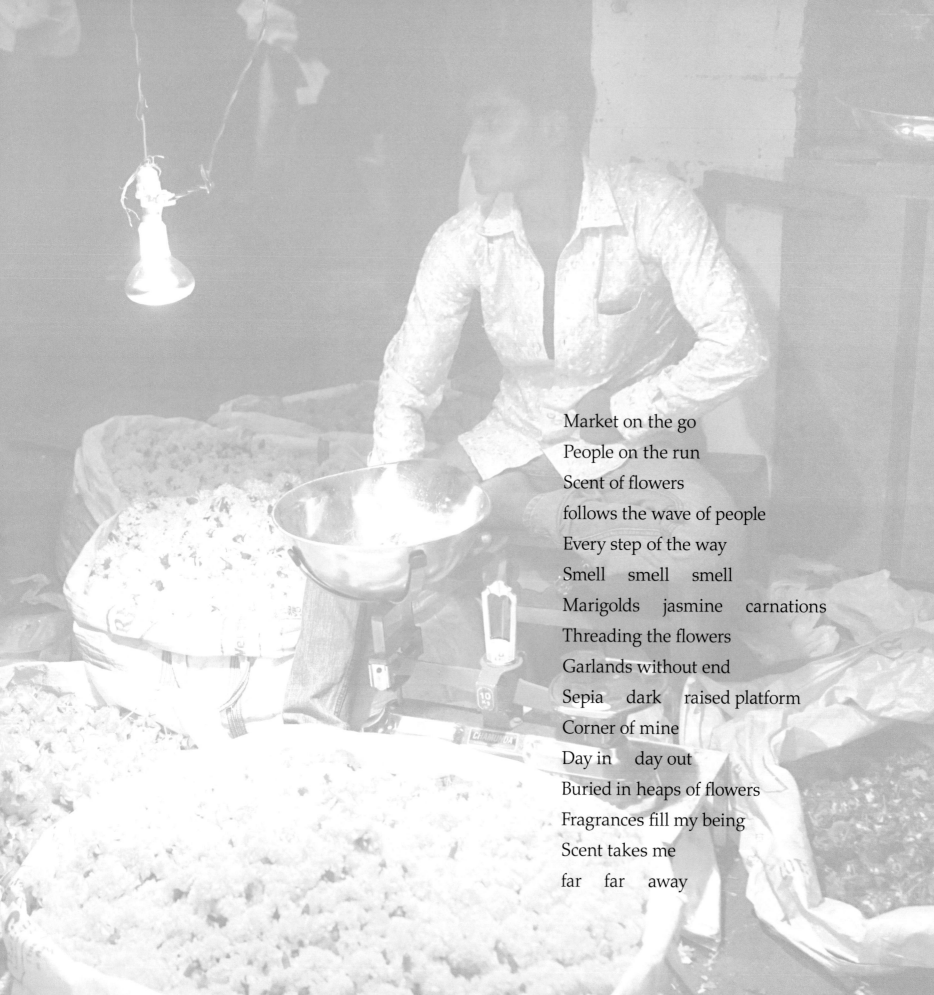

Market on the go

People on the run

Scent of flowers

follows the wave of people

Every step of the way

Smell smell smell

Marigolds jasmine carnations

Threading the flowers

Garlands without end

Sepia dark raised platform

Corner of mine

Day in day out

Buried in heaps of flowers

Fragrances fill my being

Scent takes me

far far away

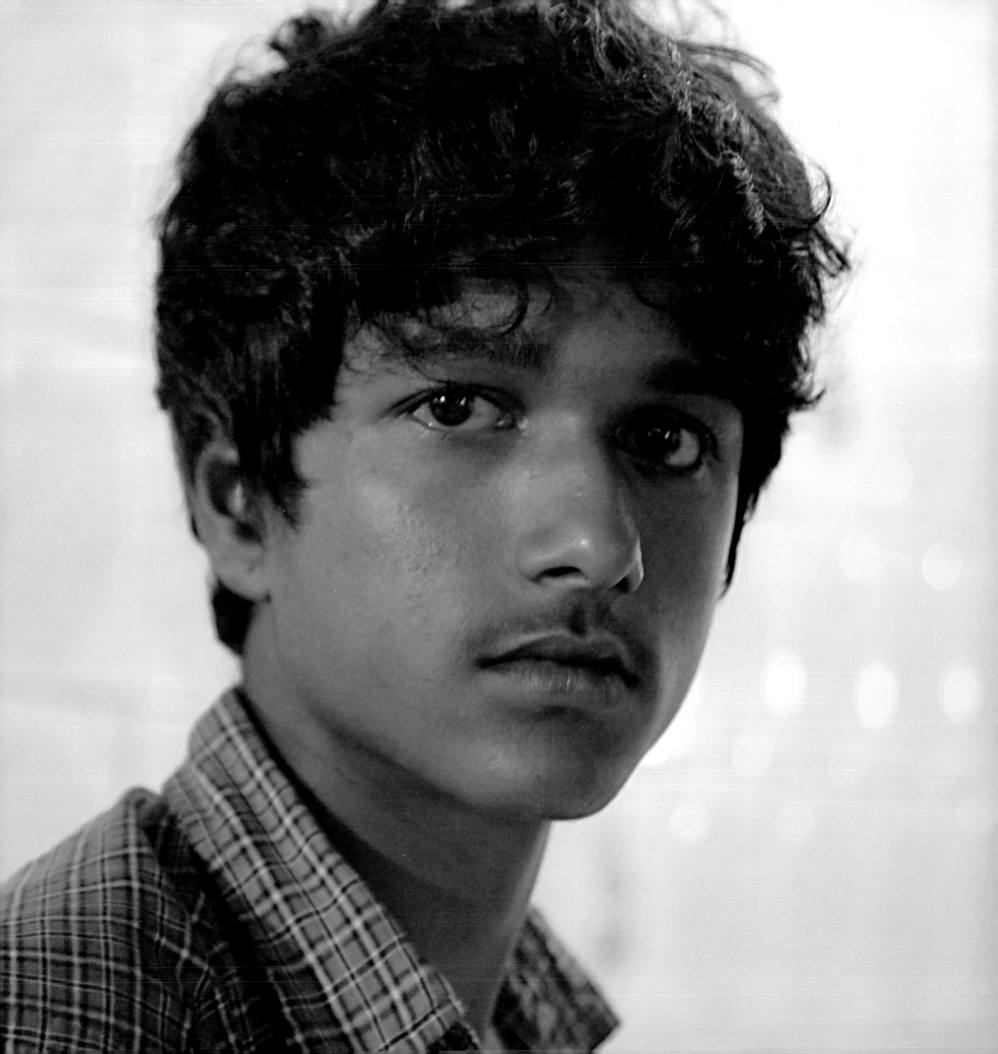

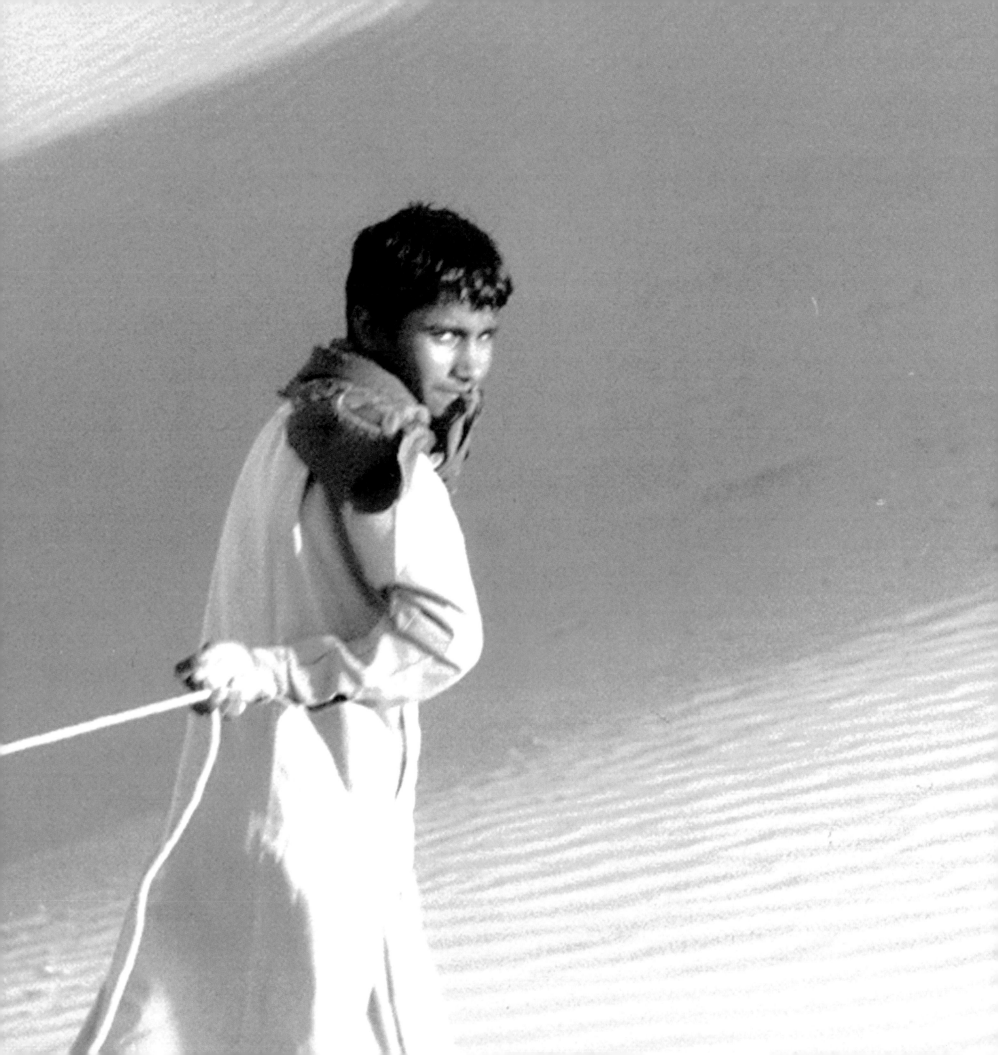

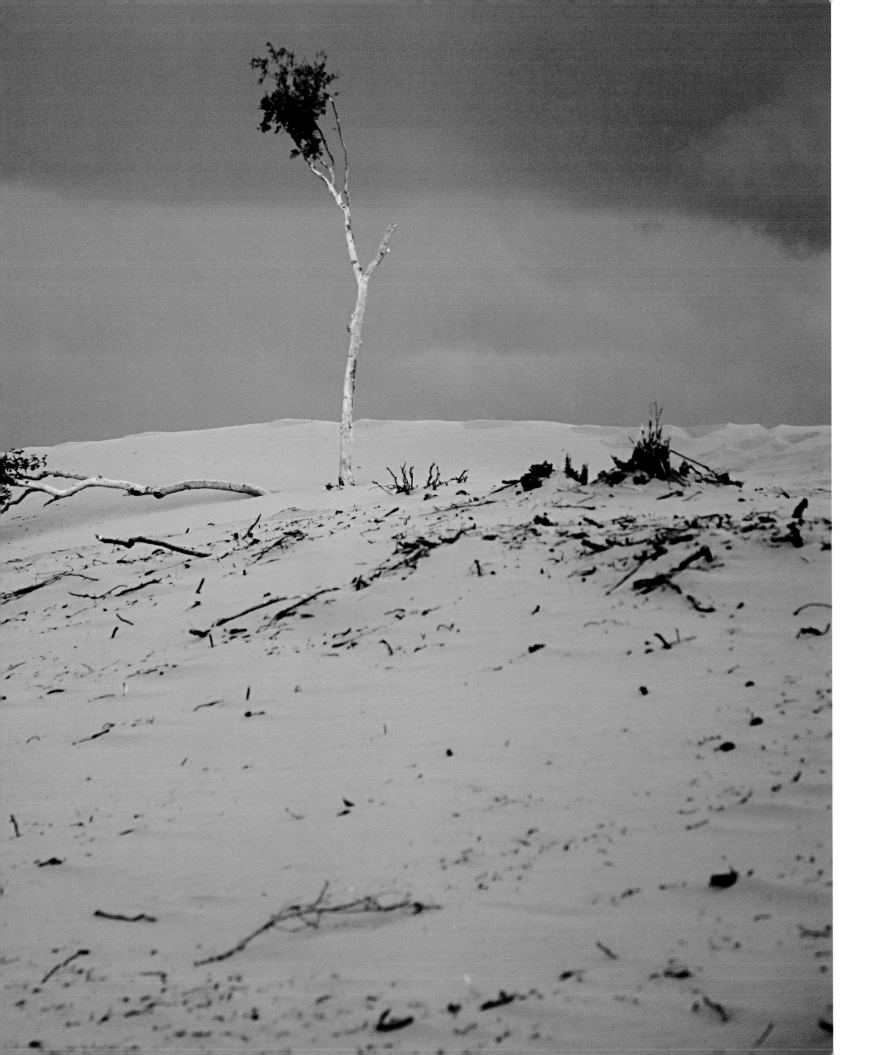

Walk through

Windy stormy burning

Darkness and temptation

Buddha within

Life is peace

Life is giving

Buddha within

Shields perilous journey

Protects mankind

Wealth of good deeds

enrich my life other lives

Sharpens my spirit enriches my heart

Lead the way

Good deeds

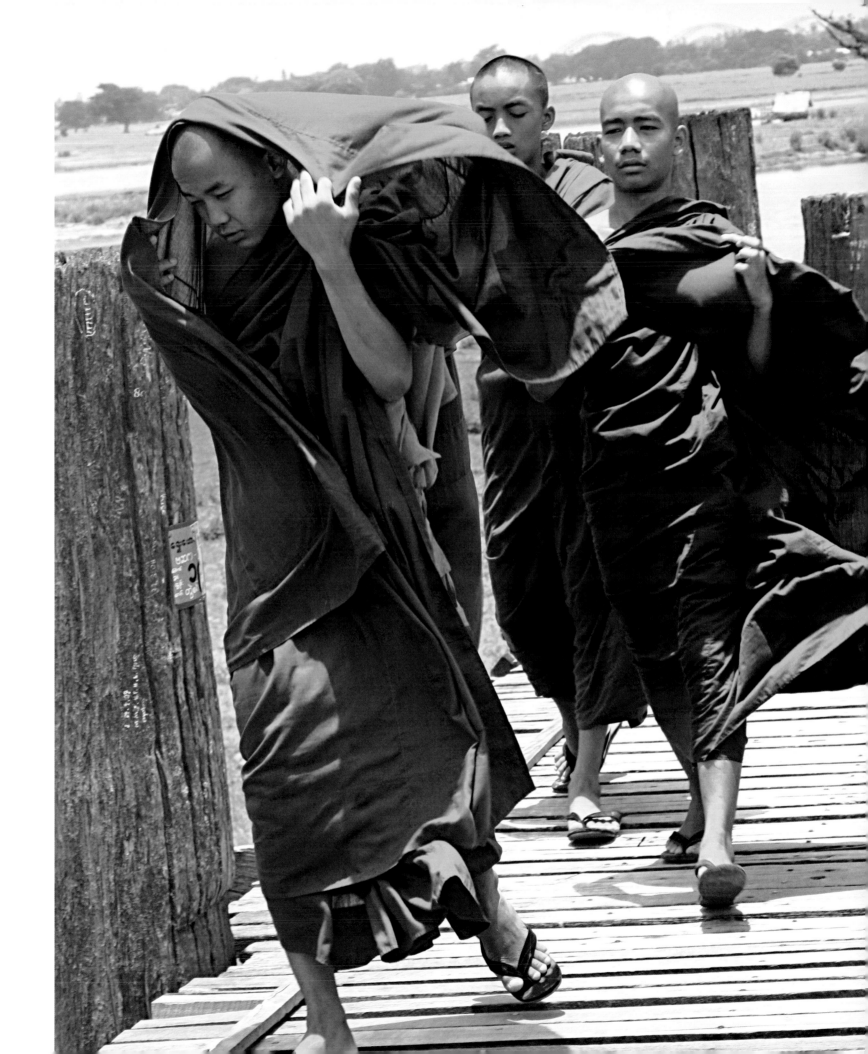

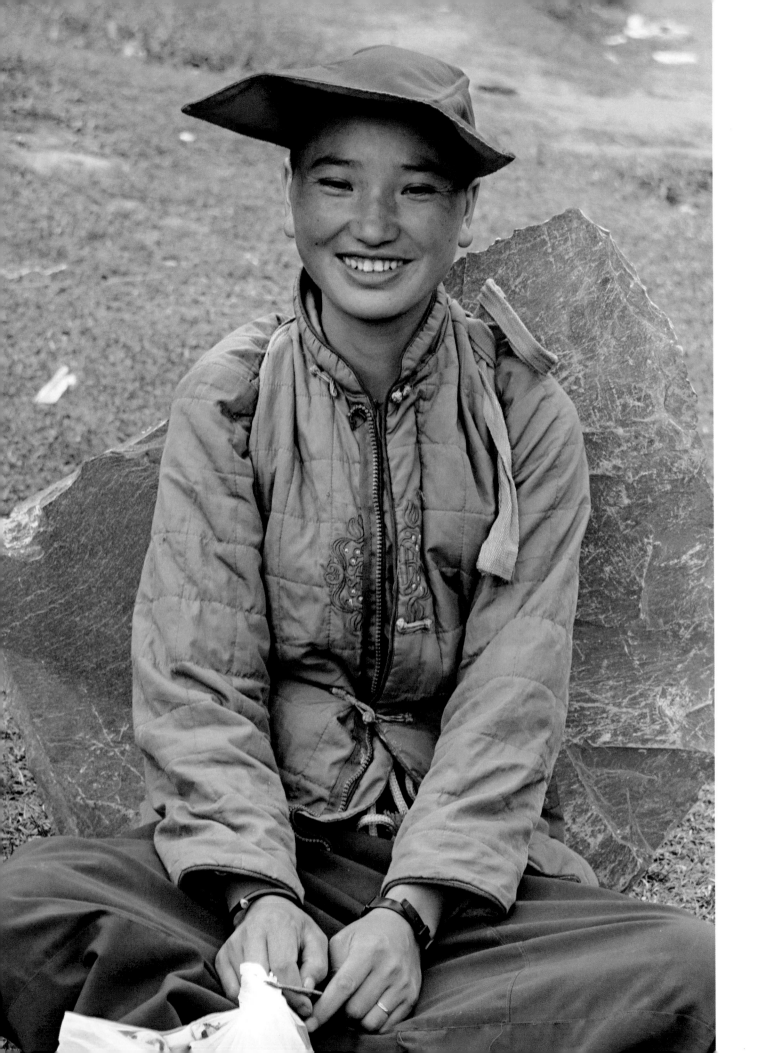

Saffron hat saffron coat

Easy

How easy that smile

Slate strapped on your back

Cement on your humped back

Lumber on your back

Walk up up up to the top

Temple to build

up to the clouds

Every ten twenty steps

break and laugh

Mantra going within

Mantra going within

No sigh no burden no suffering

Peaceful tranquil aware

Footsteps up up up

Temple growing growing

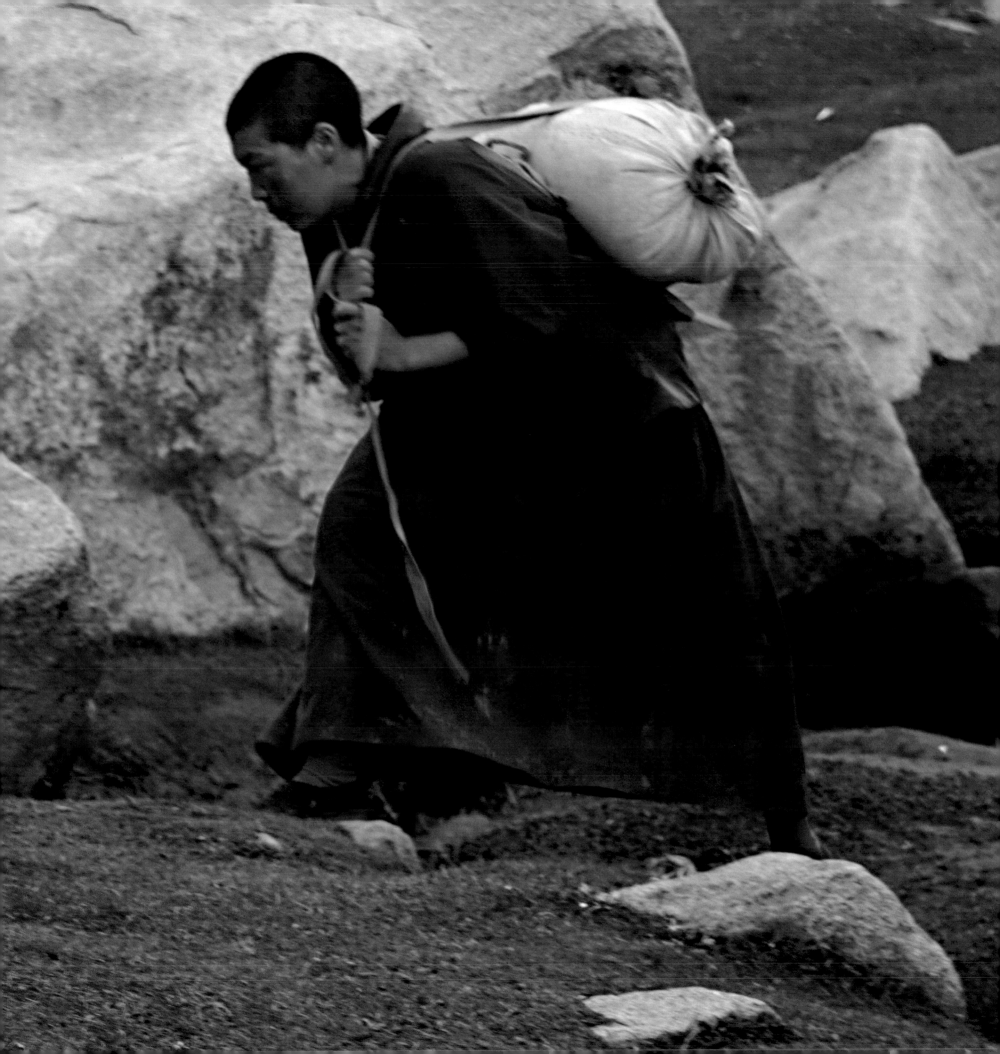

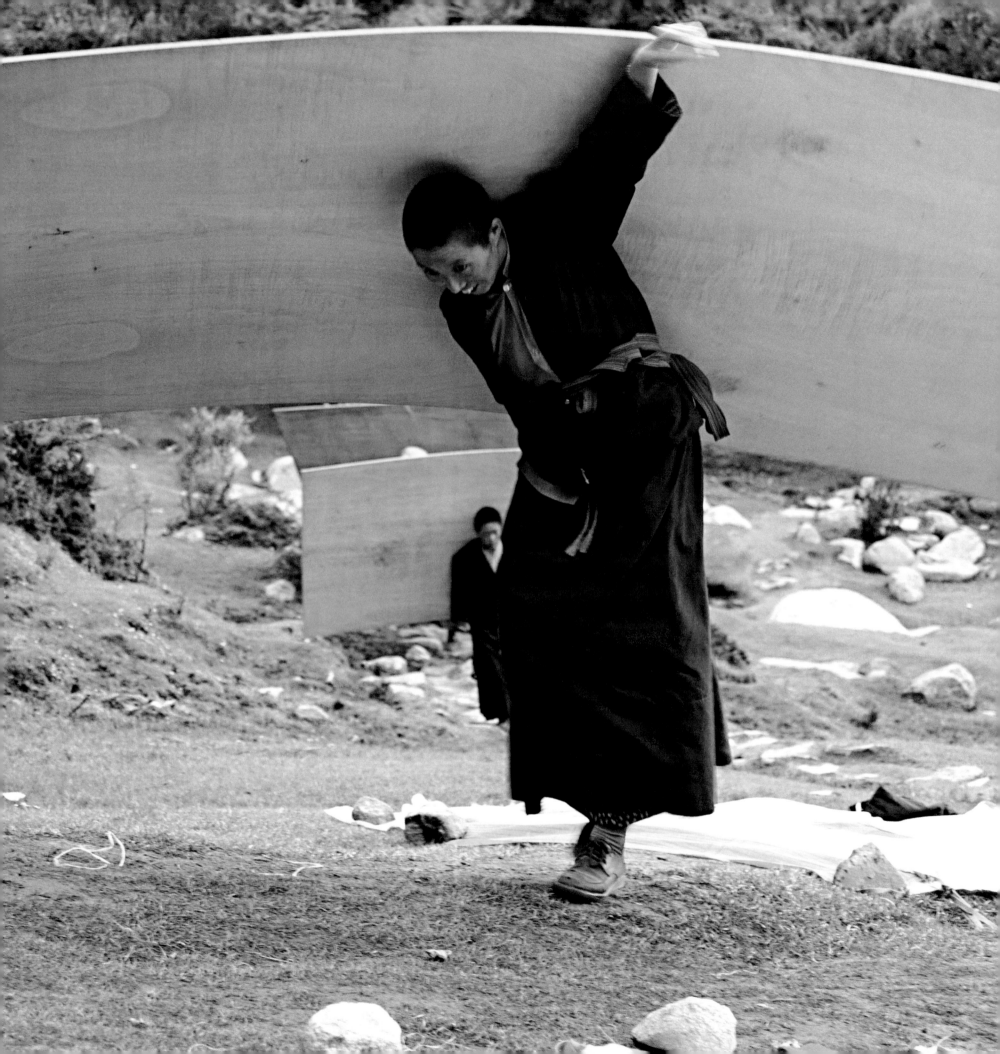

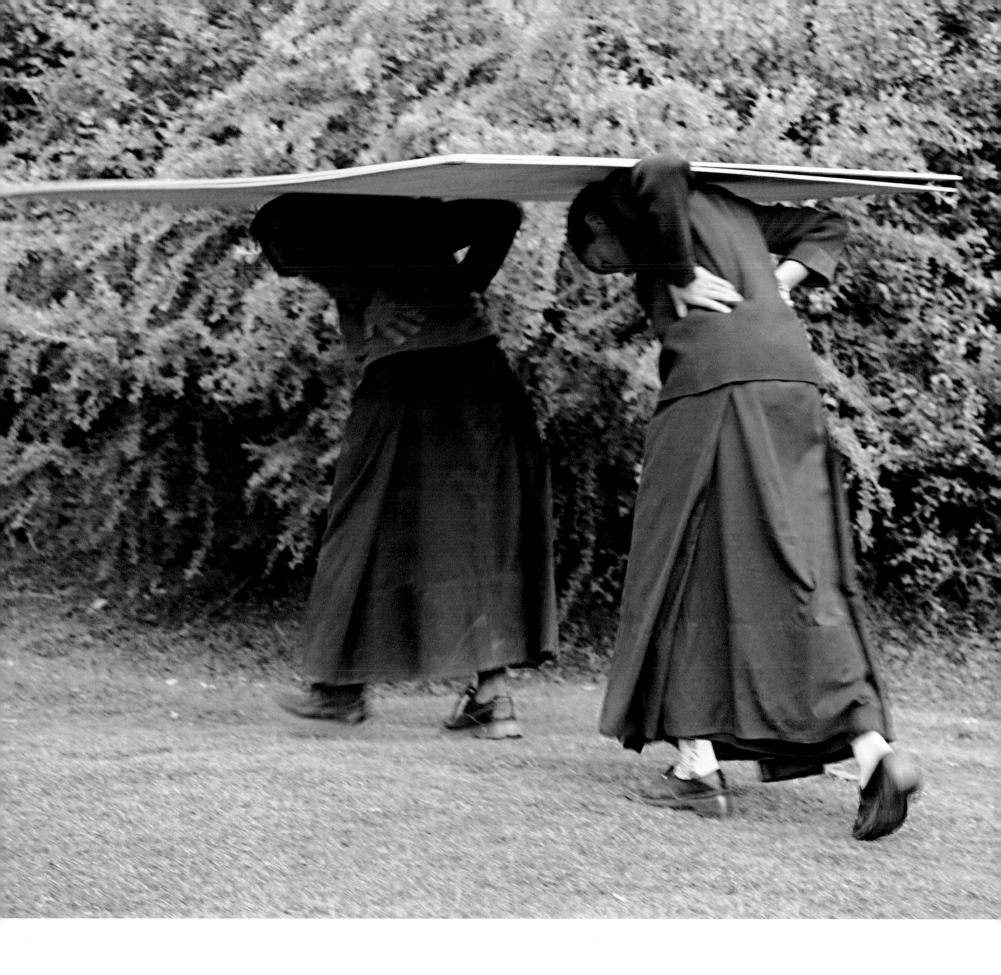

Early rise

Rush rush

Water is boiling

Food is simmering

Pots are dangling

Meal is ready

Sound of eating

Sound of murmuring

Three hundred sixty-five days

Day in day out

Eating talking laughing

Peace within

Peace within

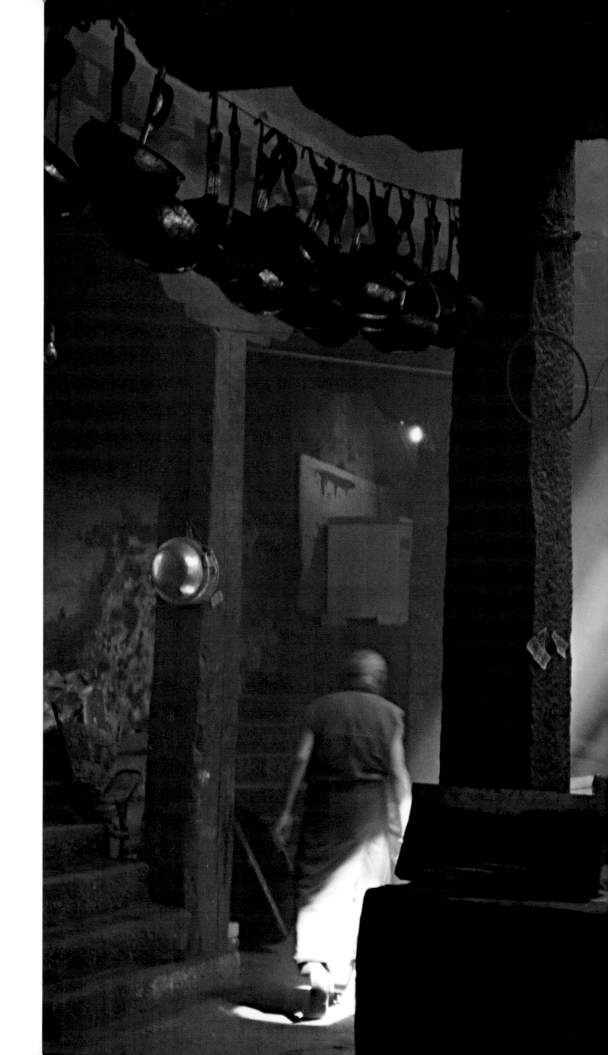

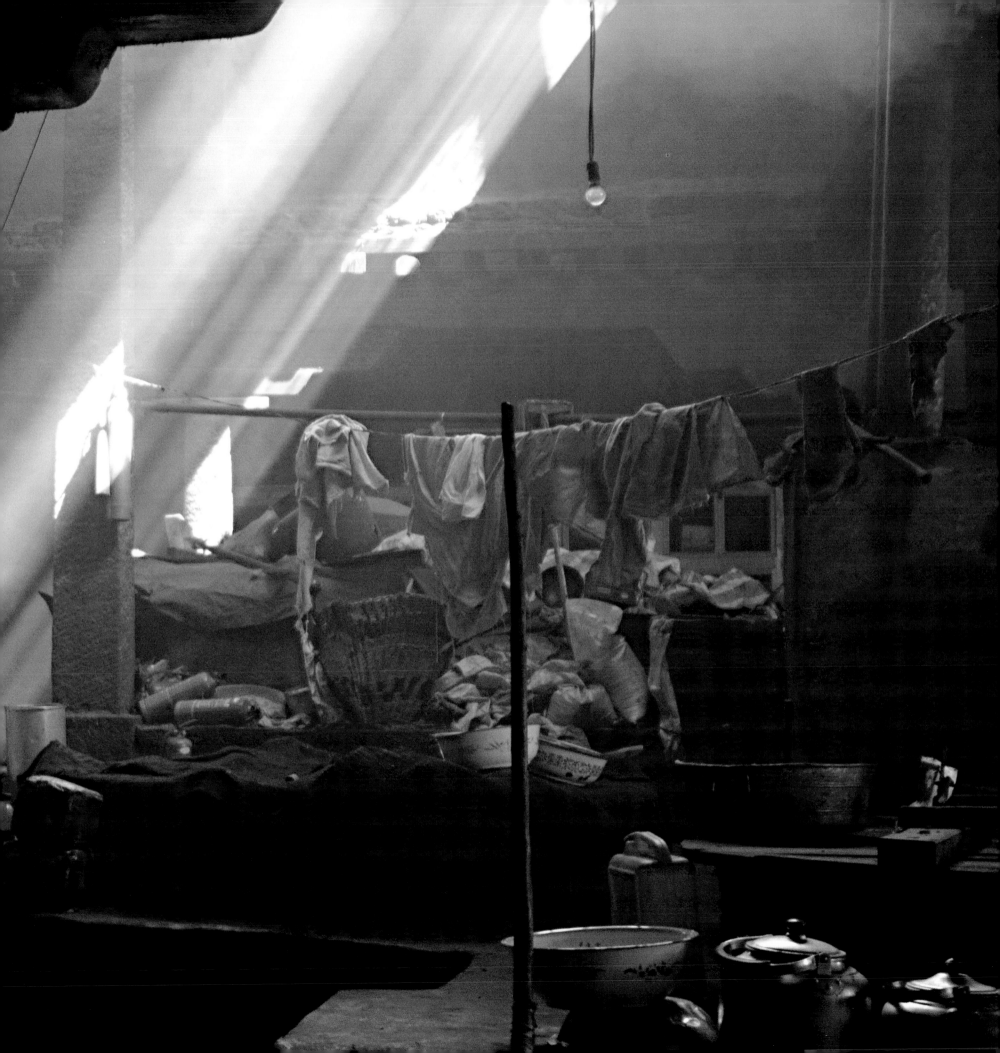

Sympathetic

Subtle smile

Strong mind

Built my house in the village

Joy to walk

to my cows

to my sheep

Dogs follow

Flies flying flying

It's all family

A basket of food to Mom

Warm glance

After day of driving

home erases my tiredness

Sip of tea

Puff of smoke

Content with a smile

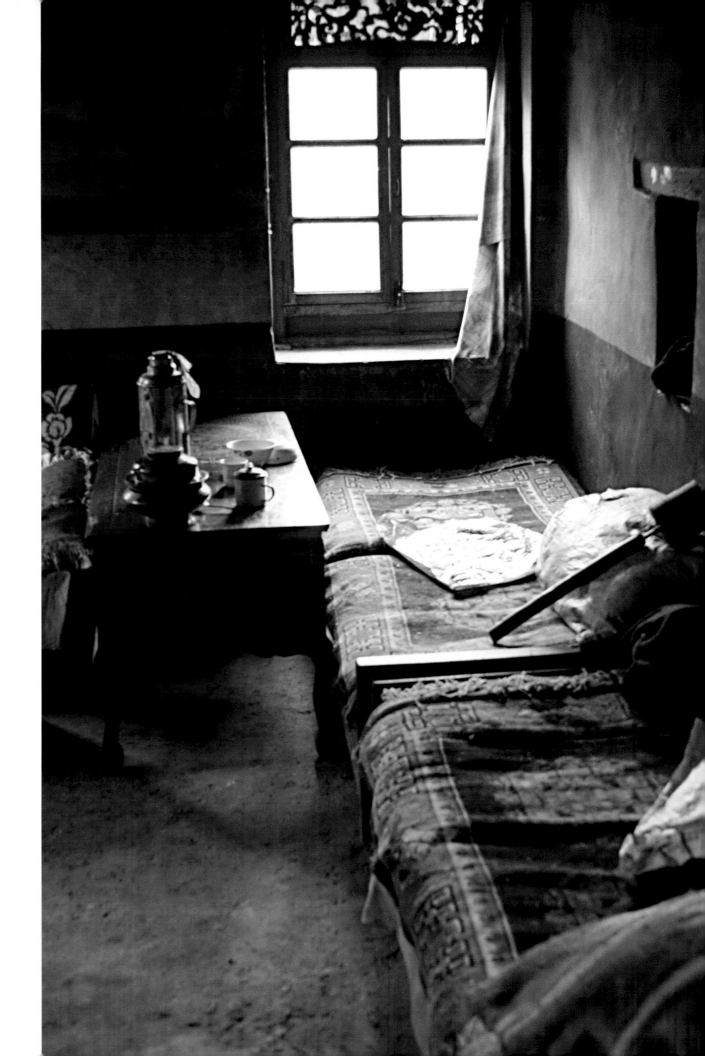

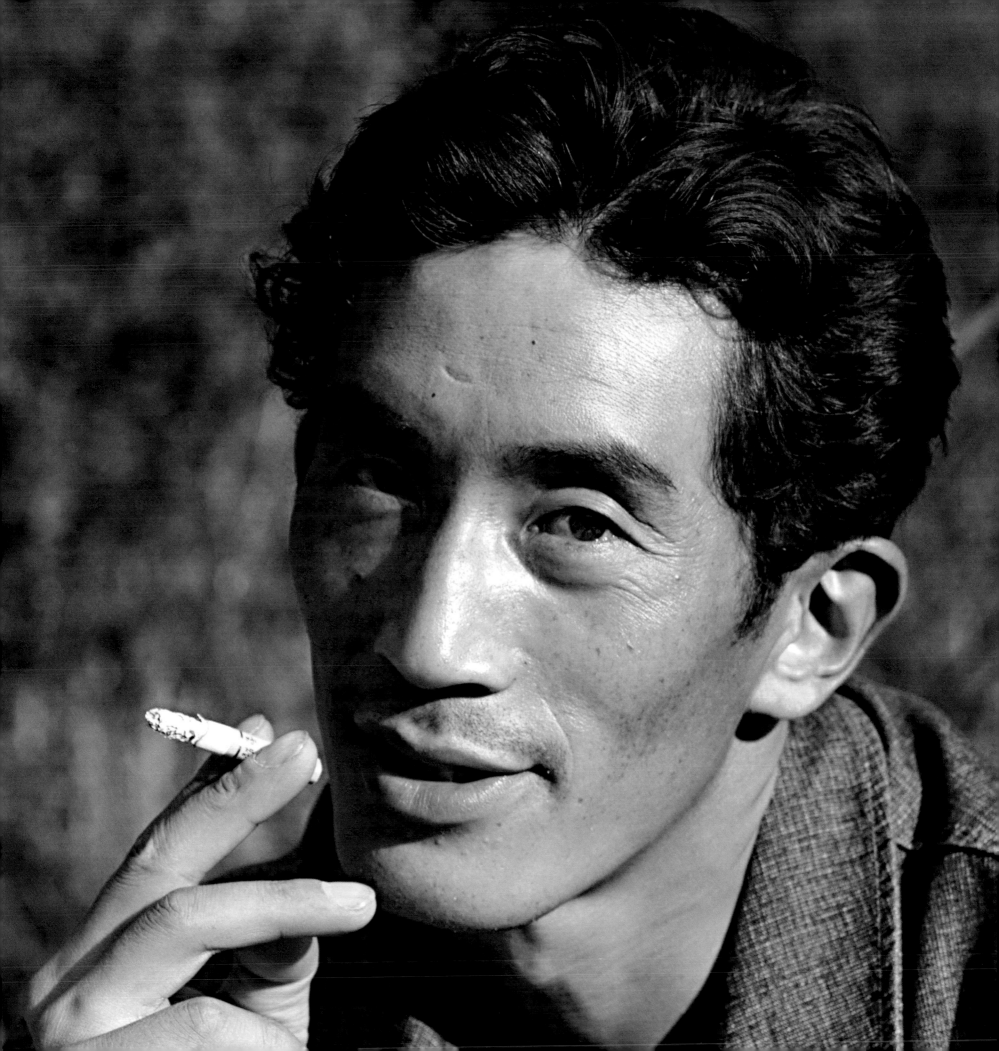

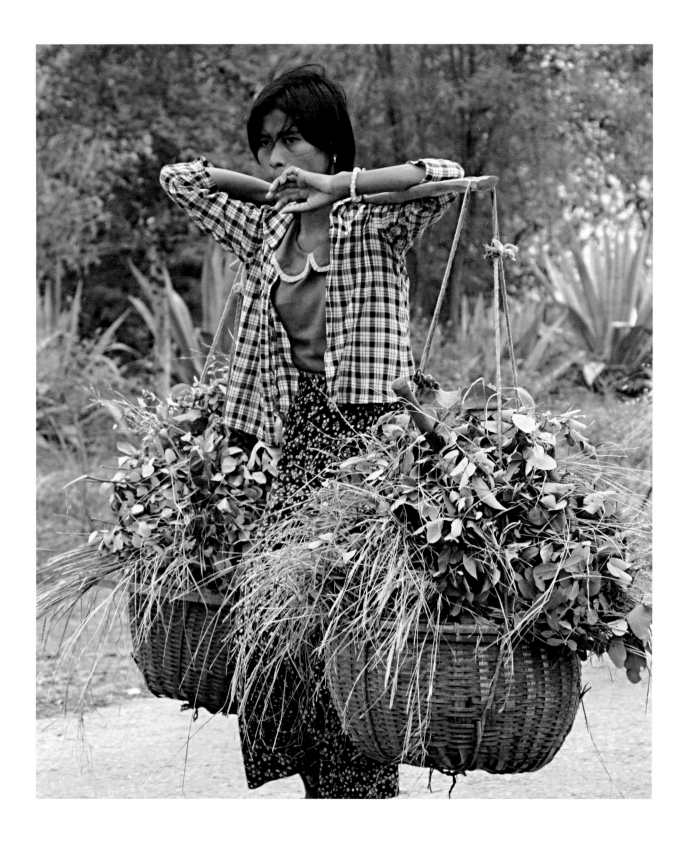

I pick I select I bundle

Leafy stringy

Green purple yellow

Fill my baskets

Balance my baskets

Free from tiredness

Mooing mooing

Bleating bleating

They will be happy

I will be happy

Make another run

Make another run

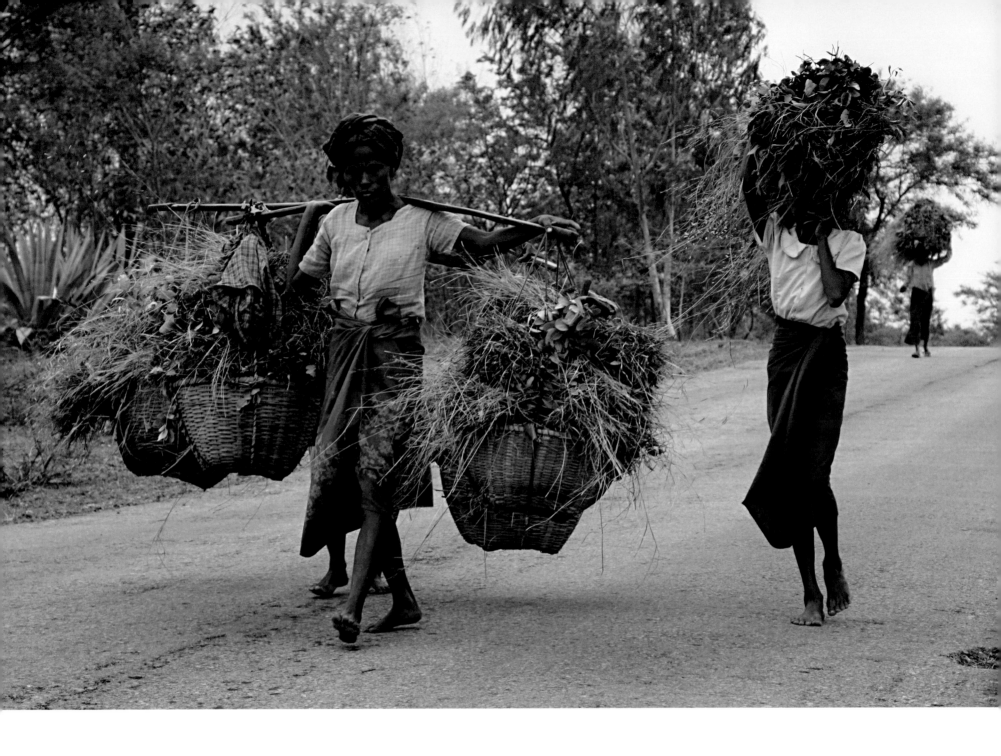

Beautiful bouquet

Glorious head gear

Elegant straight posture

Every step forward

So light so easy

Longyi swaying from side to side

Natural runway

Tall slender exquisite

Natural beauty

No pretense no fuss

No make believe

Simply natural

REALISTIC

I need to know how to grow older, embrace the next stage of life

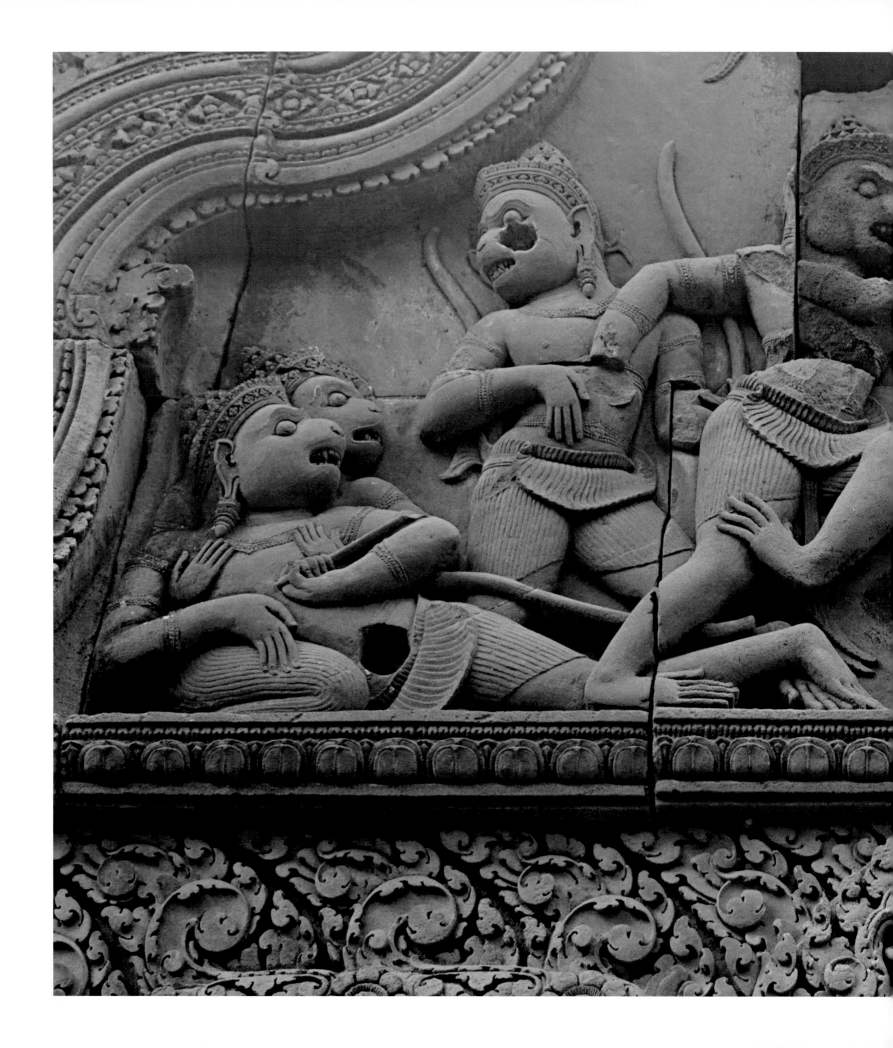

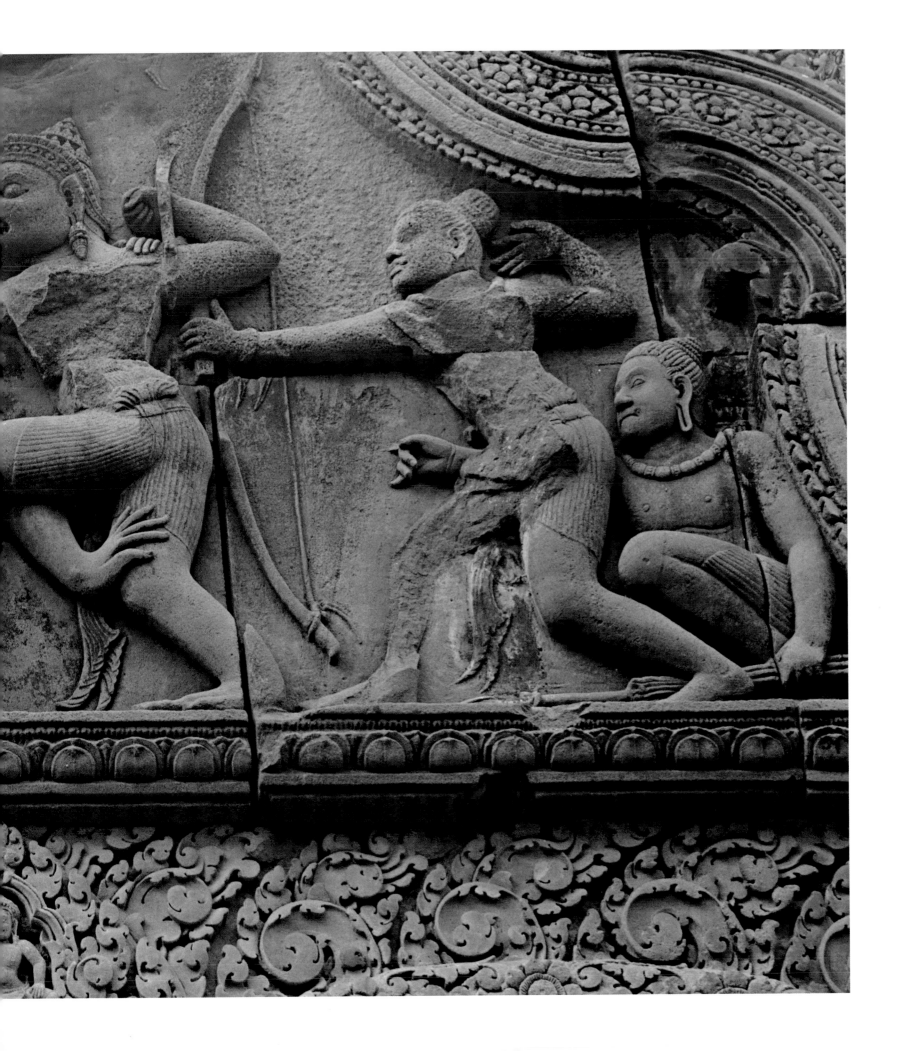

Yellow orange red pink
Floating on the river
Water mirror reflected smoke moving petals
Nostalgic mystery
Wherever you wish them to be
You gaze you smell you feel
Silently sail to somewhere
A long-lasting peaceful place
Pink red orange yellow
Satin silky sari
Dazzling your eyes
Long elegant scarves
gracefully flowing in the air
Almost almost
longing missing yearning
for someone
Shining smooth black hair
A dot a scent of flower . . .
Your final exclamation!

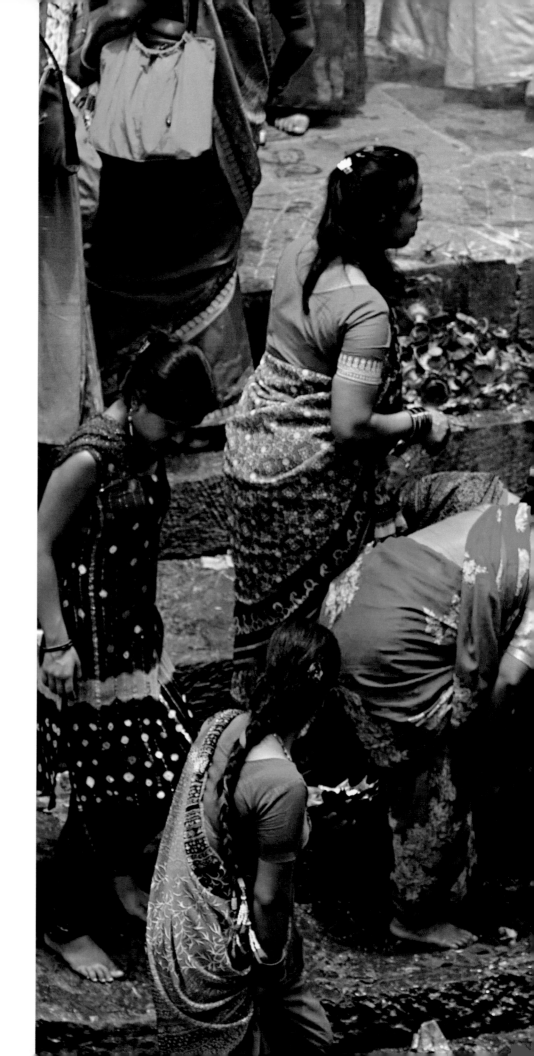

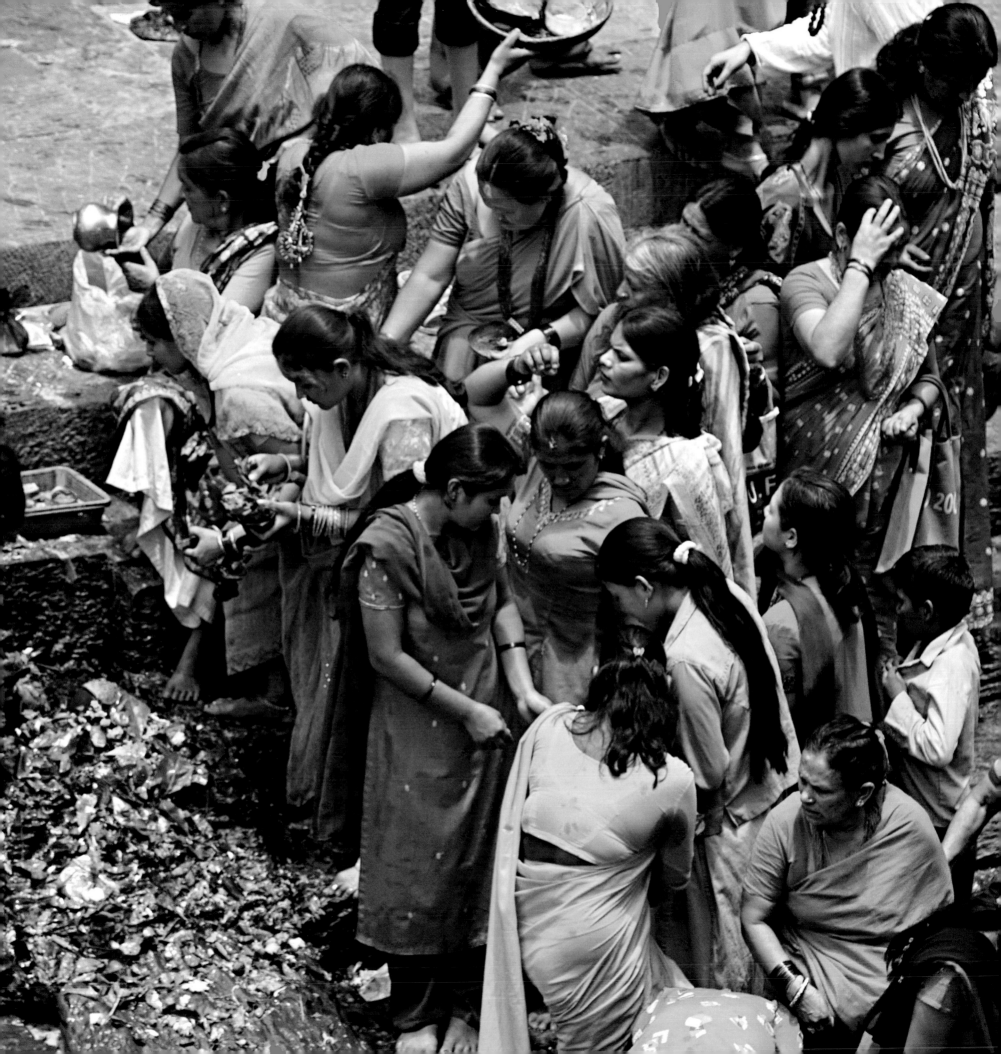

Chrysanthemum

Jasmine gardenia rose

Sweet fresh pure

Smooth shiny

Every hair in place

Whatever happens

Hair is utmost

Brings smile to my face

Lifts my spirit

Rose in my hair today

Tomorrow another day

Jasmine?

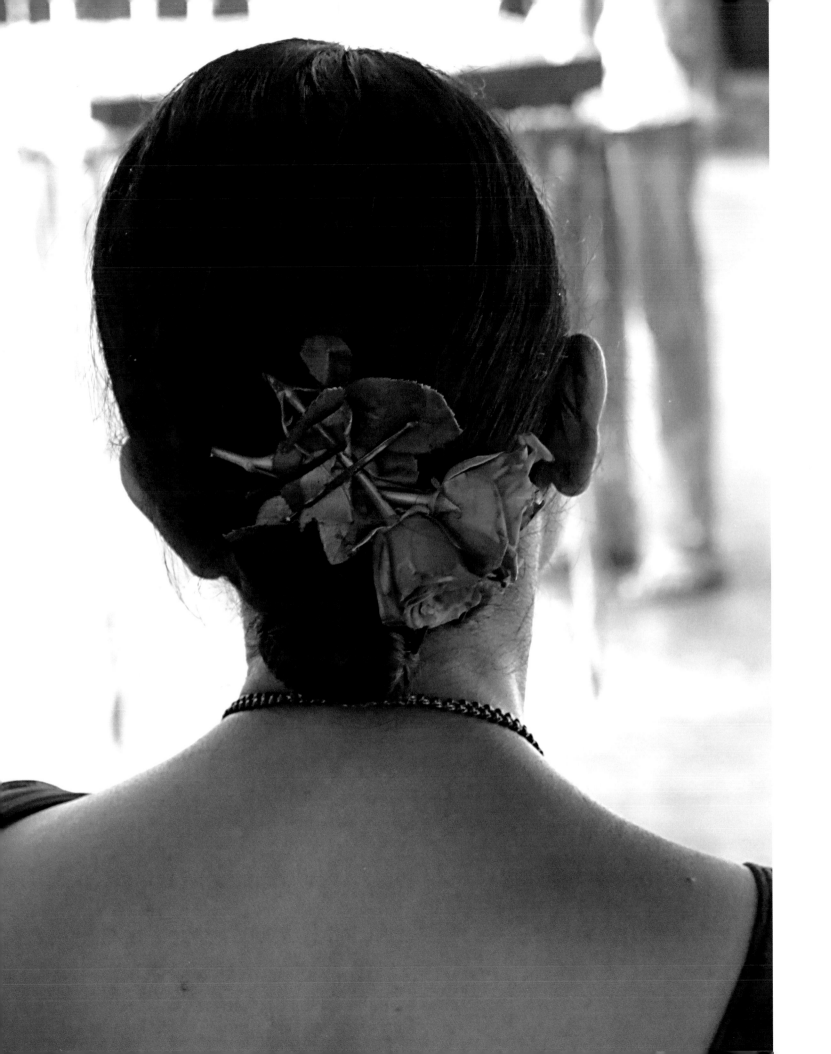

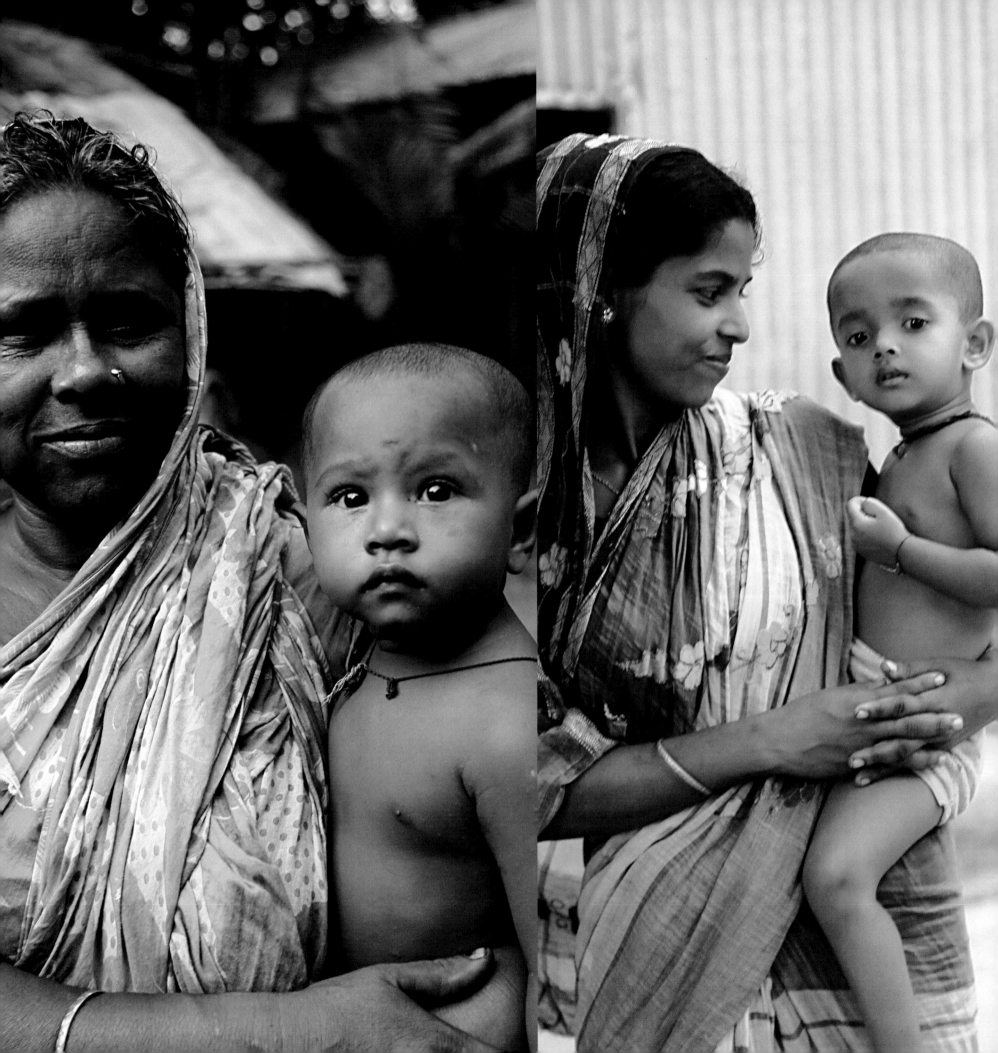

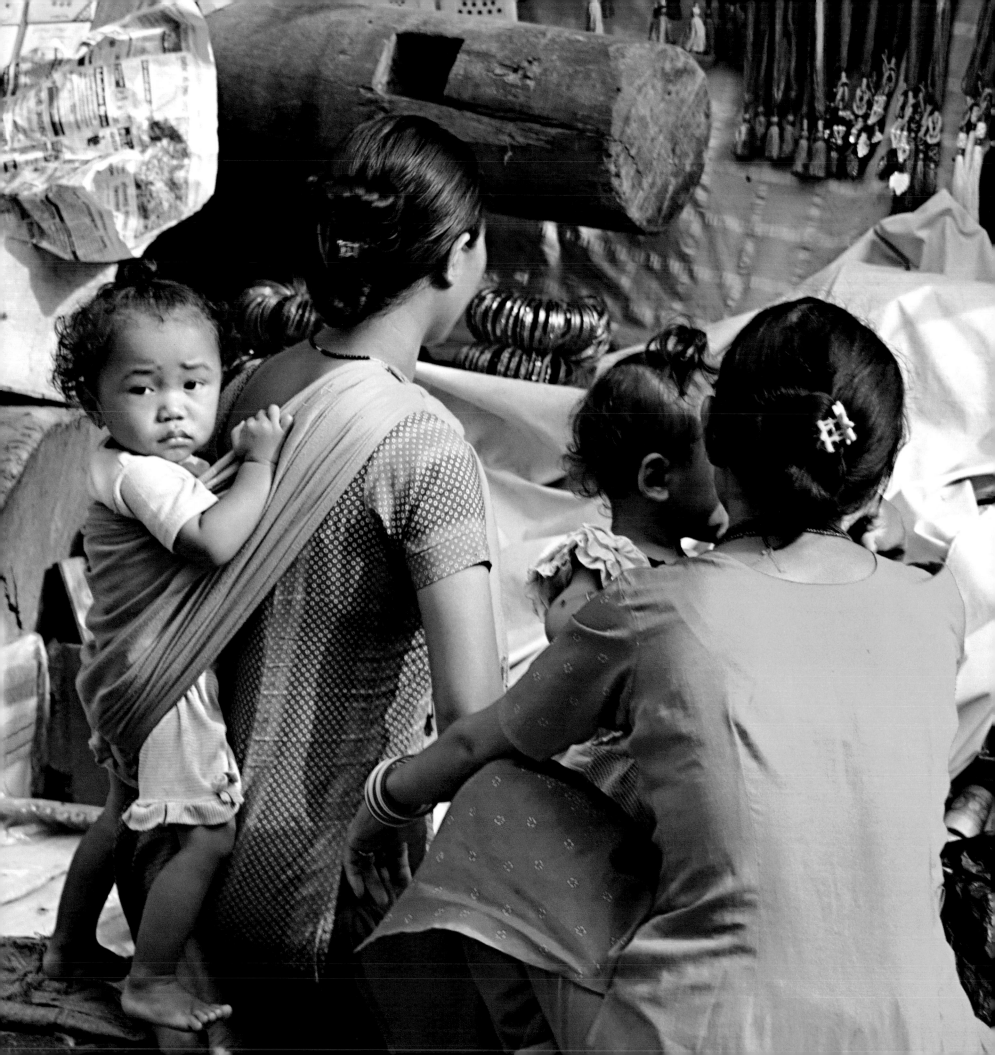

Feeling my child

Movements touch my back

Movements touch my chest

Warm sensual

Part of me part of you

What a privilege

Mine yours

What a gift

Hearts clinging

Breath linking

Reward of life

Reward of living

Raise my children

See them grow

I cook I wash

I scream I care

I cry I love

Please please

grow up

Marry have children

I teach I argue

It works

Life repeats

My future their future

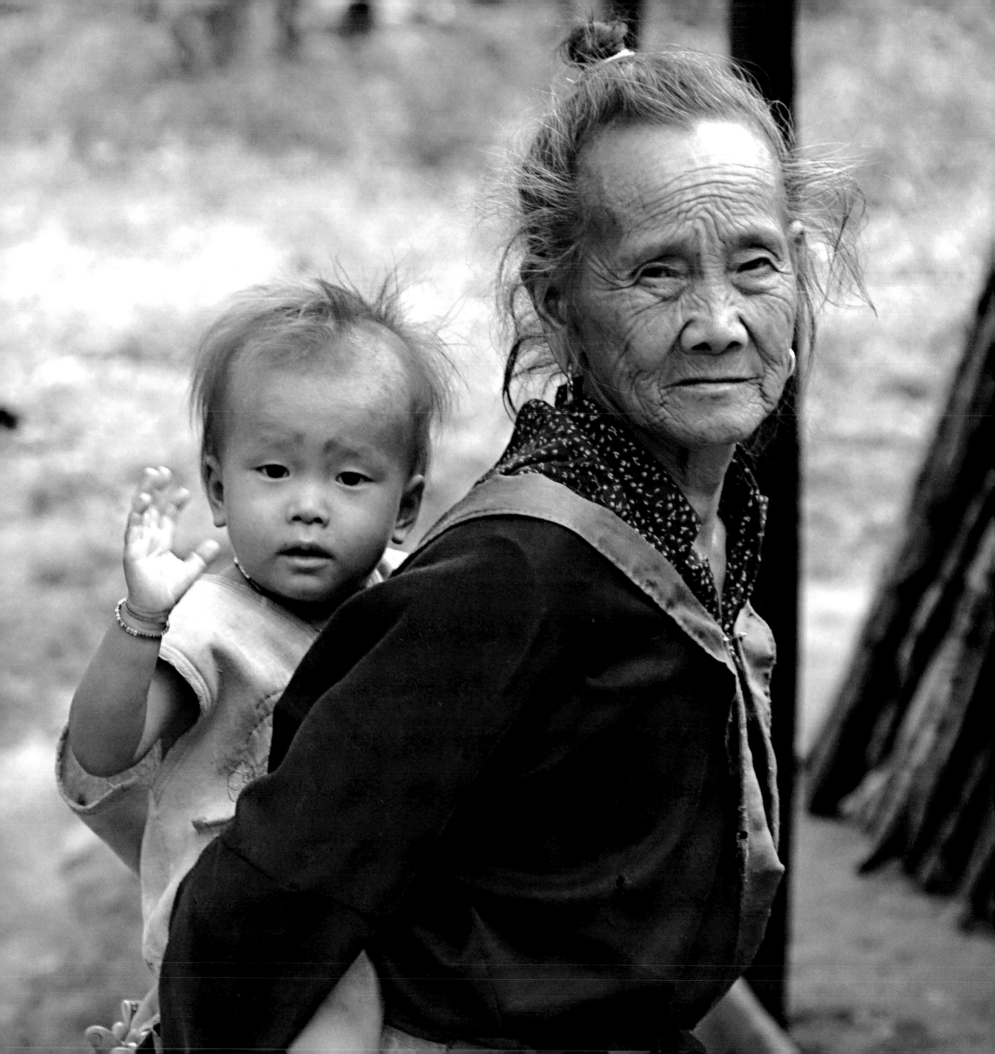

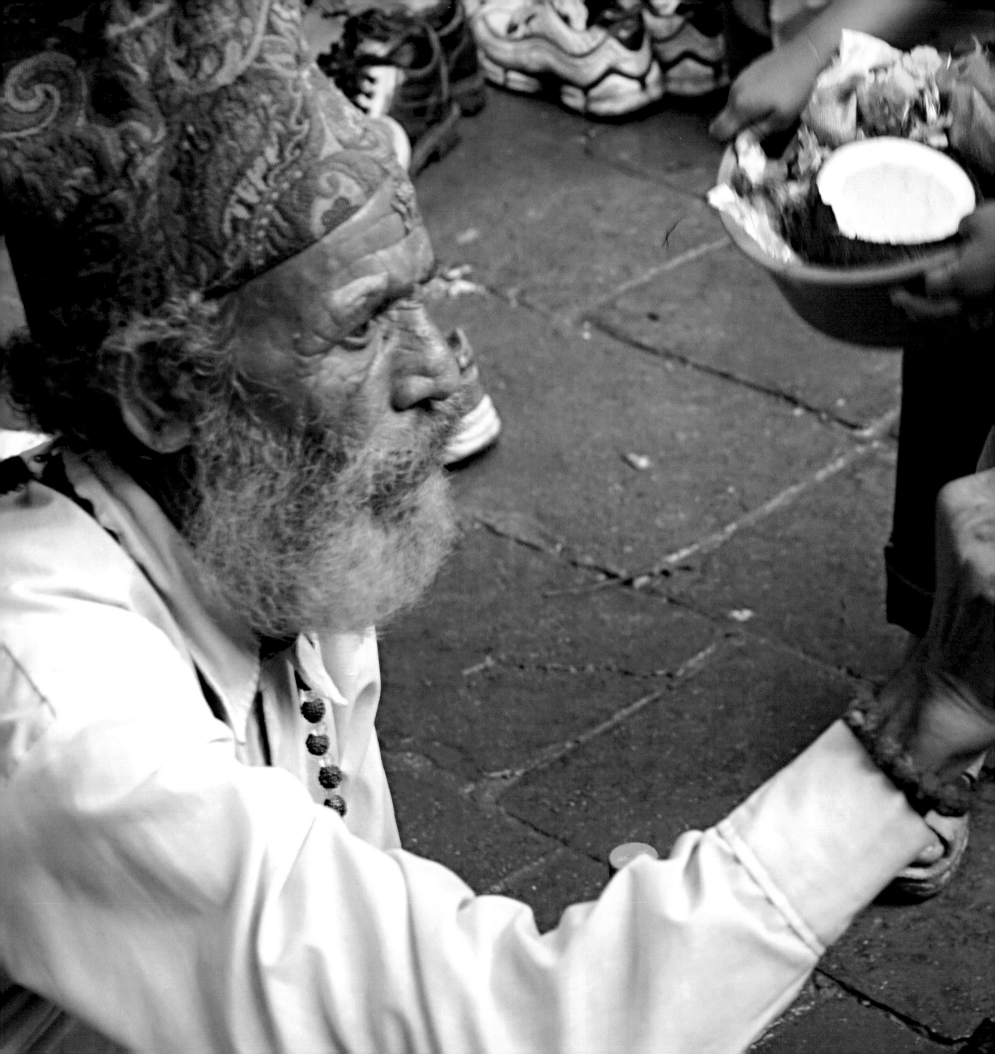

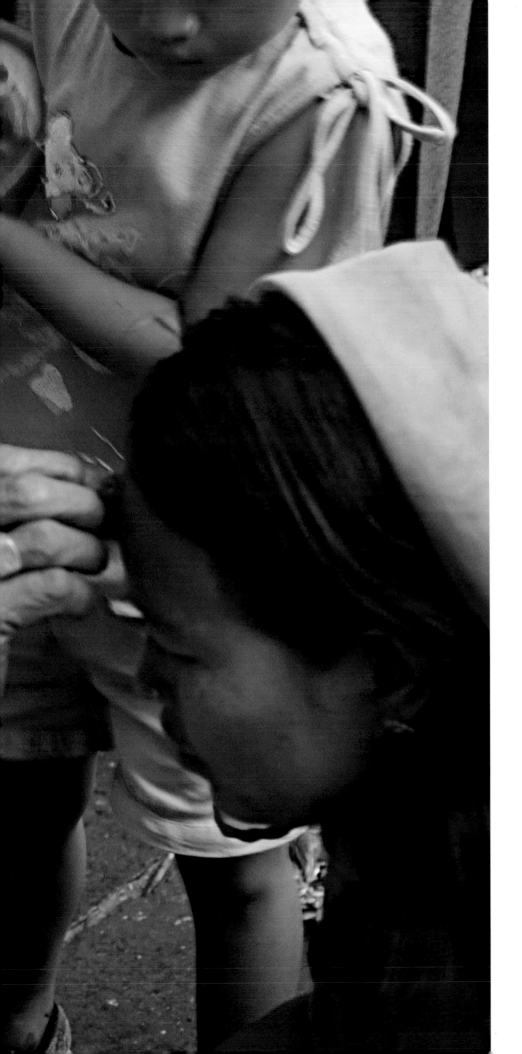

Bindi Bindi Bindi
Crimson dot saffron dot
Finger lightly touches heads
This one is crimson
This one is saffron
Blessing and protection
Pretty happy
How many how many
Lost count
Honor duty joy
Dot to sundown

Square room

Little table three chairs

Teapot cups

Simple very simple

Unintentional modern minimalism

Sun shines on the floor

Grainy texture

Sparks dance in the light

Color light intertwined

You

Tint of smile

Bit of movement

Gracefully move that chair

Flowing cloth

Serene

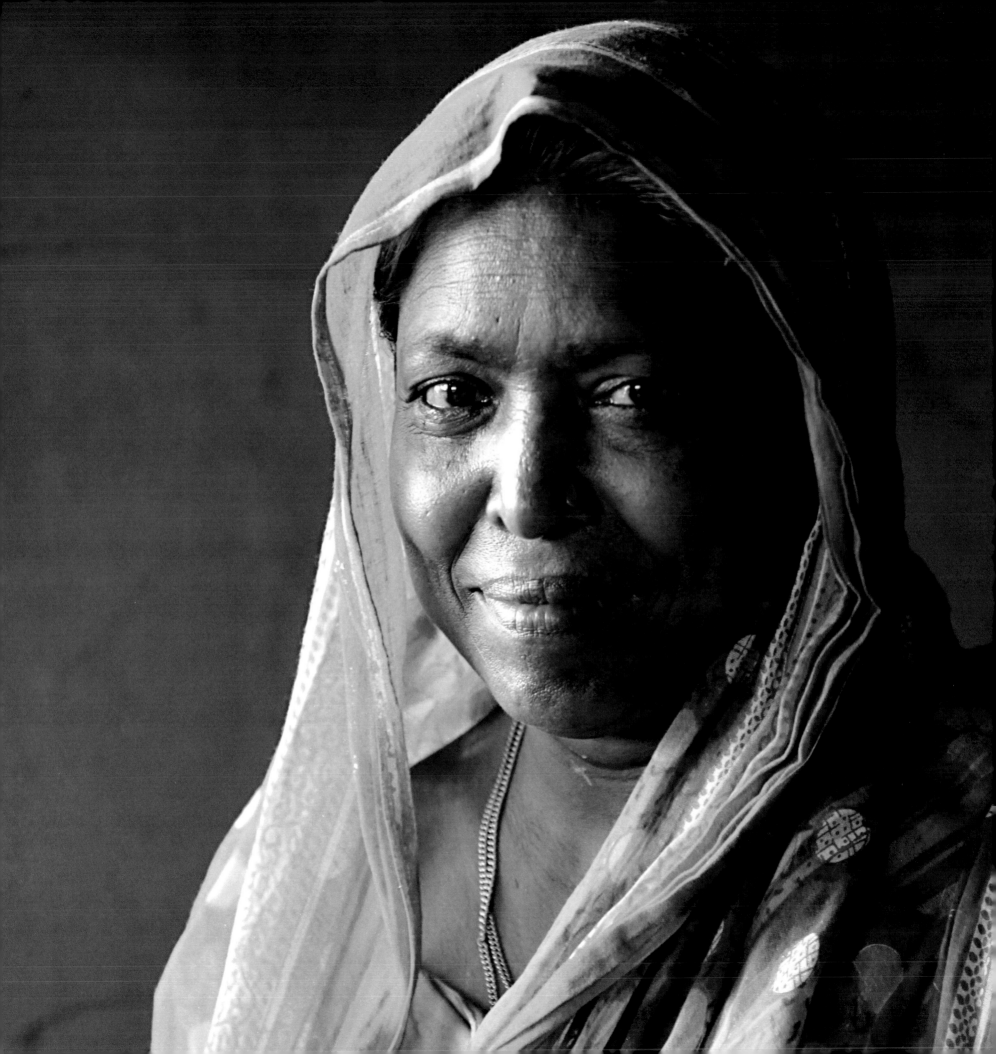

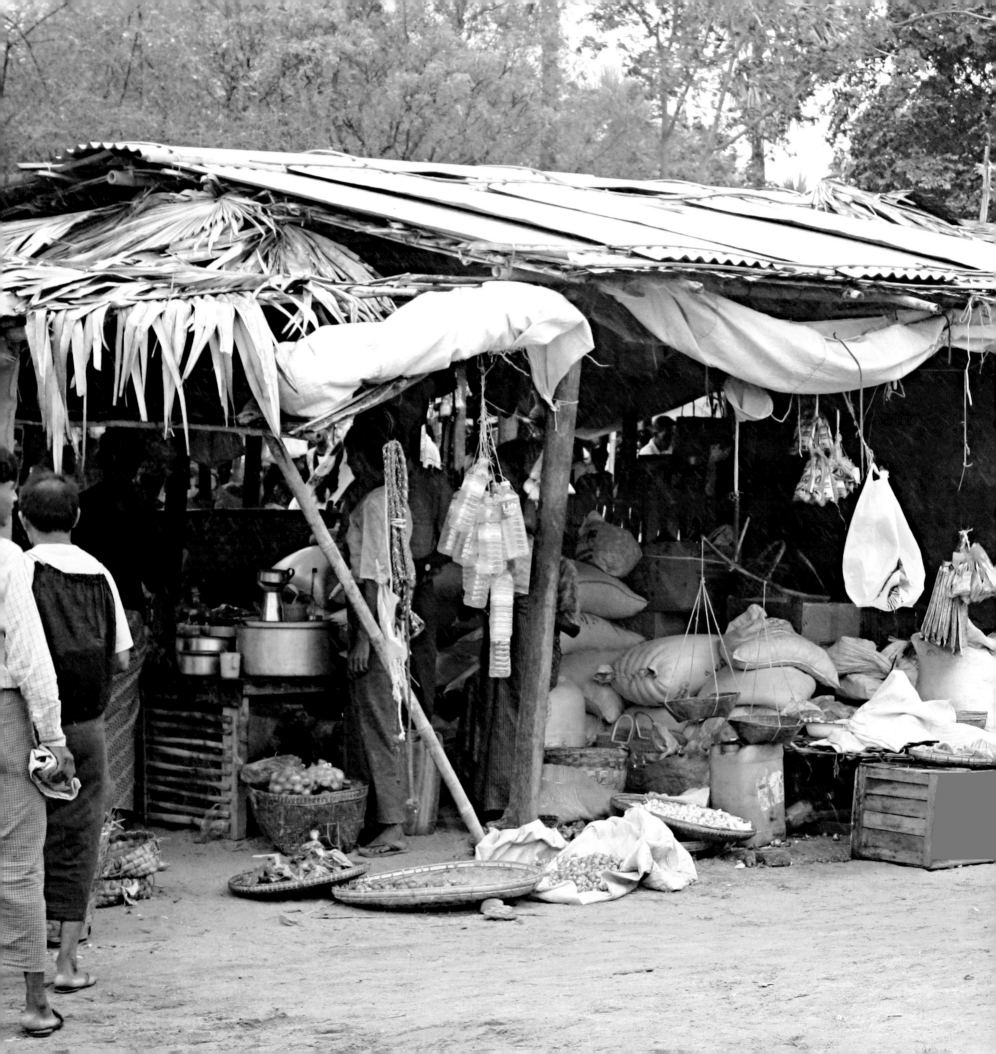

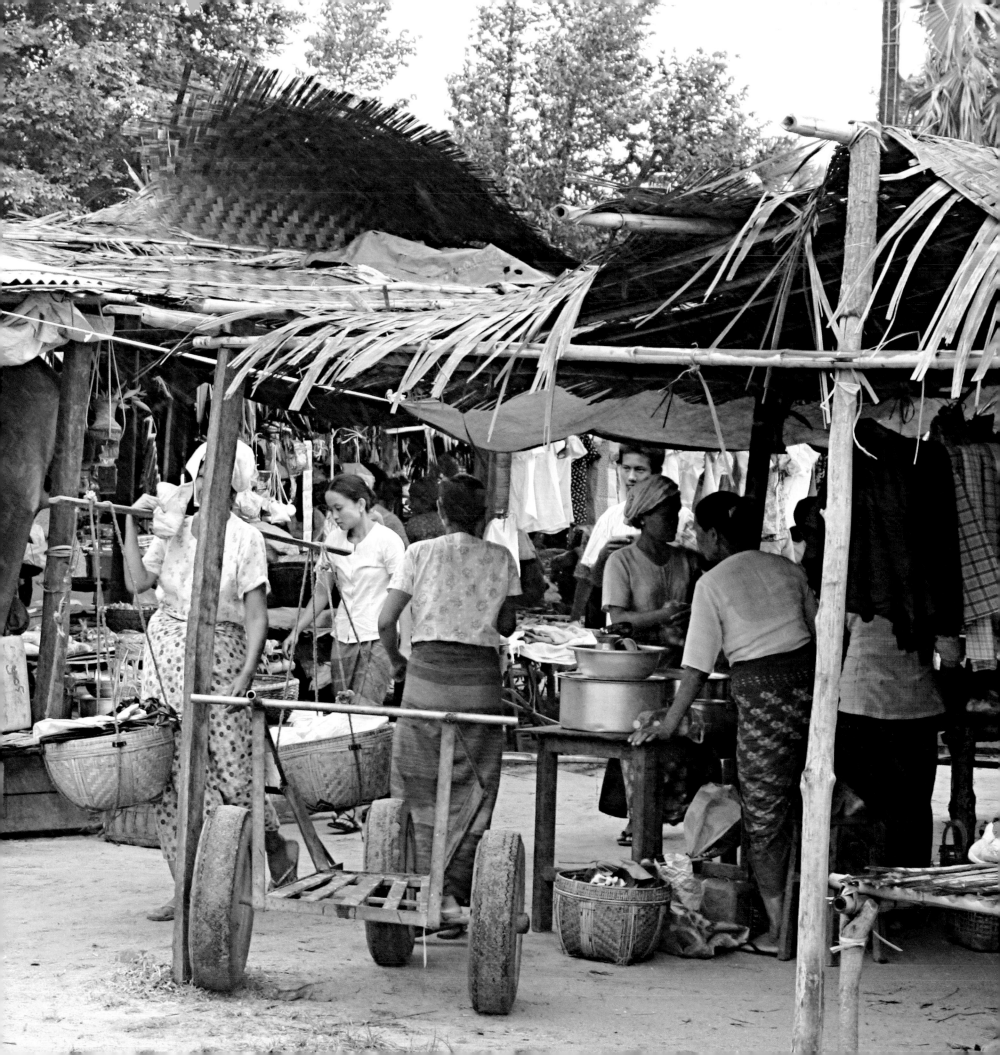

Arise at dawn

Wholesale gathering

Smell the freshness

Green red yellow

Feel the morning dew

through my fingers

Crispy tender

Back with a load

A moment to think

Waiting for someone

How much is this?

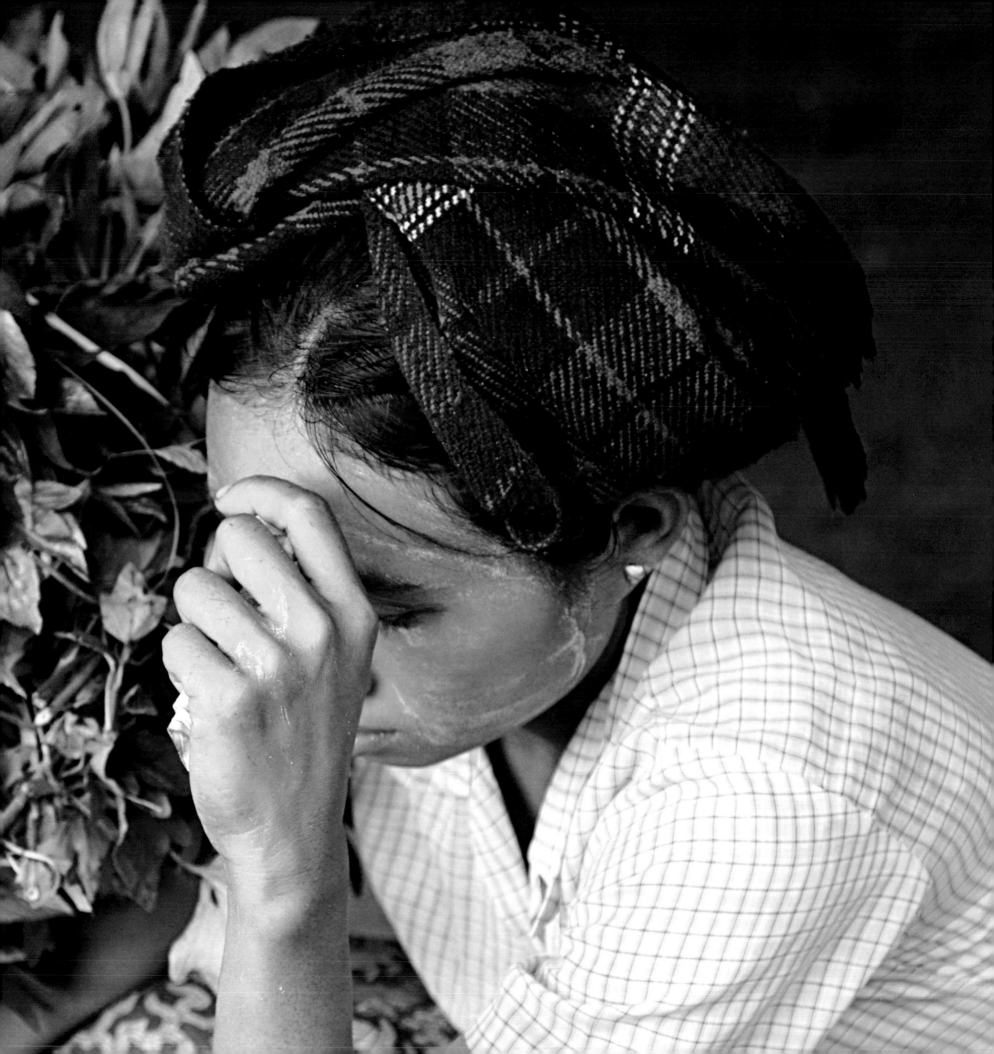

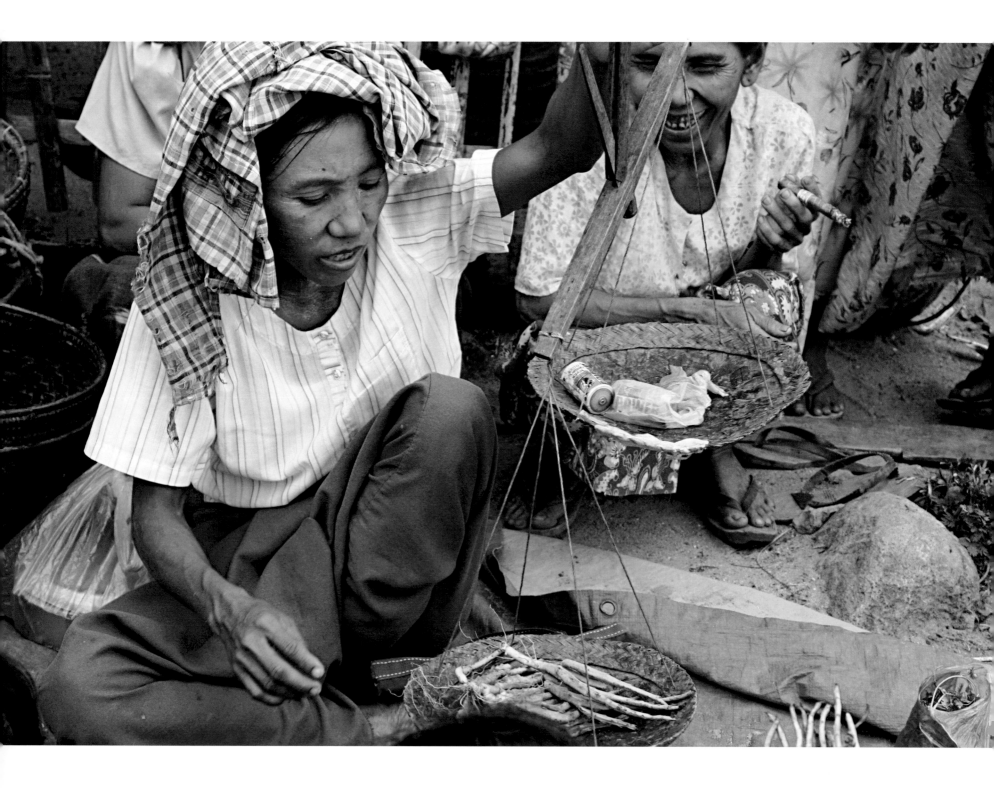

Not even not even

two more sticks

Not even not even

one more stick

Give a little take a little

Buyer is happy

I am happy

End of day all is even

There will be another one

There will be another time

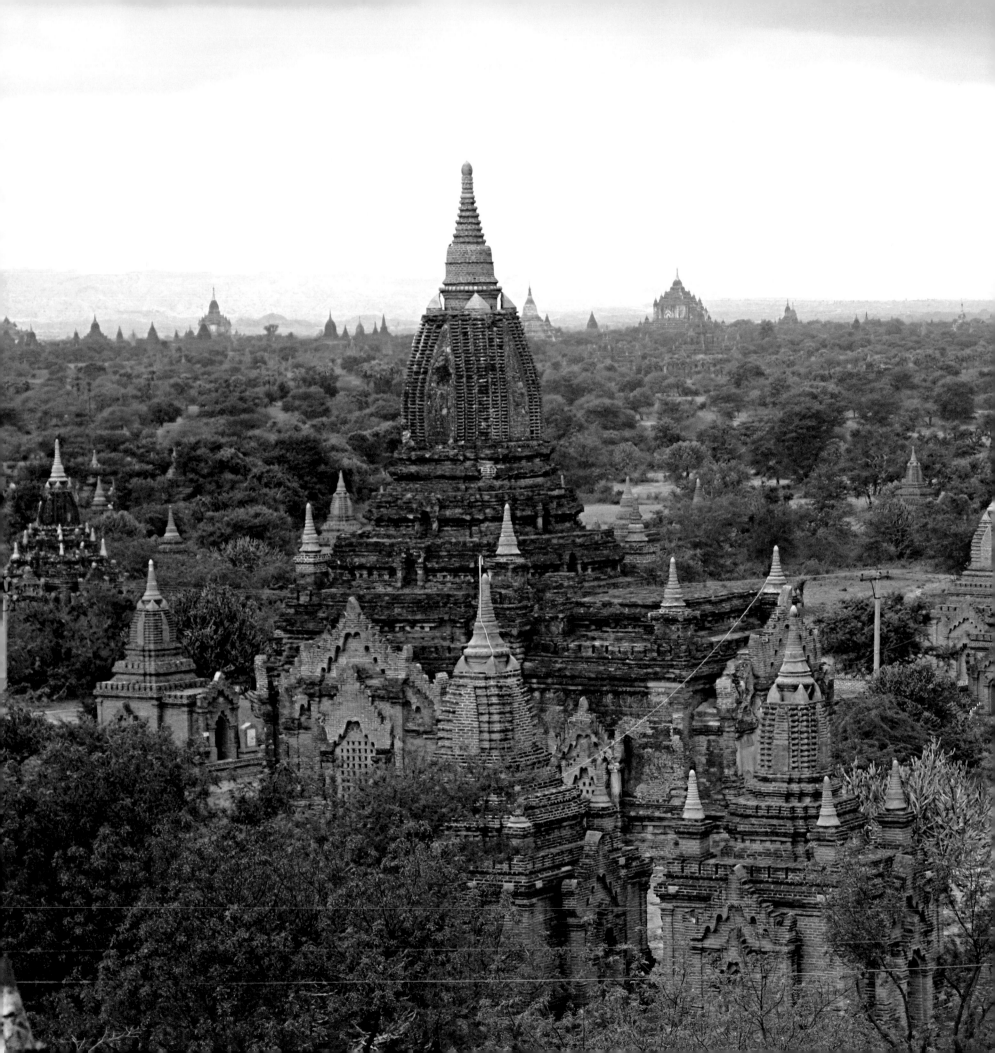

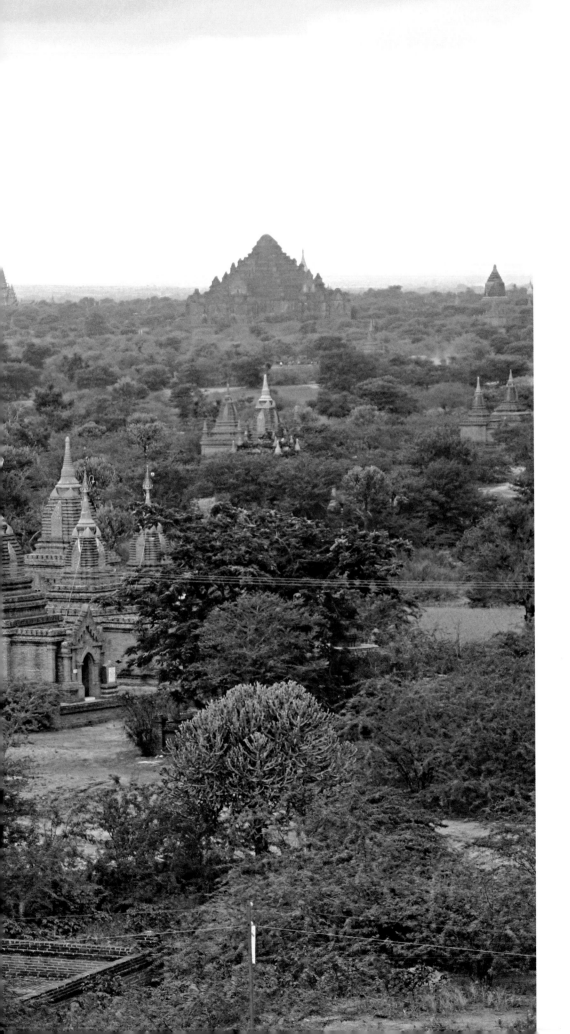

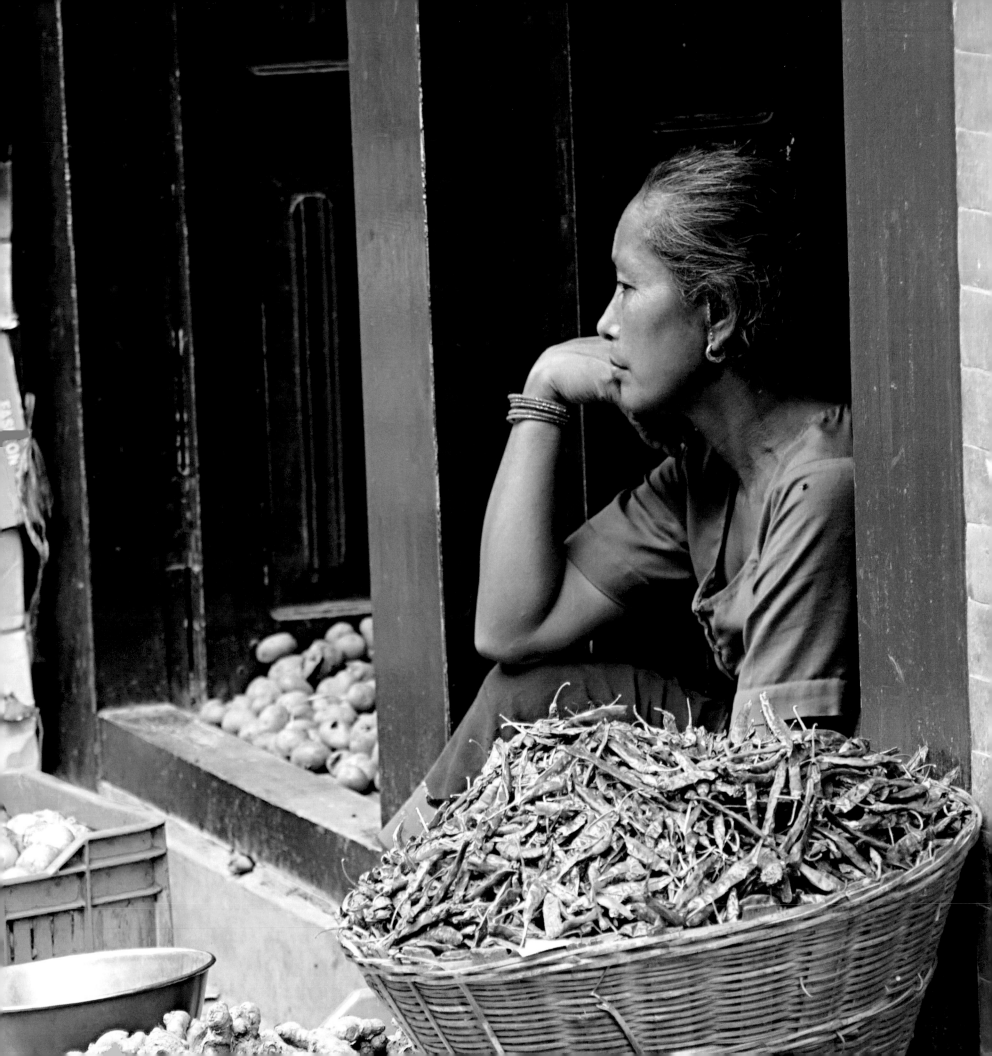

Things go wrong

Mood goes down

What should I do

Think about talking to my husband

No need to have someone tell me stupid

Think about talking to my neighbor

No need to have someone tattle on me

Talk to my children

No comments

No judgment

Just listen

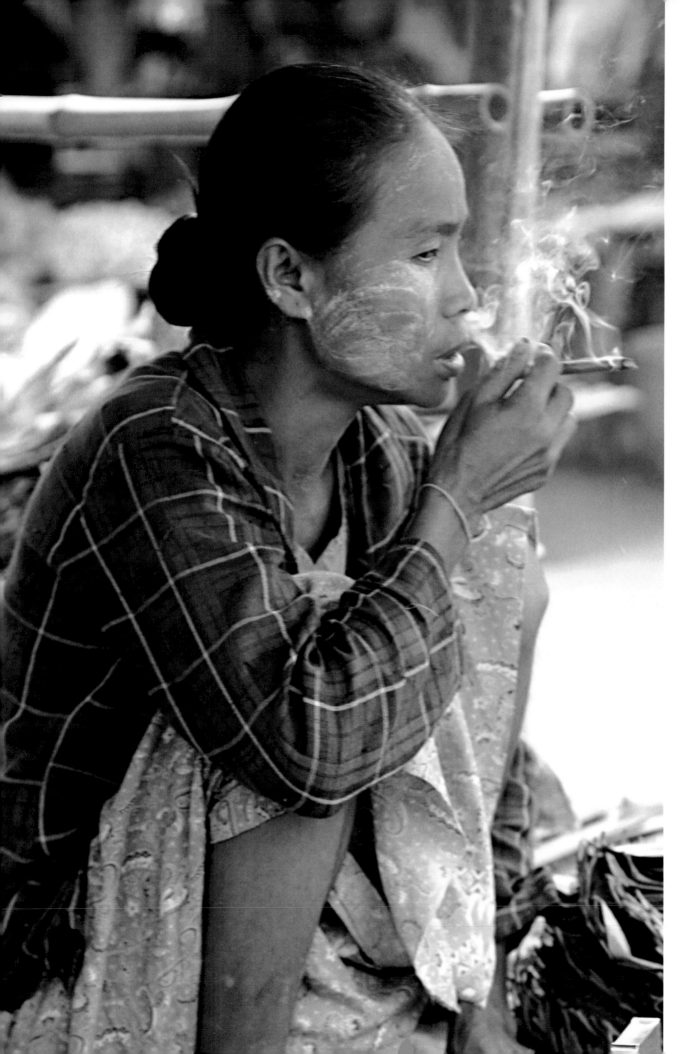

Smoke when thinking

Smoke when with friends

Smoke when in the market

Bellows into the air

Look through smoky mist

No edge to be found

Smooth all around

Friends are calm

Friends are personal

Talk about kids

Talk about husbands

Talk about joyful moments

Talk about turbulent times

Puzzles solved in the mist

Sagas find way out

Smoke is smoke mist is mist

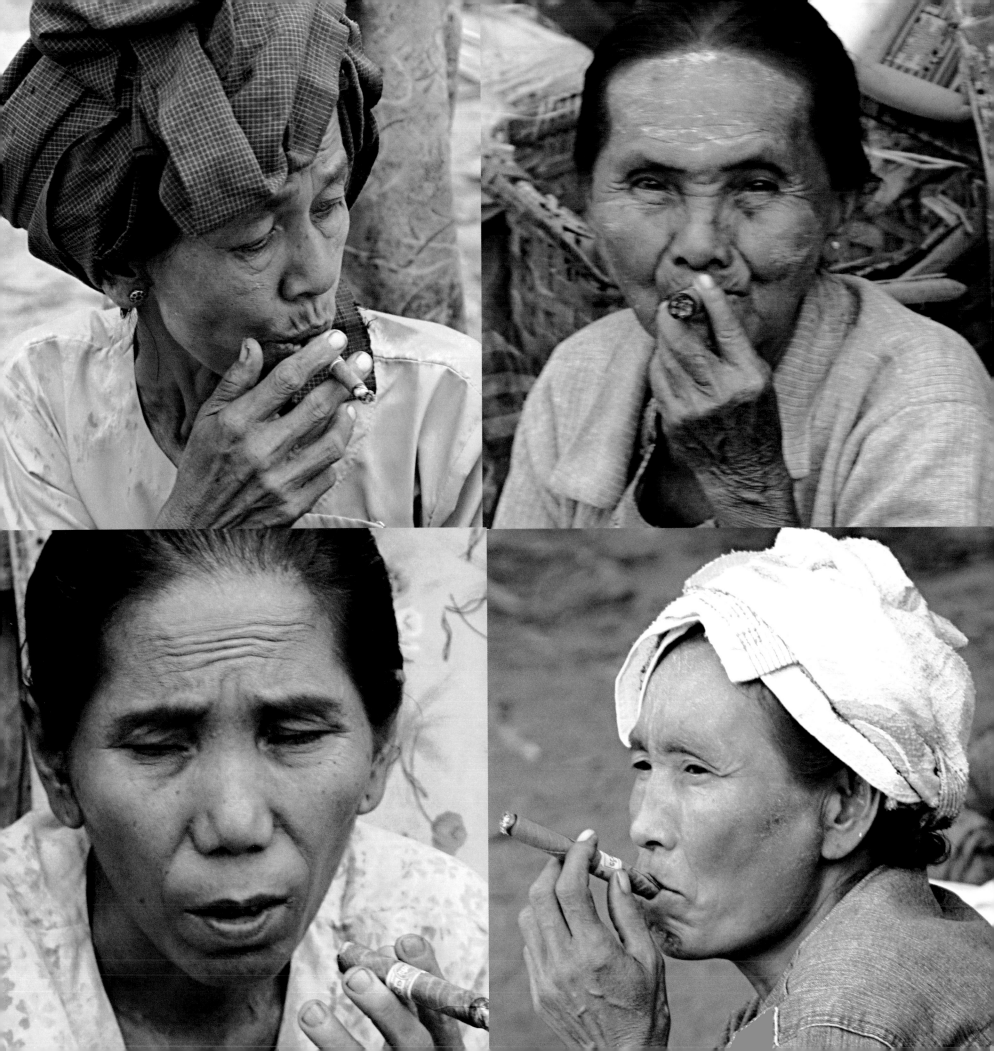

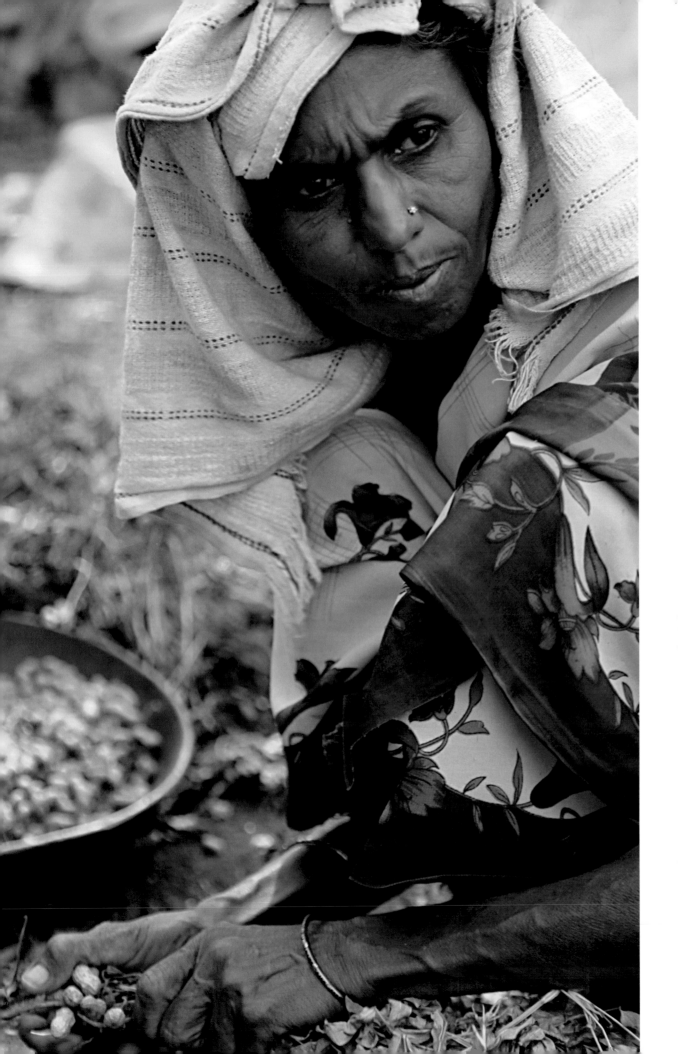

Season of peanuts

Harvest loads of peanut bushes

Baskets baskets to be dried

Sort them pick them

Remember dropping peanut seeds

Sprouts grow and grow

Suddenly leaves and white flowers

cover the field

Seems like just a day ago

Big ones to the markets

Small ones to roast and enjoy

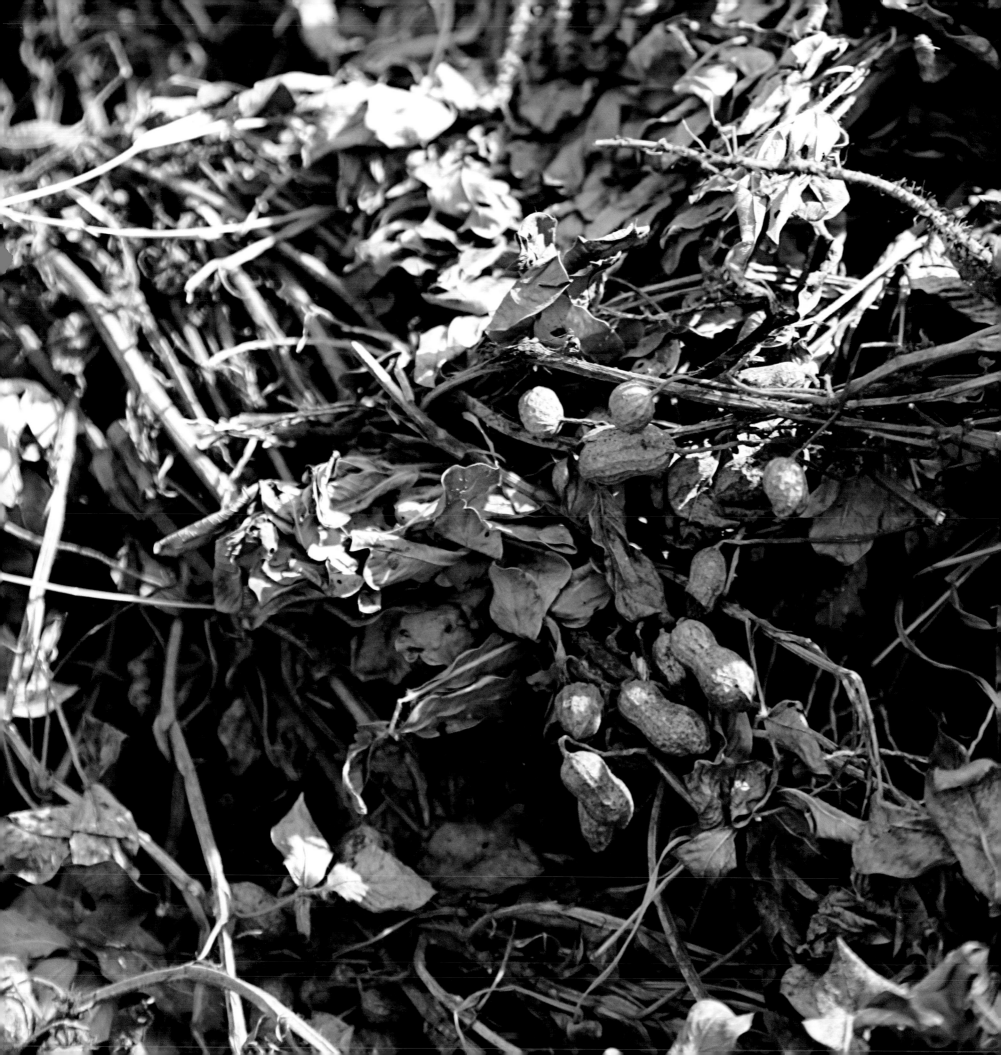

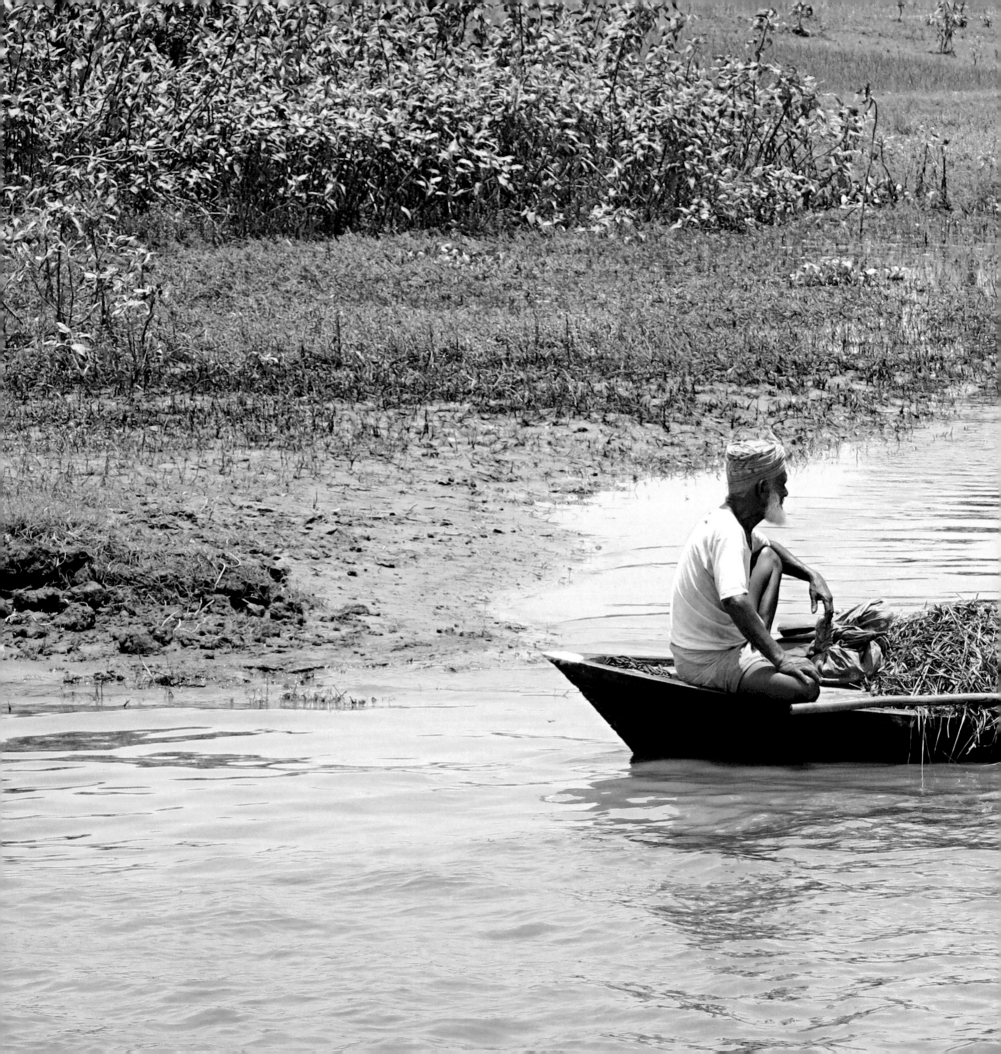

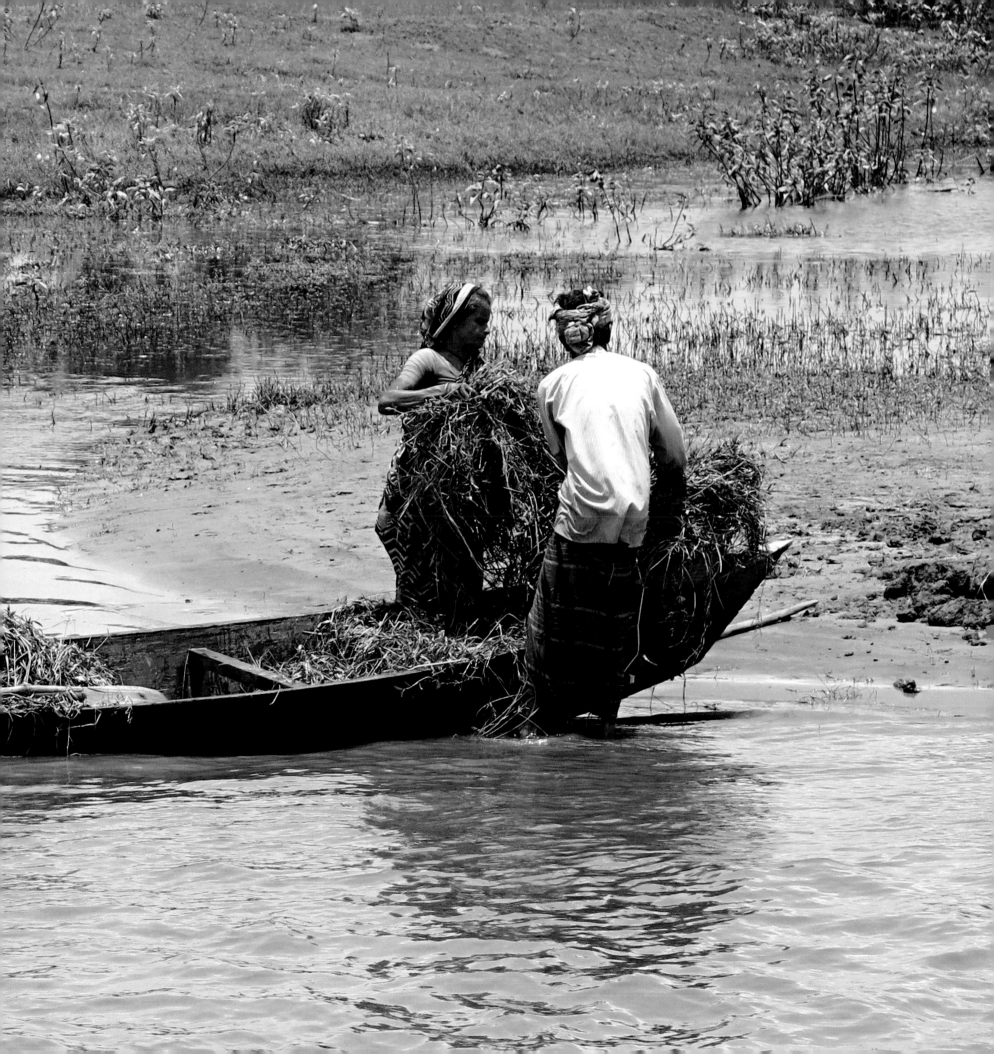

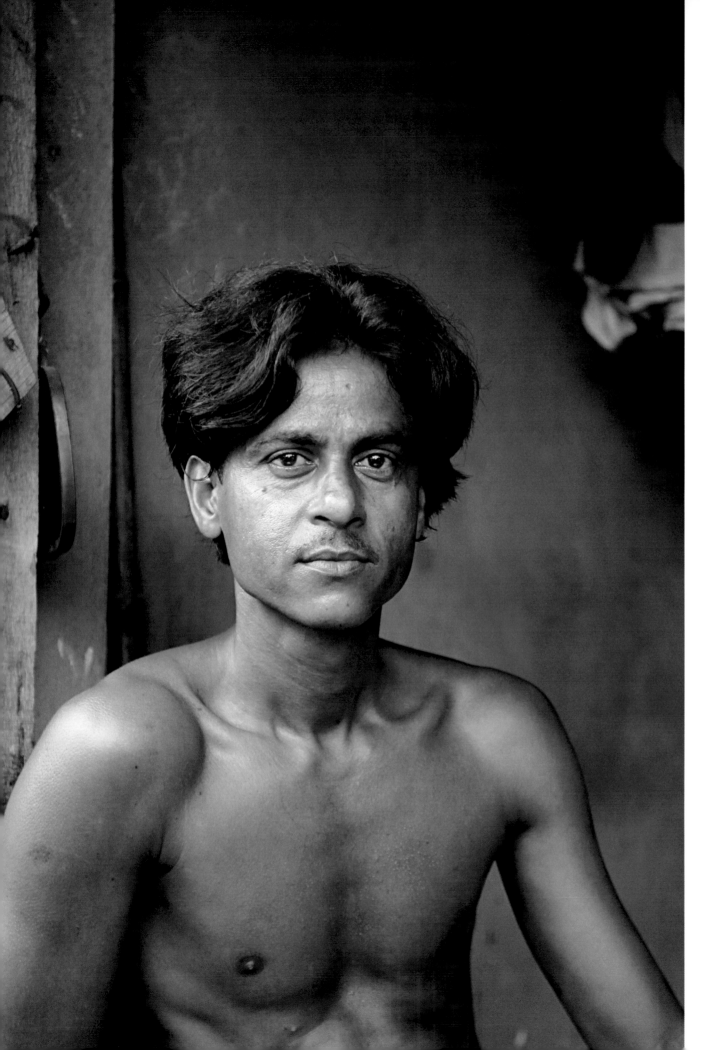

Here in the village

Grew up together

Friends forever

Work tell stores share lives

Last night sat around

Singing laughing

Drums beating

Finger cymbals clinging

Accordion playing

Faster and faster

Louder and louder

Movement up and down

Voice soaring above

Take turns harmonize

Hot sultry air

Silk scarf swinging flowing

Not affected by the heat

Excitement fills the air

Always looking forward

The next day

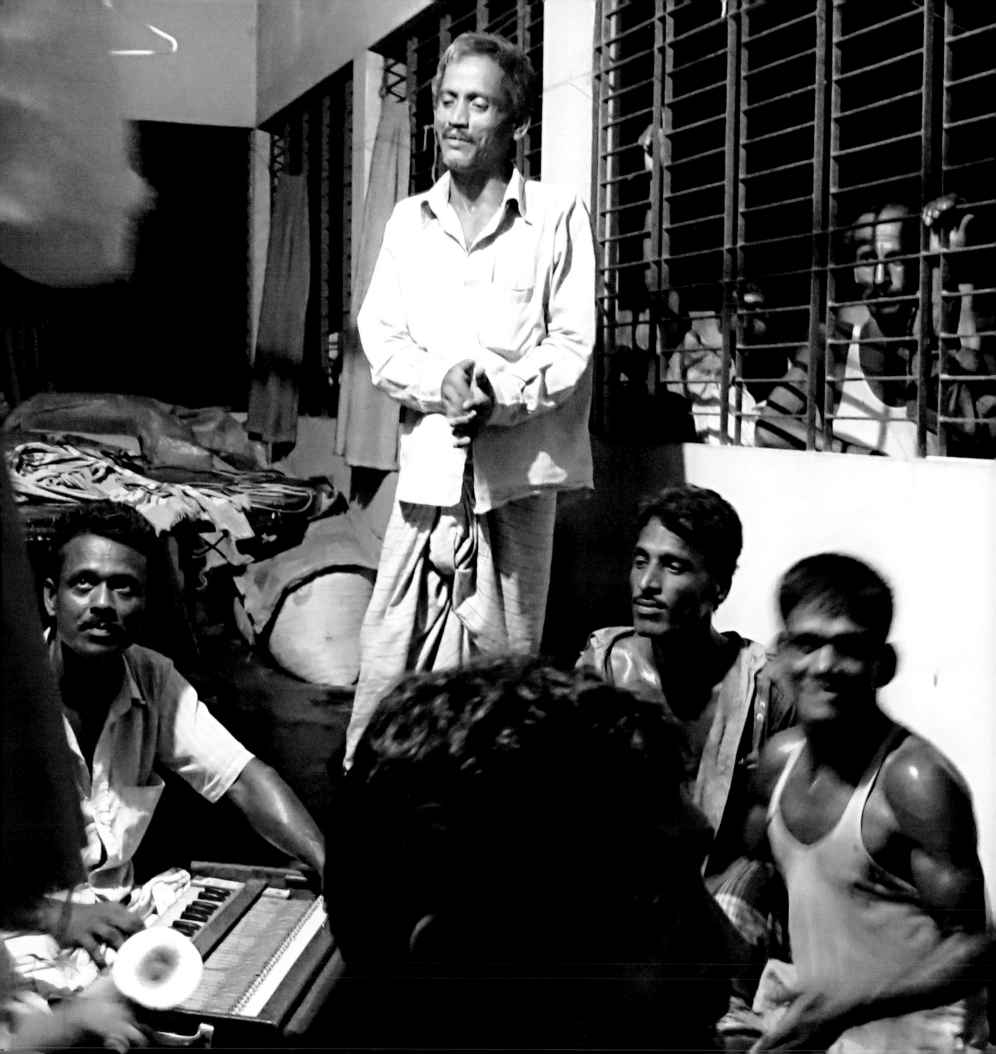

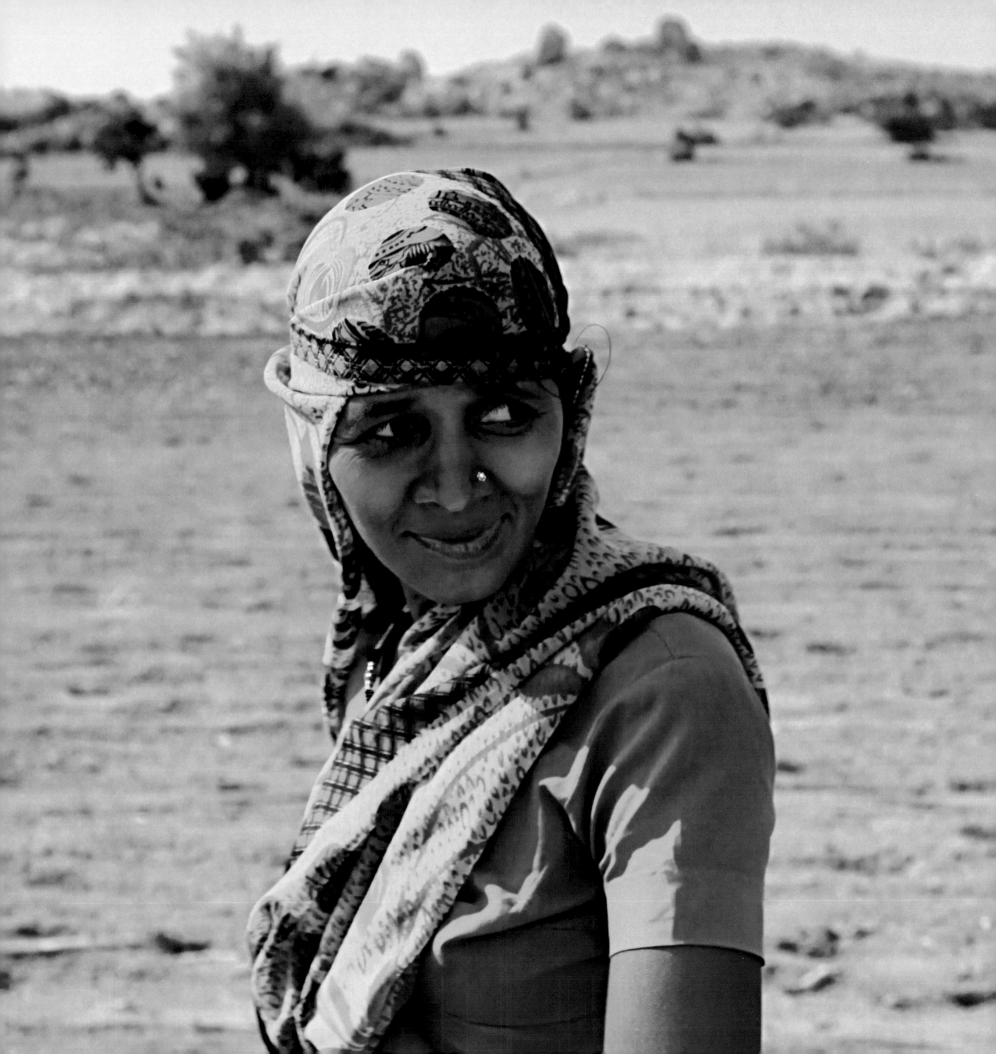

Up at dawn

Whole day of work in front

Brother ready

Uncle ready

Cow ready

Yoke on the neck

Stand look at the vast land

Done at dusk

Do it do it

Follow the cow

Follow the track

Seeds slip through my fingers

like a waterfall

It's a U-turn

Another U-turn

Halfway through

Turn head one look

It's close it's close

Next time walk in

Giant corn will cover me

Good feeling

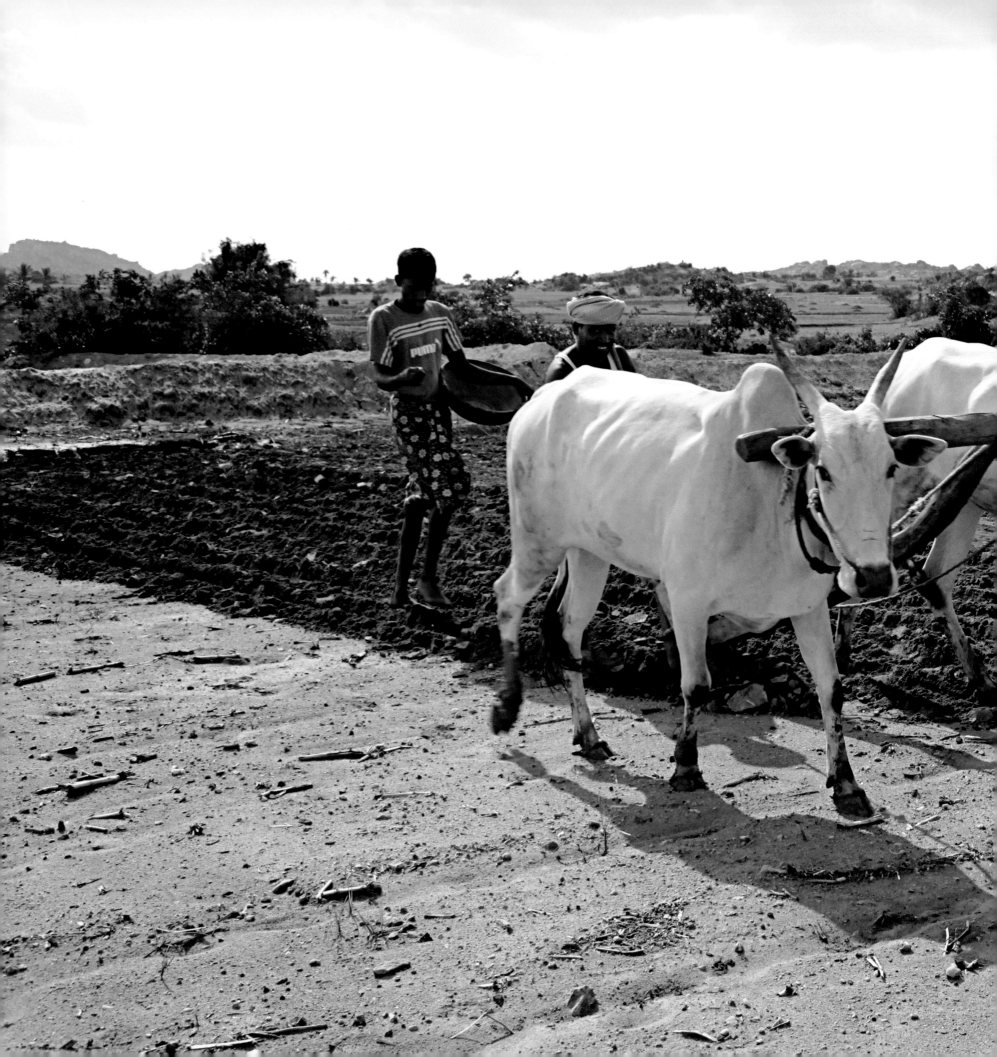

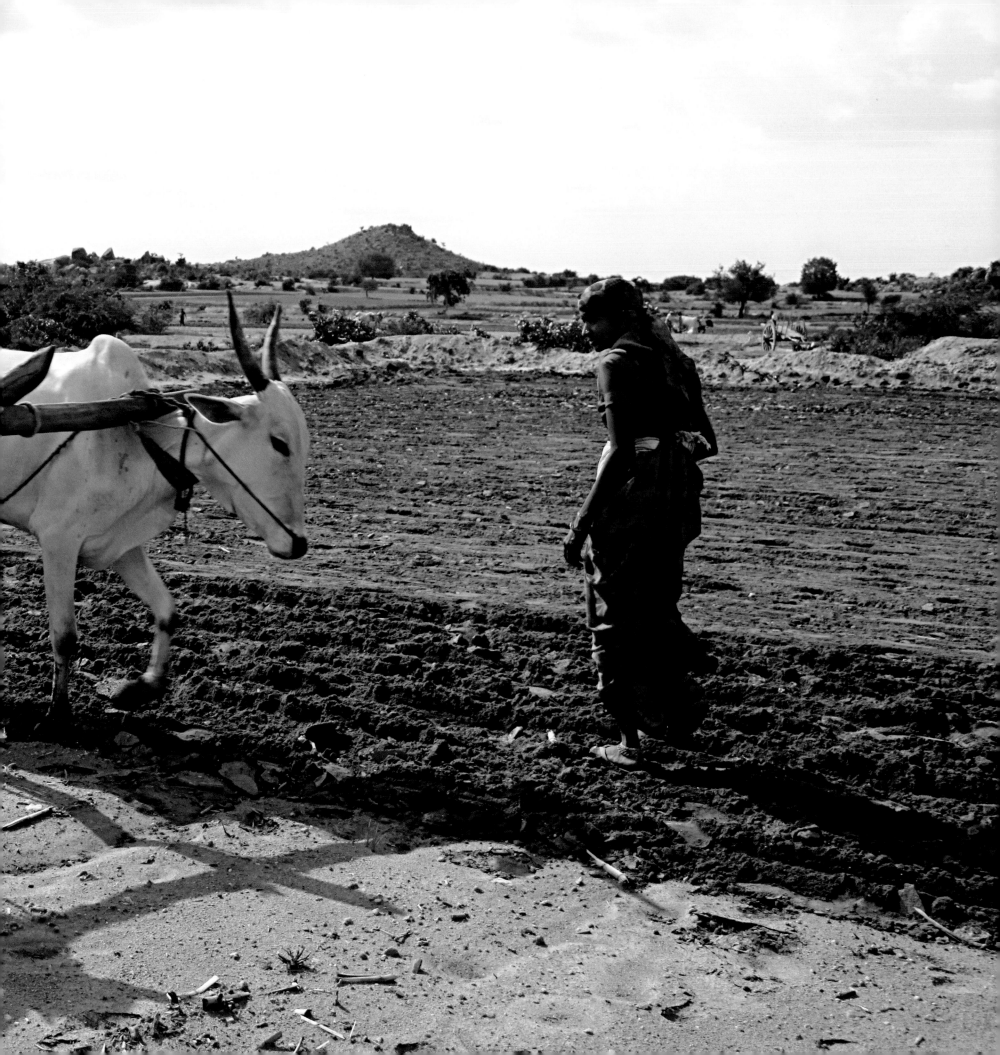

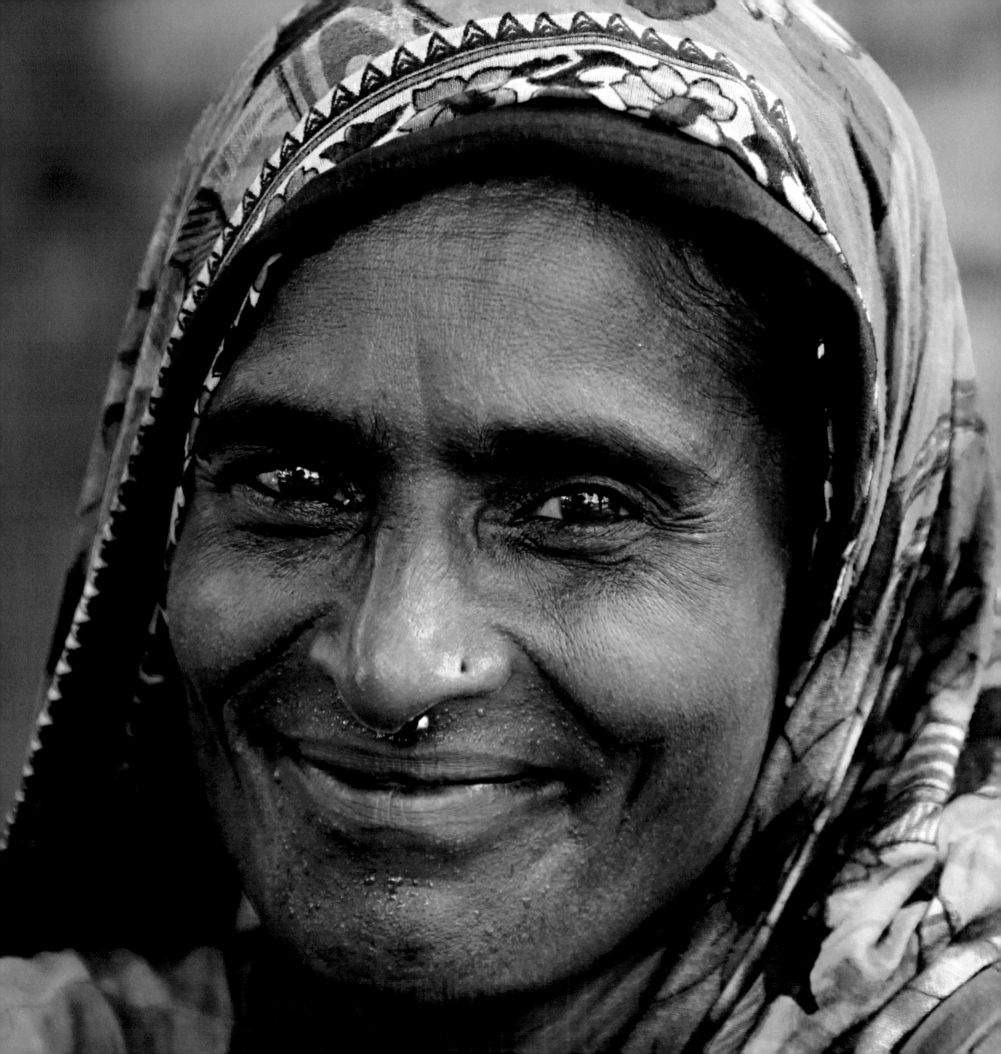

Family kids

Roof over us

Able to get up in the morning

Carry goods to market

Chat barter

Sell others' needs

Buy my needs

Always know

Always know

Smiling faces await me

When I get home

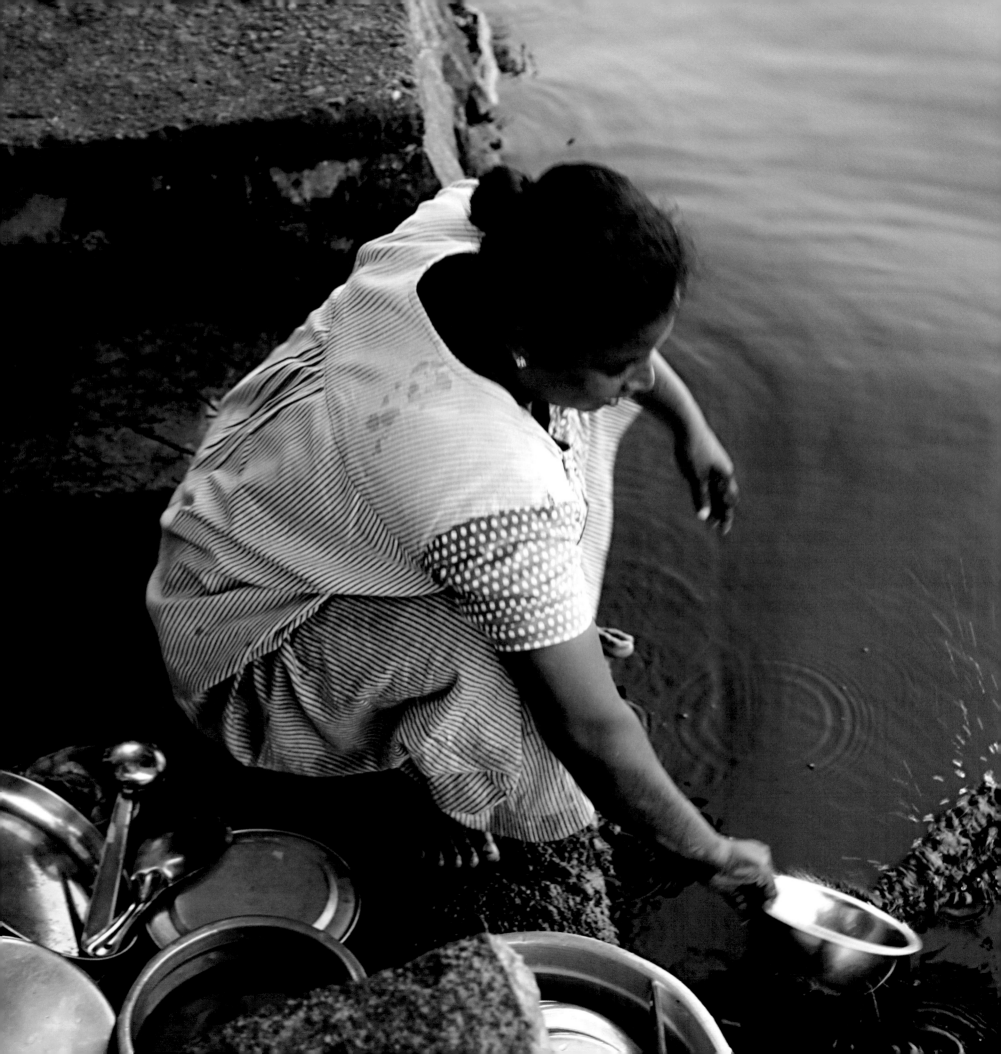

Banana tree coconut tree

Along the riverside

Green vegetation colorful blossoms

Beauty of the backwaters

Five steps from door

Five steps down water

Water flowing

Pots swishing pans clanging

No turning on no turning off

No worries no worries

Water flowing

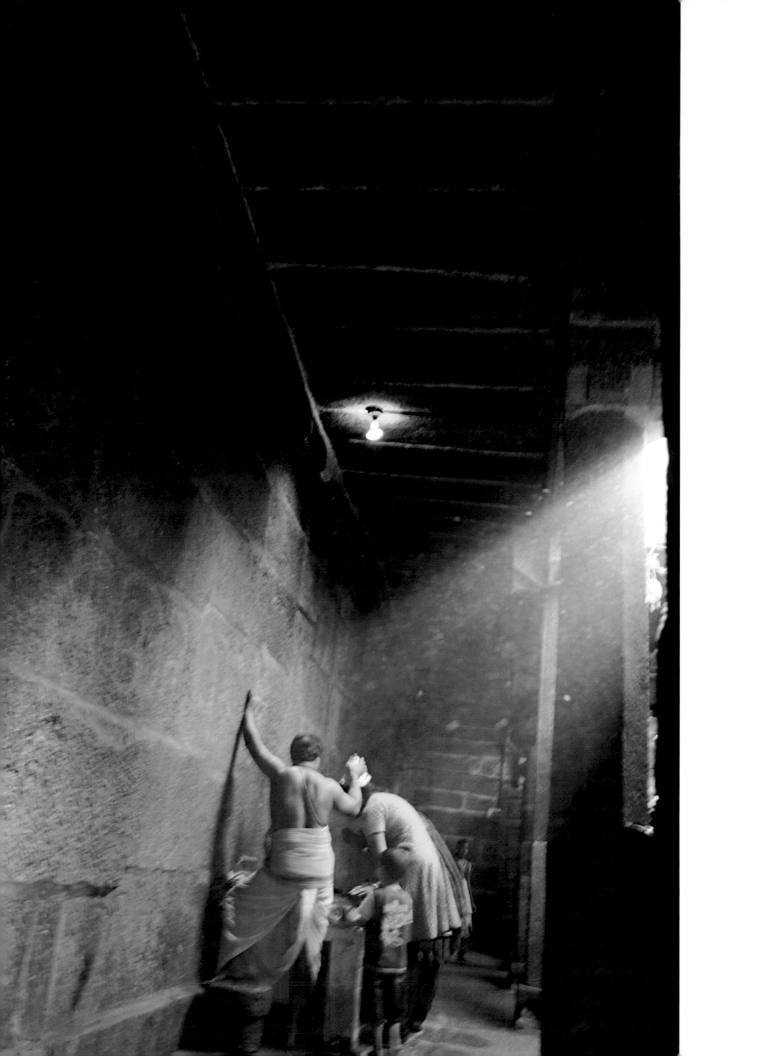

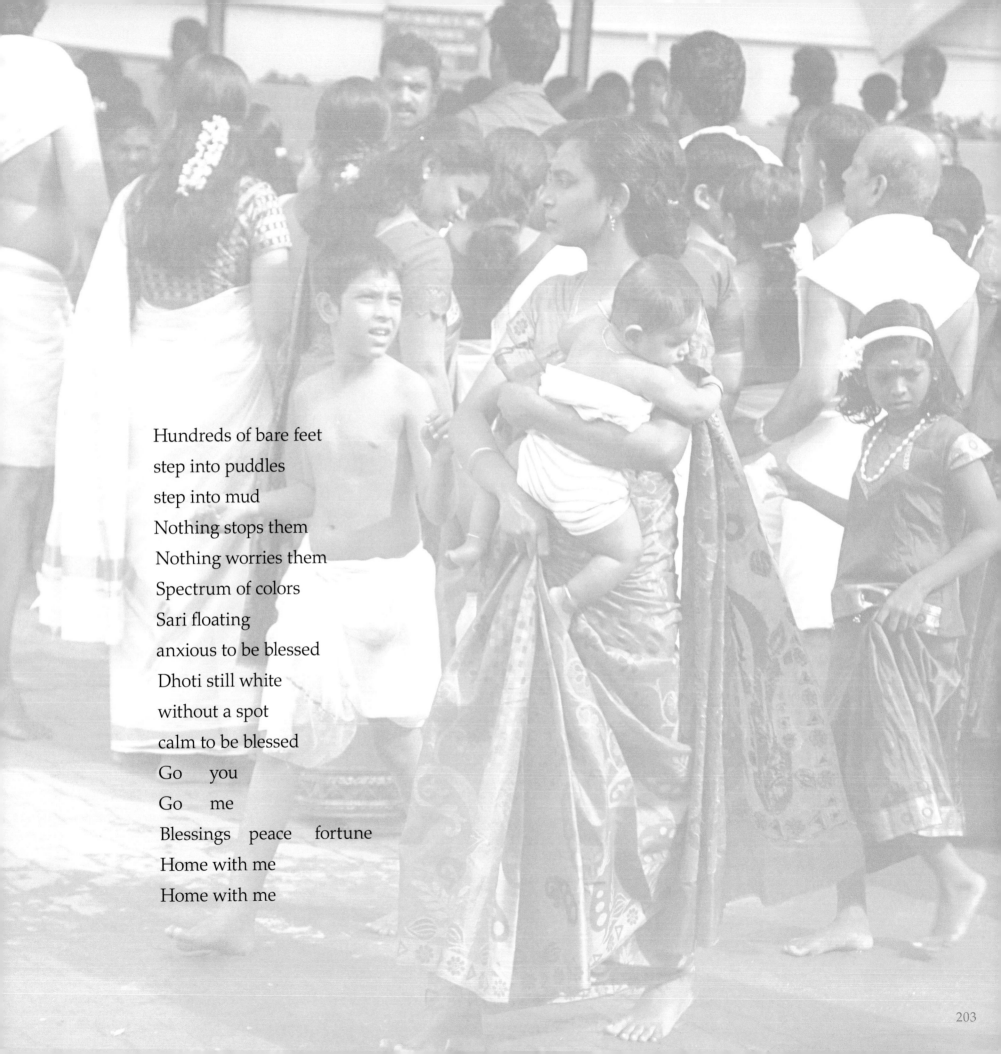

Hundreds of bare feet
step into puddles
step into mud
Nothing stops them
Nothing worries them
Spectrum of colors
Sari floating
anxious to be blessed
Dhoti still white
without a spot
calm to be blessed
Go you
Go me
Blessings peace fortune
Home with me
Home with me

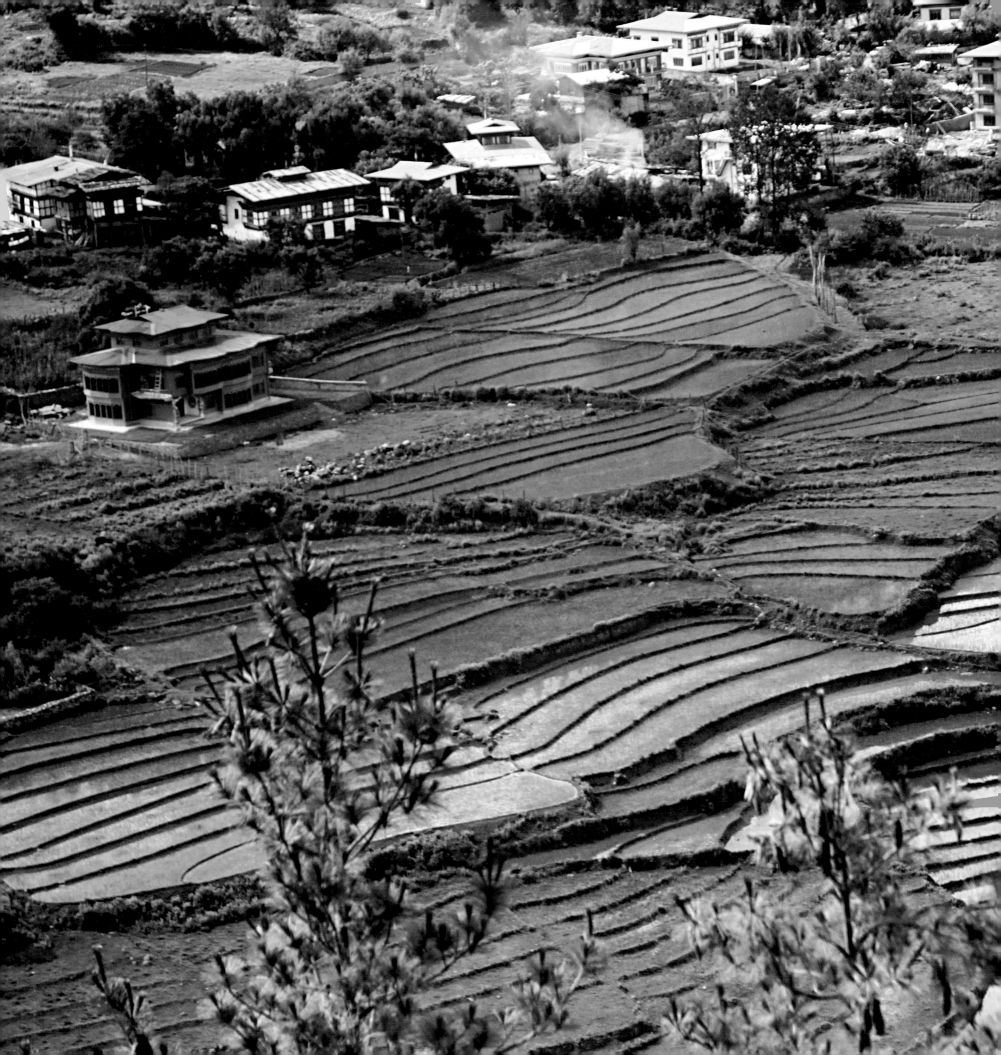

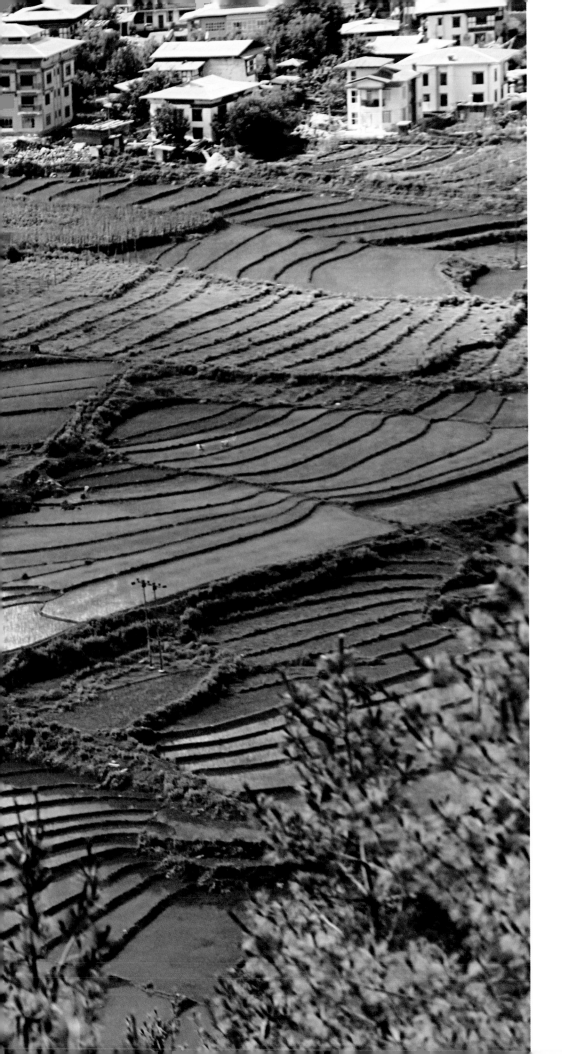

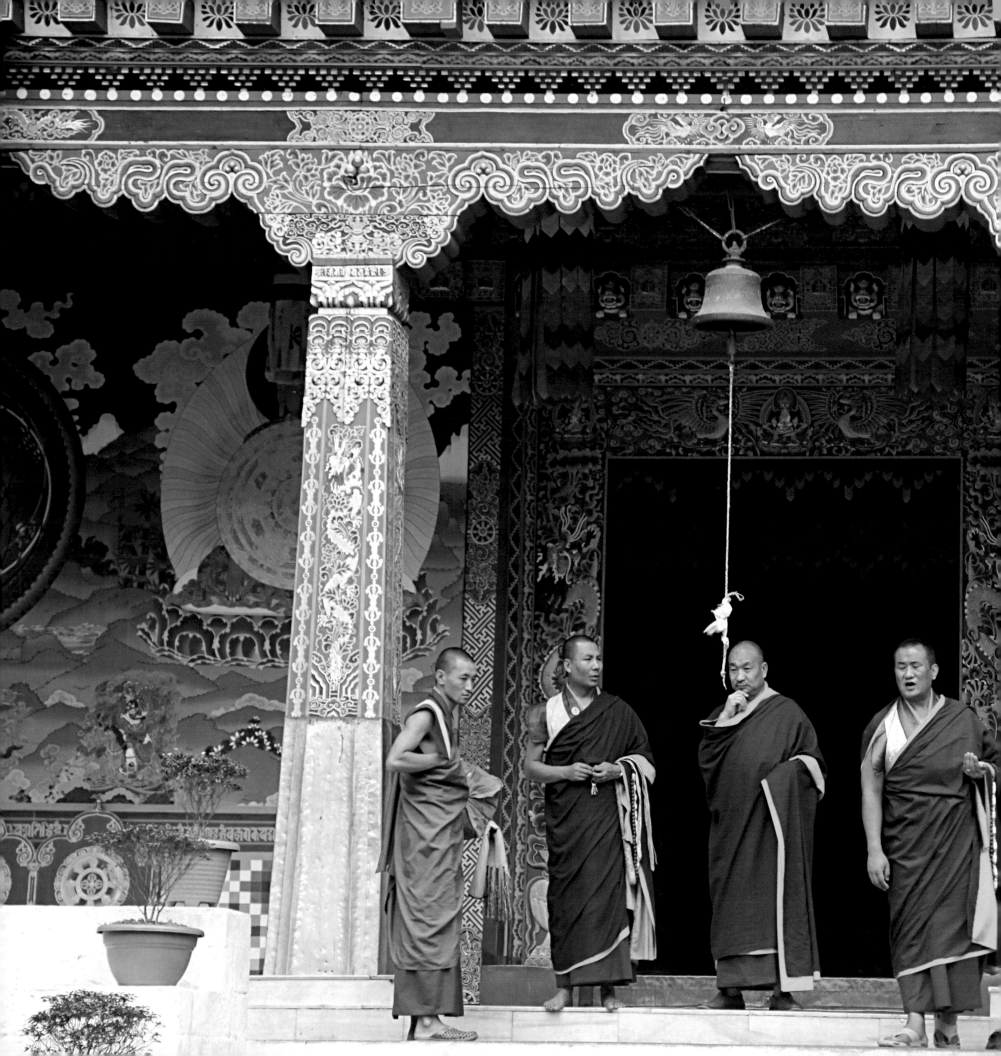

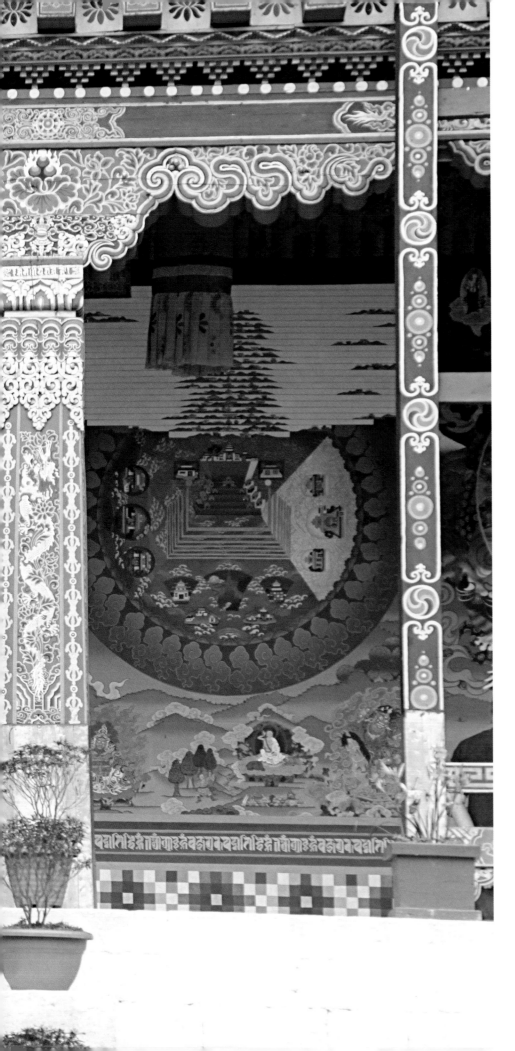

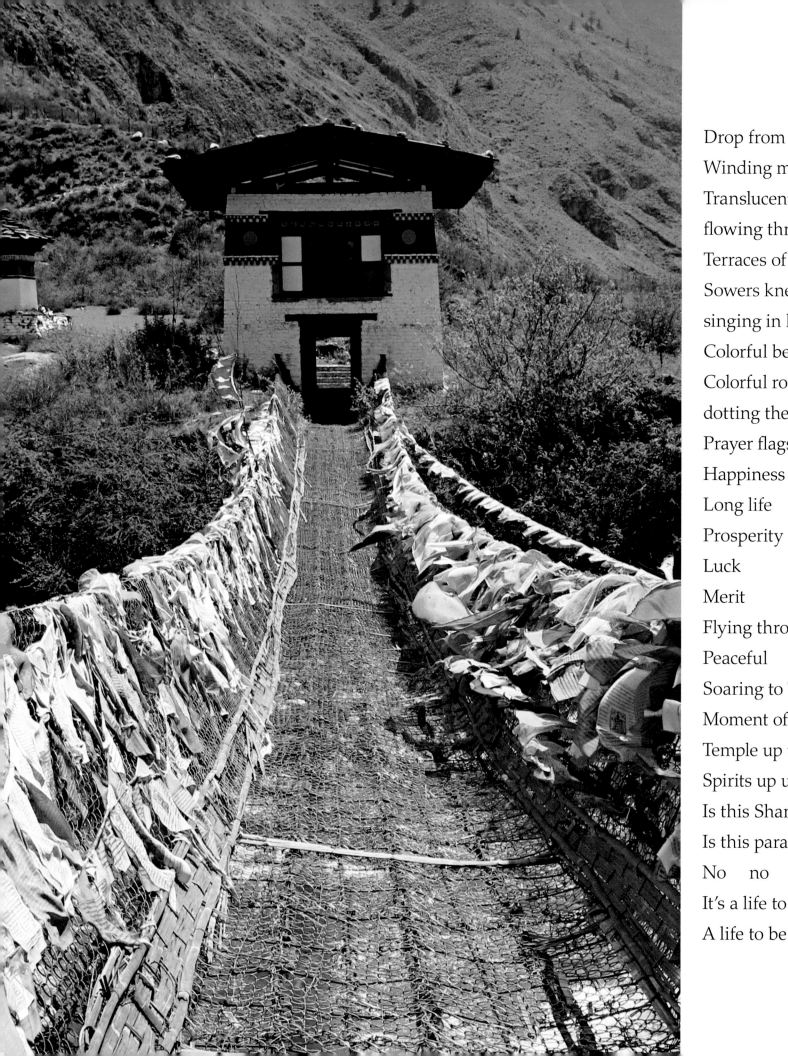

Drop from the sky
Winding mountain range
Translucent water
flowing through villages
Terraces of rice fields
Sowers kneeling in the fields
singing in harmony
Colorful beams
Colorful roofs
dotting the green hills
Prayer flags:
Happiness
Long life
Prosperity
Luck
Merit
Flying through the air
Peaceful tranquil content
Soaring to Tiger's Nest
Moment of meditation
Temple up up high
Spirits up up high
Is this Shangri-La?
Is this paradise?
No no
It's a life to be
A life to be

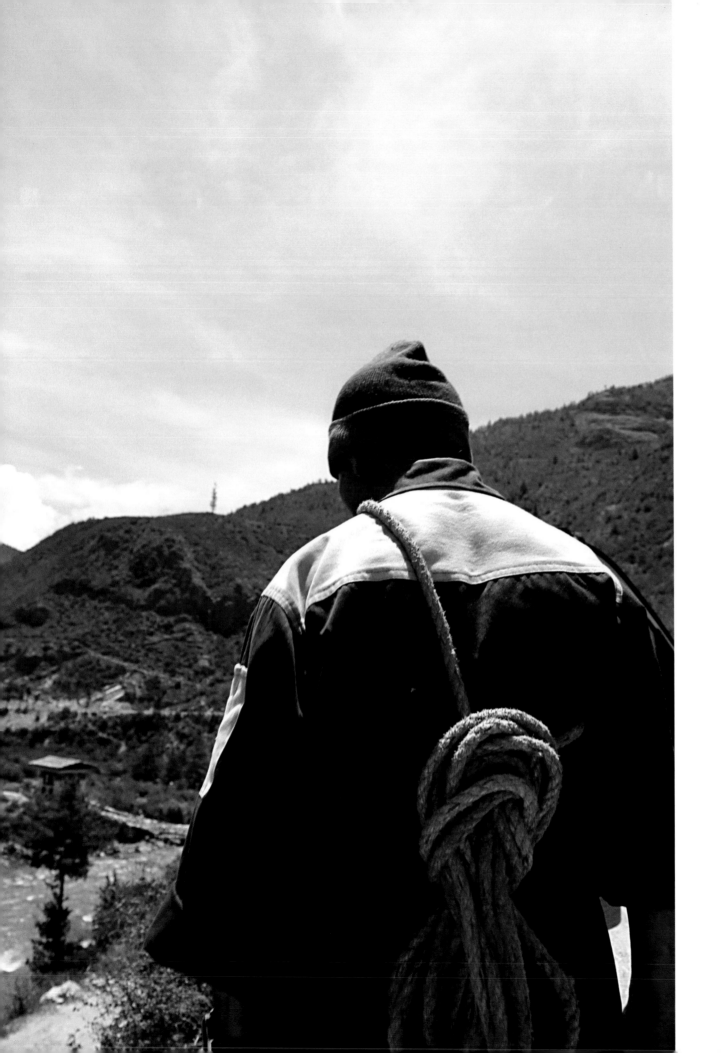

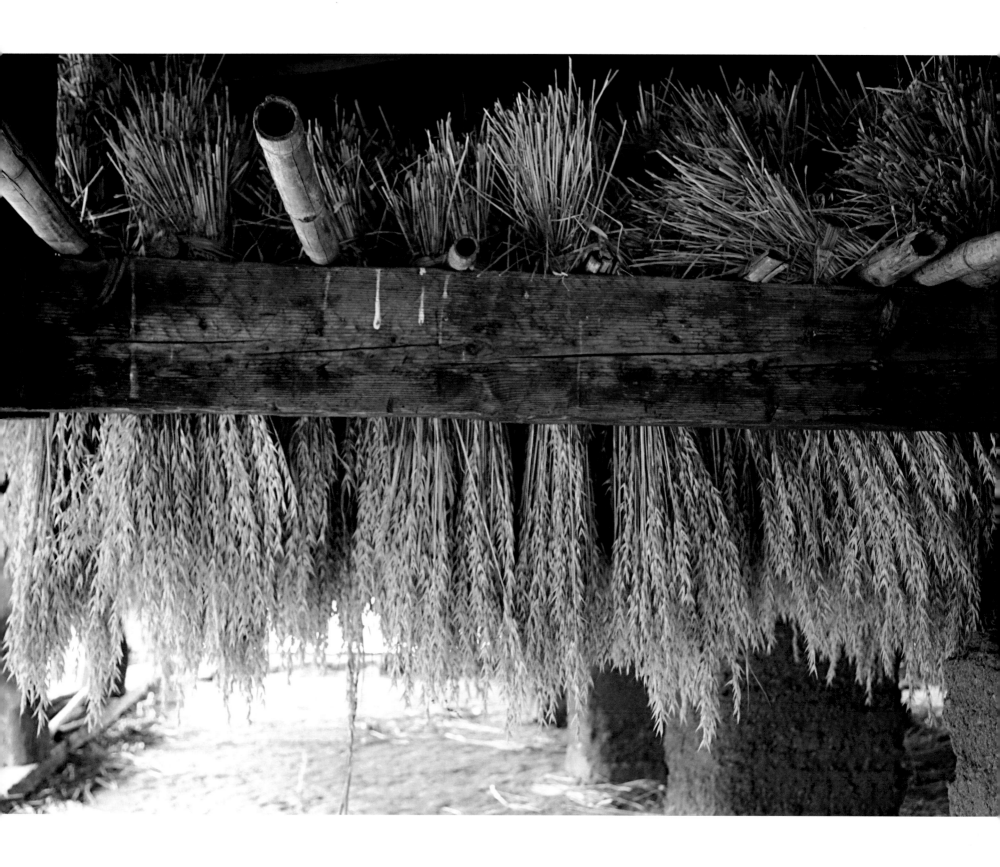

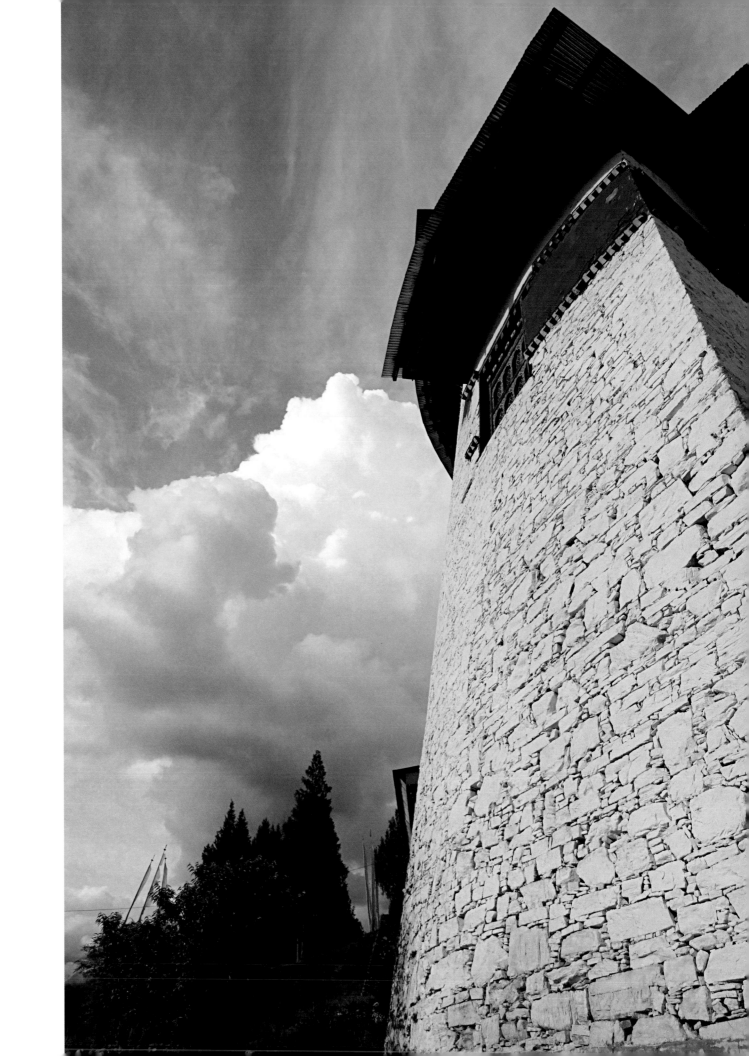

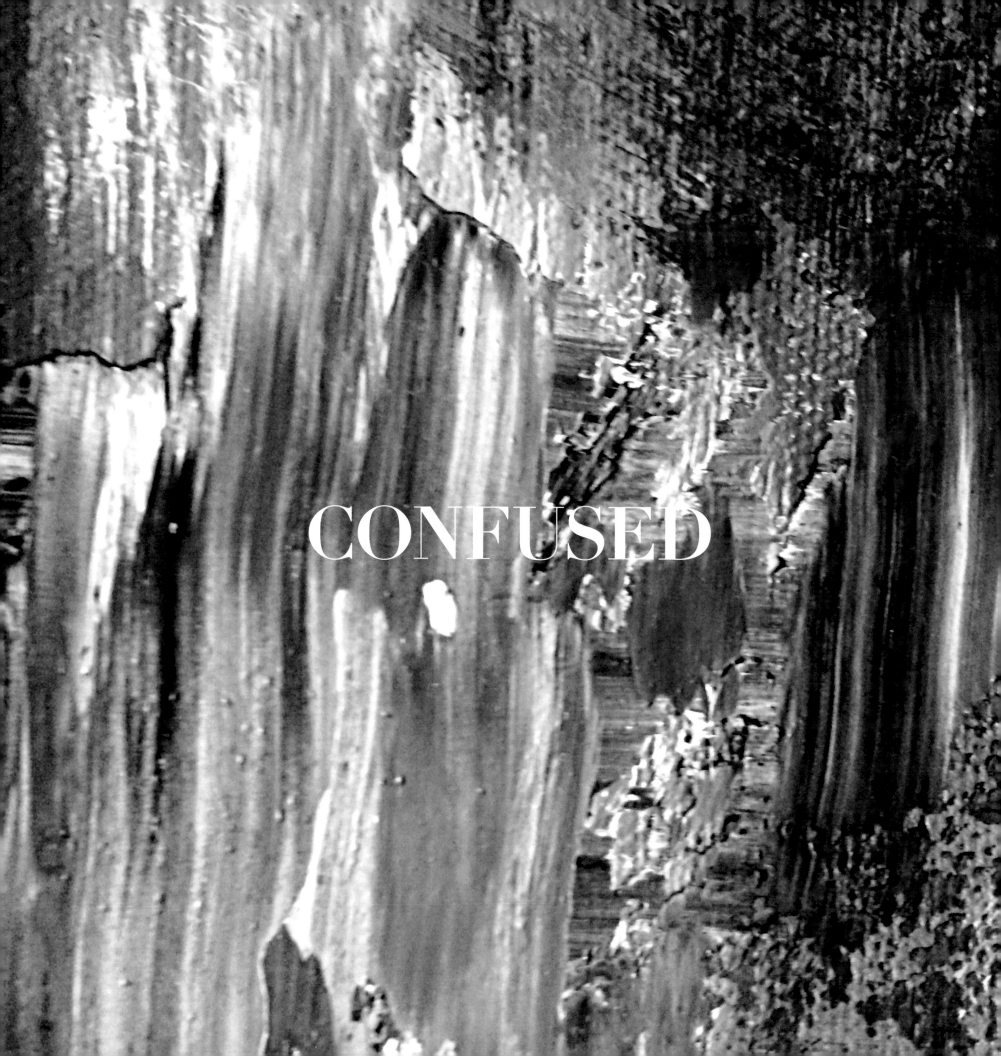

CONFUSED

Coming to terms, finding myself

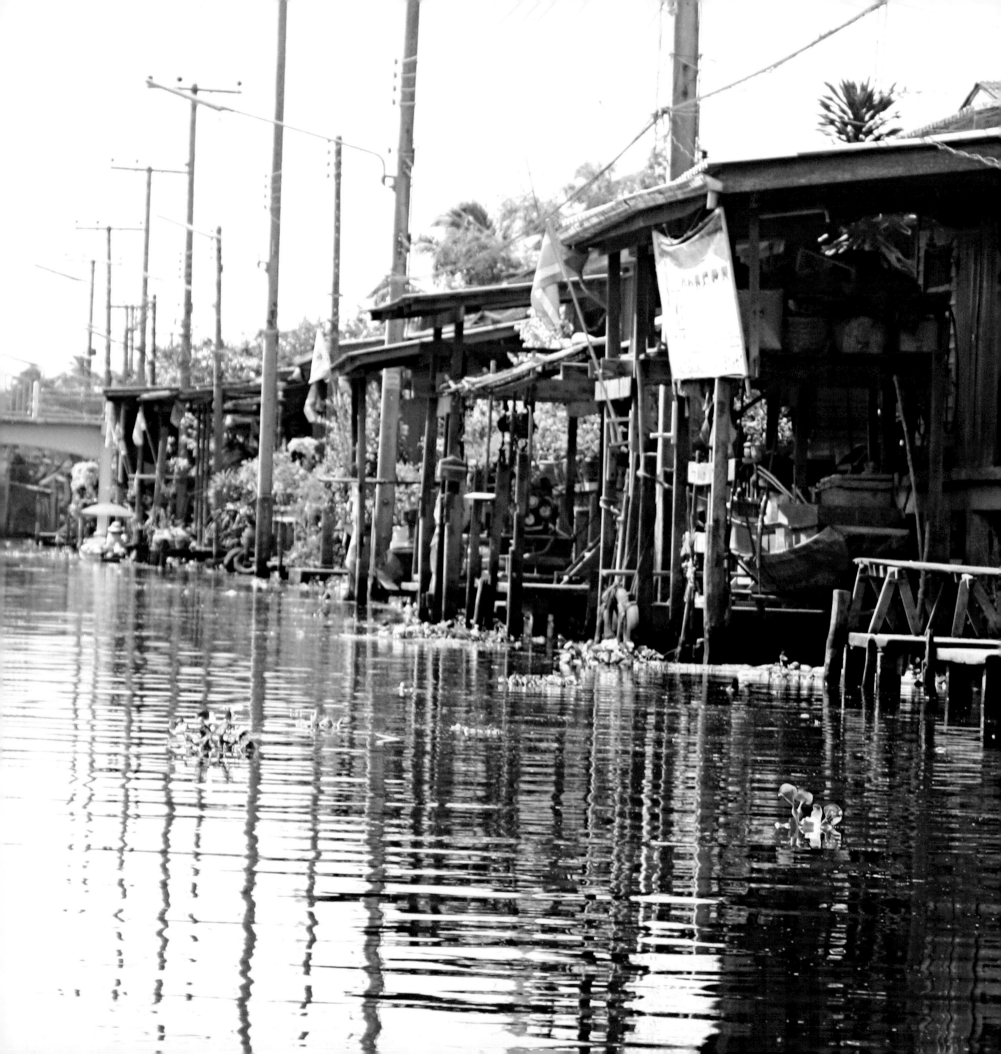

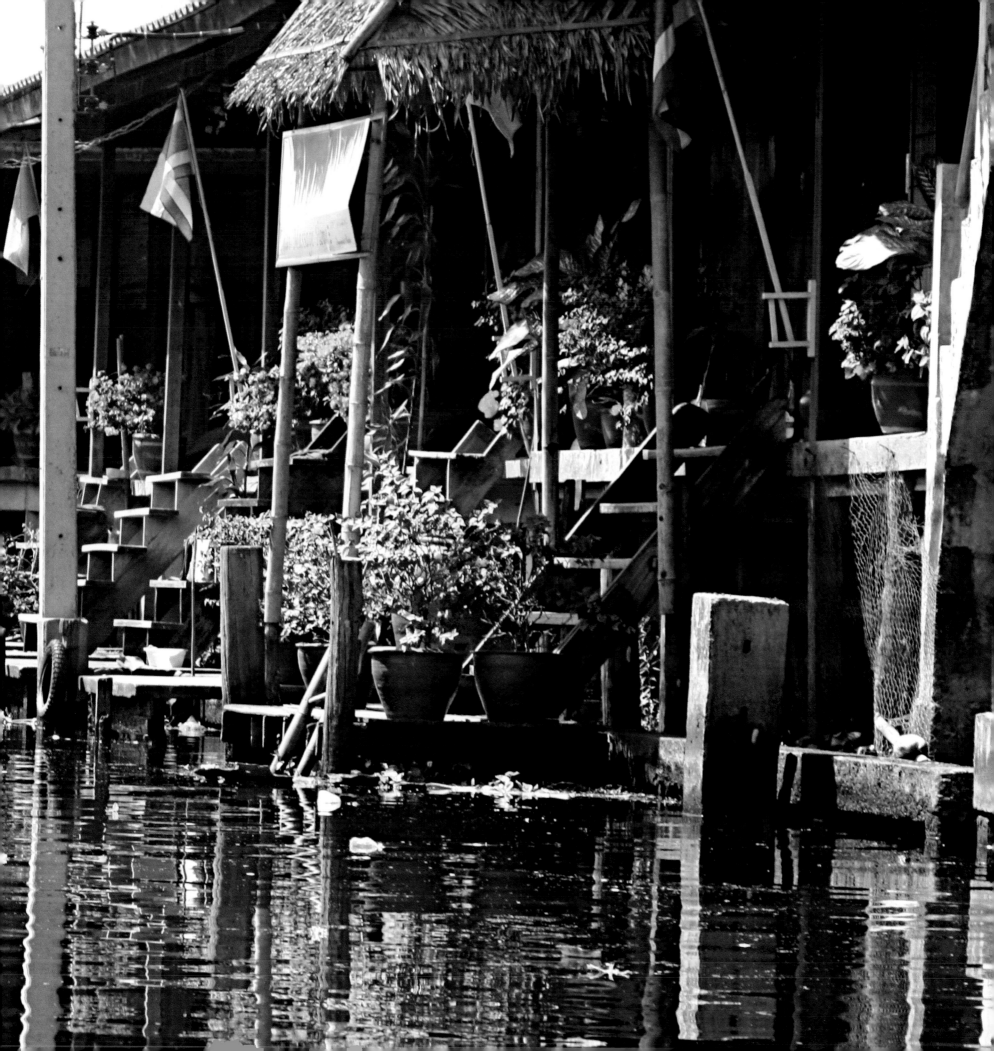

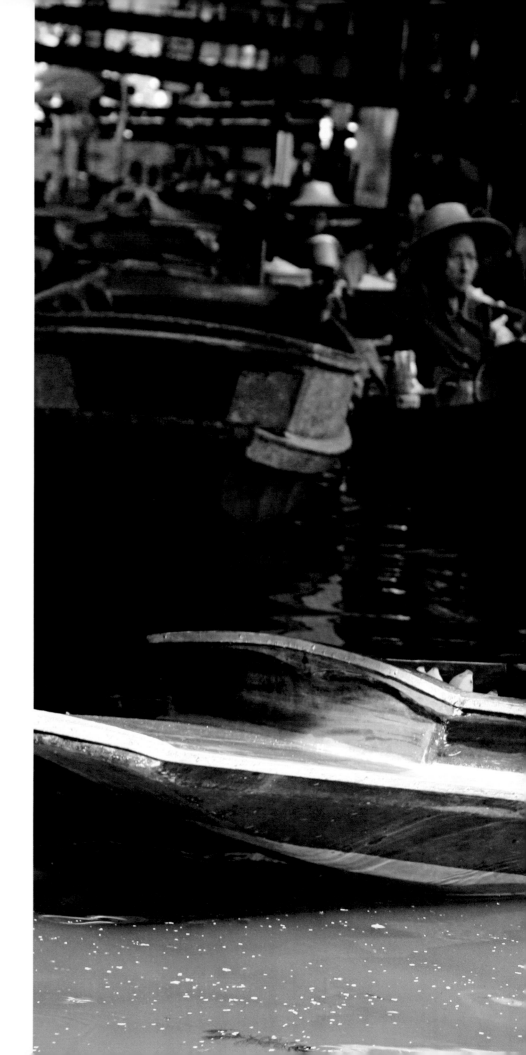

Waterway canal

Boats of coconut boats of grapefruit

Noodles cooking food frying

Pungent smell flowing waterway

Red house always likes my coconut

Gentleman at corner always buys three

Bigger boat of my friend sells many fish

Always fun bumping into friends

Exchange goods

Chat laugh

Onward

Sell more

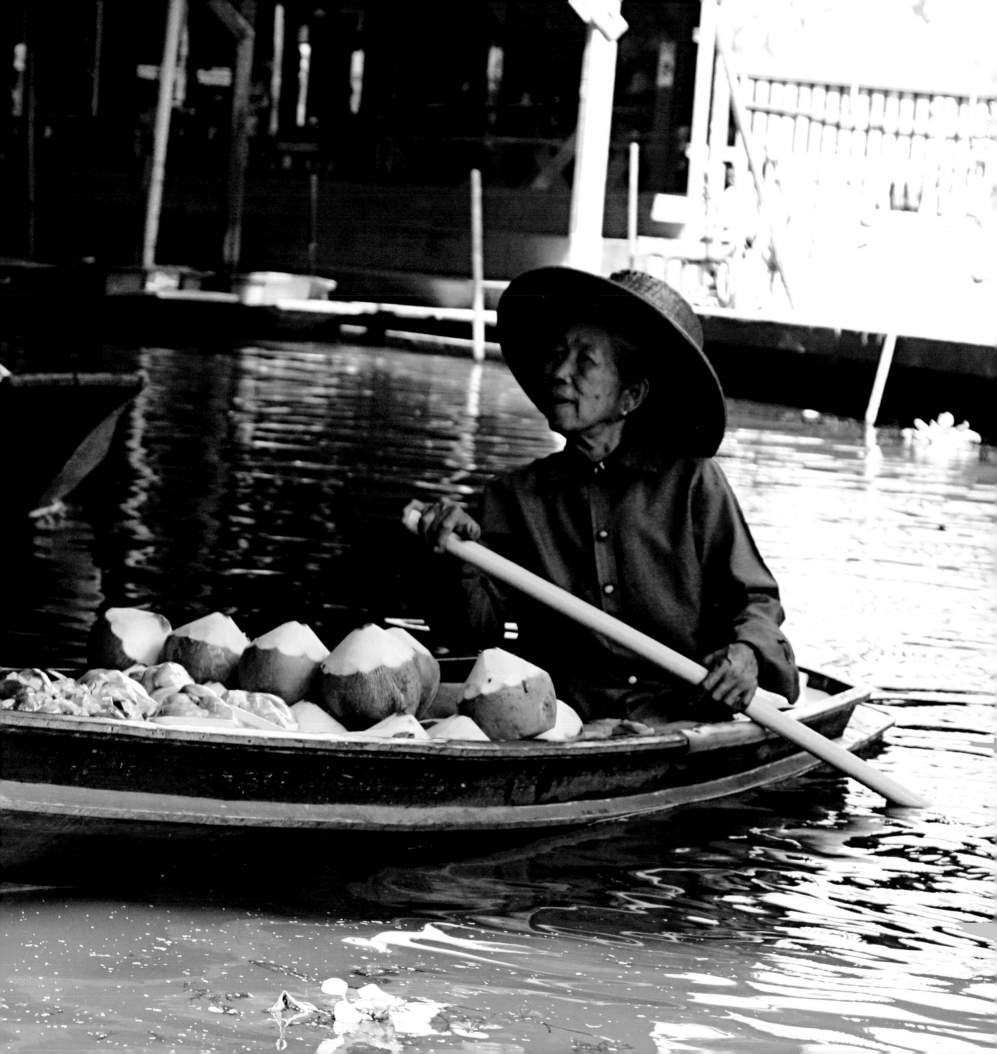

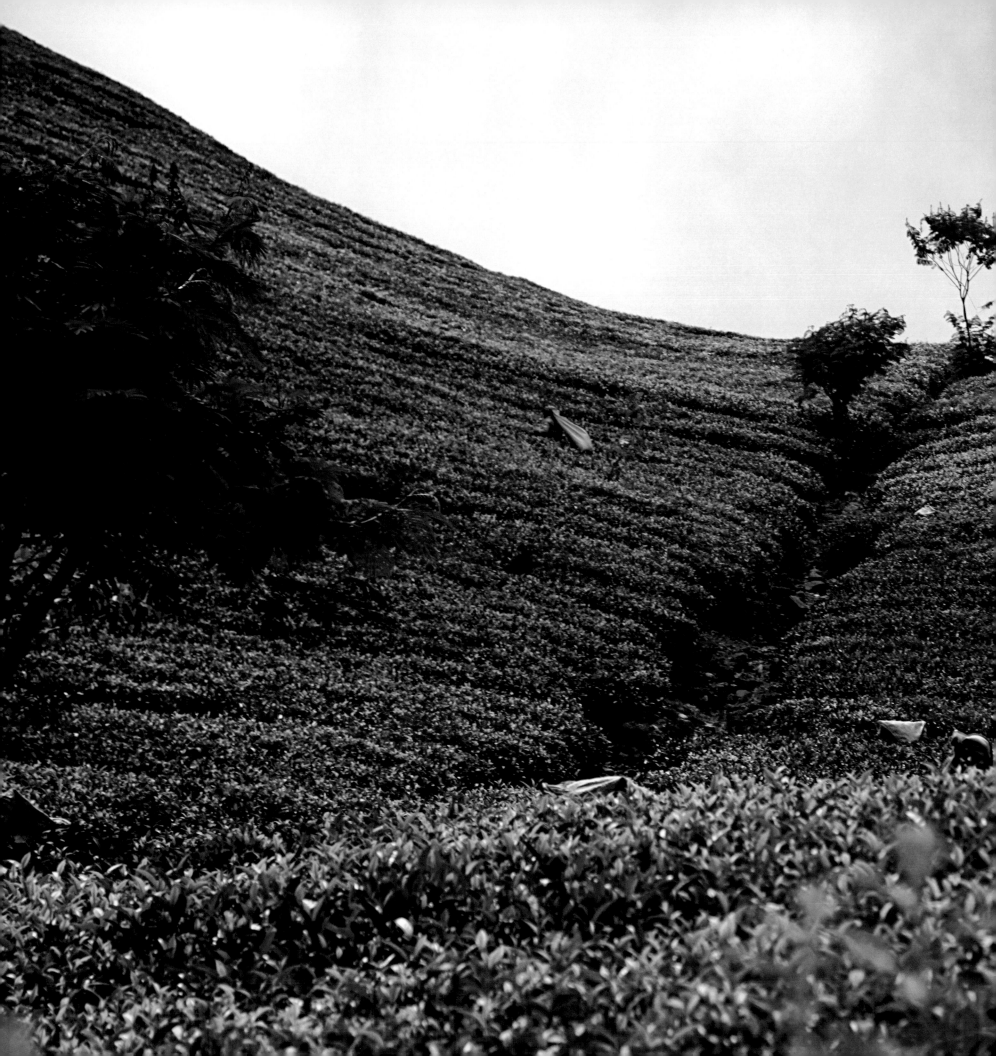

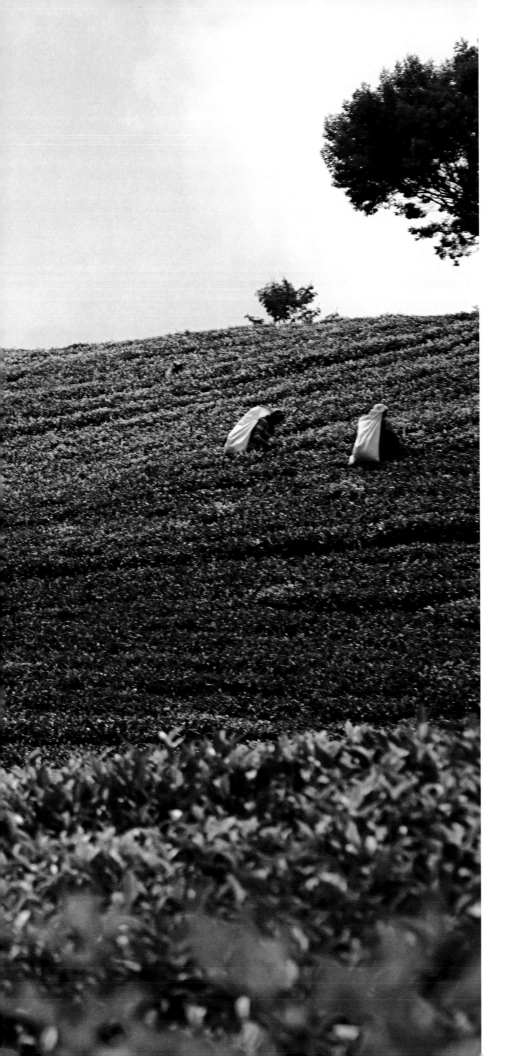

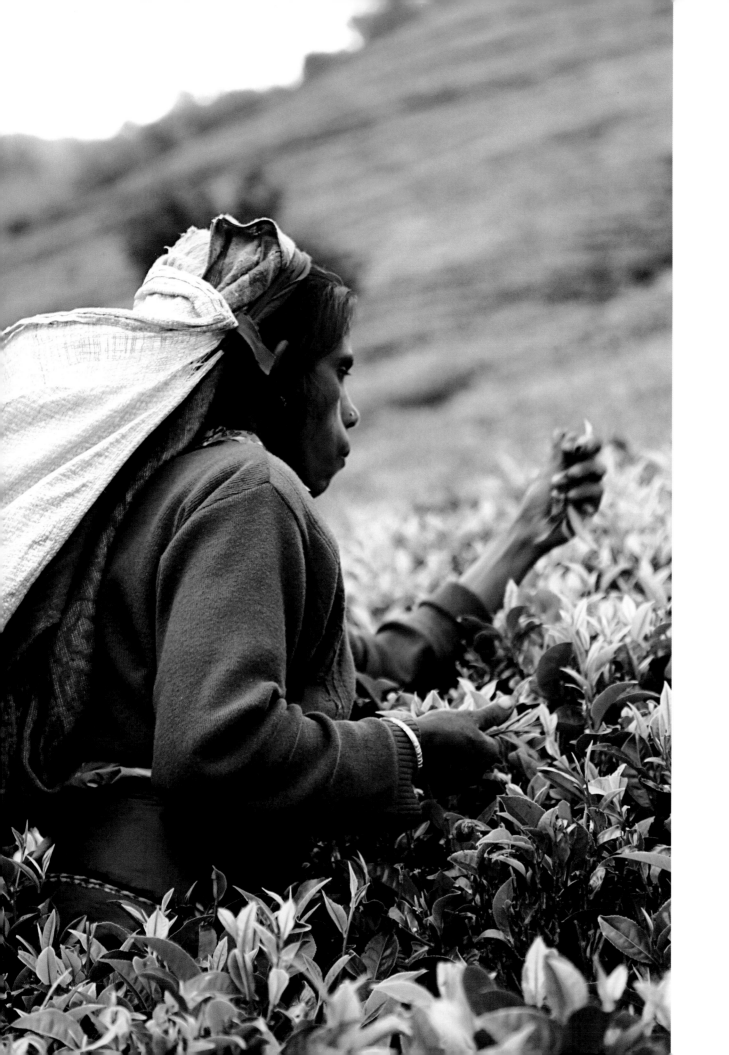

Tea garden tea field tea plantation

Whichever they are

Early spring green

midsummer green

early autumn green

Green layers wave

Move upwards downwards

To the skyline

Fast hands quick fingers

Fingertip to head bag

Repeat motions shadow the speed

Watch rolling films out of control

Bags of tea leaves fill the quota

Film ended

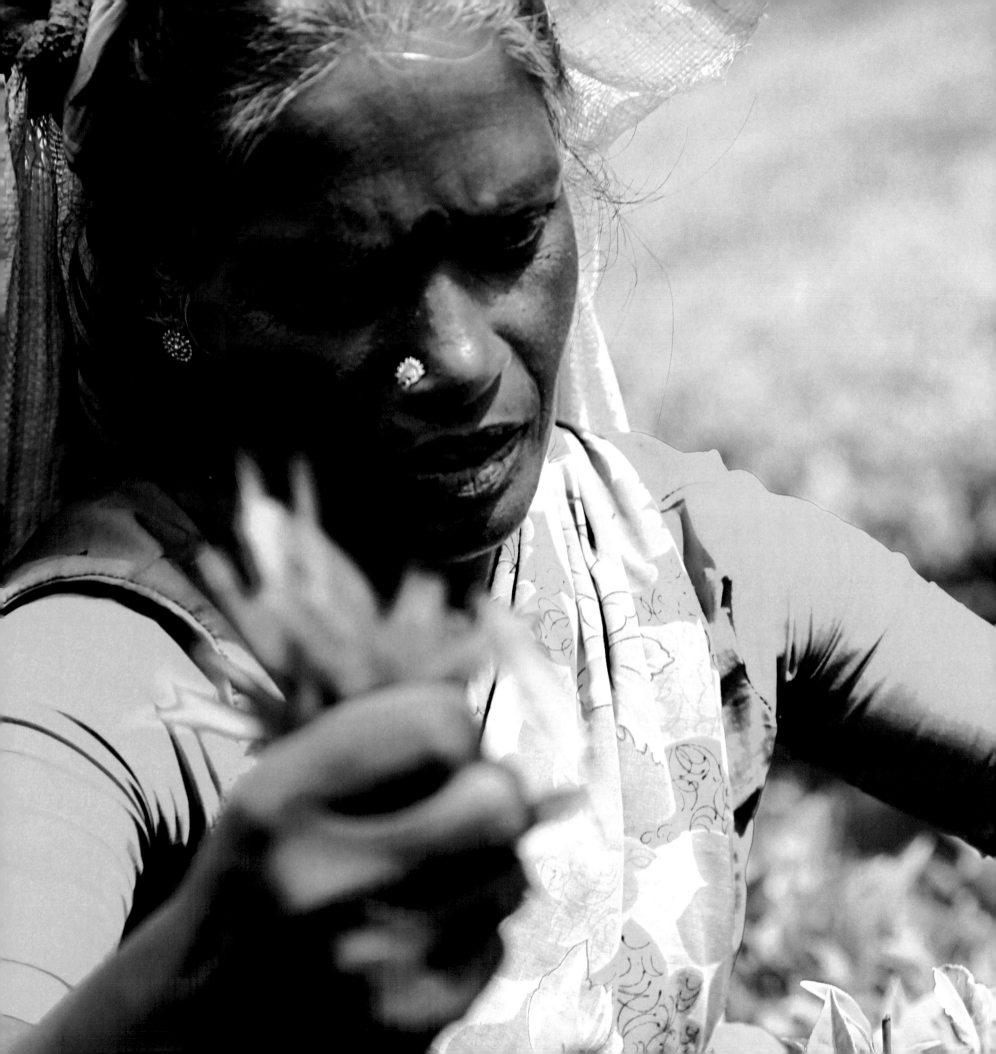

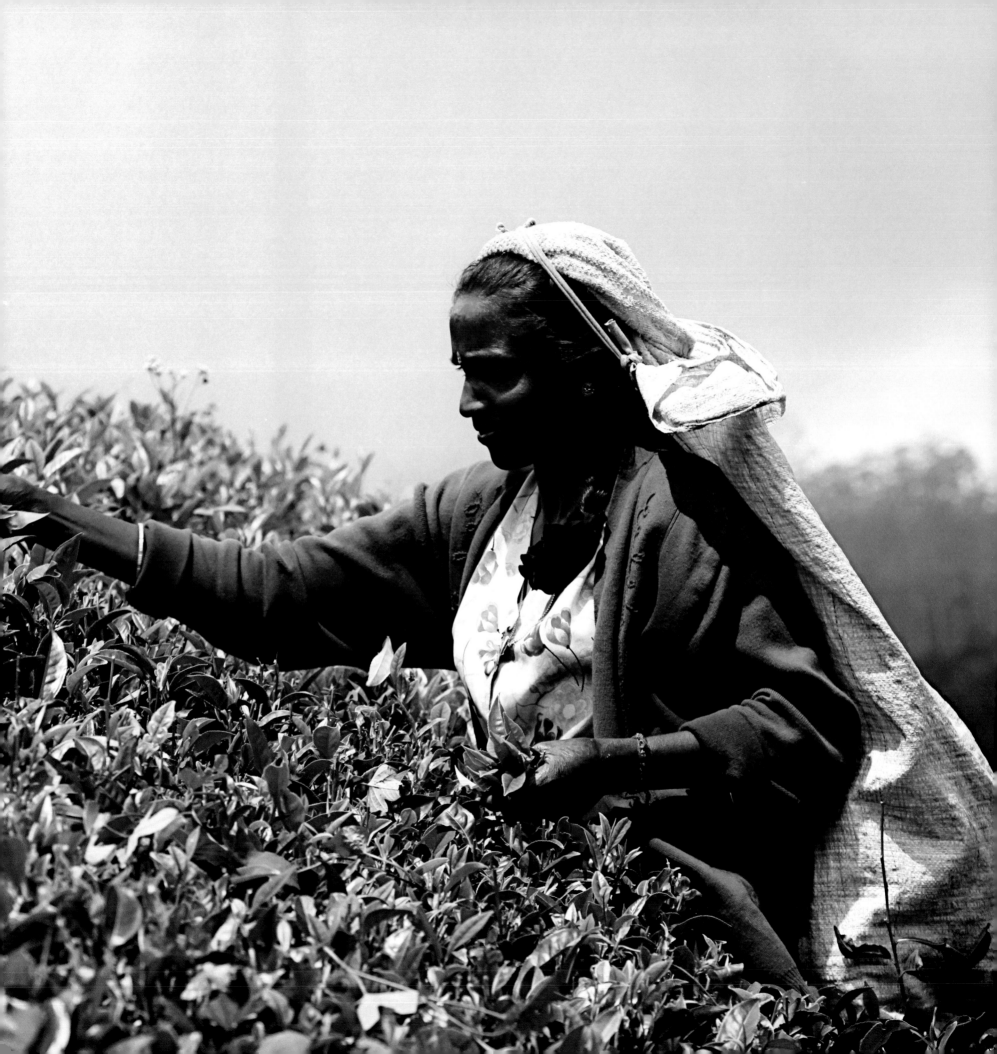

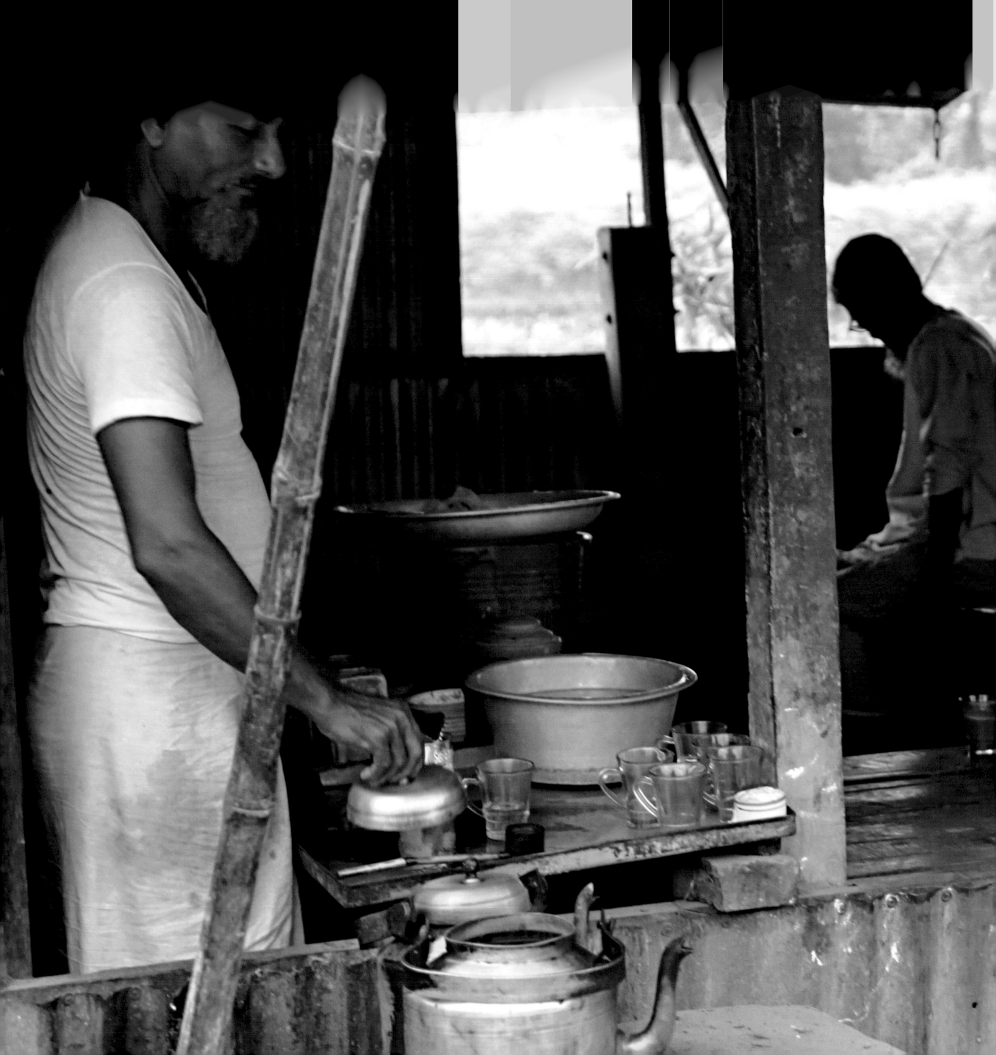

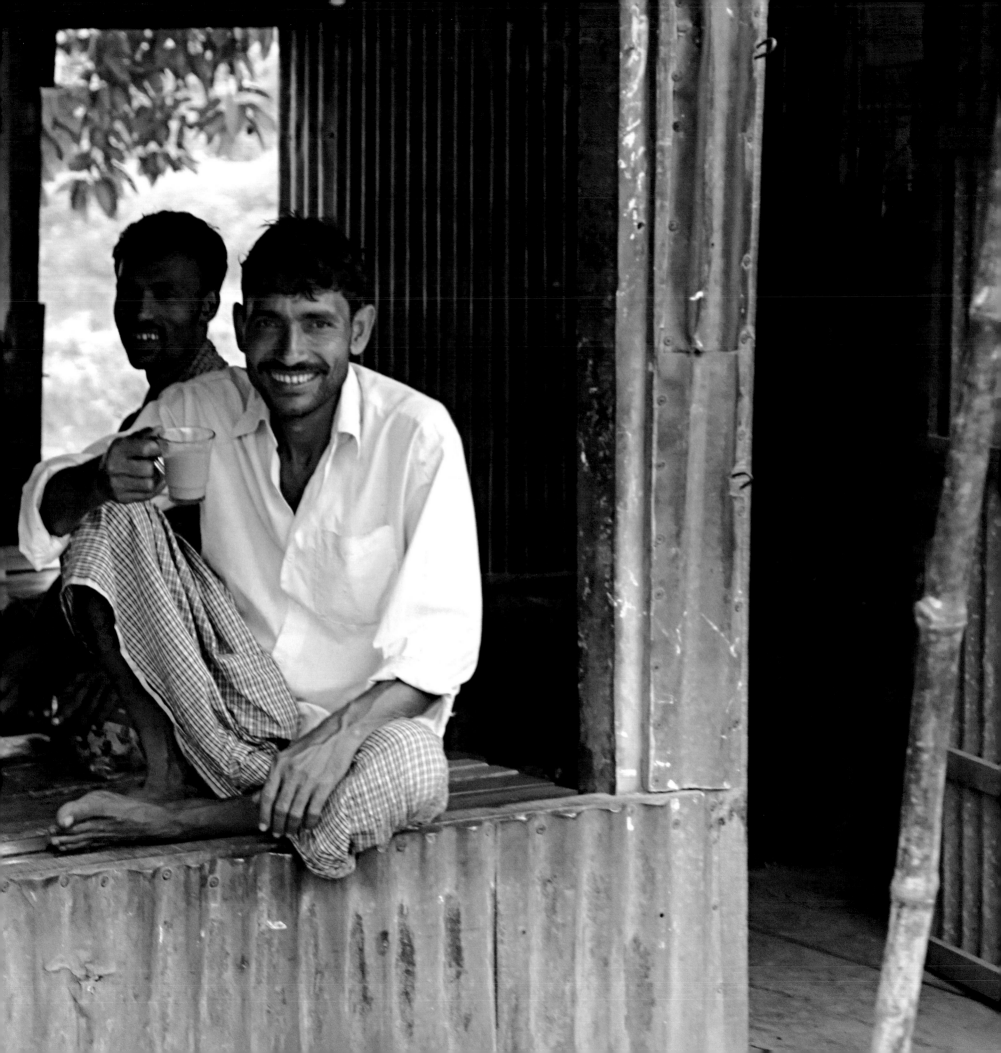

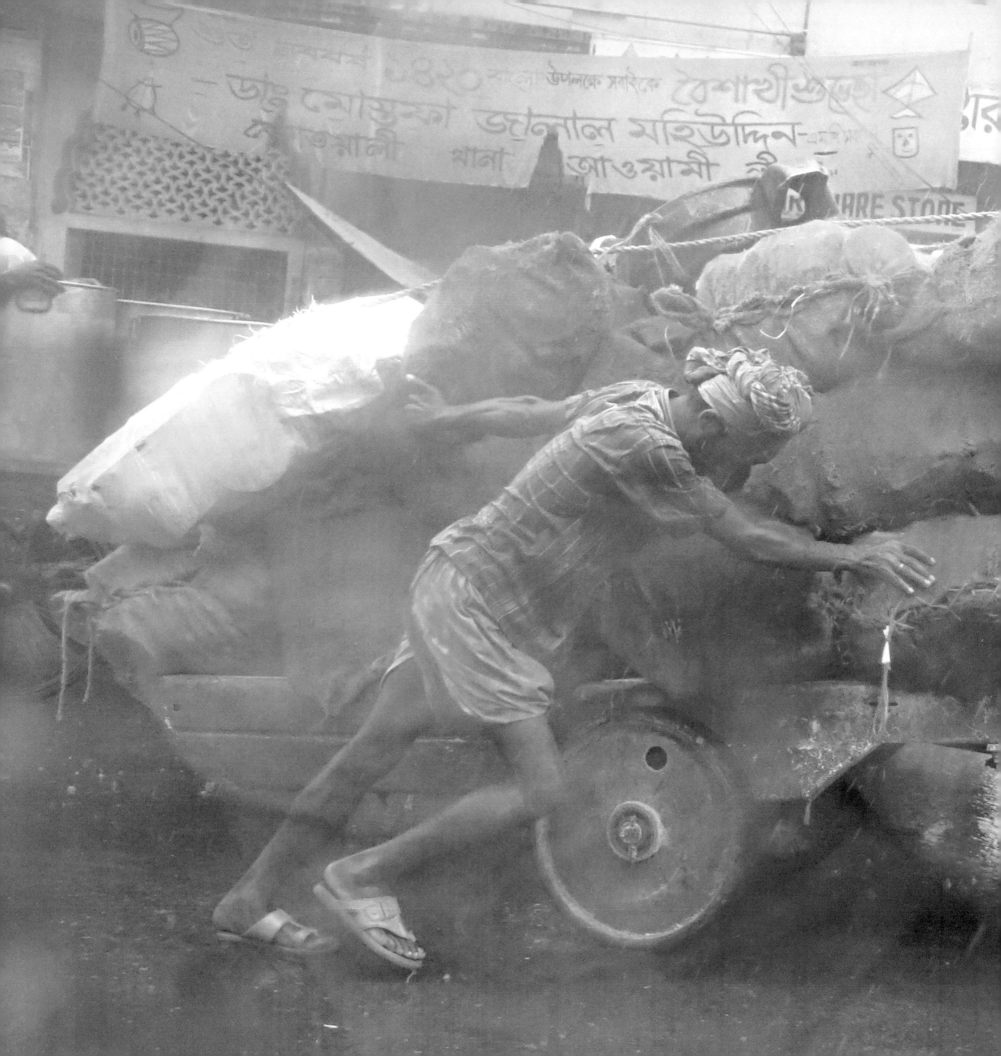

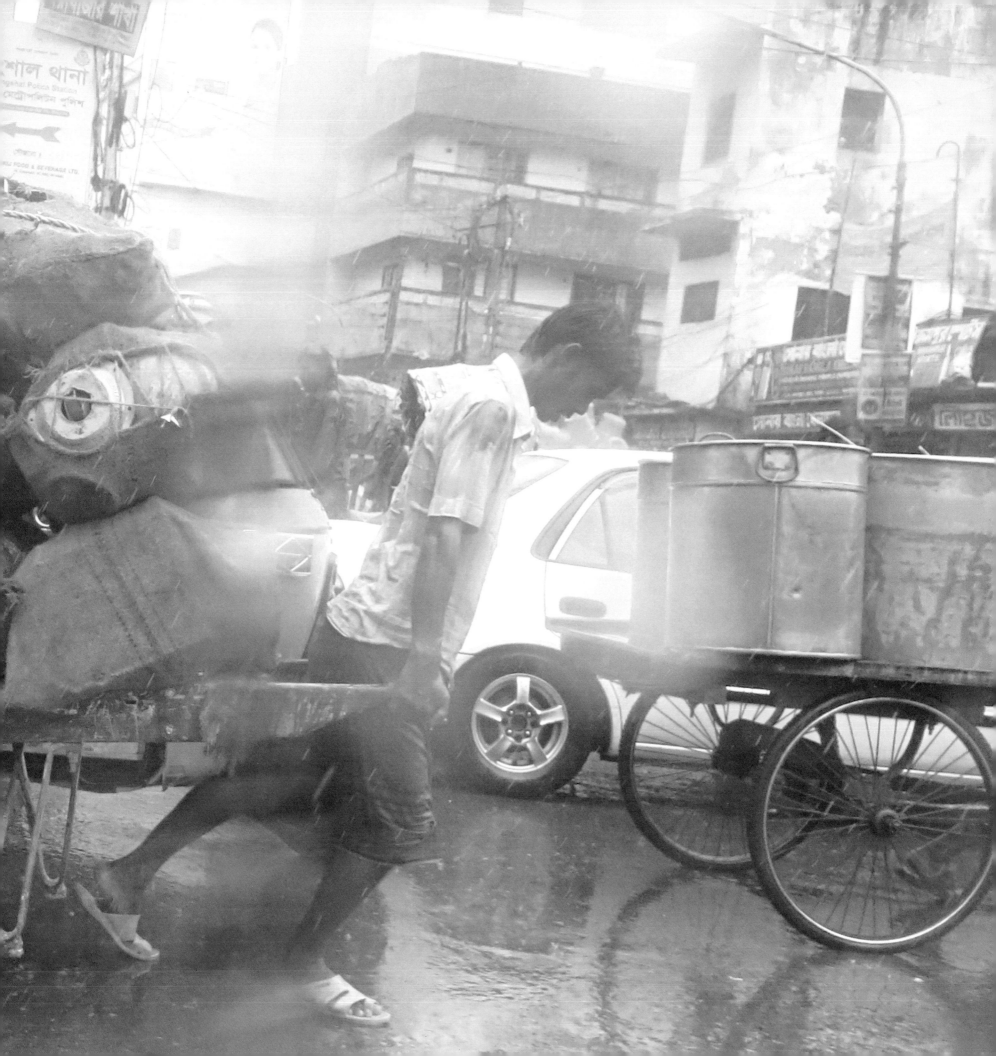

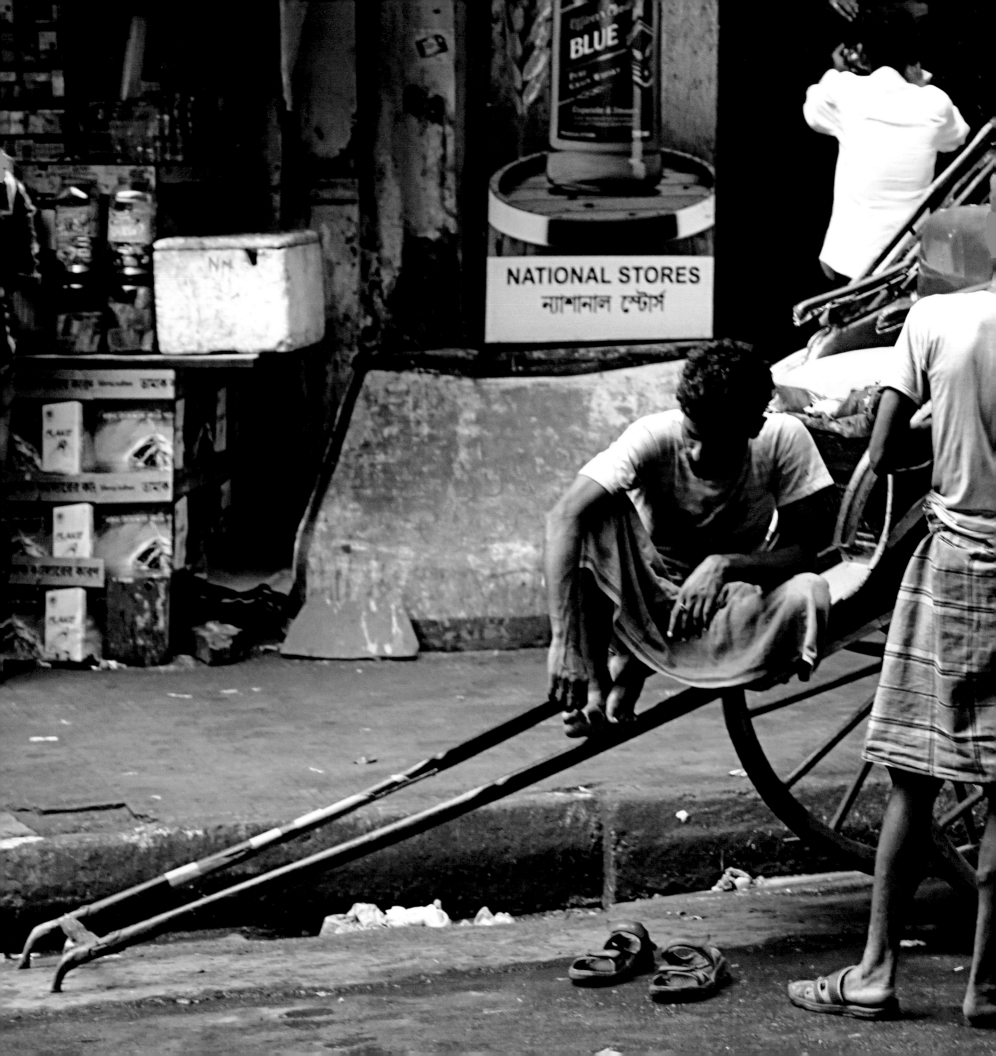

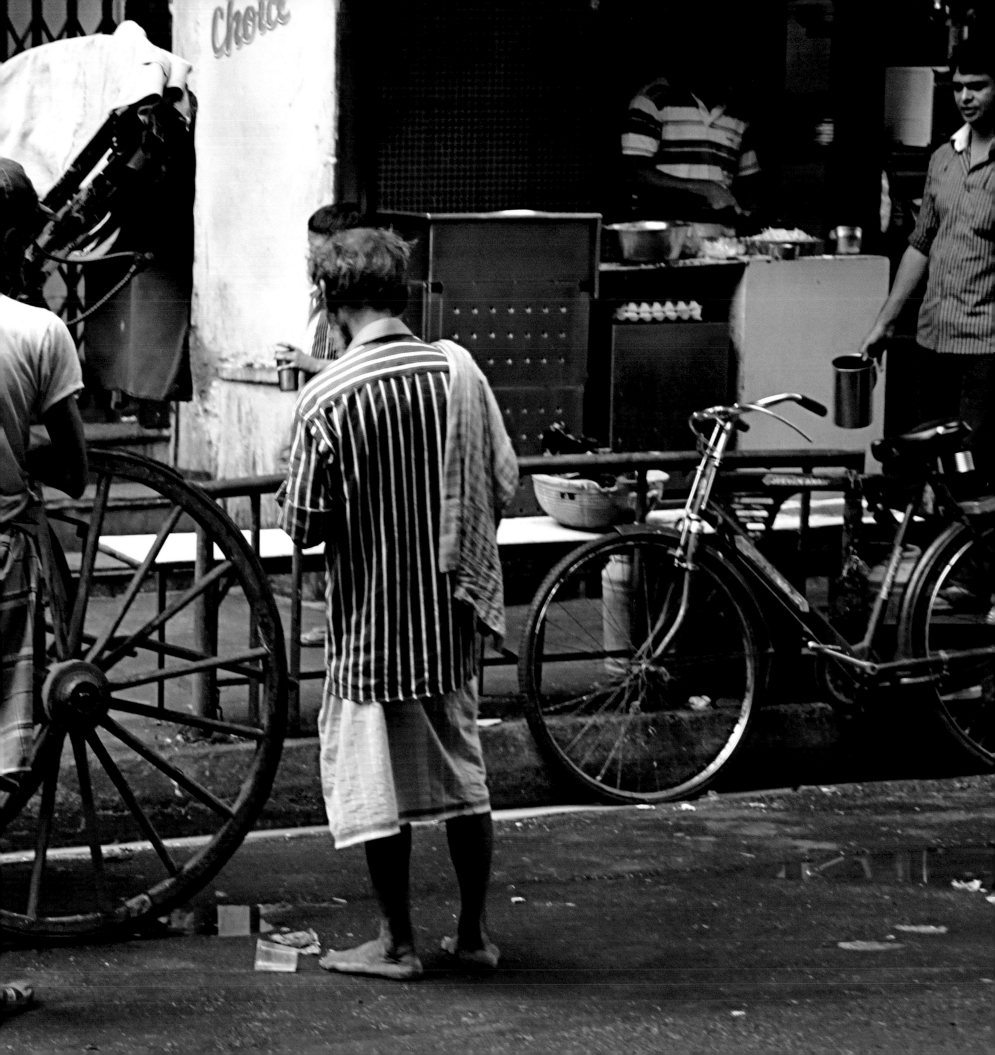

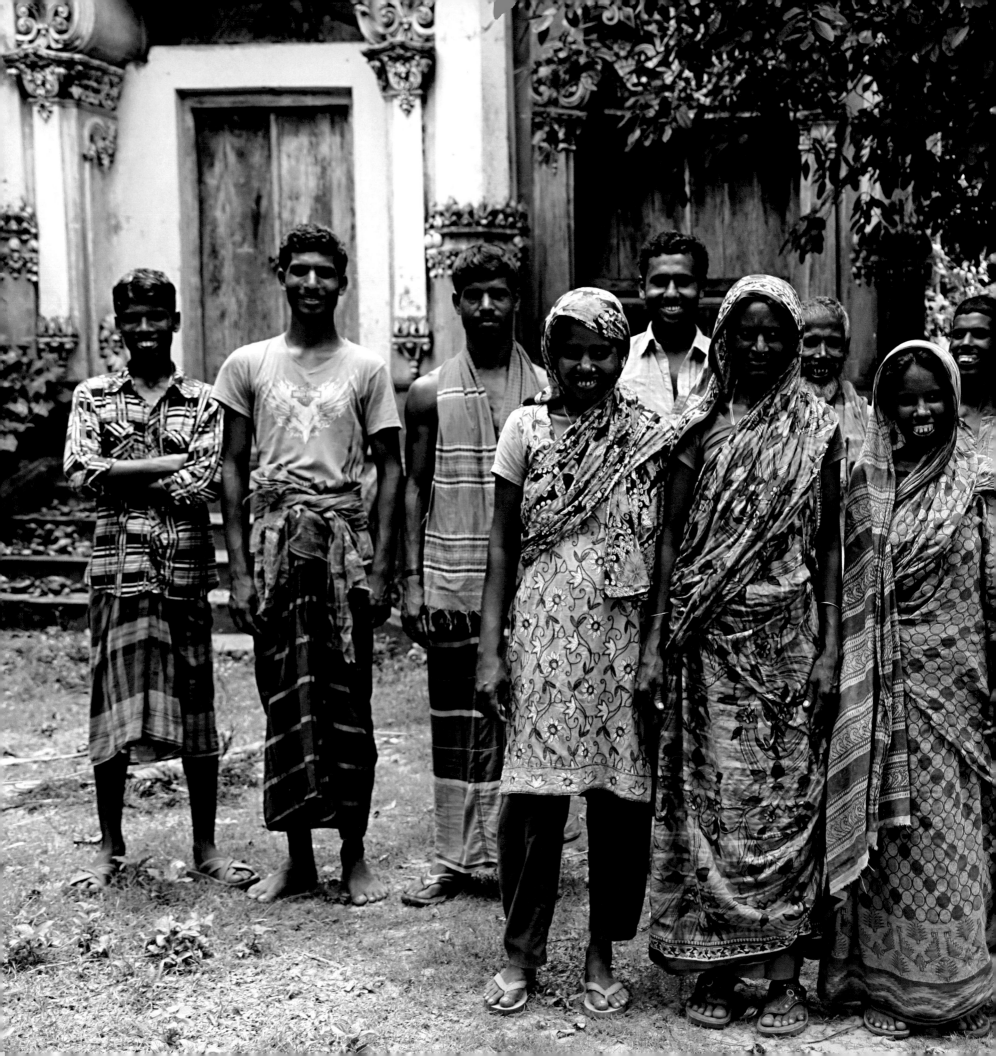

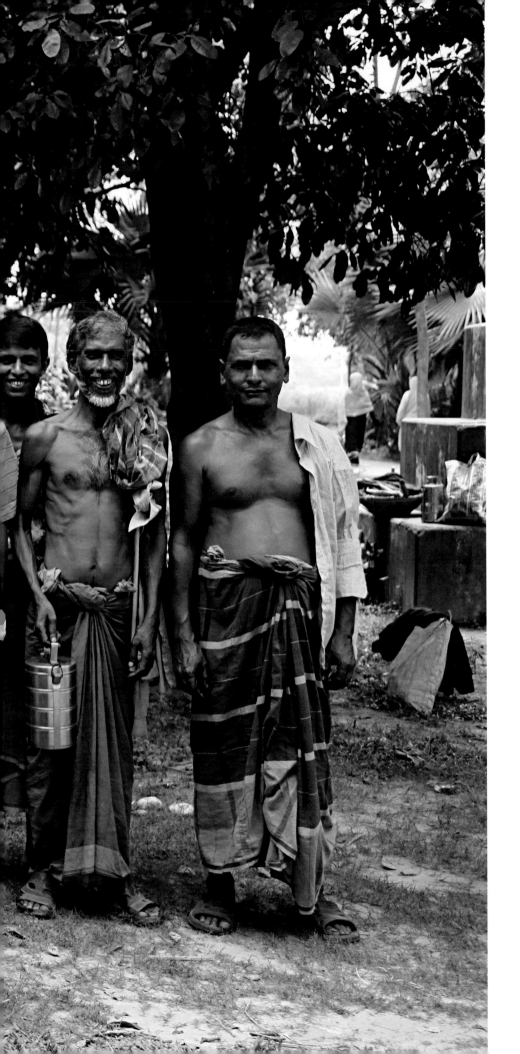

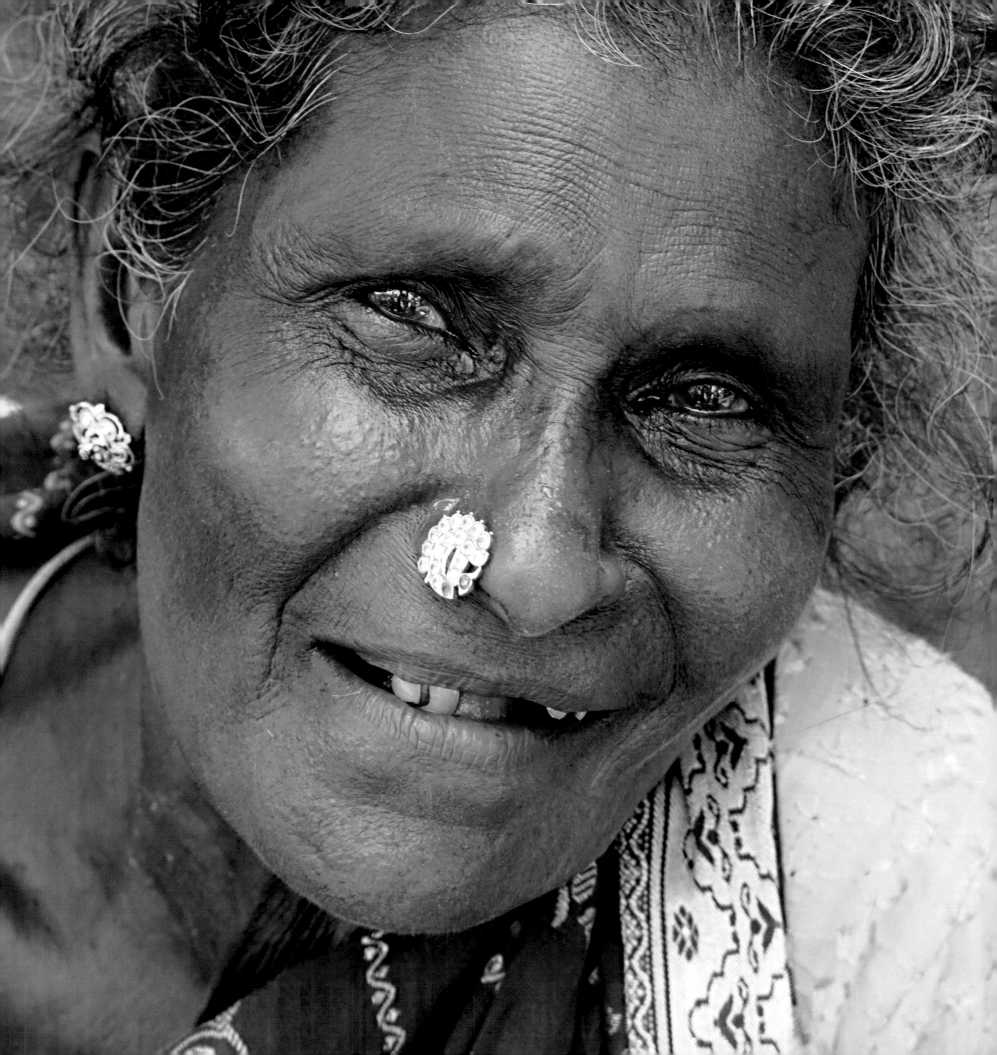

Where did the time go

Youth passed me by without any trace

Playmate at those happy times gone forever

All I have left bits and pieces faded pictures

Yellow fuzzy still warm in my hand

Almost remember what we said why we laughed

Don't move as well easily fall behind

Unknown aches any given moment

A new stage of life hearing the curtain call

Even still a sense of loss

A palace

A rich man's house

Long long ago

Surrounded by okra fields

Beautiful long leaves

Brilliant yellow flowers

You appeared

Your smile your presence

Without a word

Came from the field

Faded into the field

Where did you come from

Where did you go

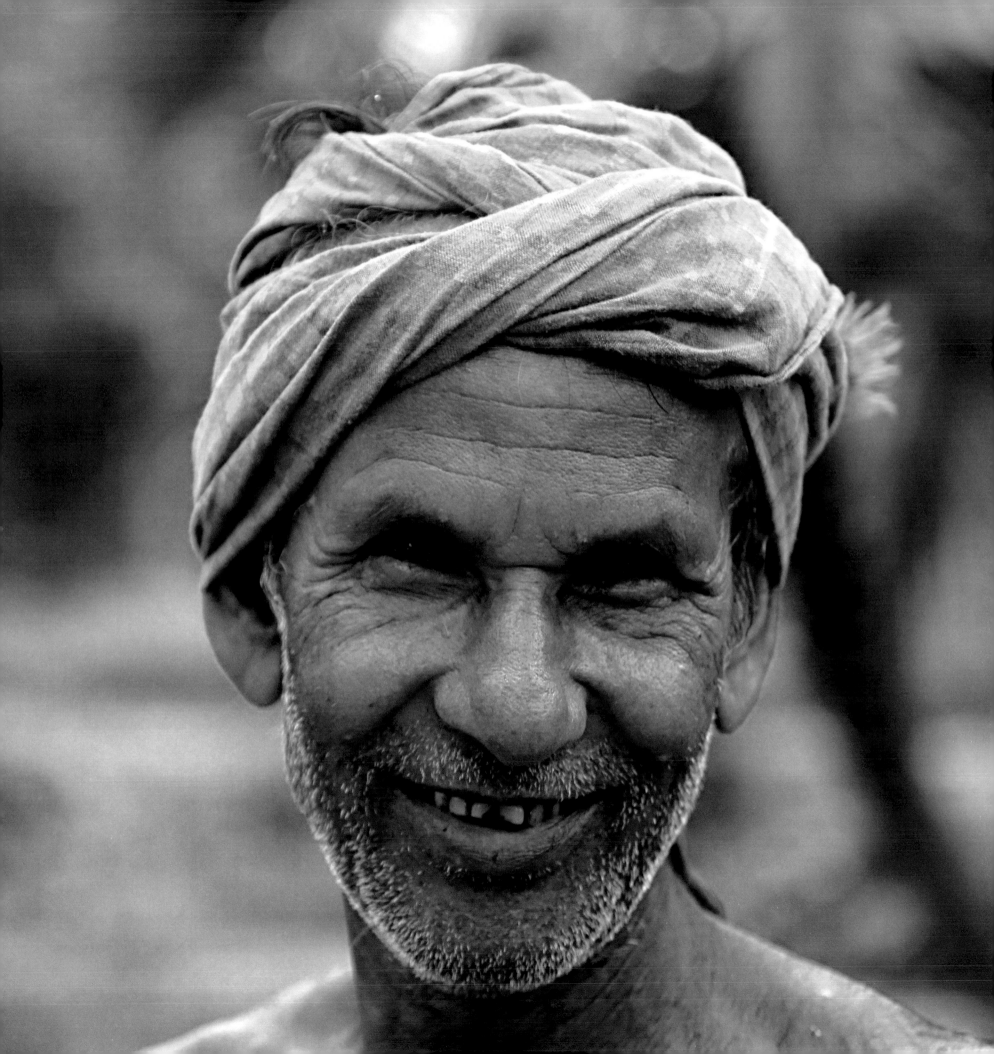

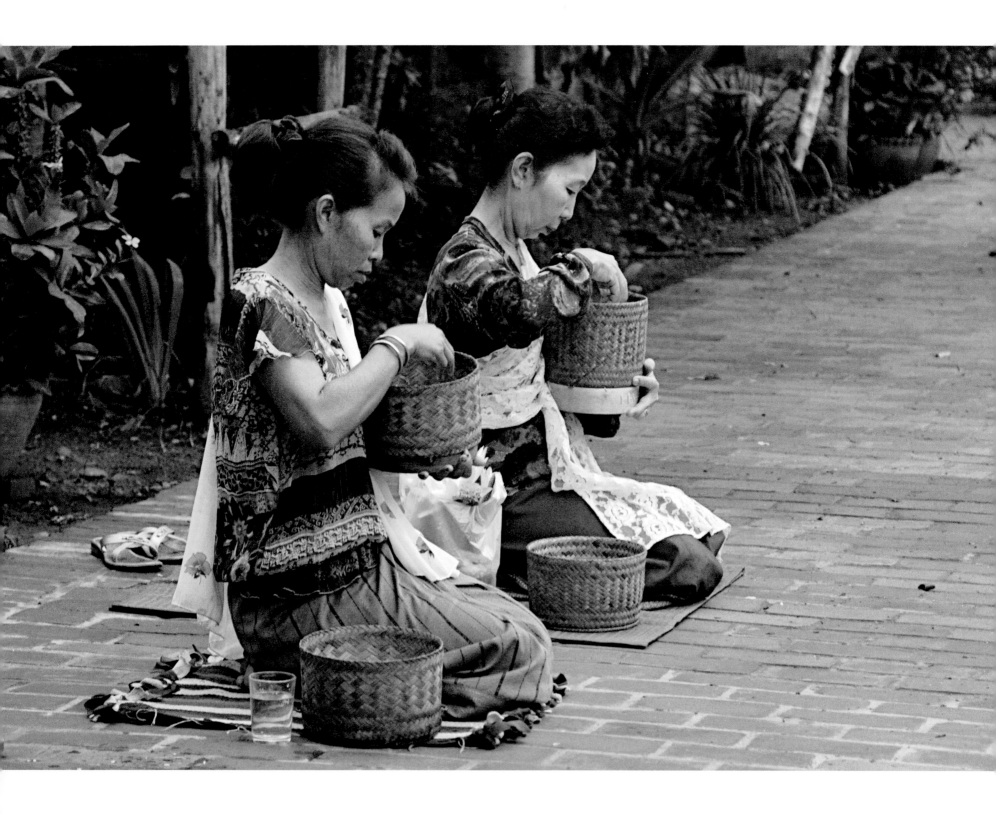

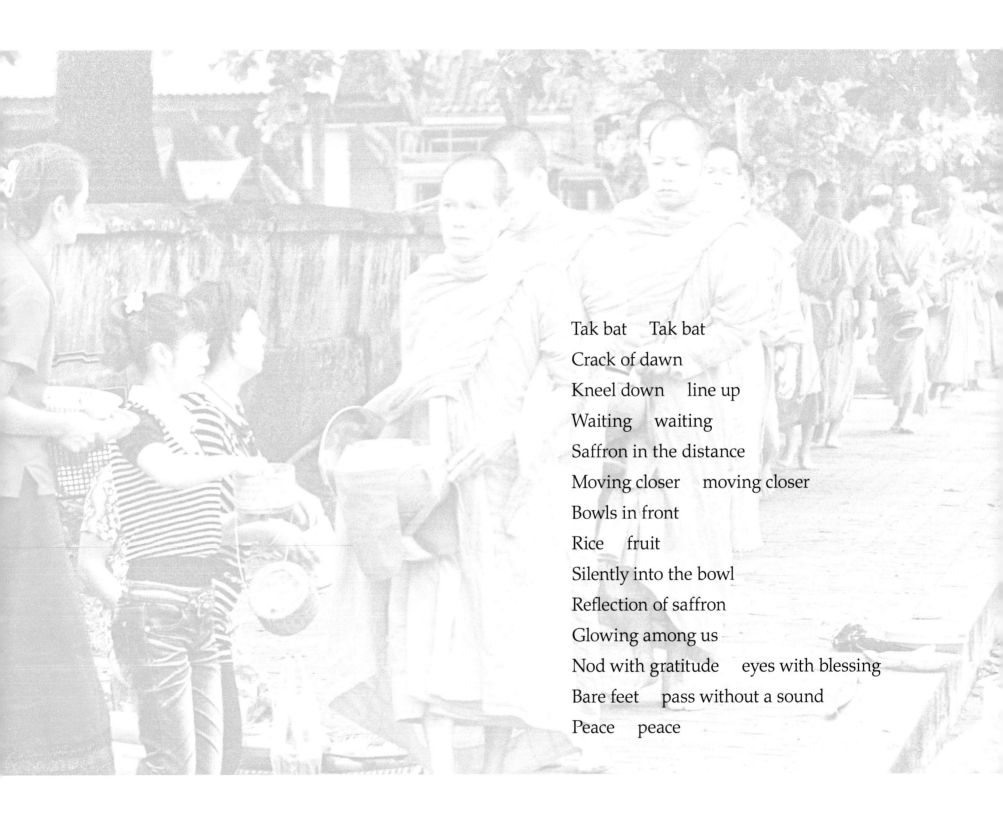

Tak bat Tak bat
Crack of dawn
Kneel down line up
Waiting waiting
Saffron in the distance
Moving closer moving closer
Bowls in front
Rice fruit
Silently into the bowl
Reflection of saffron
Glowing among us
Nod with gratitude eyes with blessing
Bare feet pass without a sound
Peace peace

Longing yearning

Not knowing where you are

You were with me sometime ago

Good time sweet time

Watched you talk watched you laugh

Still remember vivid moments

You wanted to see the world

But you were so young so tender

Wish time would go back

Relive the moment

But . . .

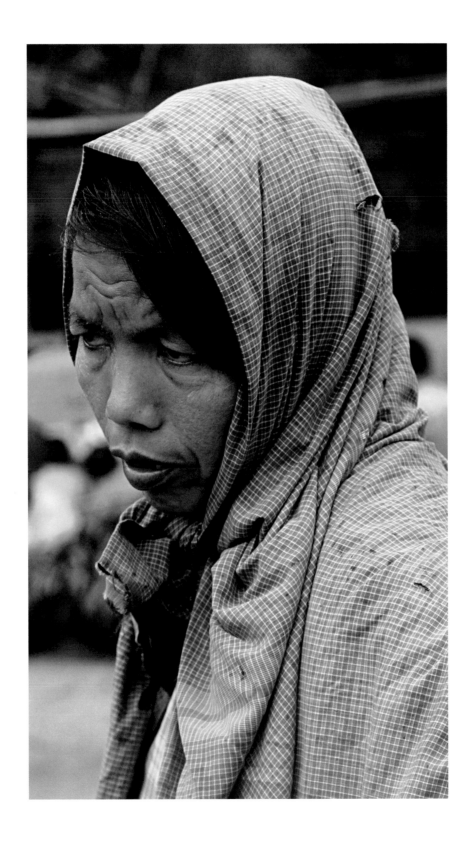

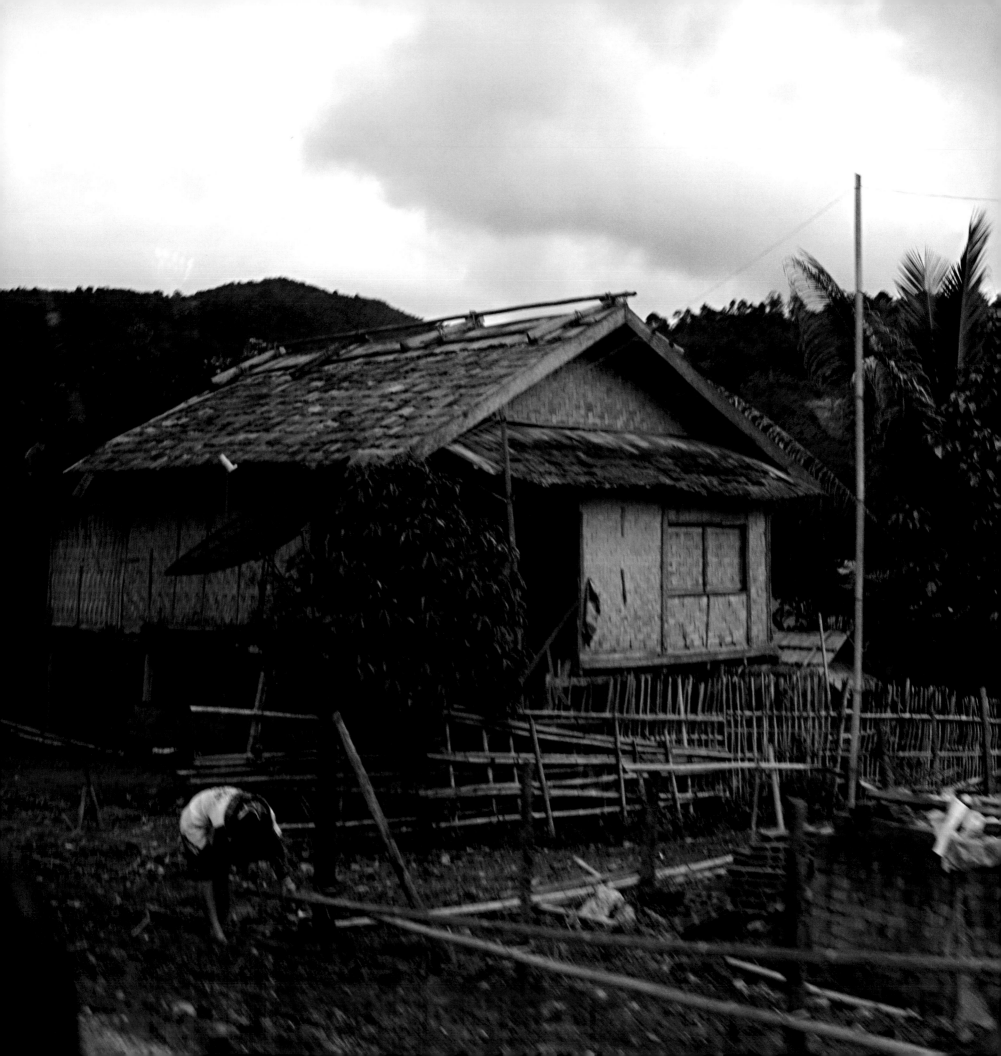

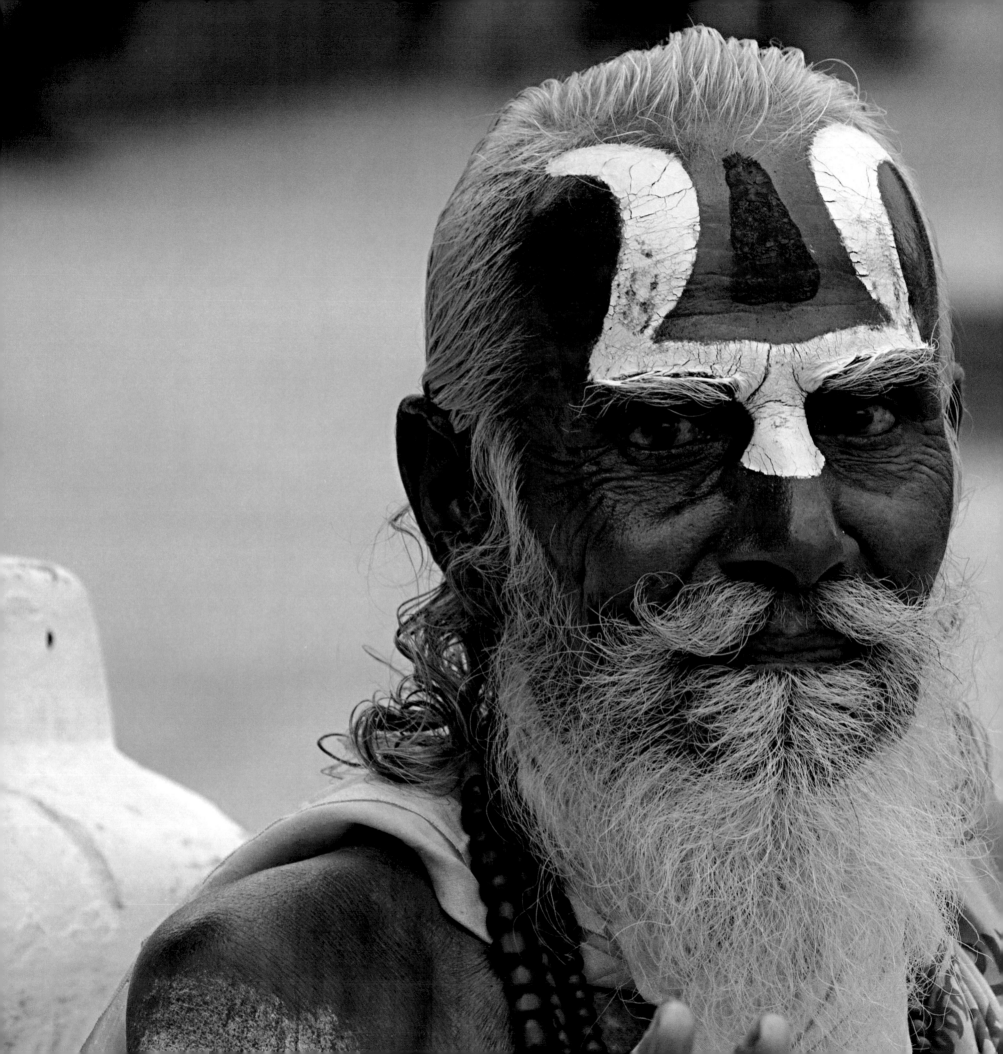

Teachers lawyers medicine men

Fortune tellers politicians actors

Face made up

Dressed up

Emotions worked up

Soft kind angry

Excited crying laughing

Hiding showing lying

End of day end of time

We're all the same

The difference

Can you find yourself

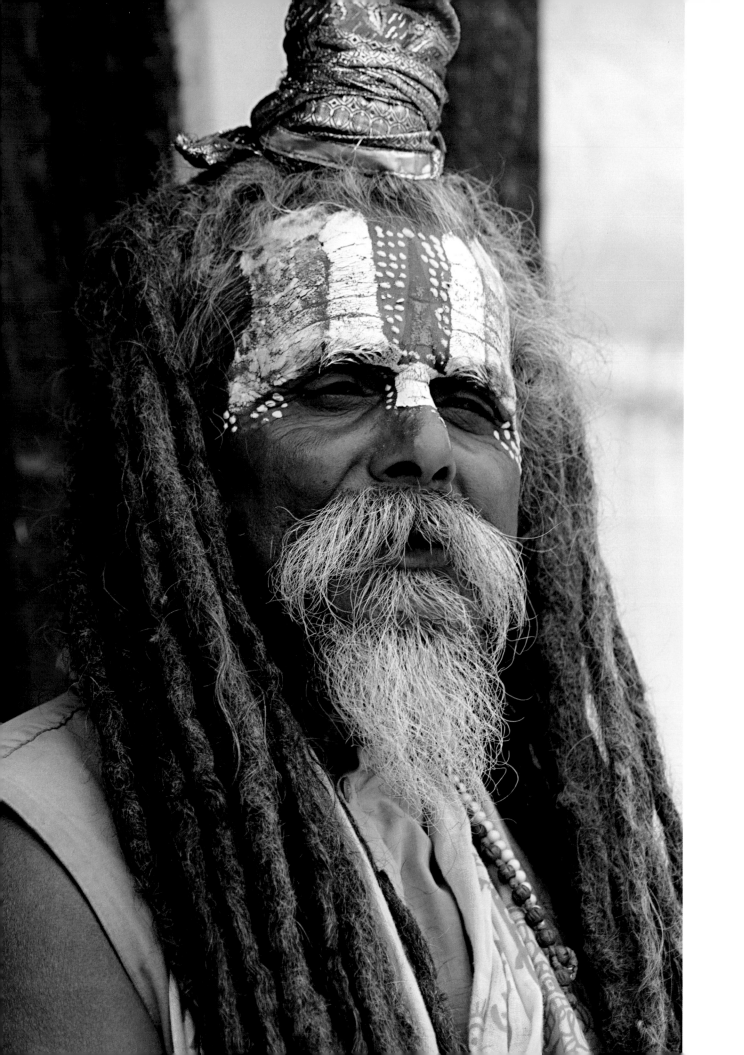

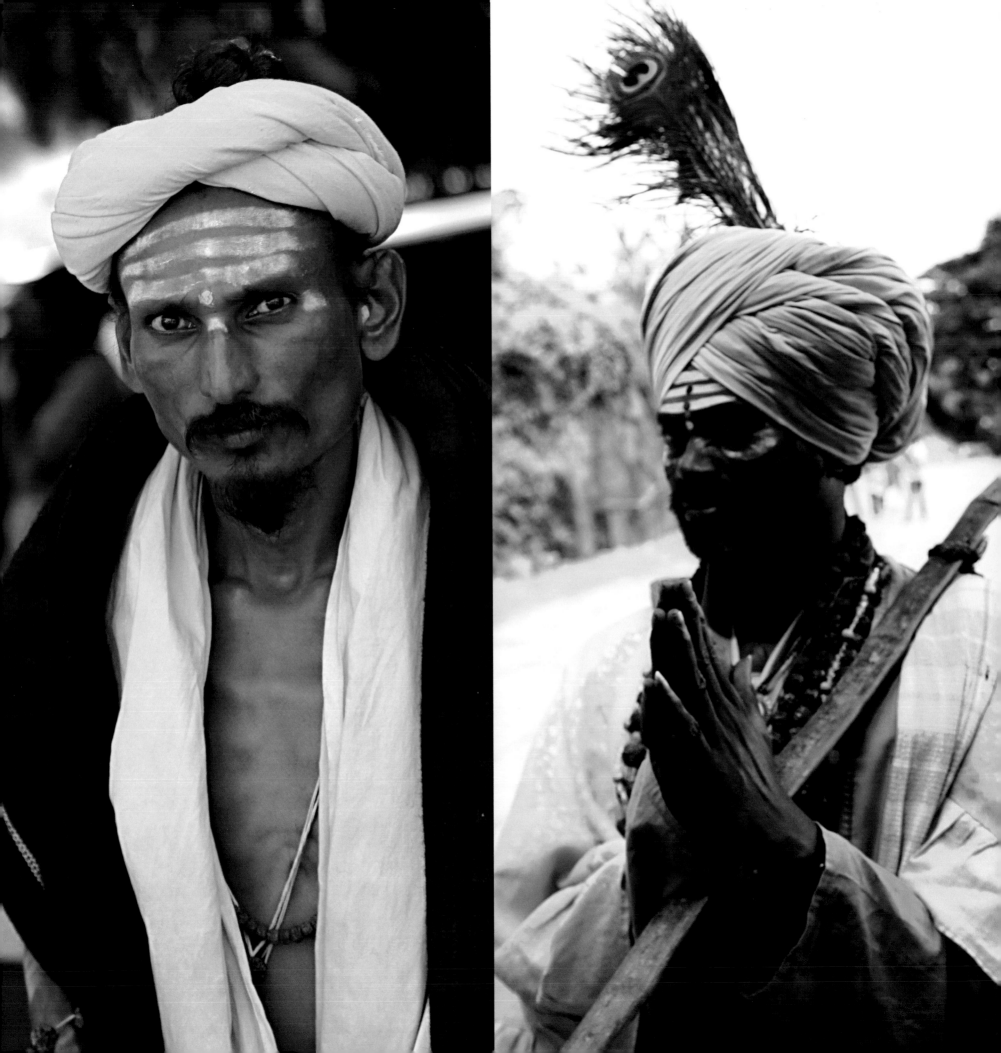

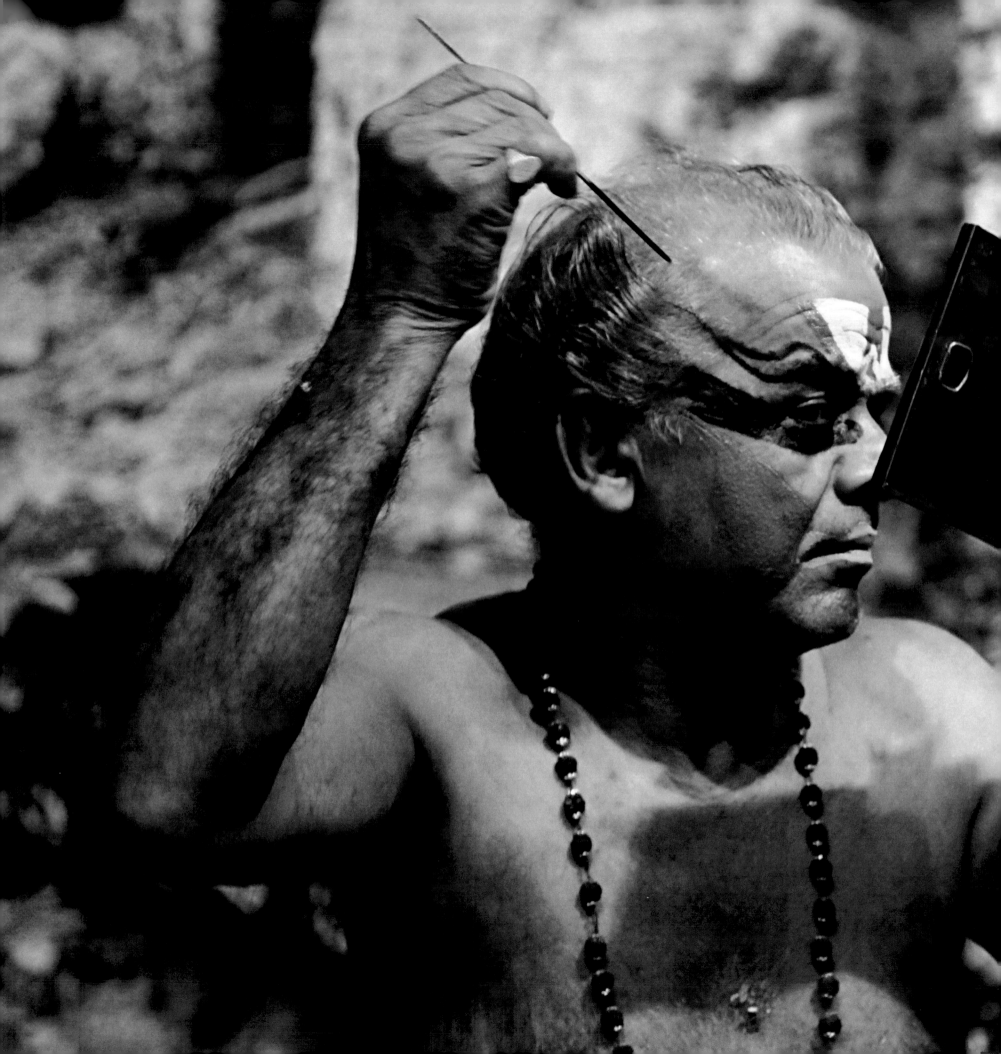

SURREAL

Sad or happy, how did I get here

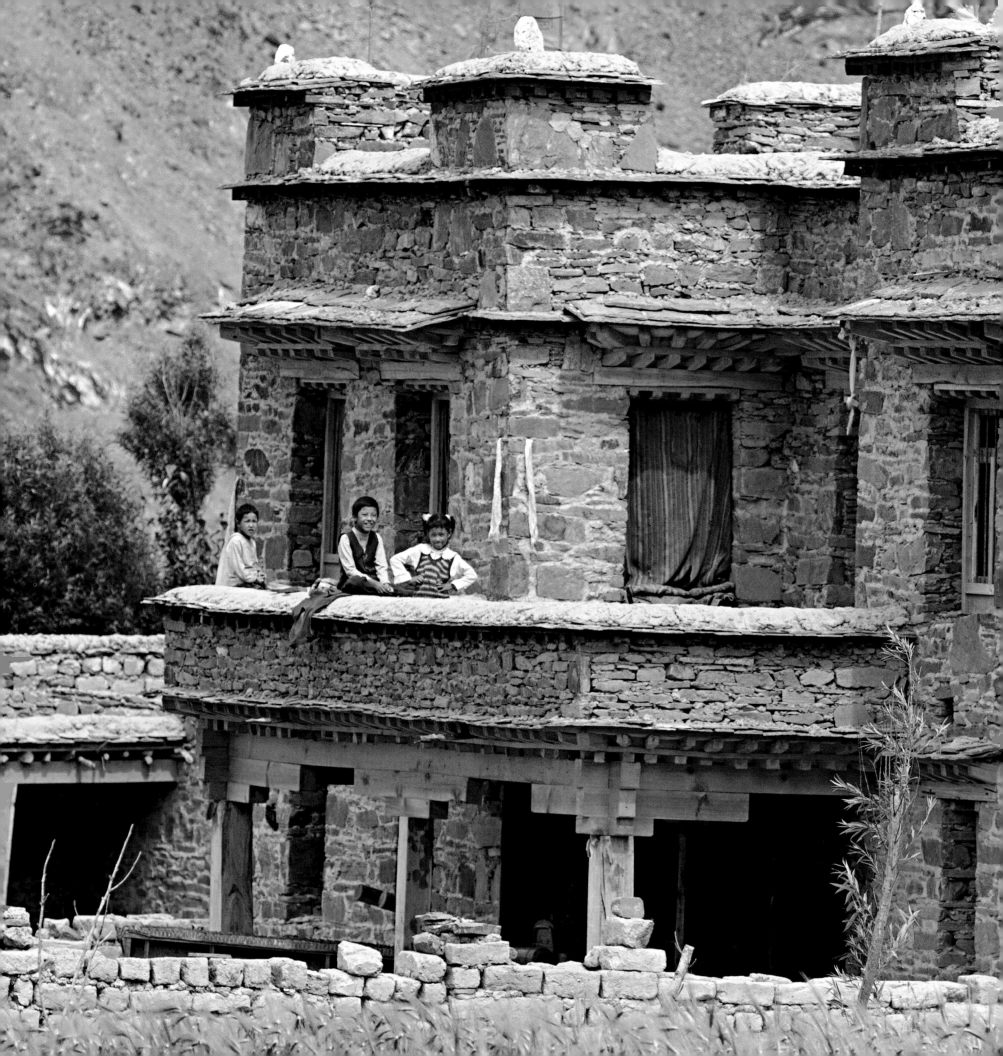

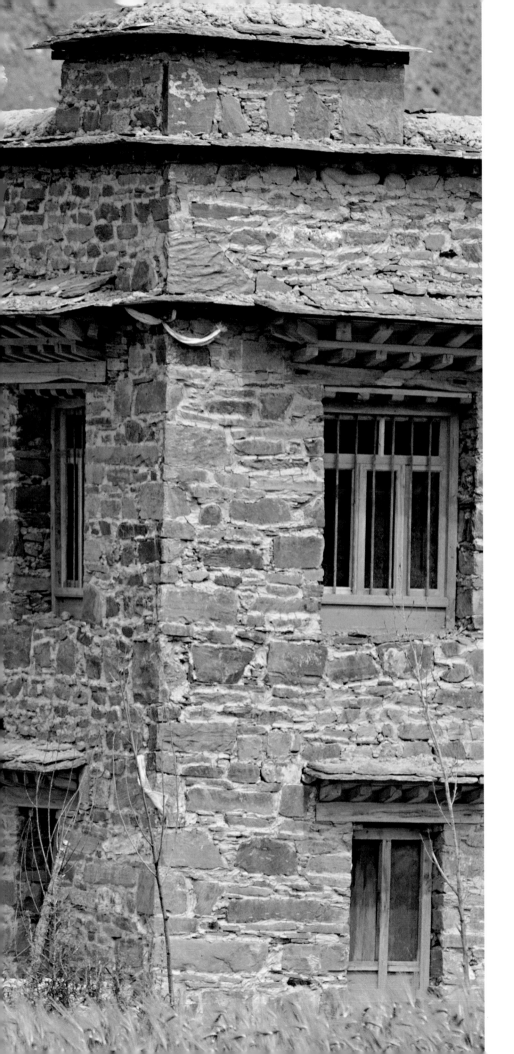

Smile eyes with many words

Sense of style strongly present

Headpiece proportionally composed

No one can create it again

The one the only

You still shy as sixty years ago

Flip the page you only fifteen

Each movement an extension of fifteen

Age only you can define

Life only you can live

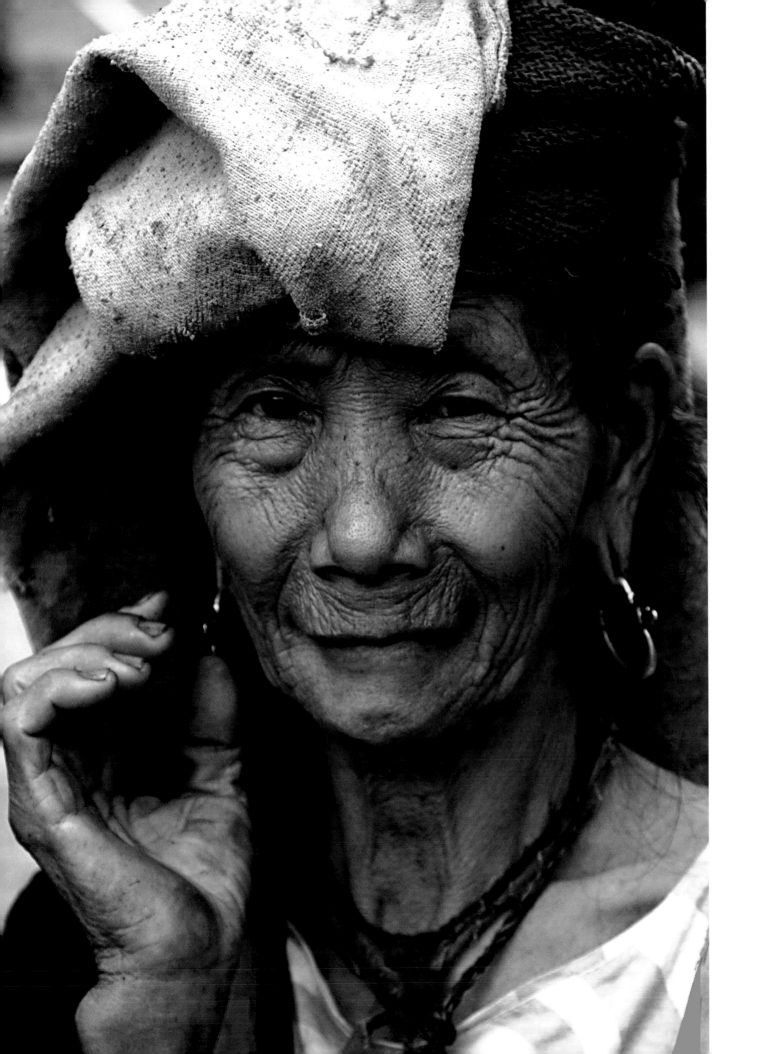

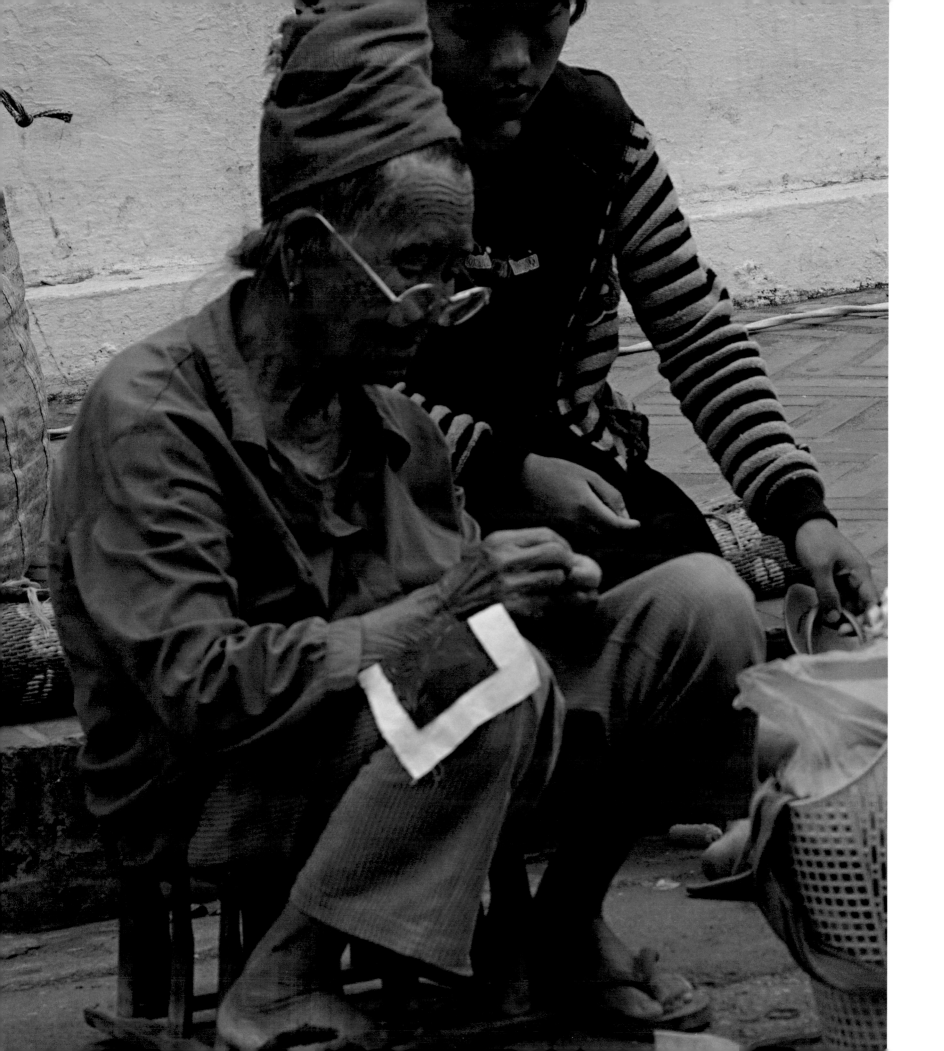

Mother taught me to thread a needle

Mother taught me to color with embroidery

Not hard to use needle not hard to use color thread

Once started be consistent be tight

No gap no rest no skip

Fifty years later I can teach the same

More you do faster you are

Persistence persistence

In my past time go to the market

Look for food look for bargains

Find my friends sit with them

Talk about my granddaughter's wedding

How we found a husband for her

Same caste good parents many many lambs

One more to go one more to go

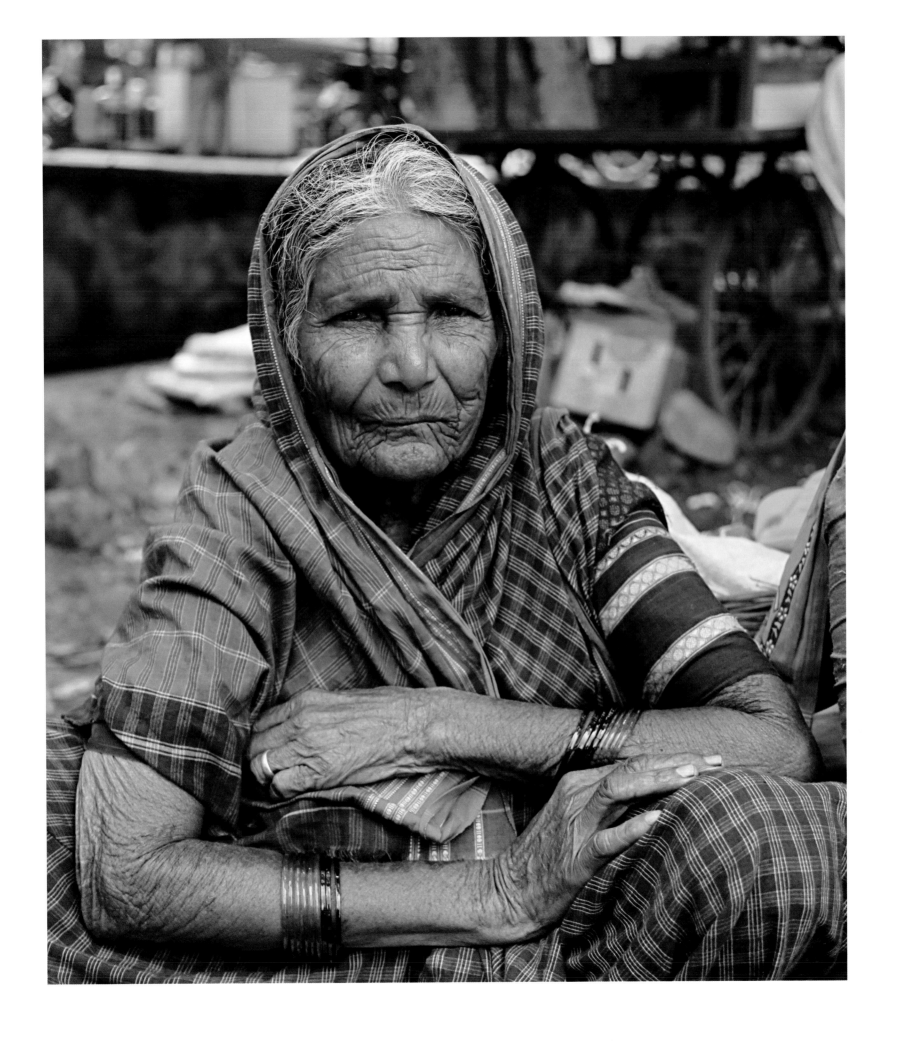

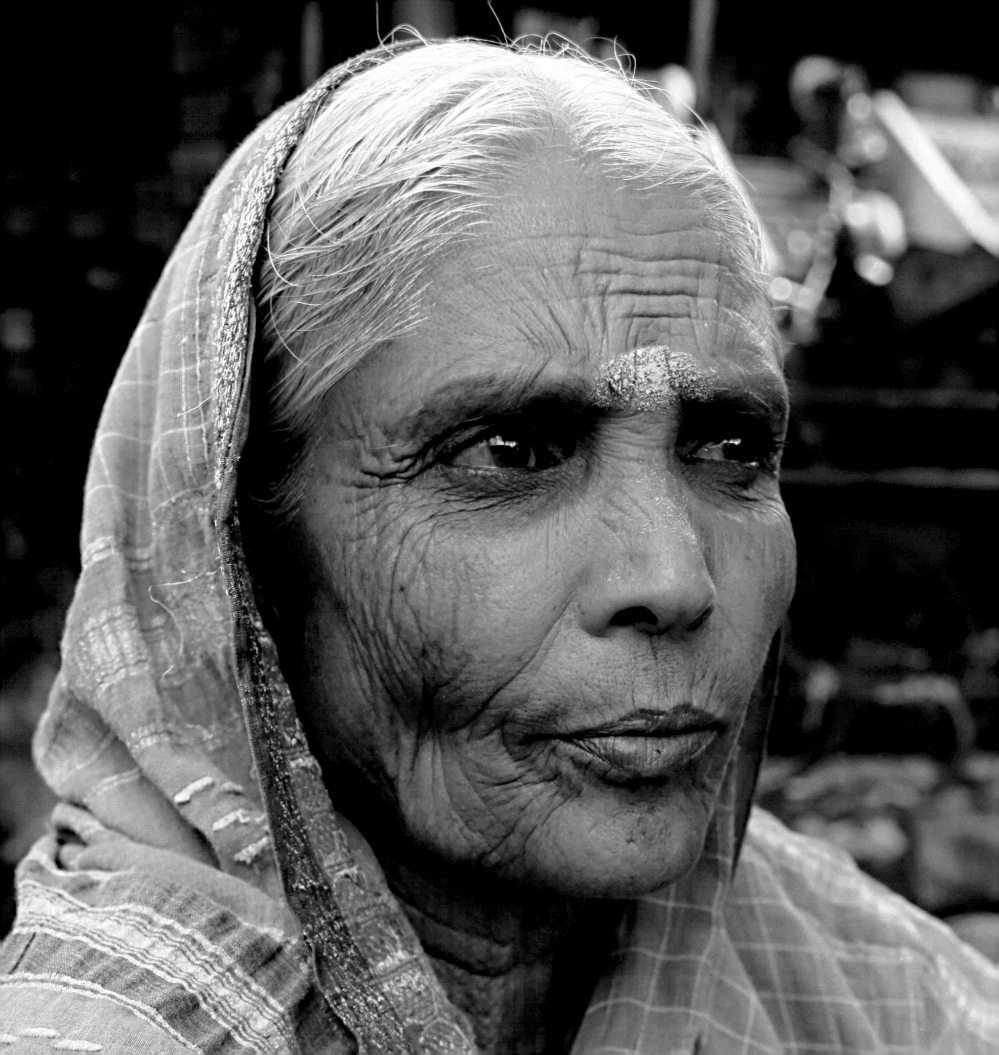

Quintessential mood

Ripples disappear in distance

Sentimental eyes

Pool of memories

Sad to see friend gone

Best fun was with her

Giggles still there

Wisecracker still there

Always a leader always brave

It's gone it's gone

Gets up in the morning

Walks through the field

Checks the early corn

Needs few days' rain

Through knee-high rows

Pulls unwanted weeds

Corn in a few weeks

Ready for market

Ready for roast

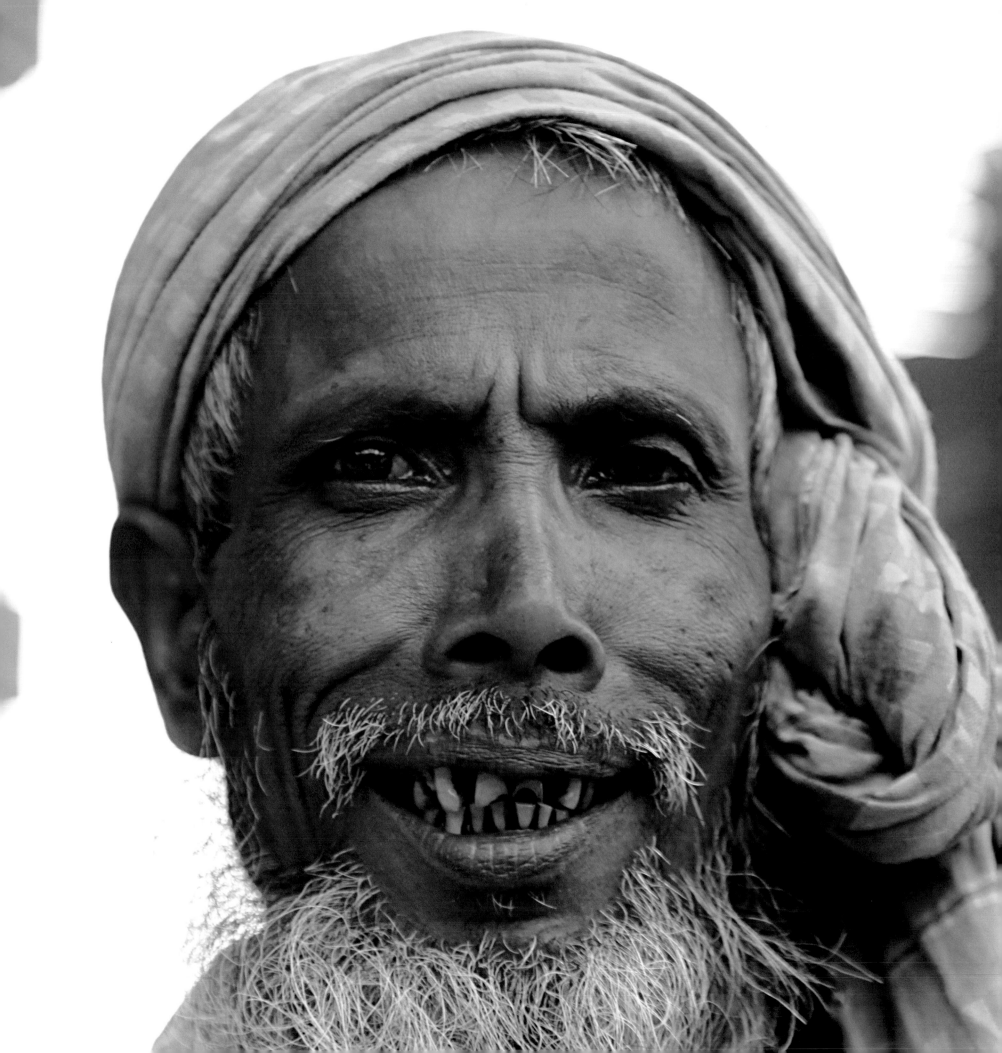

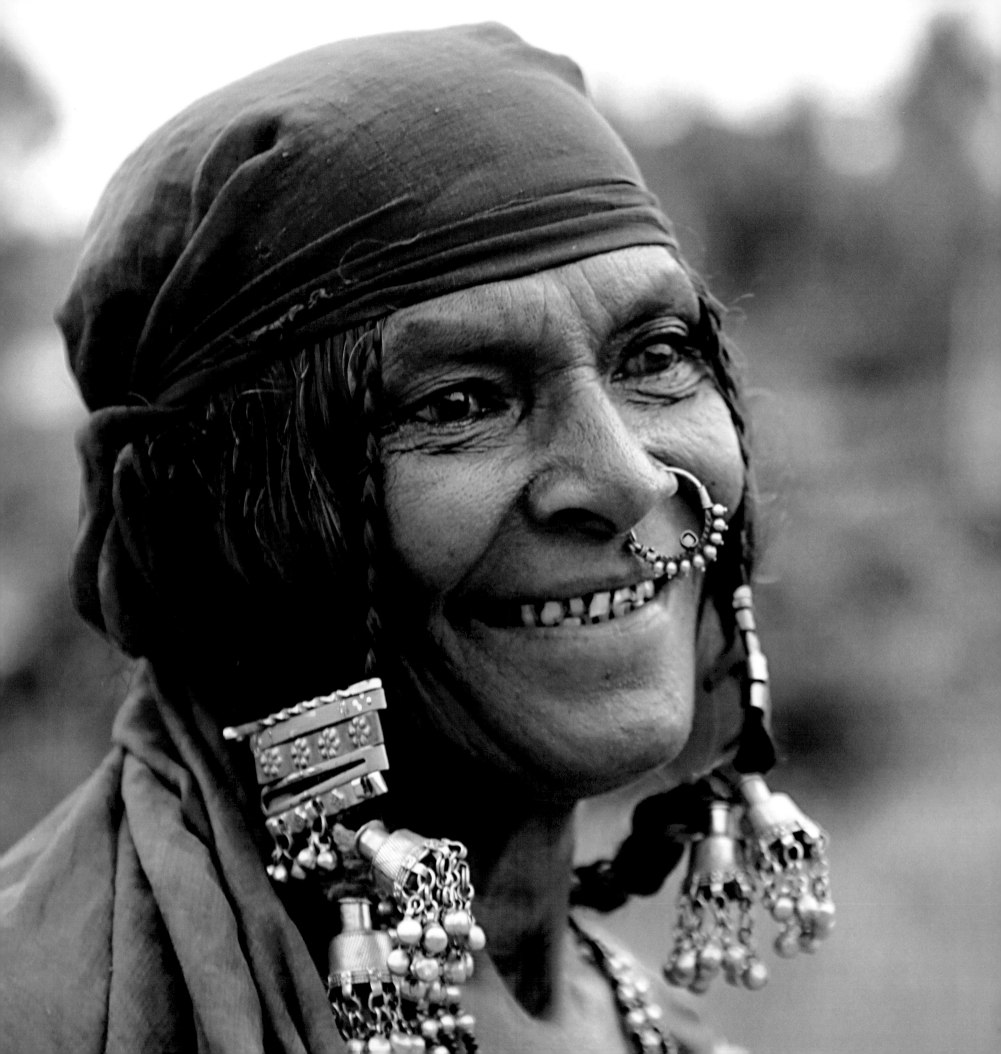

Born to have jewelry

Born to have color

Talent for intricate jewelry

Every moment a celebration

You everywhere

Brilliant color-coded clothes

Laugh smile the trademarks

Always noticed

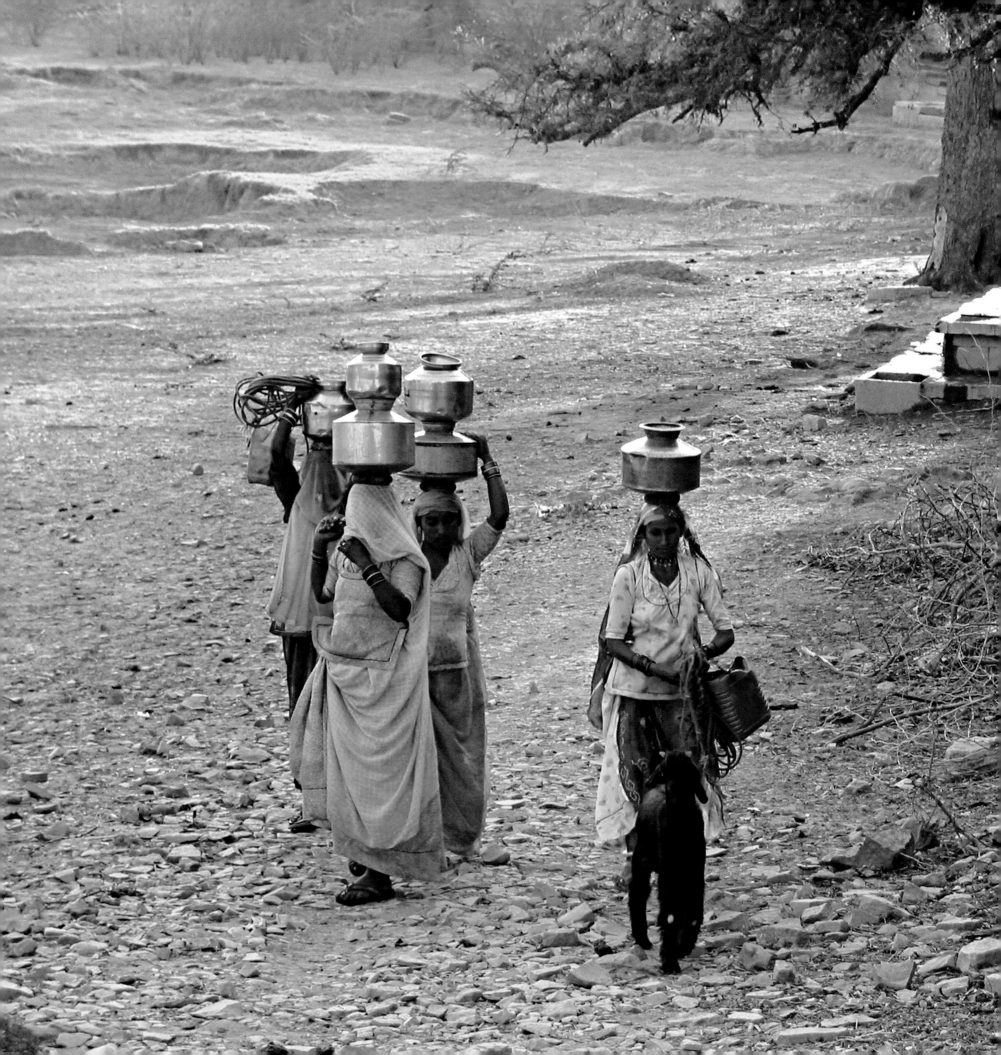

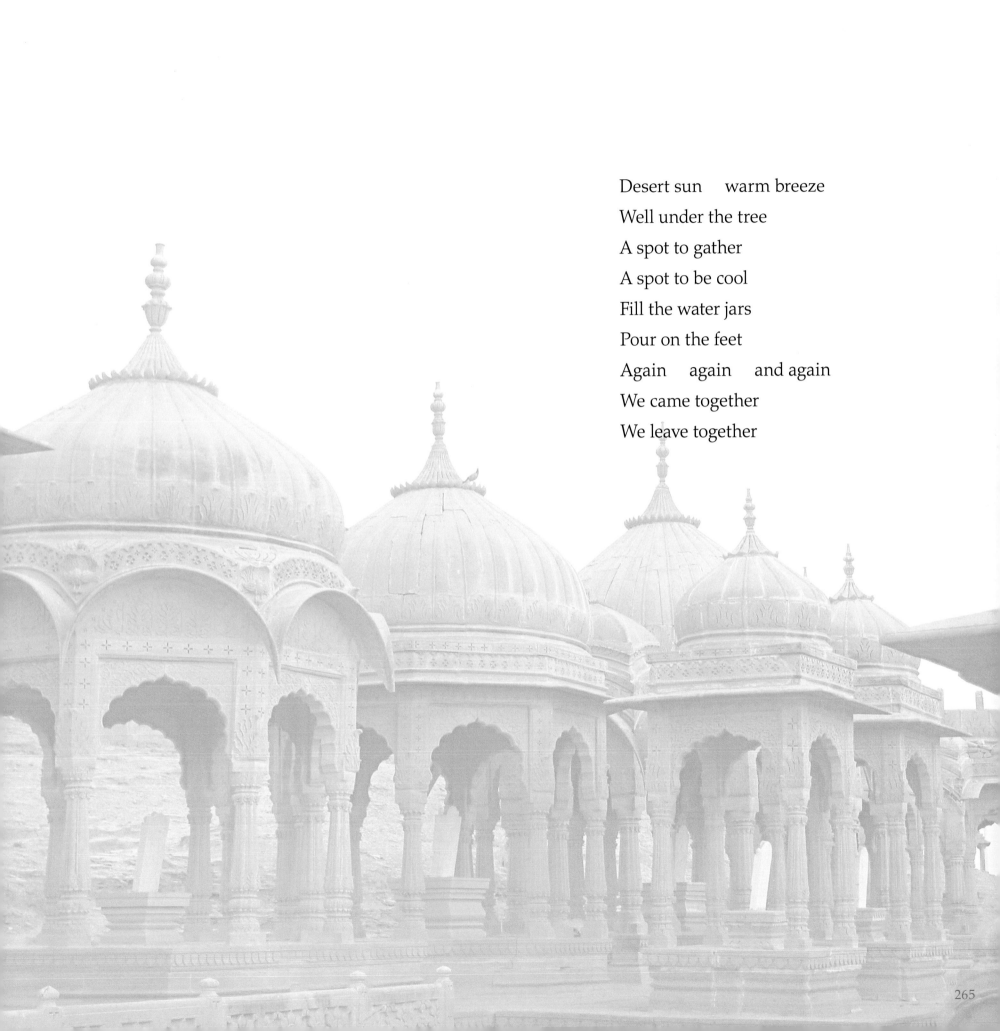

Desert sun warm breeze

Well under the tree

A spot to gather

A spot to be cool

Fill the water jars

Pour on the feet

Again again and again

We came together

We leave together

265

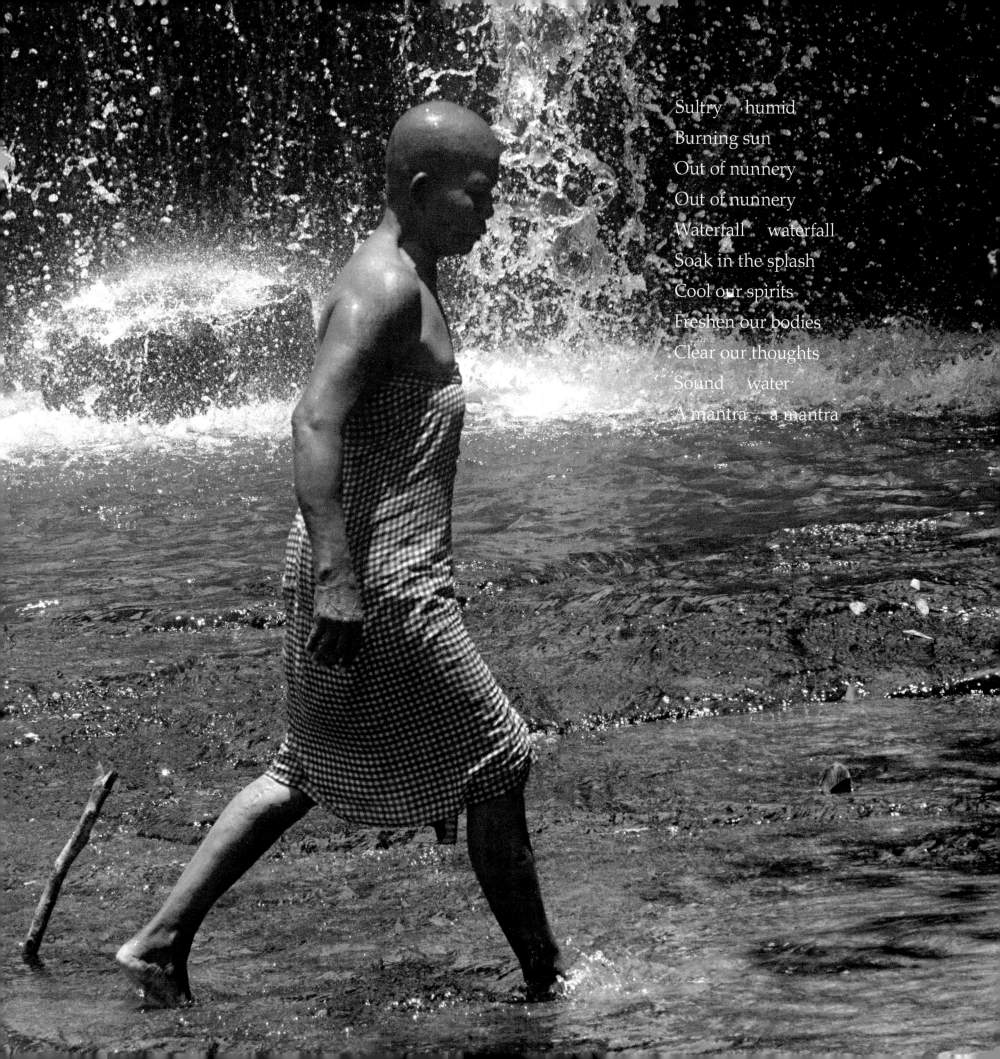

Sultry humid
Burning sun
Out of nunnery
Out of nunnery
Waterfall waterfall
Soak in the splash
Cool our spirits
Freshen our bodies
Clear our thoughts
Sound water
A mantra a mantra

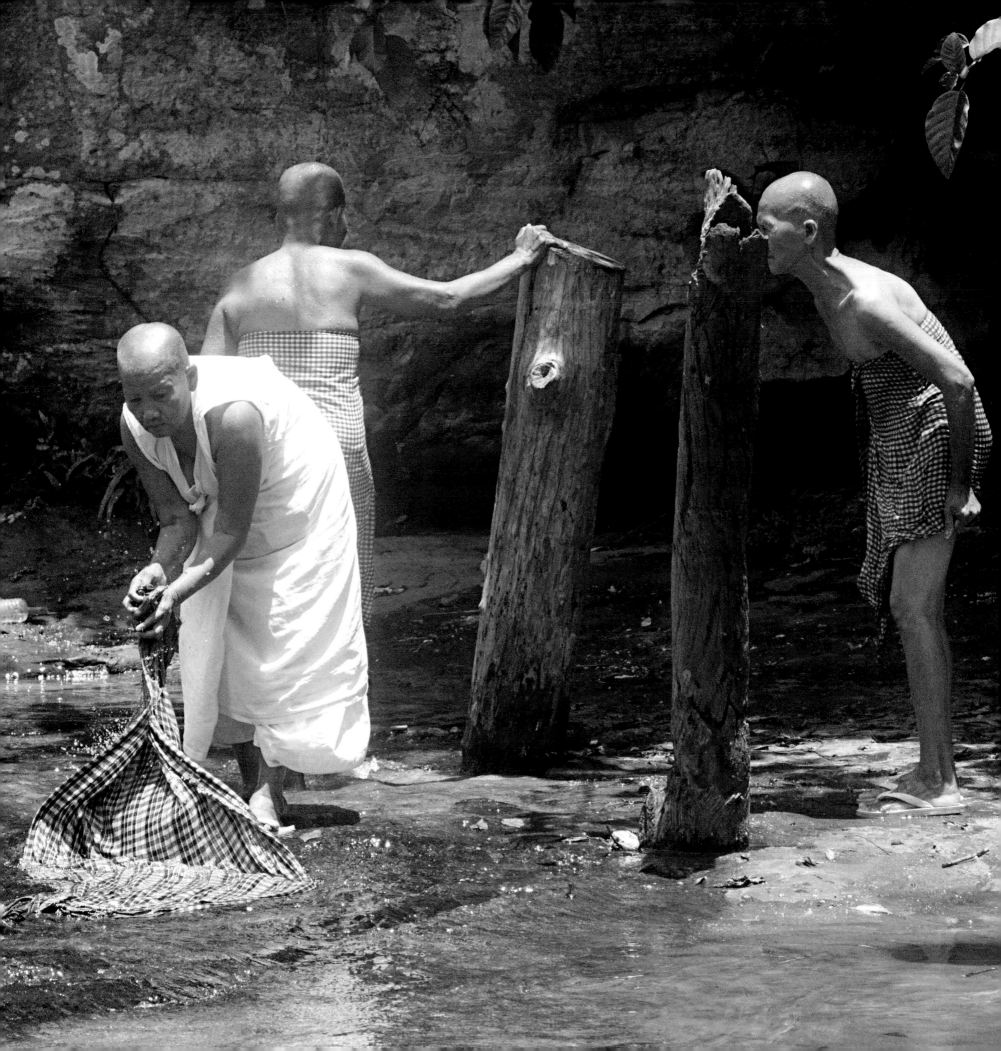

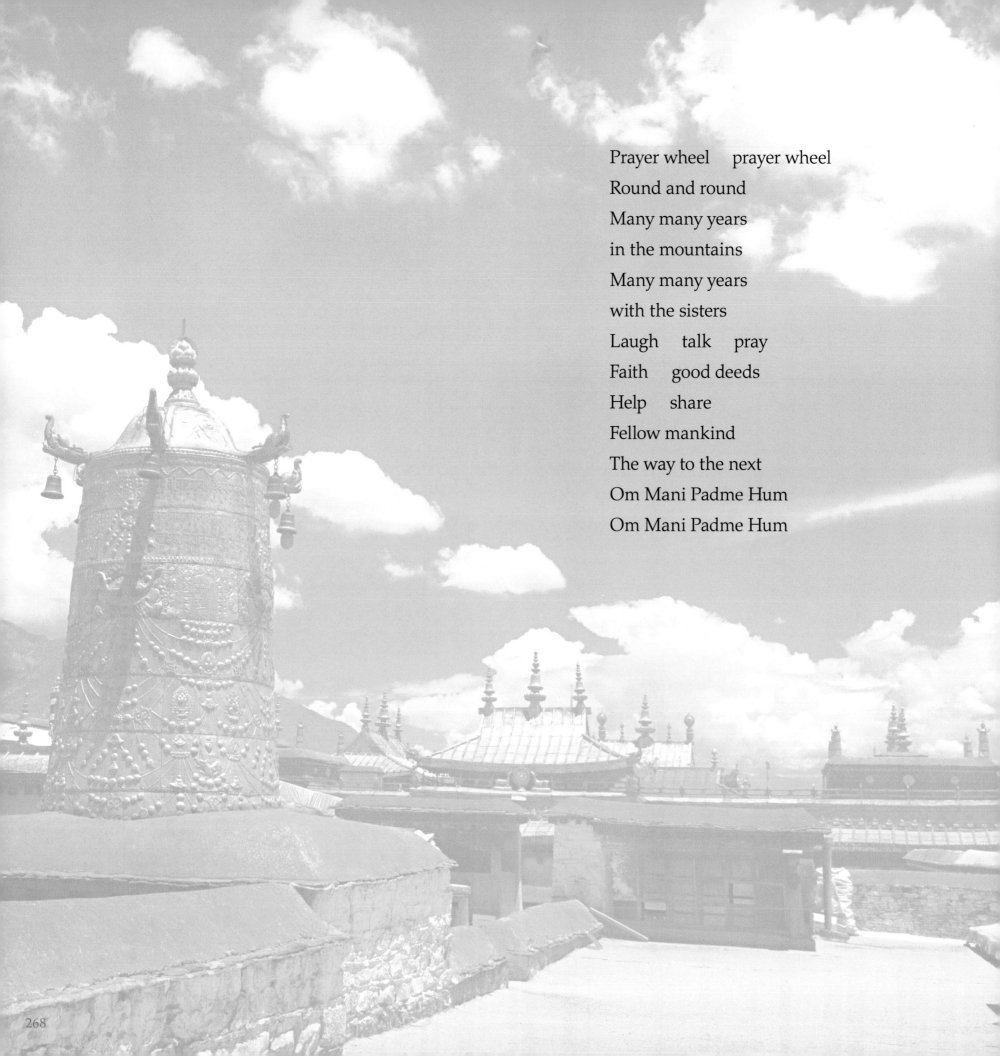

Prayer wheel prayer wheel
Round and round
Many many years
in the mountains
Many many years
with the sisters
Laugh talk pray
Faith good deeds
Help share
Fellow mankind
The way to the next
Om Mani Padme Hum
Om Mani Padme Hum

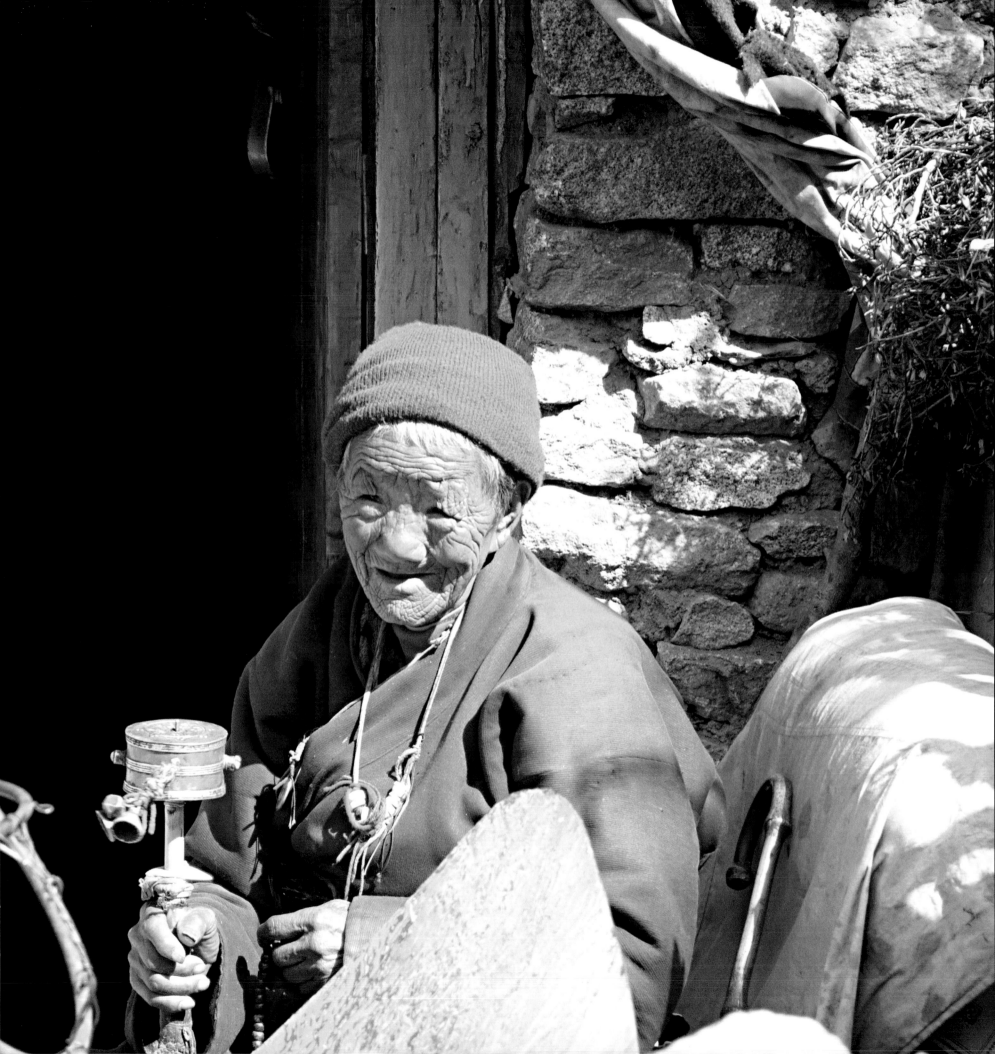

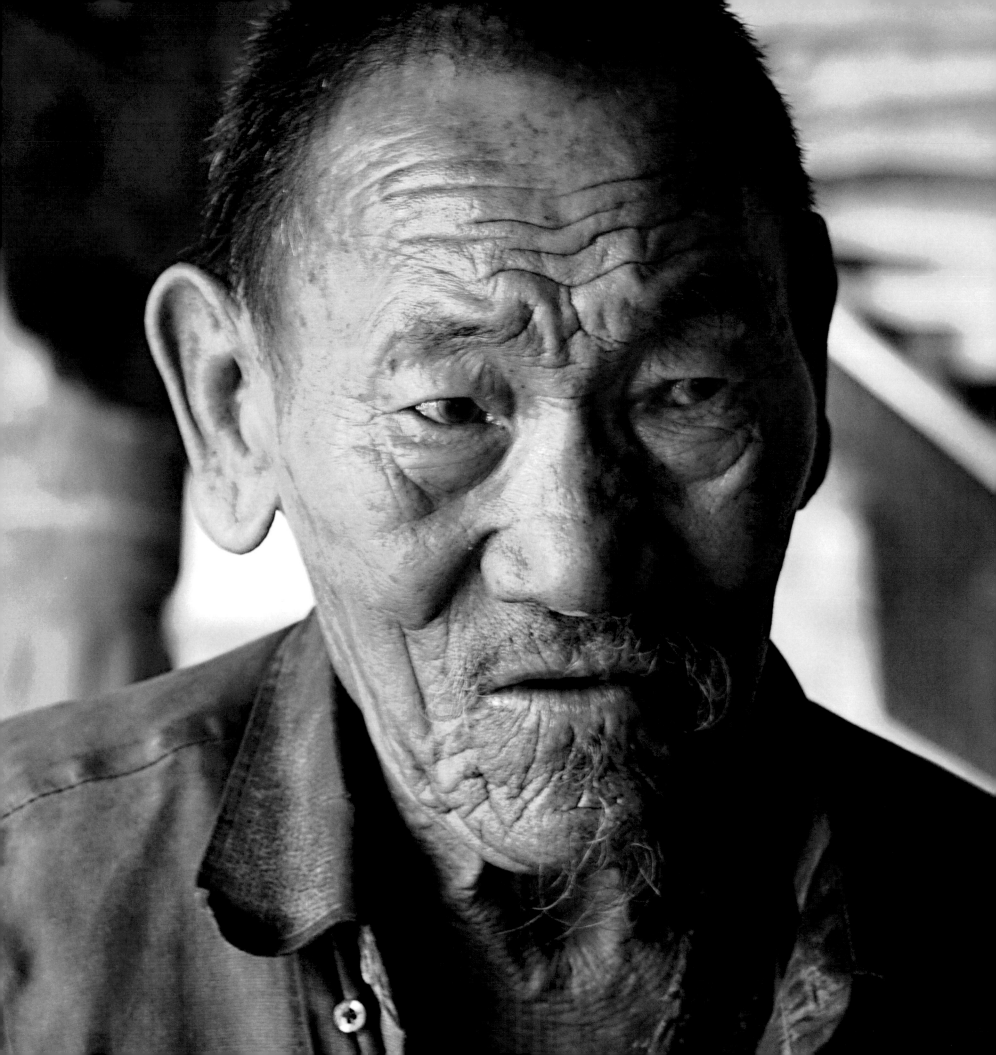

Chairs should be inside

Broom should be outside

Worshipers in

Worshipers out

Last fifty years

made sure made sure

Books in place

Tables in line

Hallway without dust

End of day

feel complete

Finish my day

I feel I touch I smell

This is my place

This is my home

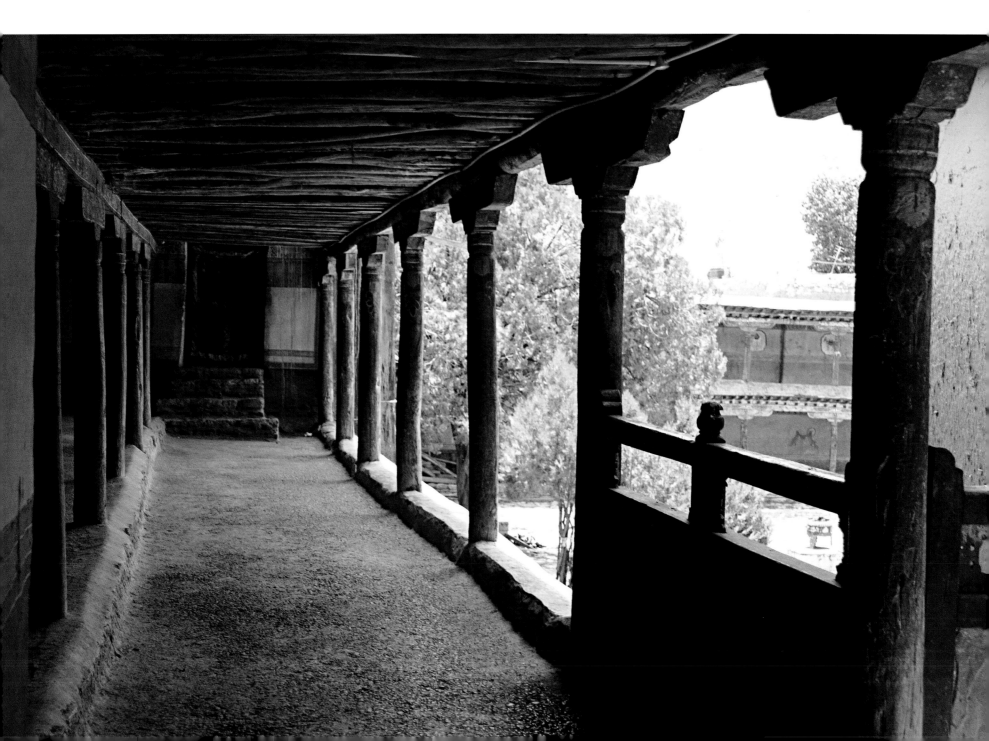

Pure air through my shack

Clear water through my feet

Feel light feel humble

Without burdens

Without desires

Without needs

Water is my prayer

Fresh air is my soul

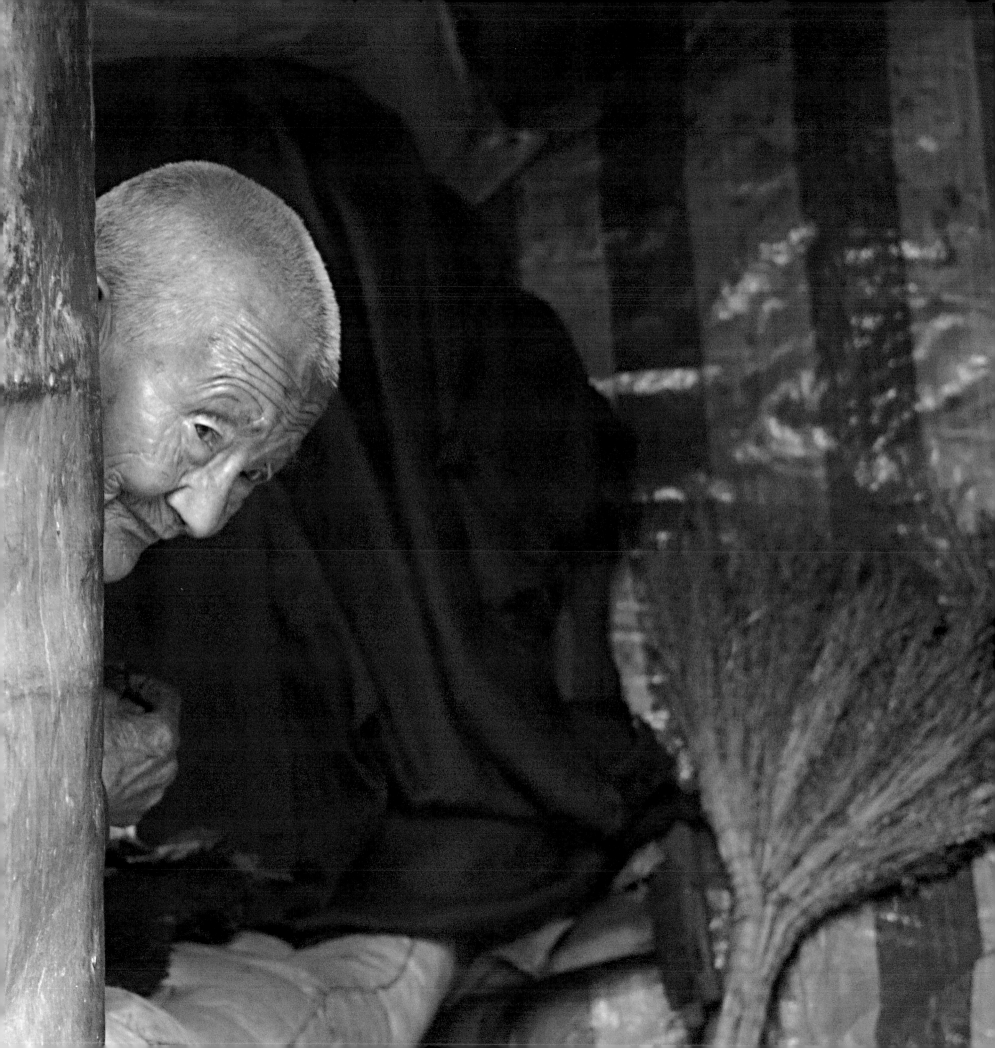

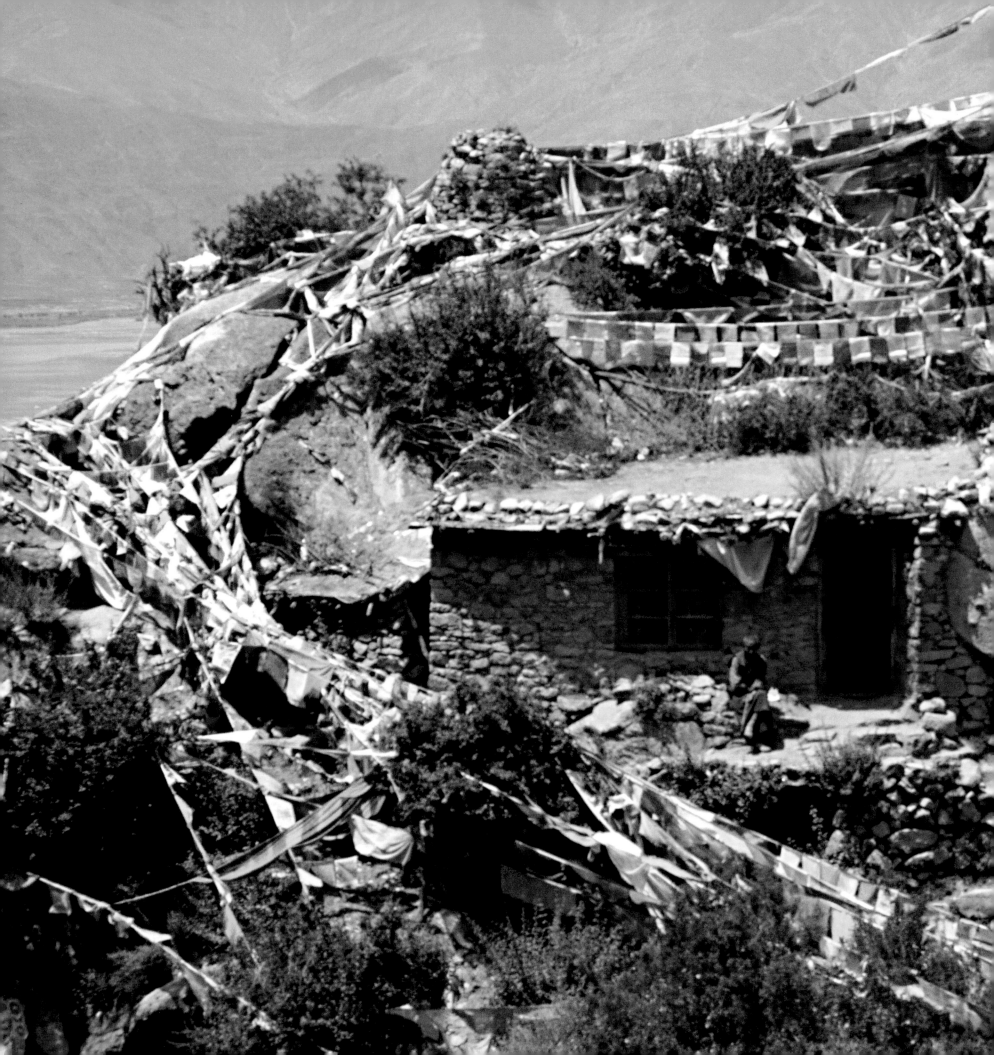

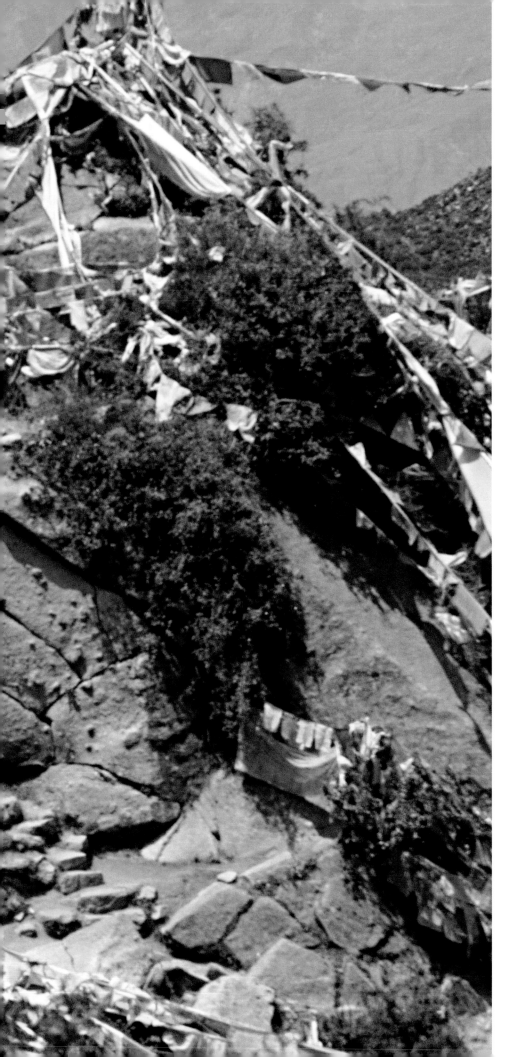

Top of the mountain

Cave shack home

Surrounded by majesty

Live study pray

Daily up daily down

Strengthen my spirit

Humble my soul

People climb up

Hang blessings

Flags flags flags

Red yellow green white blue

People go down

Fulfilled

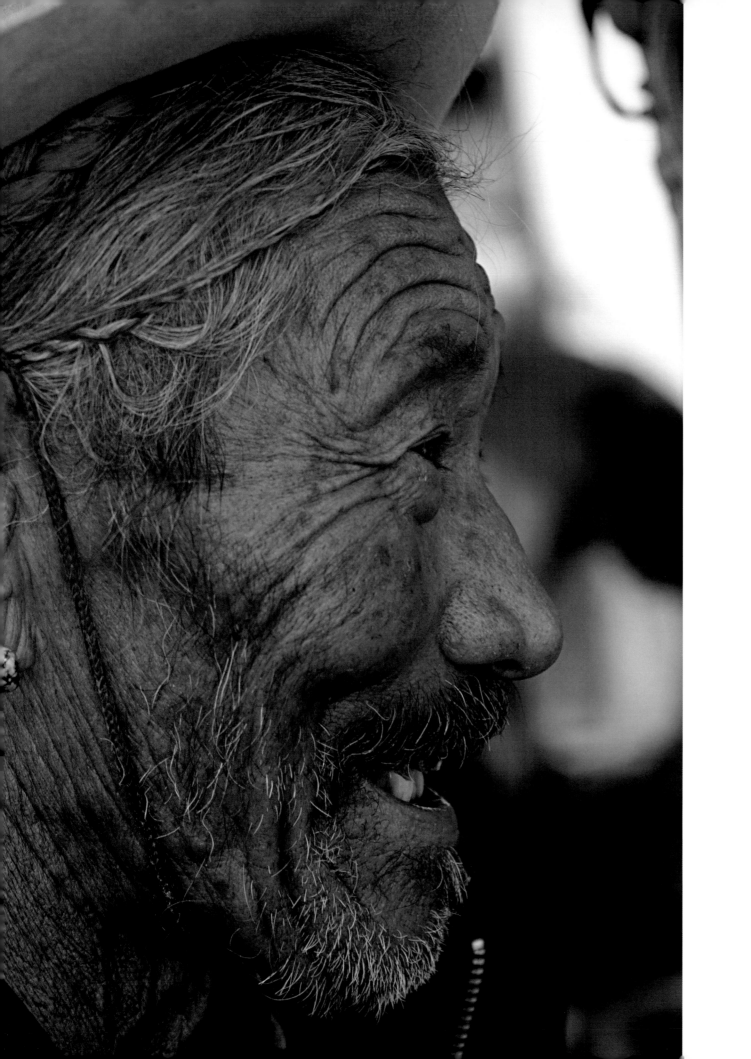

Skin of bronze

Years of experience on your face

Years of smiles carved in your face

Raspy voice with passion of caring

A father you dream to be

A grandfather you dream to have

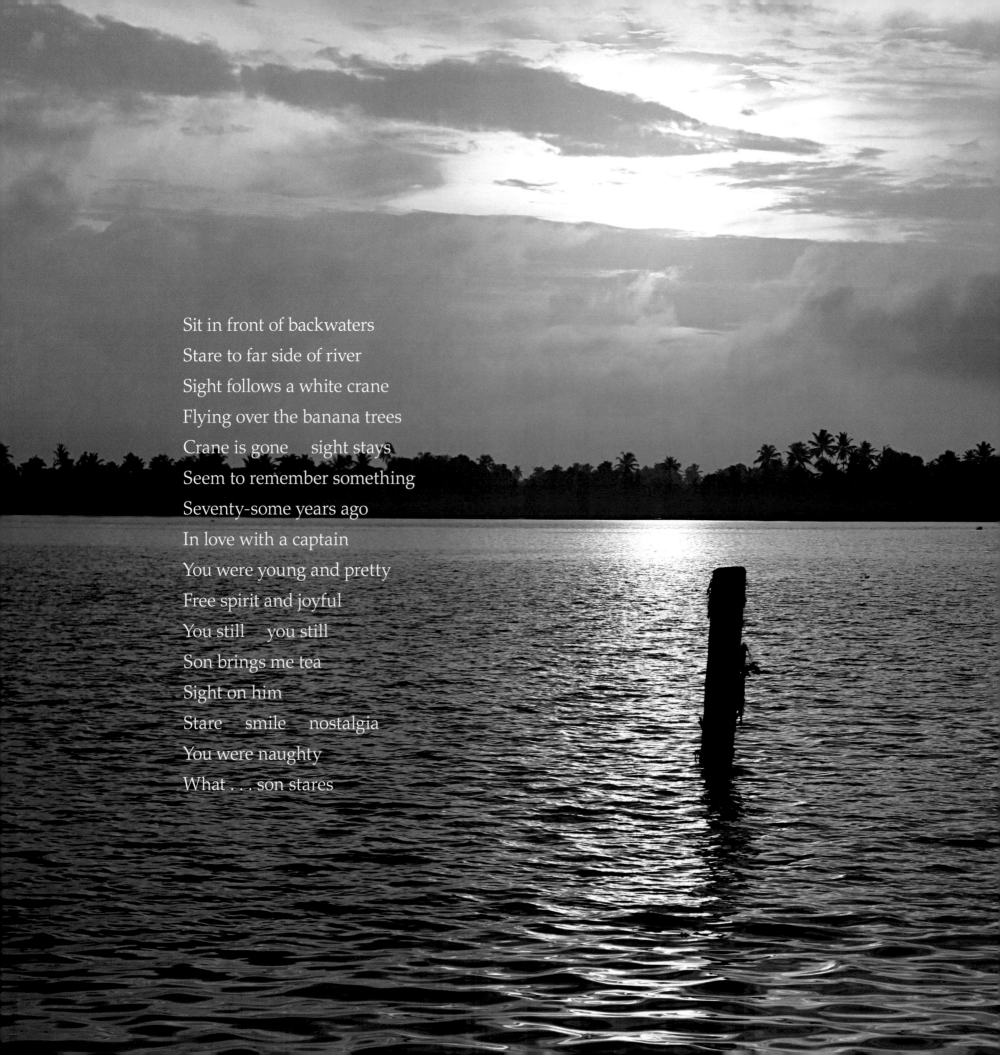

Sit in front of backwaters

Stare to far side of river

Sight follows a white crane

Flying over the banana trees

Crane is gone sight stays

Seem to remember something

Seventy-some years ago

In love with a captain

You were young and pretty

Free spirit and joyful

You still you still

Son brings me tea

Sight on him

Stare smile nostalgia

You were naughty

What . . . son stares

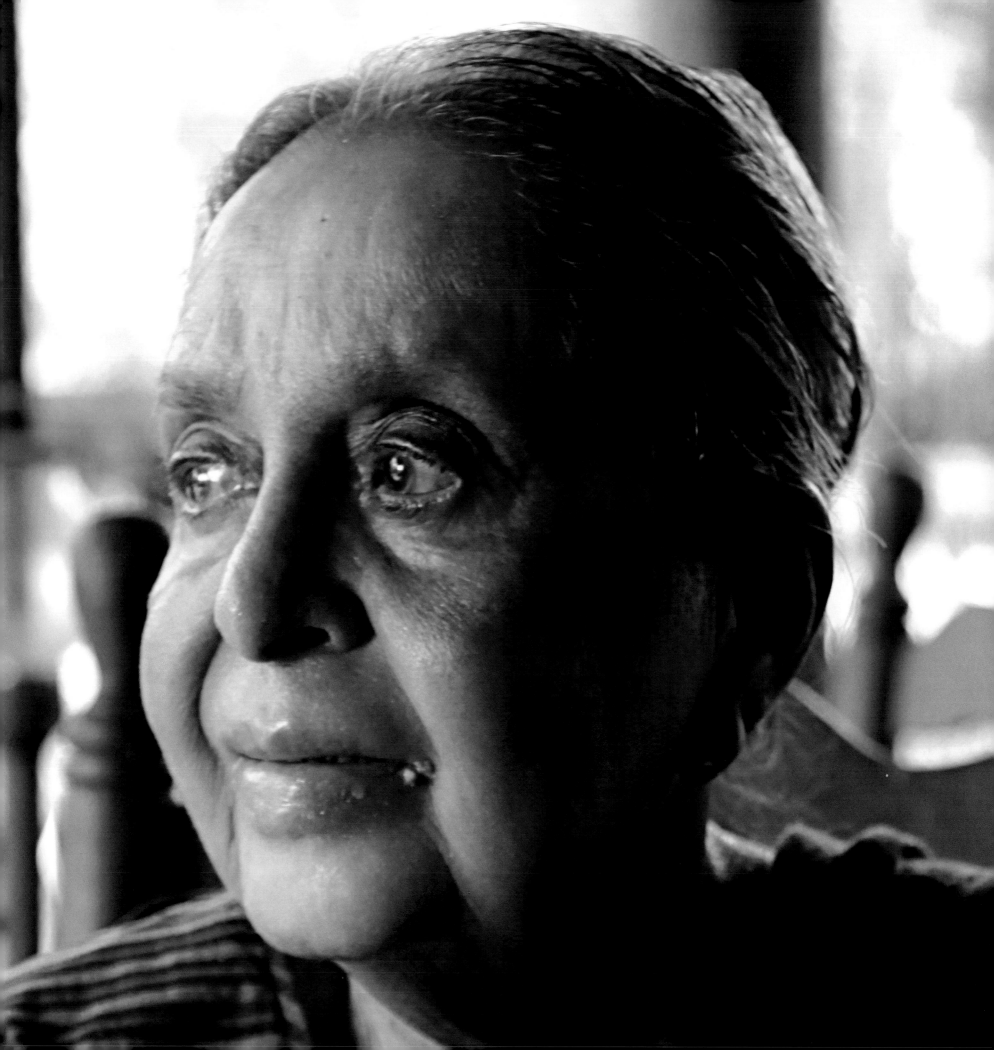

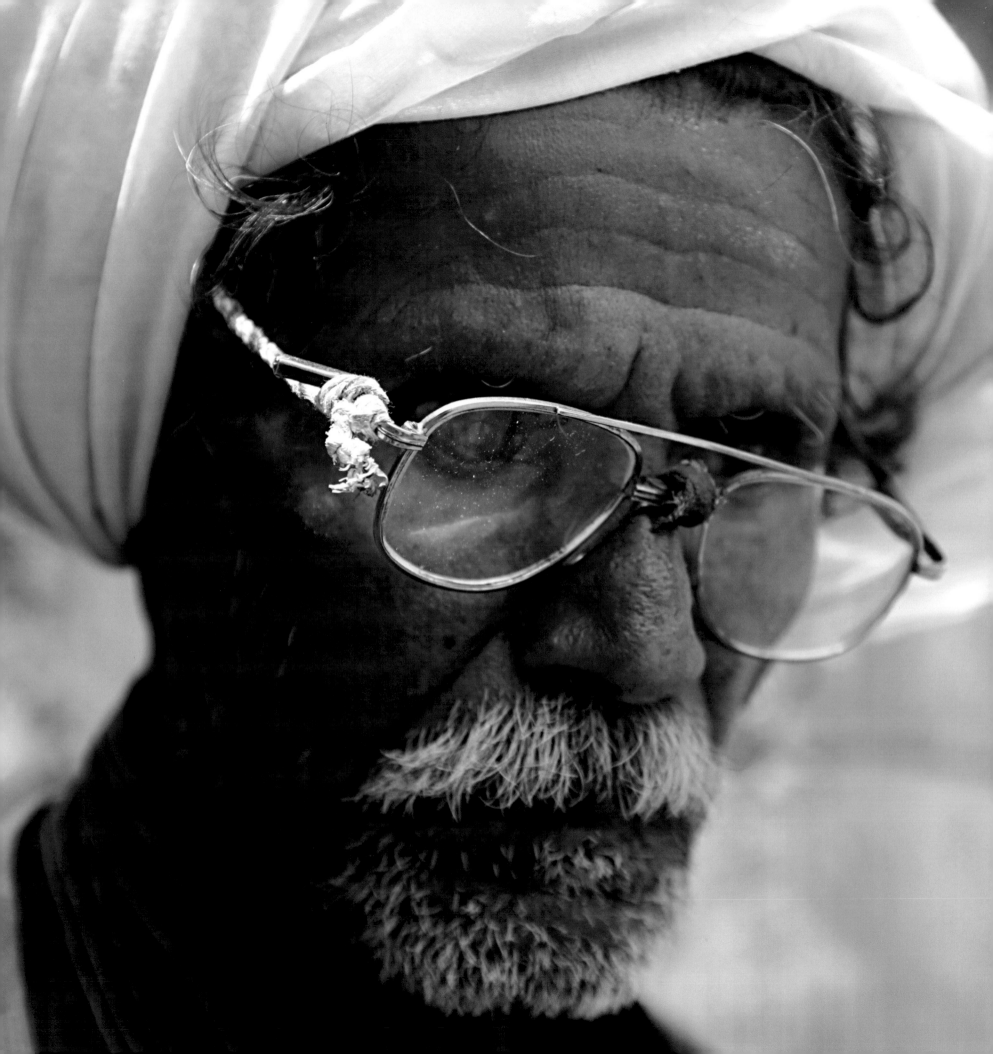

You sit on a rock

In front of the temple gate

Ignore the hot humid sun

Oblivious to the noise of people passing by

Your emotions seem still

Your eyes penetrate the earth

Profound deep intense

And yet your lips tight and firm

How I wish I am the one to understand you

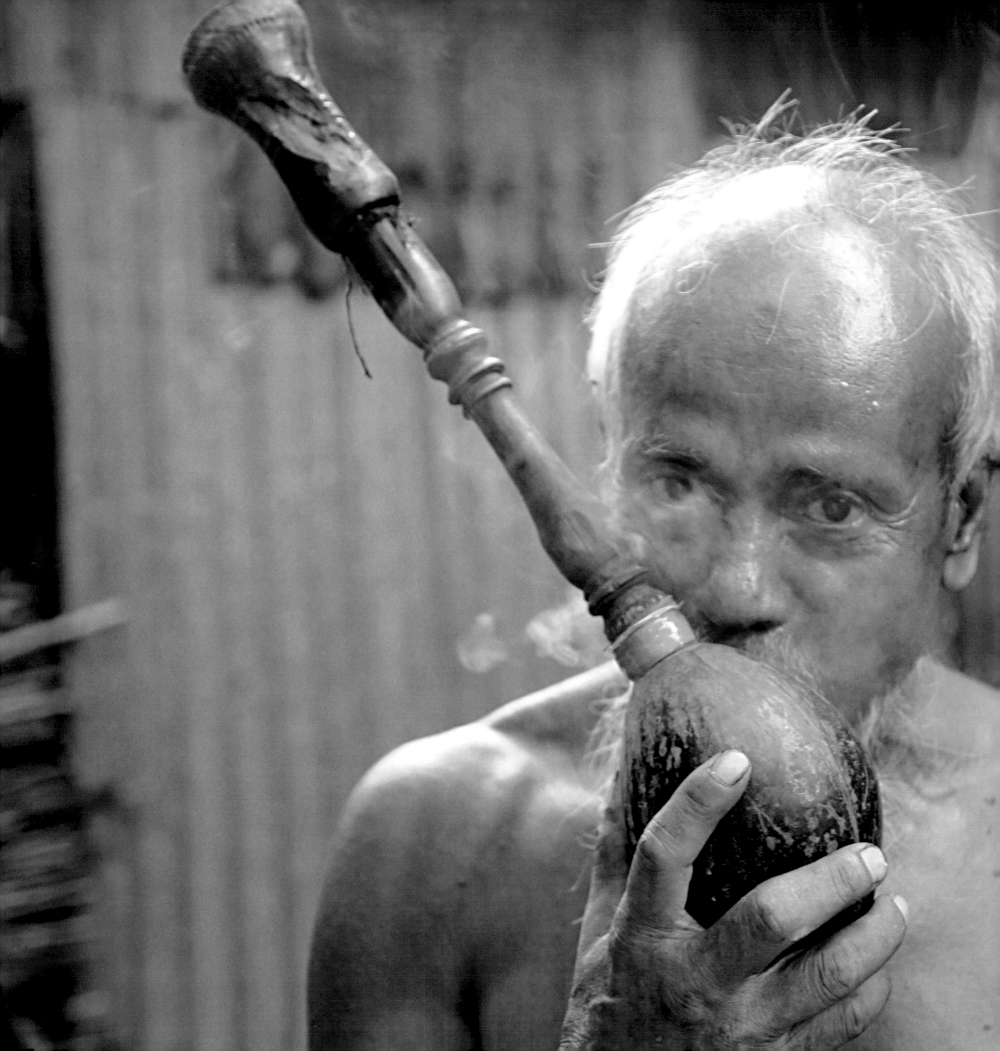

The smoke
Your eyes slowly close with inhale
Your eyes slowly open with exhale
You extend the flowing smoke
as long as you can
You walk you smoke you think
Sons grandsons family
This is the place you always want to be
Great feeling
Another puff

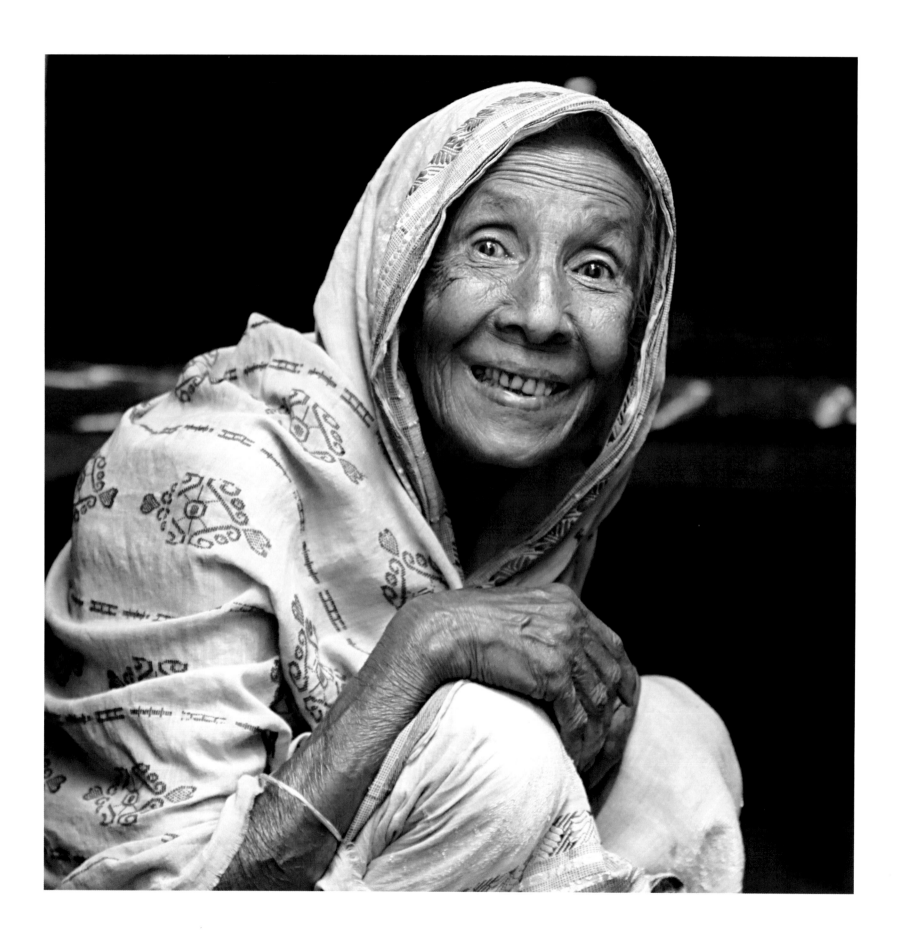

Bright yellow is my color

Little pattern pleases me

Don't know why it always lifts my spirit

My daughter knows that

My son knows that

Little do you know

I am in a yellow world

Hope just hope

My granddaughter has the same taste

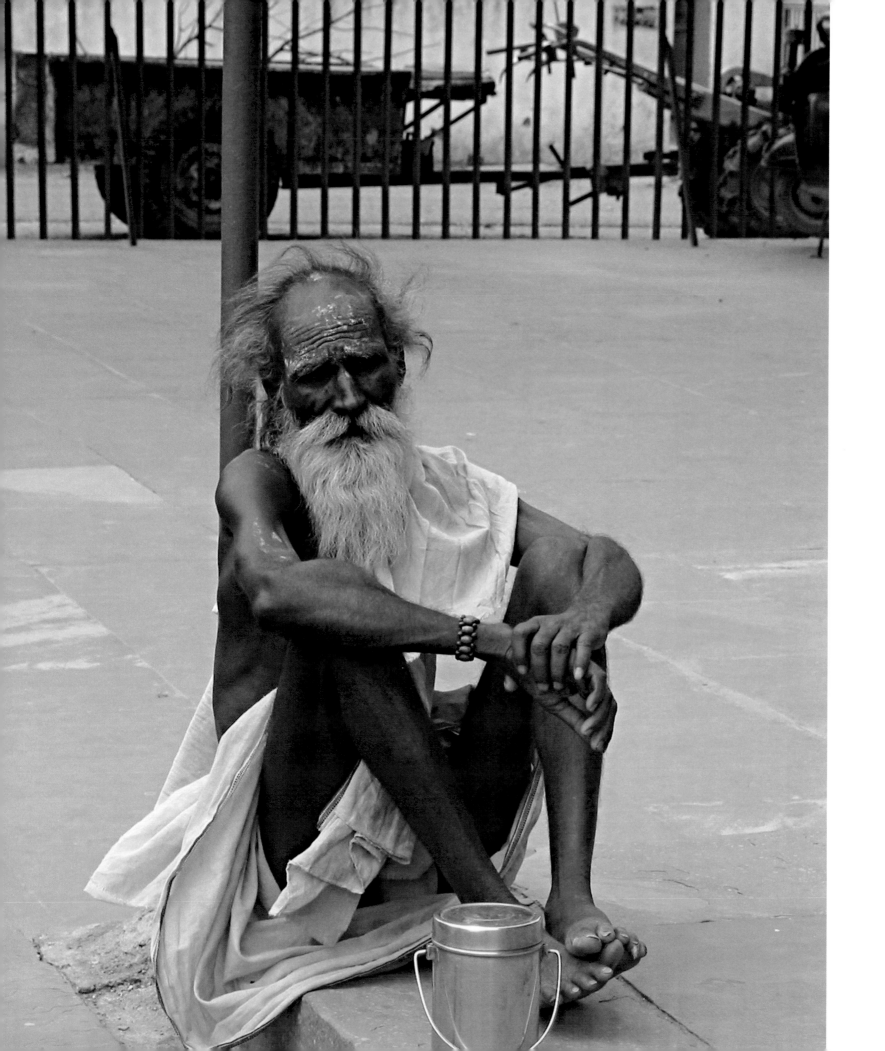

Since morning

I walk I visit

I do my chores

Tired hungry

I sit down

Feel the dryness

Feel the breeze

Open my lunch

Smell the taste

Feel at home

Close my eyes

A rest a needed rest

Try not to think

Try not to think

Take me just take me

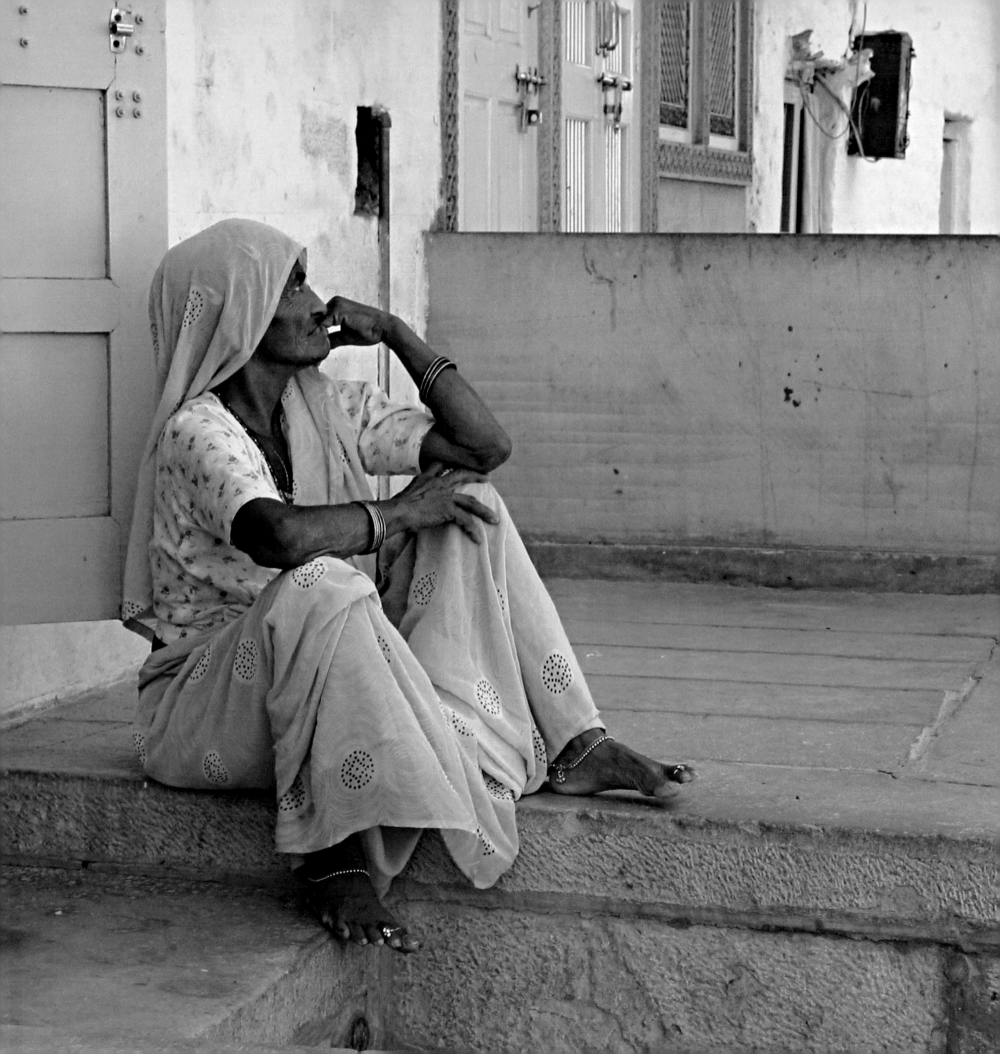

My usual spot

Like to sit here

Think about my children

Think about my neighbors

Look at the sky

Watch clouds pass

Think of my lives

Think of my days

What to cook what not to

What they like what they don't

Did I forget to say thanks to my next-door neighbor

Did I forget to give sweets to the neighbor across

I like my moment here very moment here

To think not to think

ASCENDING

I leave this world with nothing

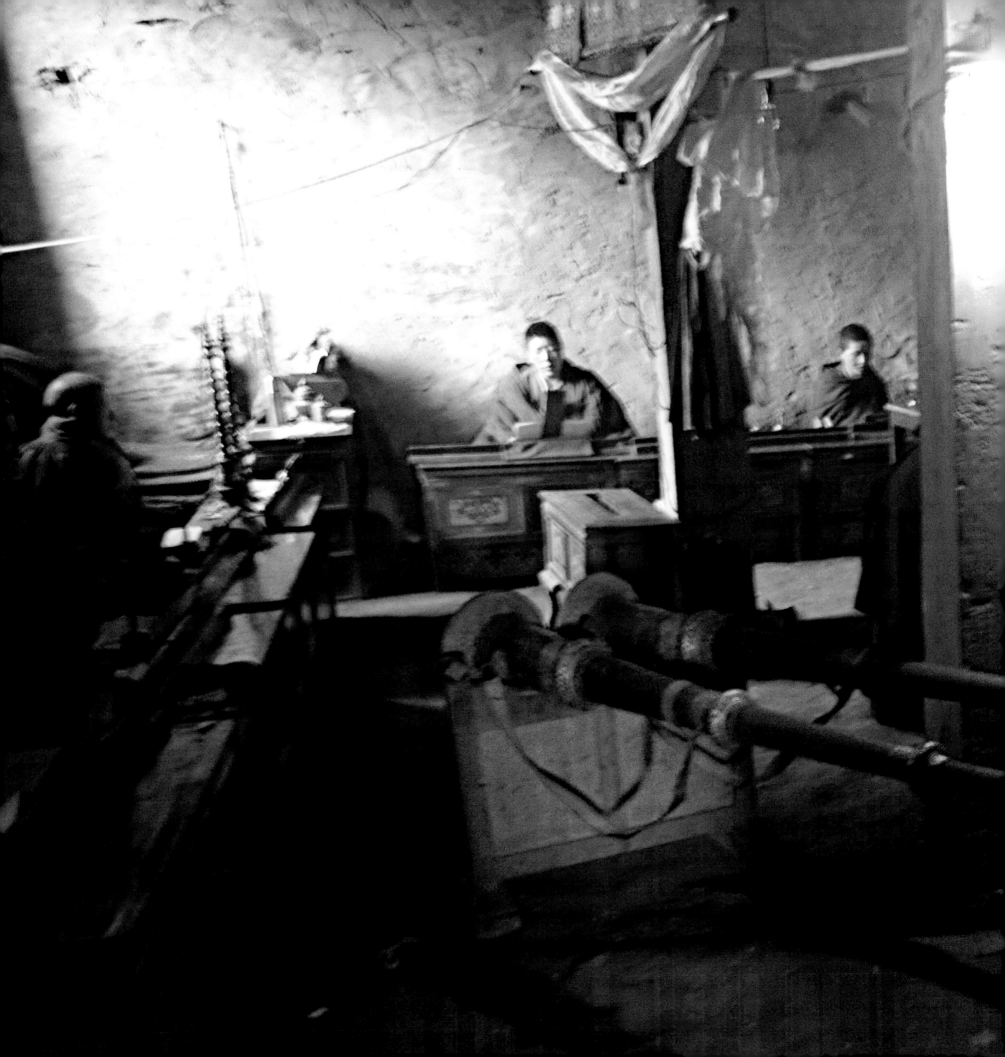

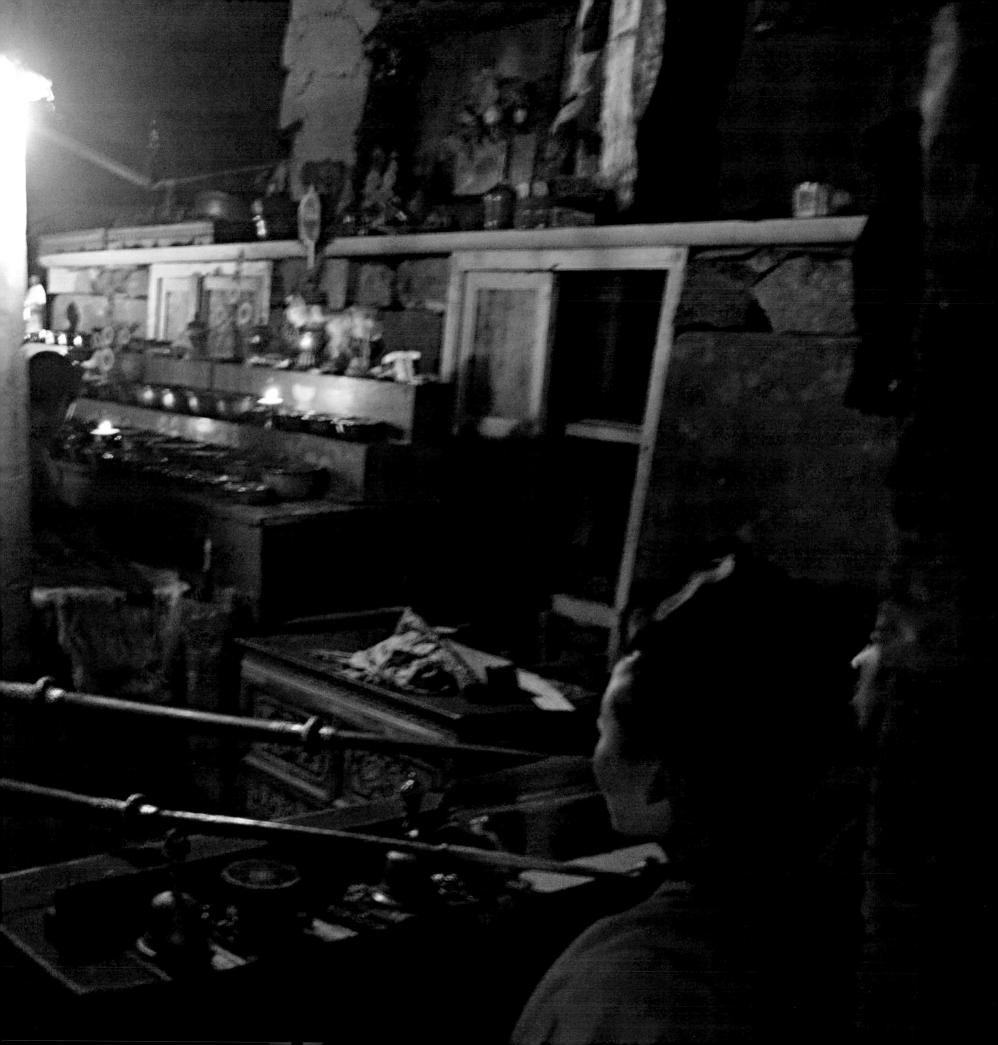

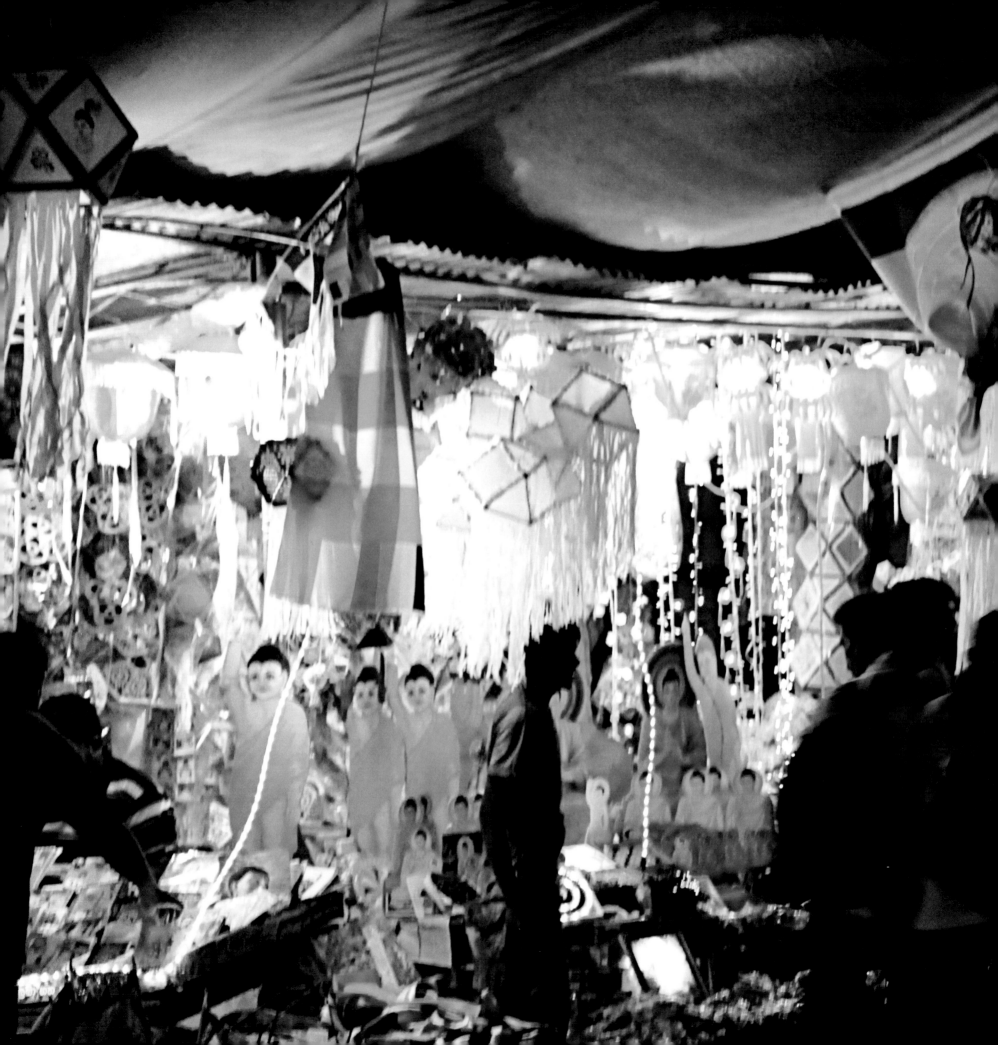

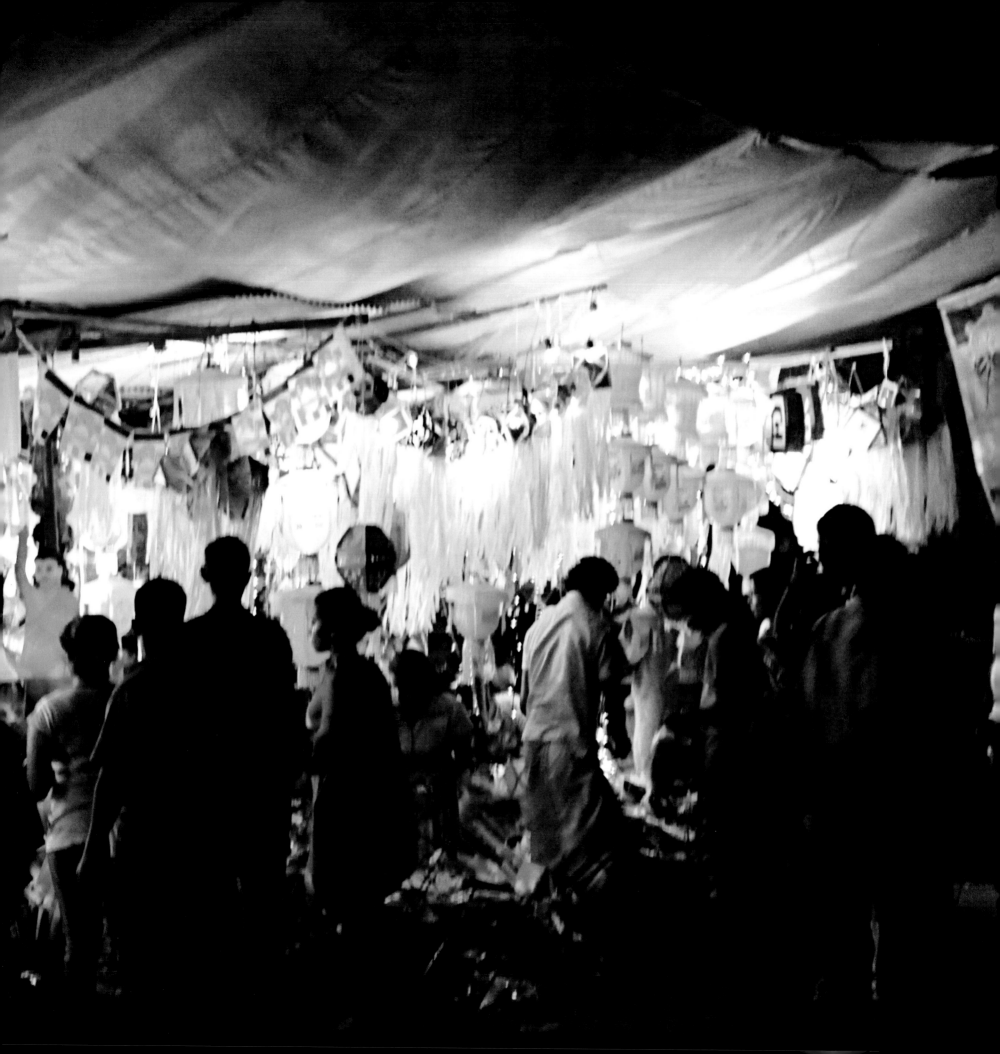

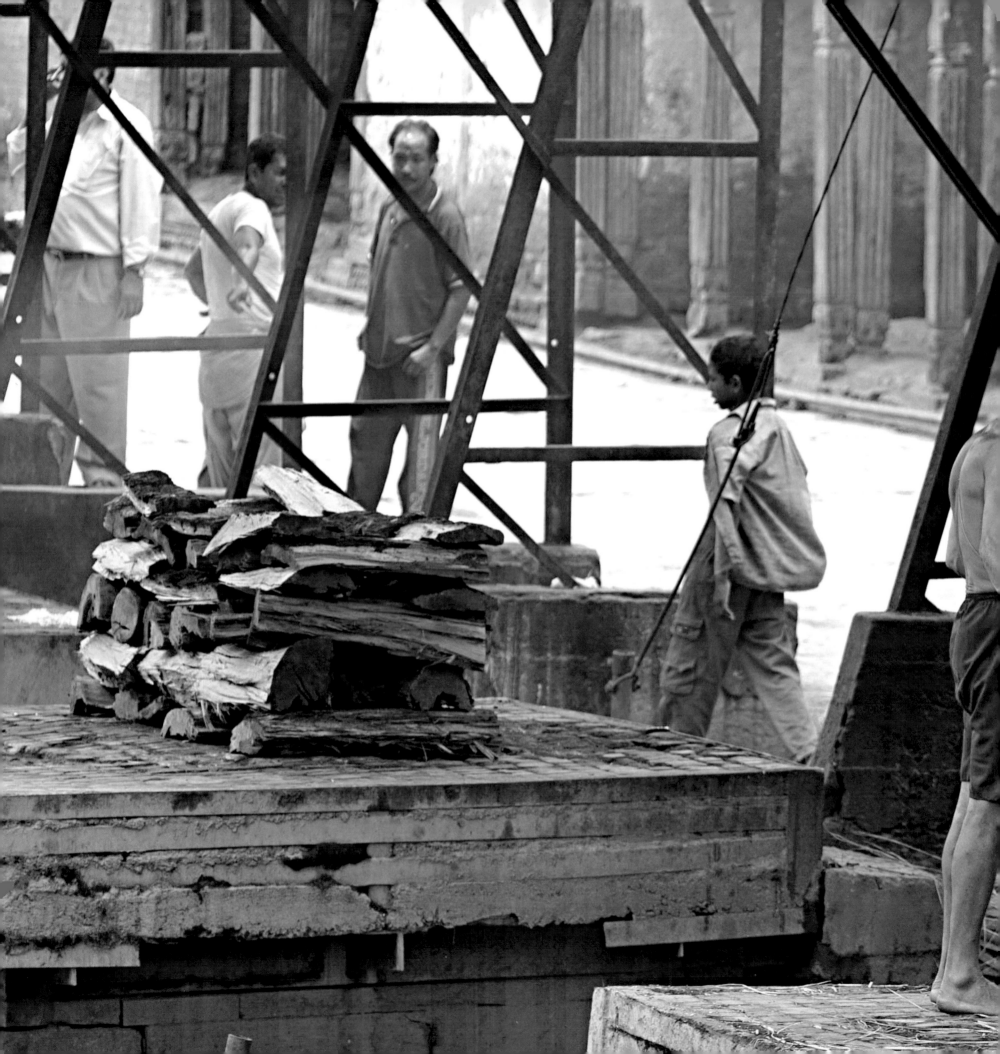

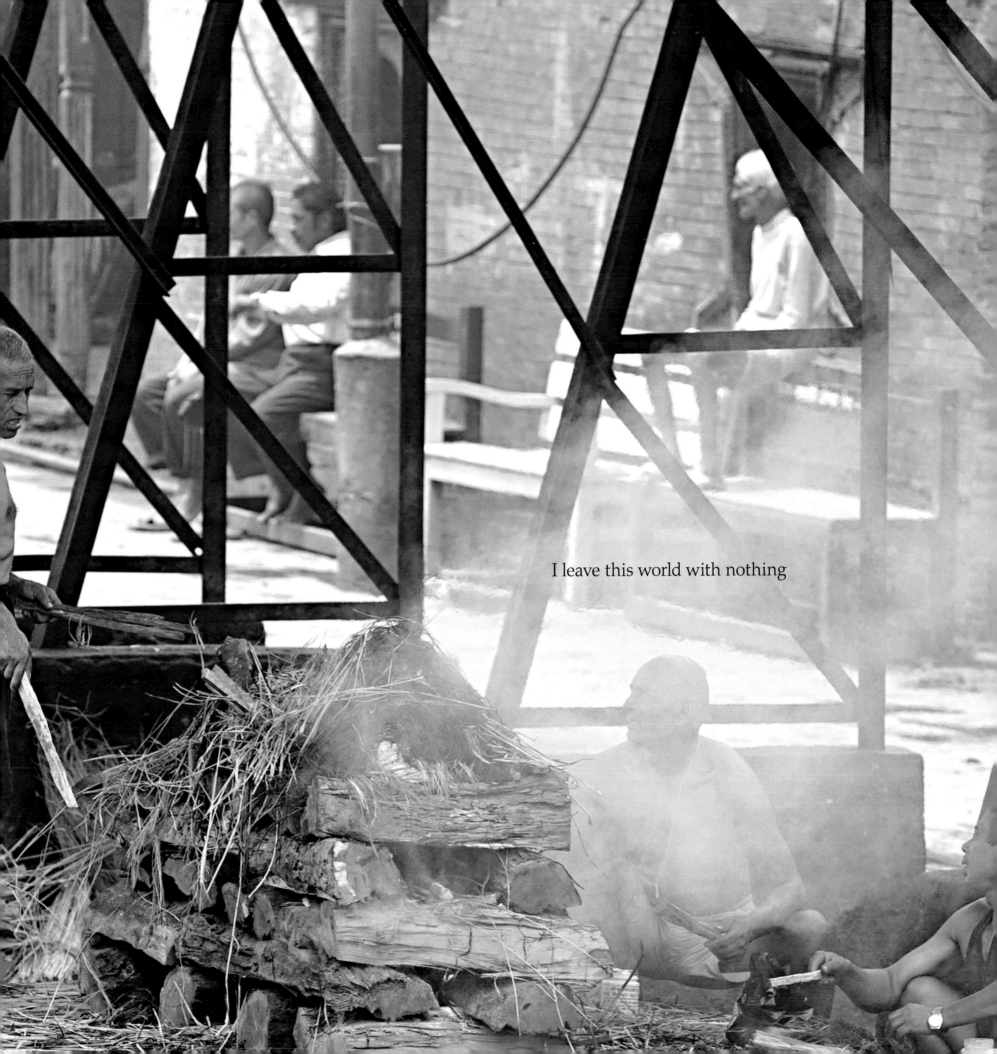

I leave this world with nothing

A cluster of clouds

Journeying through life without a plan

Just like the cluster of clouds

Going with the flow

Anything goes

Catching the moment

If I don't I will be dark I will be gray

I will be yellow orange red

Through my eyes the world is the same way

I go places I meet people

I find that moment

That moment finds me

Challenges me excites me intrigues me

Makes me cry makes me laugh makes me think

Before they change

Before they slip away

Going places meeting people

They are my canvas

They are my films

They are my paintings

They are my photos

Catch me when I am still me

BING YANG